ASIA

OLIVIER FÖLLMI

Preface by José Frèches

Design by Benoît Nacci

Captions by Virginie de Borchgrave d'Altena

ASIA

ABRAMS, NEW YORK

The Worlds of Asia

To honor the recognized wise men; to number the righteous
to tell the world once again that this or that man lived,
and was noble and his countenance virtuous

—Victor Segalen, "With No Reign Mark," from *Stèles*

When we think of Asia, of its peoples, of its thousand-year-old civilizations, most of which—how fortunate for us all!—still rise to the surface of the sea of global modernity that has swamped our world, we must guard against hasty judgments; we must put away the cheap stack of superficially exotic postcards that too often define the continent.

The Western world has always seemed inherently unable to understand Asia—an Asia extremely distant, it is true, from Occidental rationality—and this, together with their desire to rule the rest of the planet, has too often caused Westerners to believe their values superior to those of Eastern civilization. Pierre Loti and Victor Hugo bemoaned this attitude when recalling the October 1860 looting and burning of Beijing's Old Summer Palace by the French and English, which irresistibly summons up the cliché of the bull in the china shop. Imagine if the Chinese army, having reached Paris on their war junks, had torched Versailles. For Loti, this destruction represented "the collapse of Peking, and thus the collapse of a world robbed of its prestige and stripped of its mystery, the destruction of one of the last refuges of the unknown and of the fabulous on earth, one of the last remaining centers of ancient civilization, incomprehensible, even a little mythical, to us now." As for Hugo, he compared France and England to "two bandits returning to Europe arm in arm, smiling," having accomplished a dirty job.

"Having forgotten the difference between themselves and others after speaking of gentleness and compassion," as expressed by the great sage and Tibetan monk Milarepa (1040–1123), and also reflected by Danielle and Olivier Föllmi in this volume who, to borrow the striking words of the Scottish poet Kenneth White, invite the reader into a "luminous chaos," a leap into the waters, sometimes calm, sometimes tumultuous, of "incomprehensible beauty."

All things considered, instead of "Asia" we should speak of "Asias," this multitude of worlds evoked by the Föllmi's vision, both fascinating and plural, of this teeming constellation of countries and peoples, impossible to define in a few words. This Asia of diverse languages and civilizations is presented here in the form of an homage: to its immense spaces—sometimes dizzyingly vertical, sometimes stretching flat to the horizon—broken up and continuous at the same time; to its sublime, ruined walls, reaching up toward the sky; to its plants, by turn twisting, creeping, climbing, even zoomorphic in form, ingeniously finding a way to penetrate the narrowest crevice and to colonize, sometimes completely incongruously, the smallest fertile space; to the sun that dissolves the mist whose writhing forms fill chasms and wreathe the mountaintops; to the rain whose heavy curtain beats down upon the fragile hat-umbrellas of women who pick rice and brightens the orange robes of monks walking to the pagoda. . . .

The contrasts can be extreme: on one hand are the opulent gardens created by mountain farmers, terraced rice paddies sculpted by water buffalo; on the other is the choking, sandy dust blown down from the northern deserts, against which China struggles—a task that makes the the travails of Hercules seem the merest peccadillo—to establish a pathetic barrier by creating what has been dubbed the Great Green Wall.

Yet all in all, nature has been hospitable in Asia. Along the continent's immense rivers, most particularly in China, on the banks of the Yellow River, a nomadic population settled ten

thousand years ago to form the most numerous people in the world today. The various peoples of Asia have gathered together in the same places, where they live together in harmony, despite their demographic density.

But if we needed to extract a particular element from the kaleidoscope to show the singularity of Asia—because it truly is singular, and all lovers of Asia know this—it would be the extremely graceful gestures of the Asian people.

As for the rest, words are inadequate to describe the forms, colors, odors, and flavors of this fascinating continent. Still, a few key words, perhaps, might help convey to the reader the secrets of these ancient civilizations, which will never release their hold on you once they have claimed your heart.

Time.

Let us imagine the people of Asia the way Paul Claudel described them at the beginning of the twentieth century in Fuzhou, the Chinese village where he was consul. To illustrate the relativity of our lives and points of view, he wrote that, at the very moment when Napoleon was suffering his defeat at the battle of Waterloo, a fisherman was emerging from the Indian Ocean after his exhausting dive. At the moment that we wrote the lines you are reading now, a woman was breastfeeding her baby in Myanmar; an old Chinese man was hanging his birdcage on the branch of a tree; a Shinto priest was celebrating a marriage in the suburbs of Tokyo; a Hong Kong "golden boy" tapped on his laptop.

Asian time is different from our own. It is a time that does not devour, a time that is not our enemy, a time made for man.

That's a good thing, because plenty of time is needed to read the thirty thousand verses of the great poem by Thai Sunthorn Phu (1786–1855), or the ten volumes of the celebrated Lotus Sutra, the foundation text of Mahayana Buddhism, written in the first century AD, which throughout Asia is as important as the Bible is in the West. This immense "luminous text" gives innumerable rewards. Even if it is not as lengthy, the Book of Tao also demands plenty of time to understand its mysteries.

In the West, time is the sand that drains from an hourglass. Hours pass and never return, and we live our lives in a frantic race against time that leads inevitably toward death. In Asia, time is a wheel that revolves; time passes but always returns. Life is not a race against the clock but a cycle that in every respect, in one way or another, one day, will reproduce itself. This is why Asian time is the comforter par excellence.

Spirituality.

In Asia, the spiritual and the intangible infiltrate everything. There is spirituality in the cherry blossom that opens overnight; in the waterfall that cascades down with a crash from the top of a cliff; in the statue of Bodhisattva that projects his compassionate shadow over the devoted who offer him flowers; in the casks of sake transformed into offerings to ancestors, balanced gently on the branches of a tree; in the eye of the cormorant standing on the

edge of a fisherman's flat-bottomed boat, scruti-
nizing the fish as they rise to the surface of the lake;
even in the cherry trees that, every spring, punctuate the sky
with the metallic blue with their crooked branches. . . . But how
could one not also see spirituality in the irrationality of the decorative
profusion of neon lights that accentuate the vertical lines of the skyscrapers of
Shanghai, the emblematic city of modern China?

Wisdom.

Ineffable wisdom: witnessed in the hundreds of millions of individuals attentive to the universe's faintest pulse,
seeking to align themselves in harmony with its resonance. In meditation in front of the blank wall of Zen, an adept
my better comprehend reality, situate himself in the real.

The people of Asia are wise in many ways: They know how to retreat from the hubbub of the world, yet for the last three
decades they have contributed—and how!—to global civilization, as Asia has become the world's principal exporter of all kinds
of products.

And yet, this writer feels disquietude: Will the wisdom of Asia be intact thirty years hence? The answer to that question will depend in
large part on the way the inhabitants of our planet live in the future.

Humility.

In Asia, humility, discretion, and restraint are the rule. Above all the Asian celebrates, like the paleontologist who reconstructs a mythical
animal from the faint lines in the clay, the economy of means and the ability to use a little to do a lot, to use the empty to give value to the
full. The single black line of the Zen painter is said to take longer to contemplate than elaborate figurative frescoes several yards long; the
juxtaposition of ten words in a haiku may more succinctly sum up the complexity of the world than the thousands of verses of the imme-
morial epics that, elsewhere, celebrate the superiority of some man or some system; the complex Taoist concept of Wu Wei, or "non-
action," considers that simply allowing the natural course of events to take place is more effective than interfering action that—more
often—is nothing but useless posturing.

By banishing digressions to arrive at the essential, we touch on the void. Divesting ourselves of the incidentals, of background noise, we
hear the music whose magic is only revealed when we have arrived at "the furthest end of the void." The void is that which for you is
impassable. The absolute challenge of the void: because the notion of emptiness is that which strikes most against the human spirit,
it is equally that which is the richest and most fertile for it as well.

Restraint.

Above all, restraint in expression and in posture: never imposing oneself, always exchanging and offer-
ing. This restraint can be very extreme. When a man has respect for another, it can be seen. As
Roland Barthes describes it so eloquently, in the quintessentially Asian "gesture of chop-
sticks, further softened by their material—wood or lacquer—there is something
maternal, the same precisely measured care one would use to move an infant:
a force, in the operative sense of the word, no longer a drive."

Laughter.

The laughter of Asian people is the
opposite of mockery. In a soci-
ety where people are so

numerous, the smile is a duty to others, the mark of consideration. In Asia, people are always smiling. Is laughter also the best remedy for misfortune? People regard both the fullness and the void of existence, look toward the ethereal clouds that hide the Buddha and the Tao, then they dive toward the unfathomable abysses where the dragon that watches over mankind sleeps. . . .

In the eyes of statues that smile into eternity, in the eyes of the people—including the most simple—we discover what we had formerly been so little accustomed to finding in ourselves: that interior peace without which mankind will never find the remedy for his many trials.

Mountains.

In Asia, all summits are sacred because they are close to the sky. It is for this reason that those mountains inhabited by friendly deities who welcome men benevolently always seem as described higher than the others. Under the iron rule of the sun, "which does not only serve to heat the domestic sky like an oven full of embers" (Claudel), or under the tempering rain, to climb these slopes—walking on twisting paths to mount an assault on the sky, like following the Tao's steep path along the edge of the abyss—is considered a saintly activity.

Rice.

In itself, this soupy foodstuff, which cannot be chewed like Western bread, which is cooked in steam, to which men devote themselves, hunched over the ground and often crouched down in the mud as they strive to give it as much water to drink as it needs, is a perfect symbol for the way people live in Asia.

Water.

What would Asia be without water, without its crystalline basins, without its sacred springs and its small-dished votives, without its rivers blessed by the gods, without the sea in which float the Immortal Isles, without the monsoons, as Claudel wrote, those "menses of the virgin earth that inundate these vast, flat lands, hardly distinguishable from the ocean from which they emerge, which drink up the rain without overflowing"?

But now it is time for us to plunge into this tribute to Asia, which invites us to breathe in its inspiration and let ourselves be carried on its winds!

—José Frèches

Here is the place where they found each other
the lovers in love with the changeable flute

—Victor Segalen, "Musical Stone," from *Stèles*

7

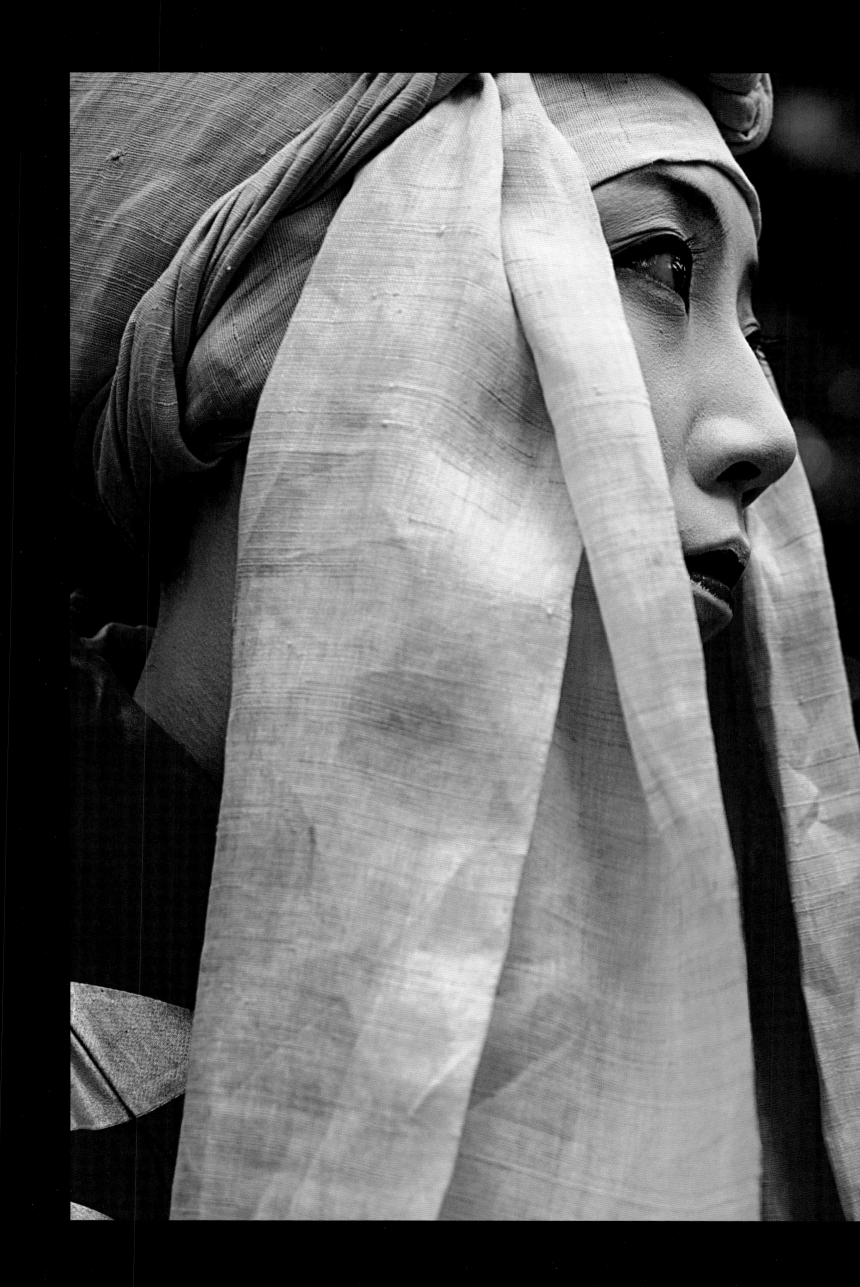

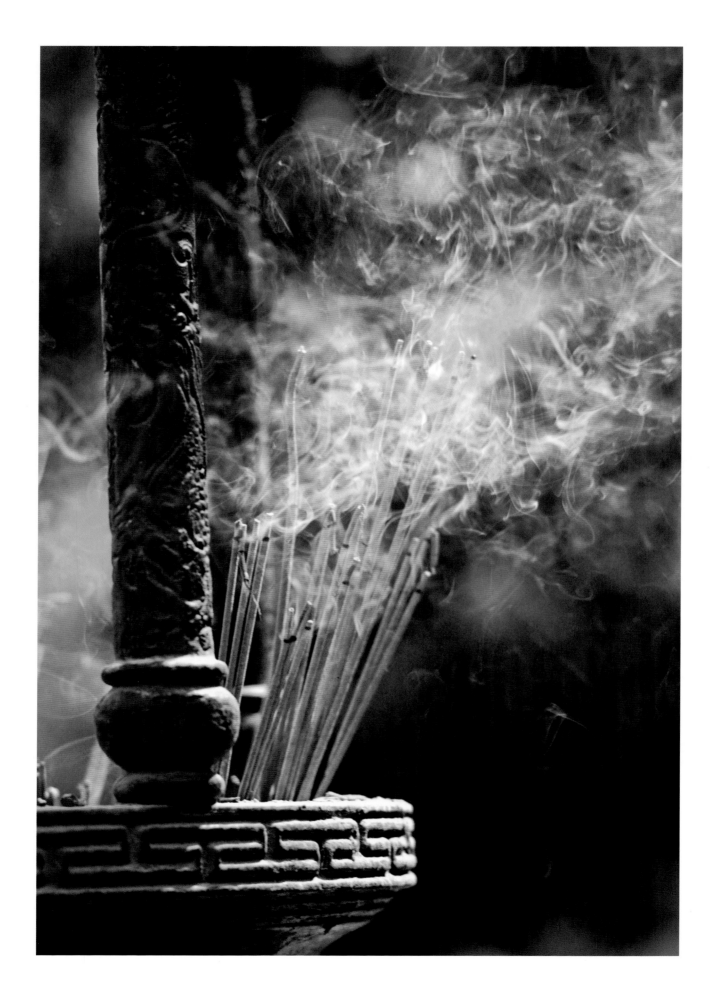

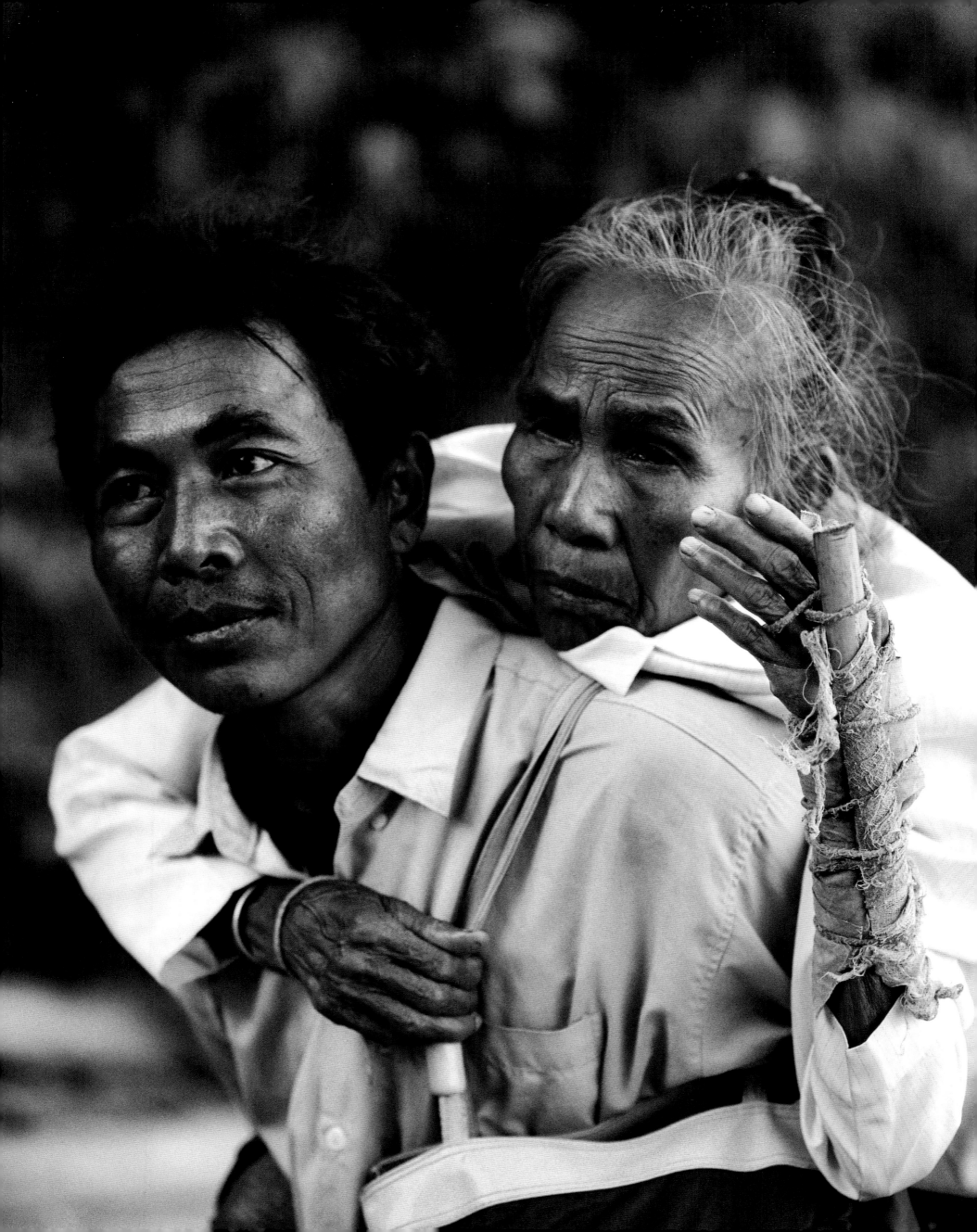

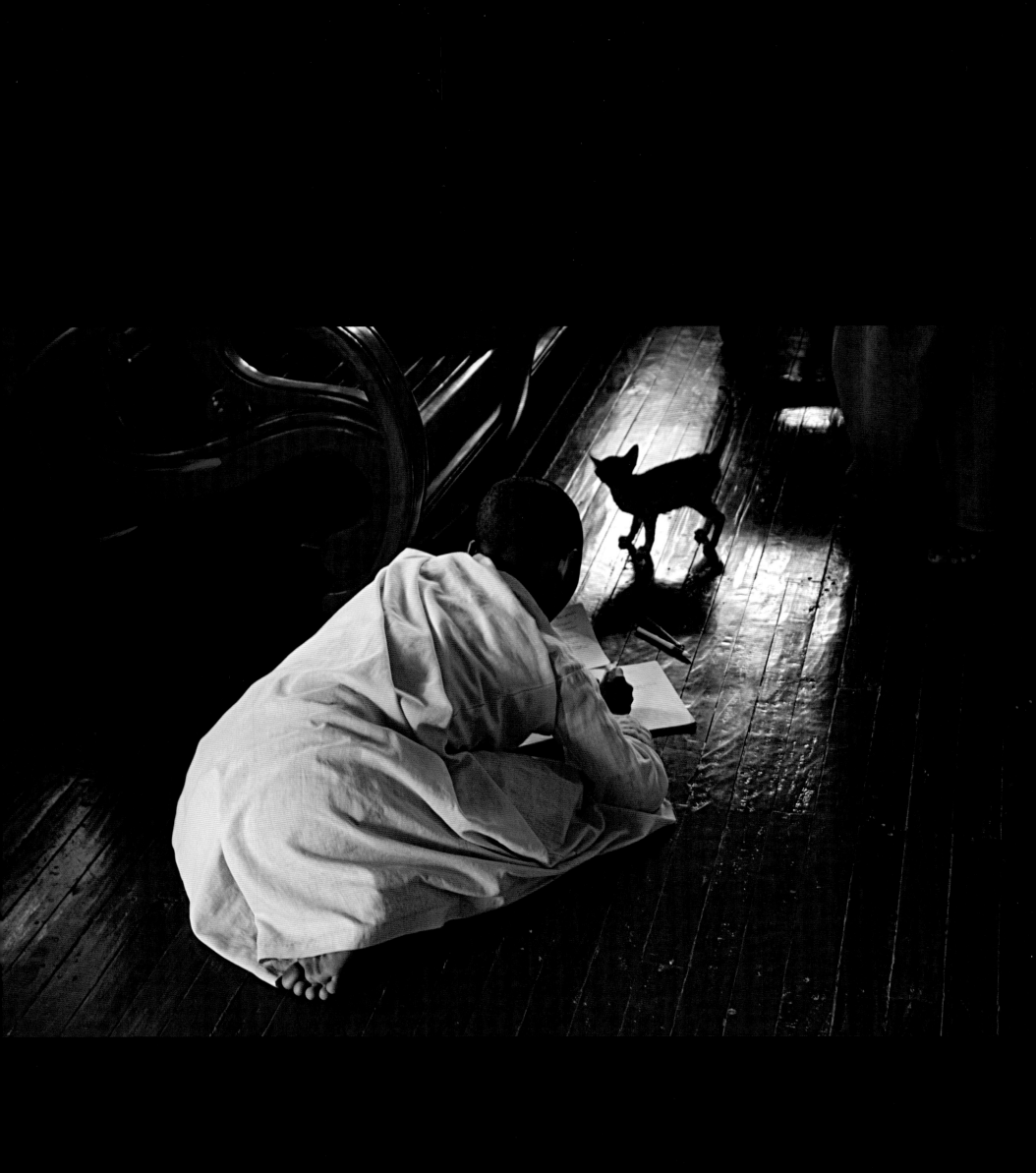

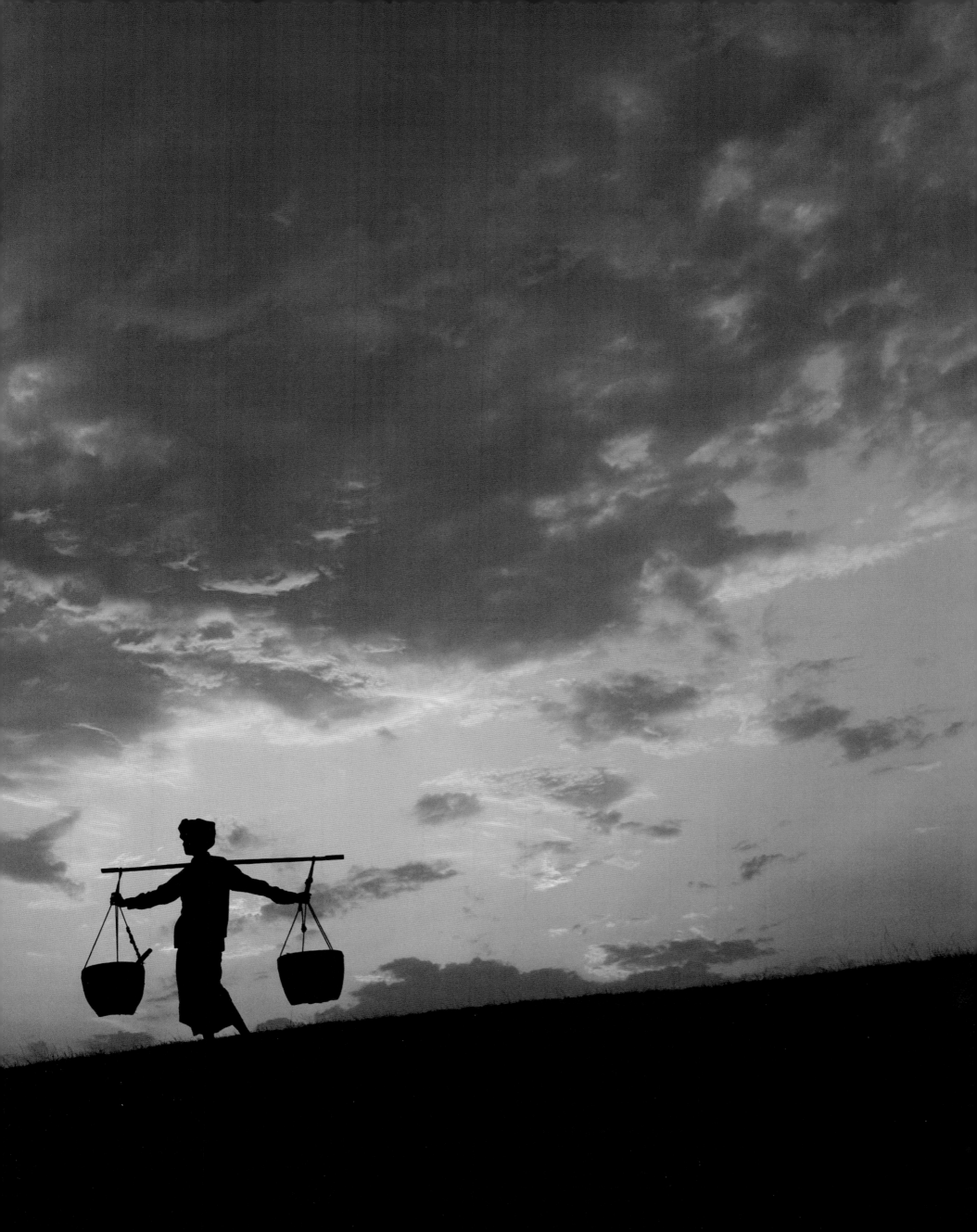

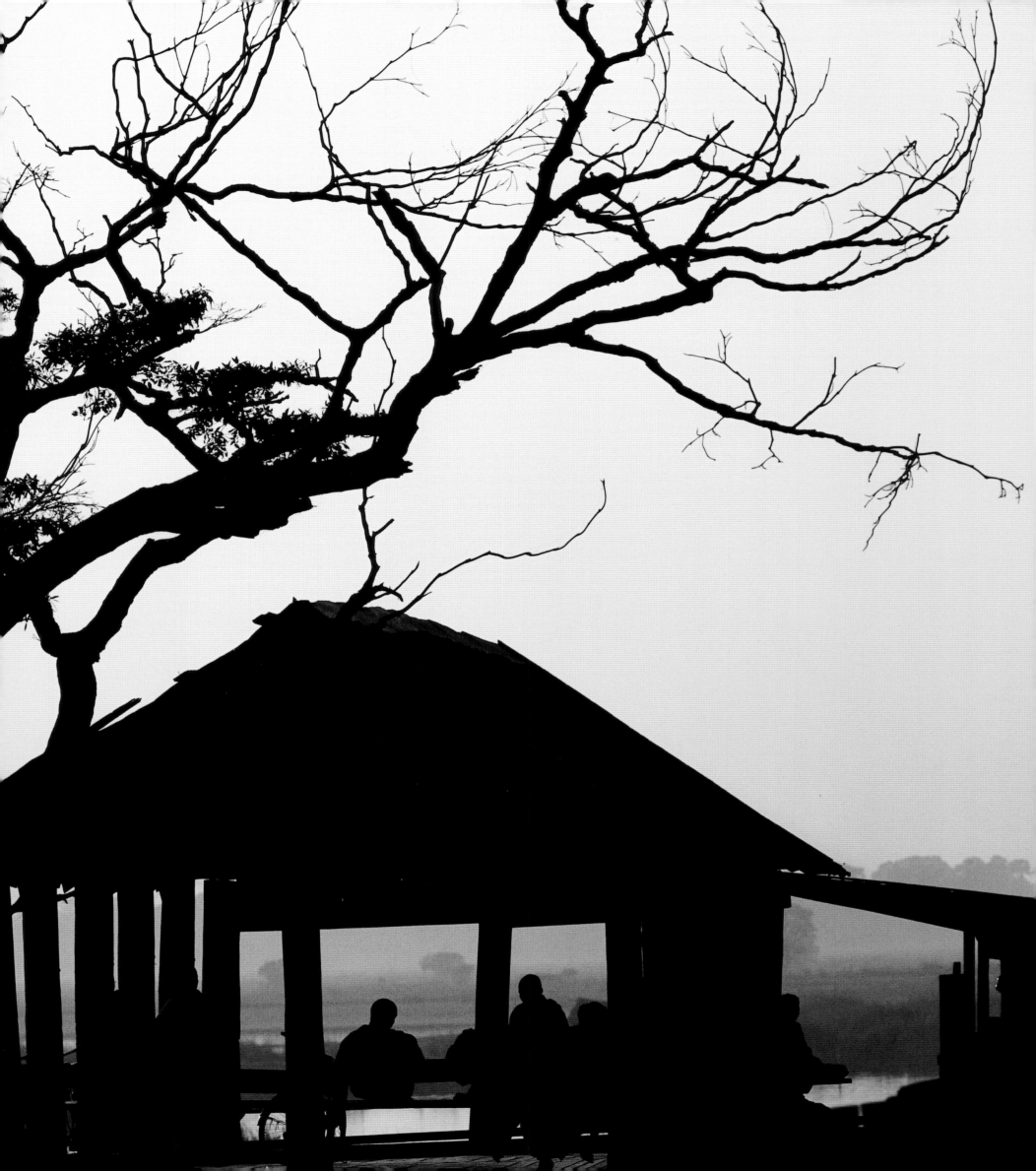

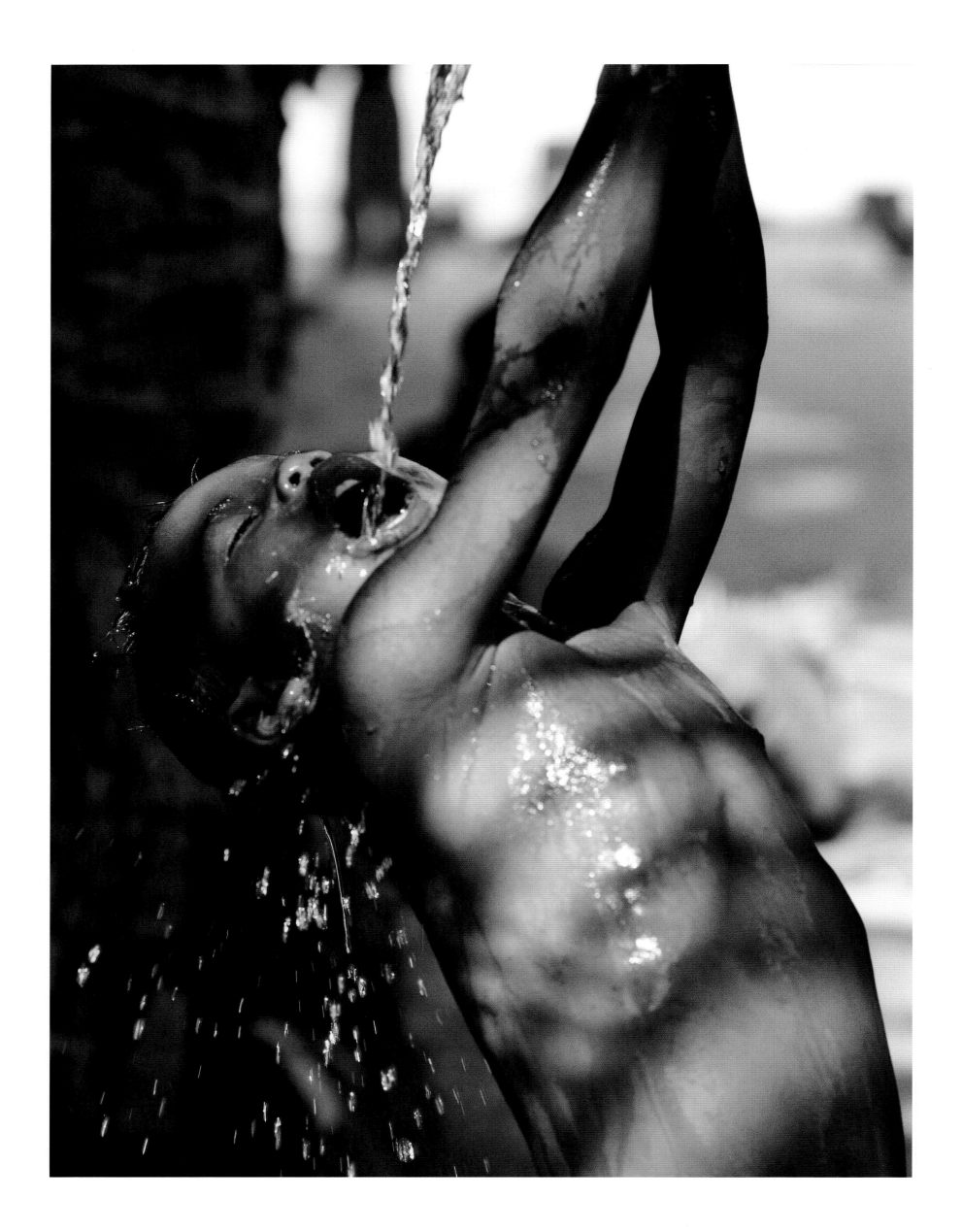

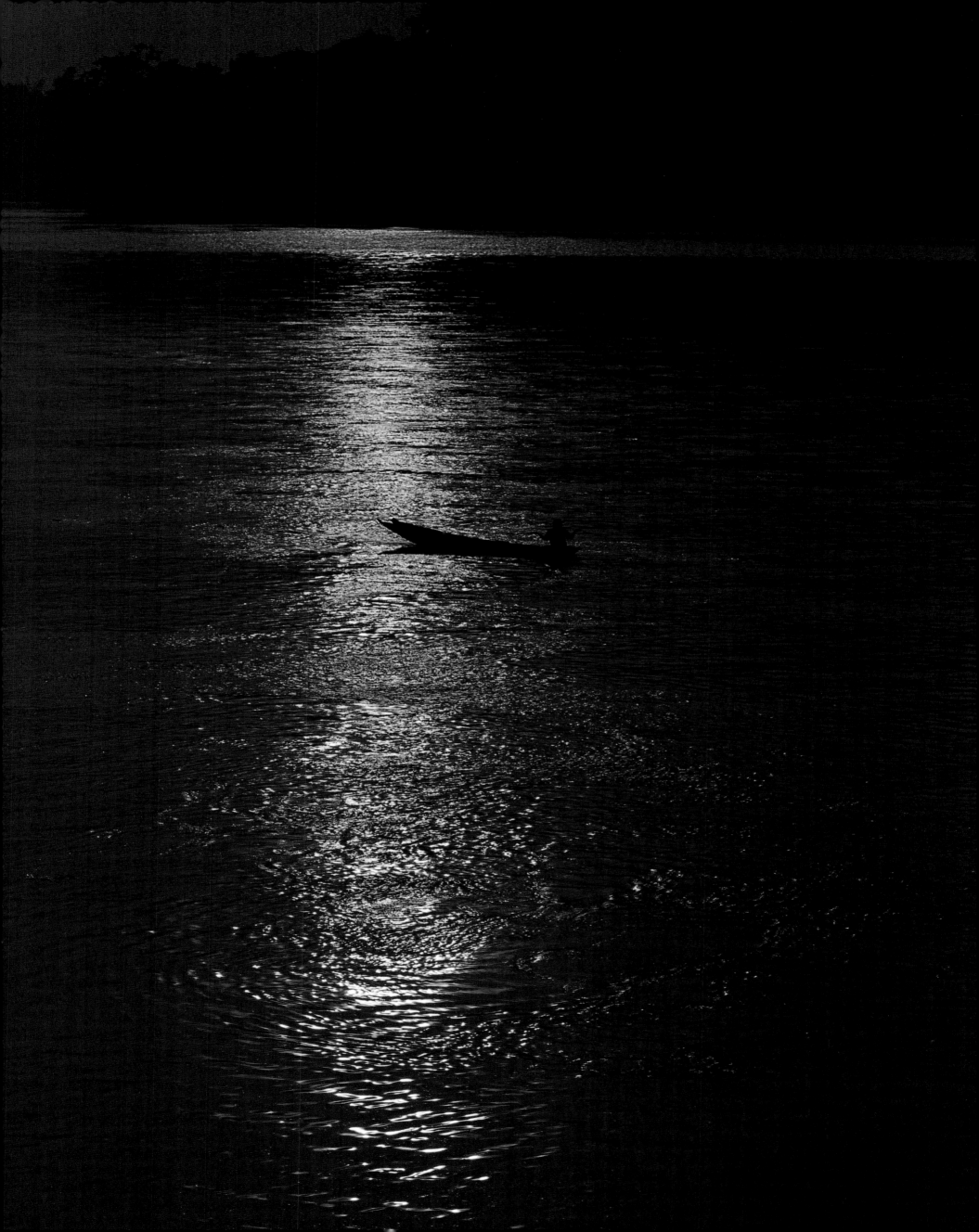

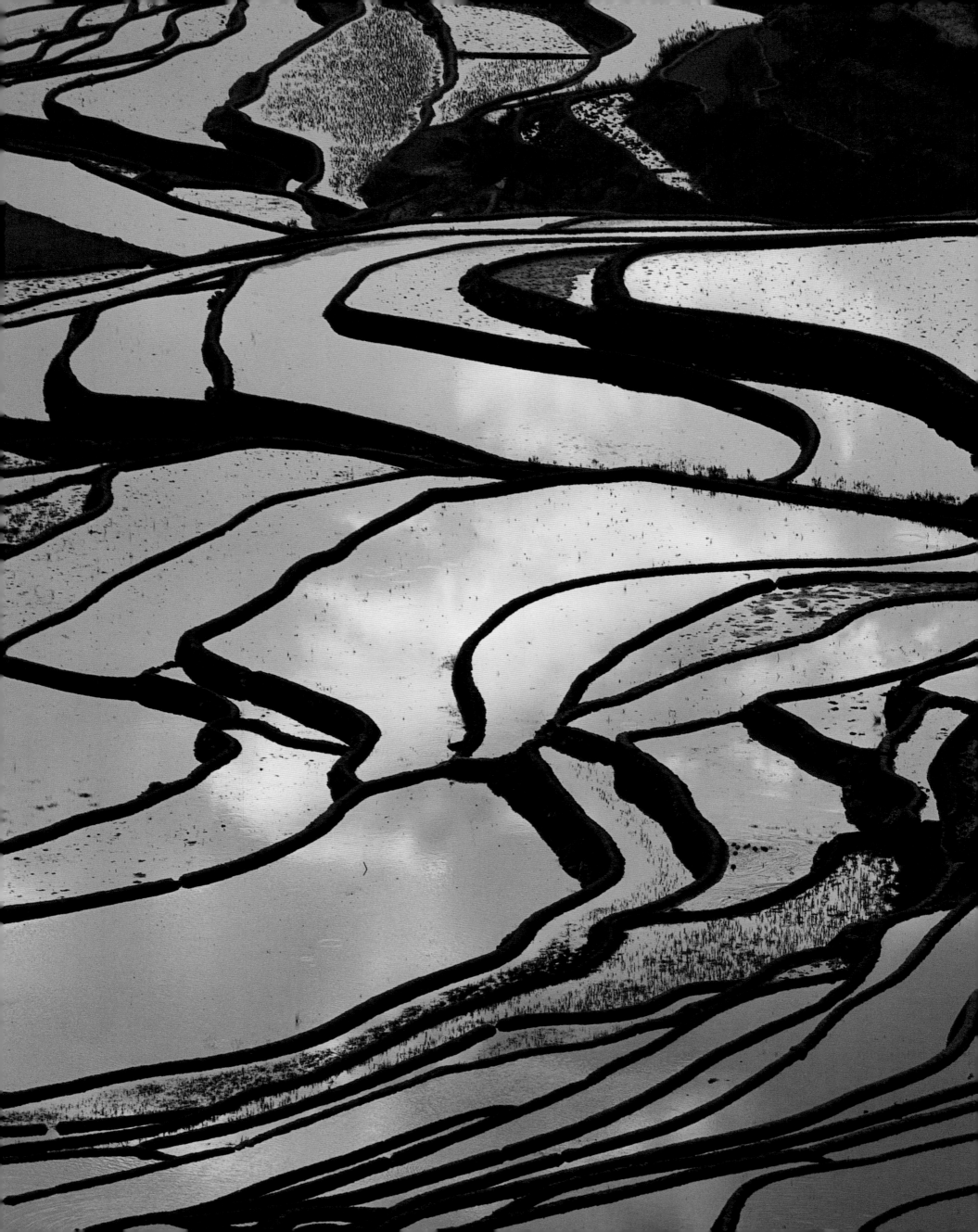

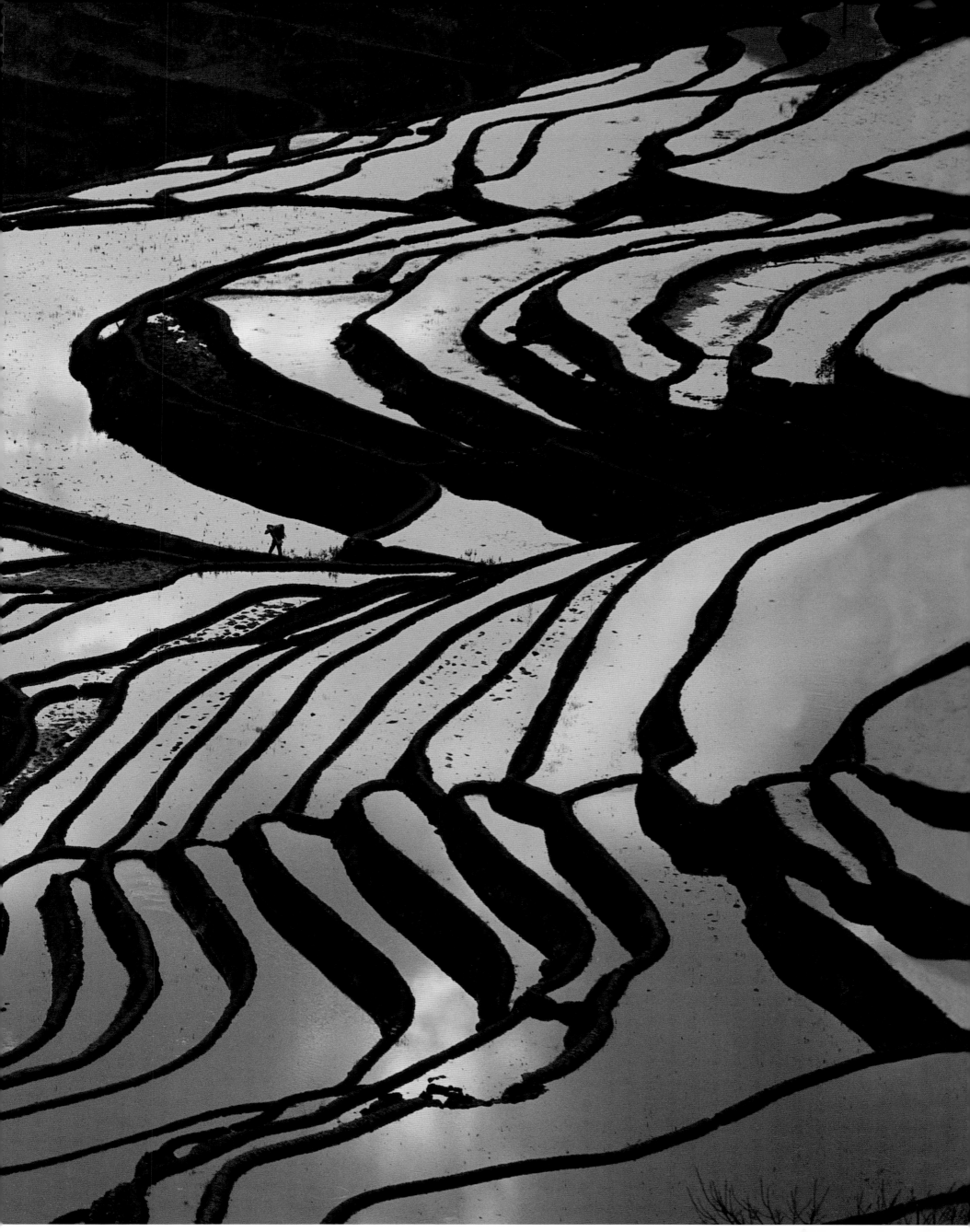

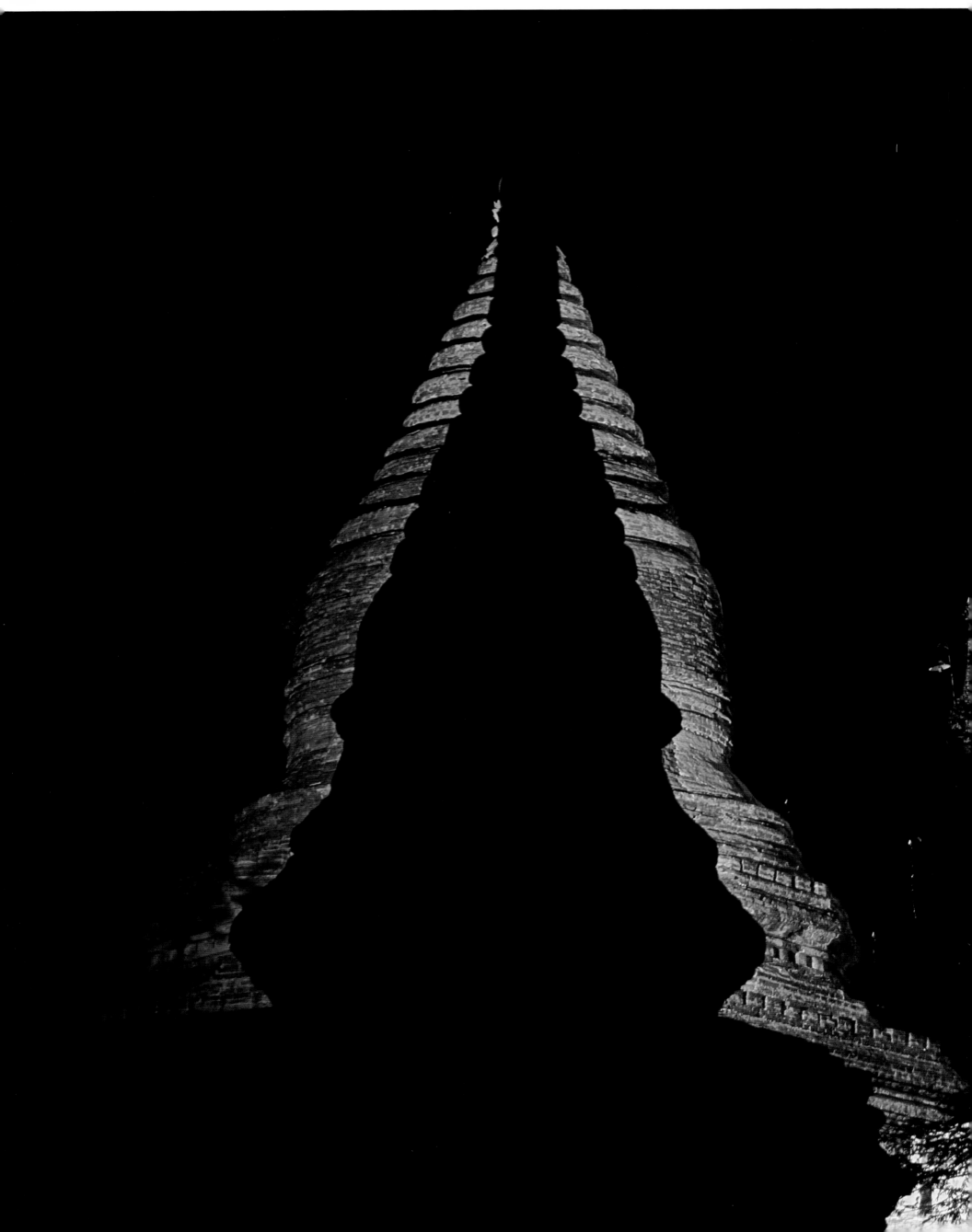

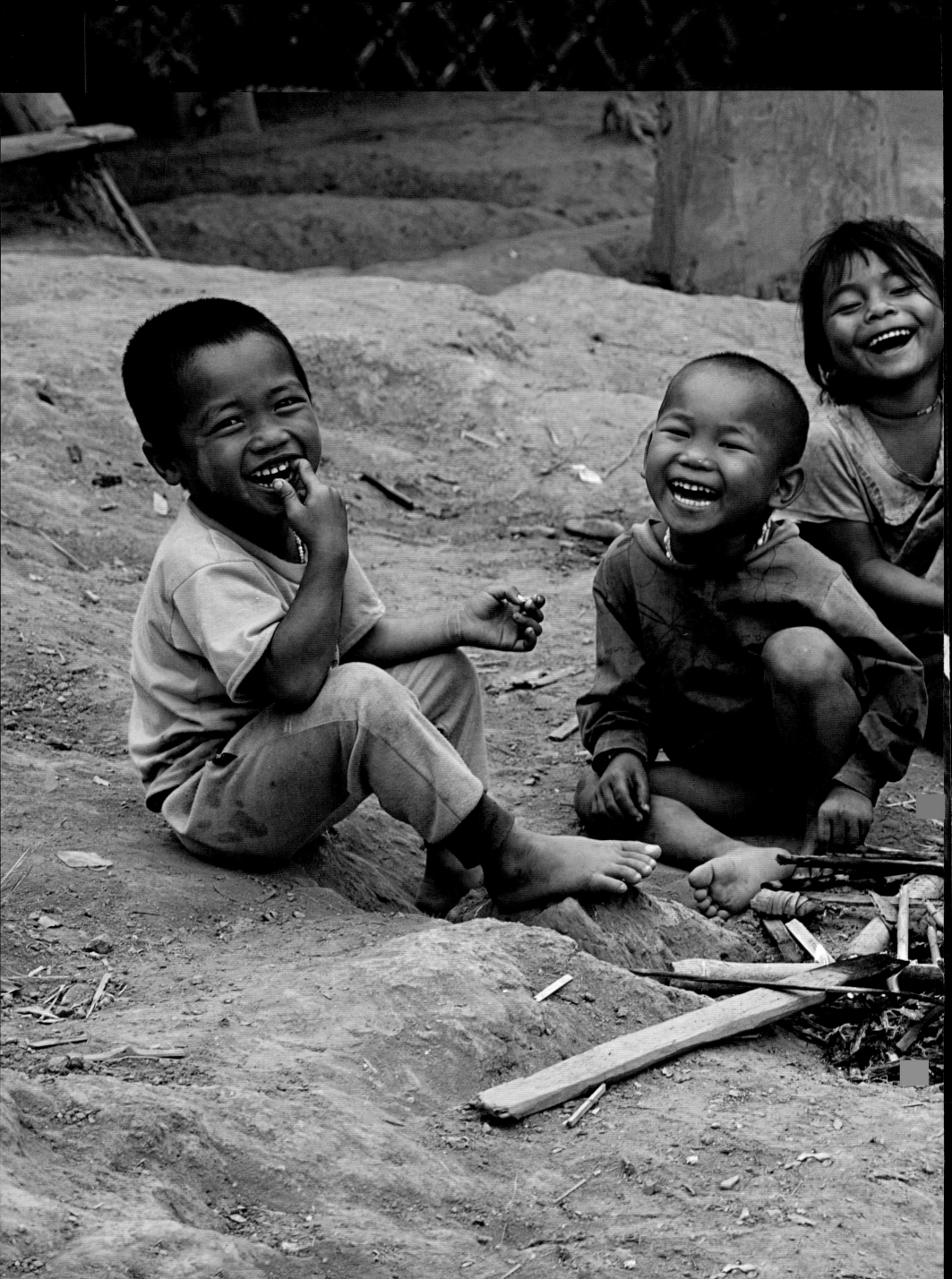

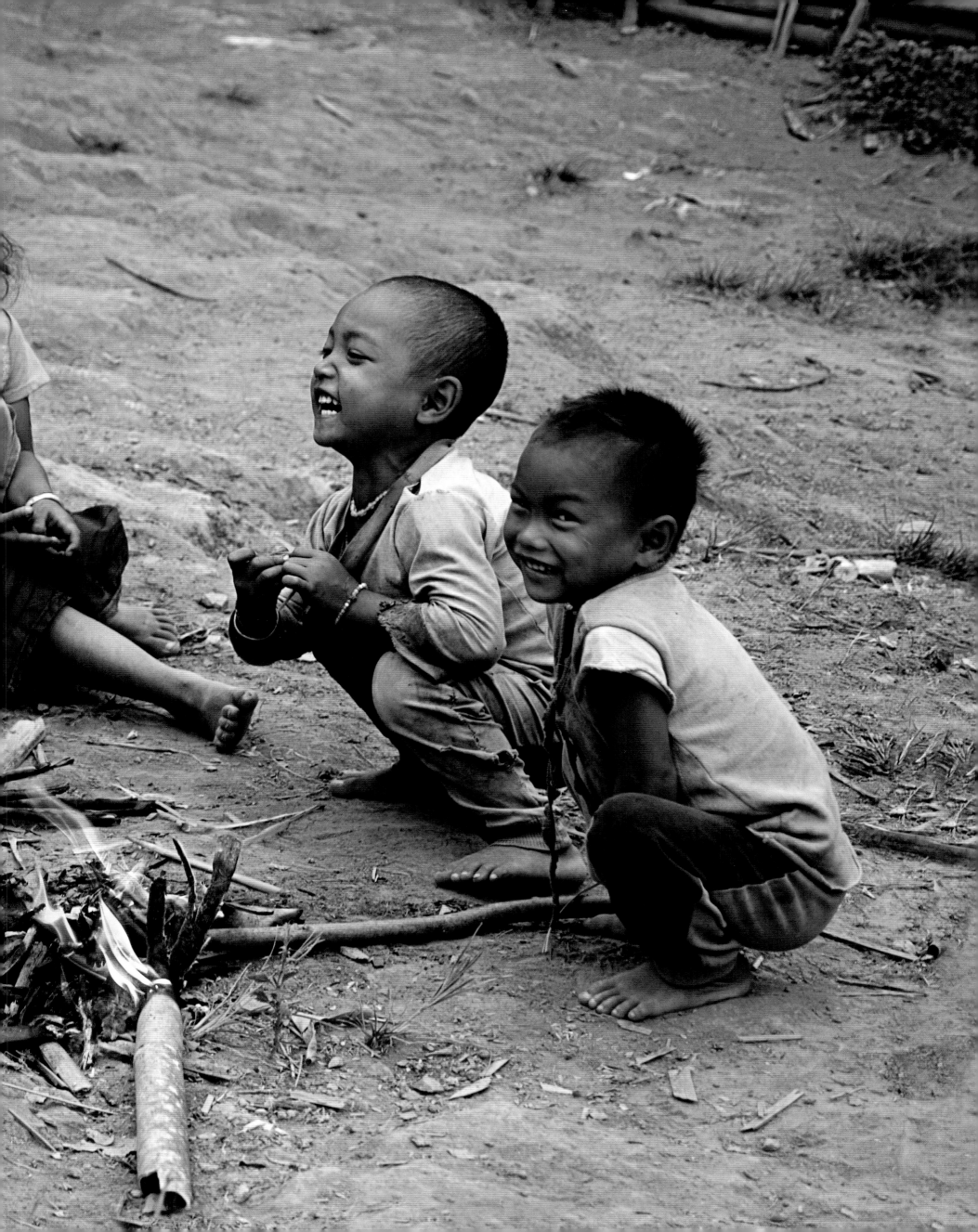

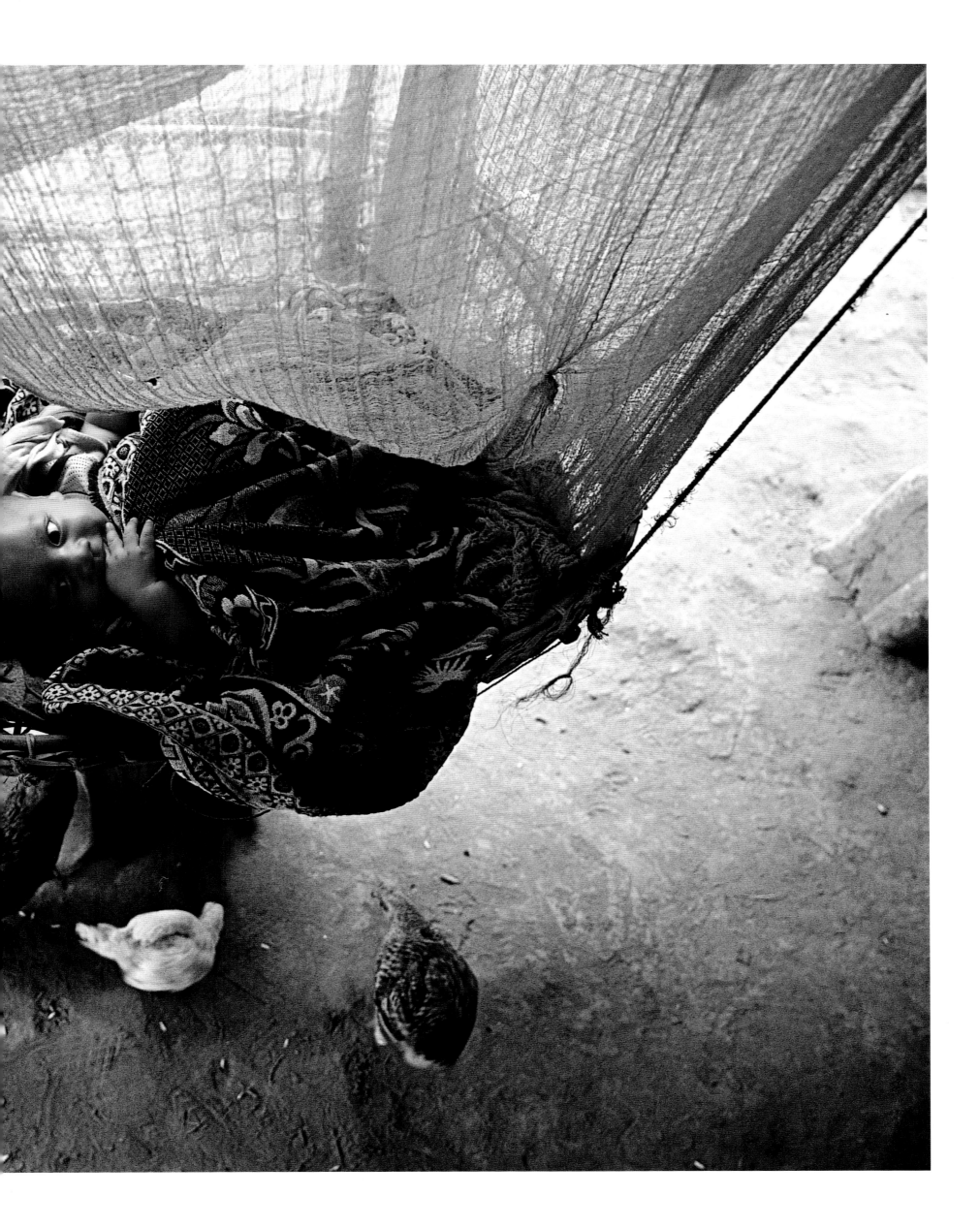

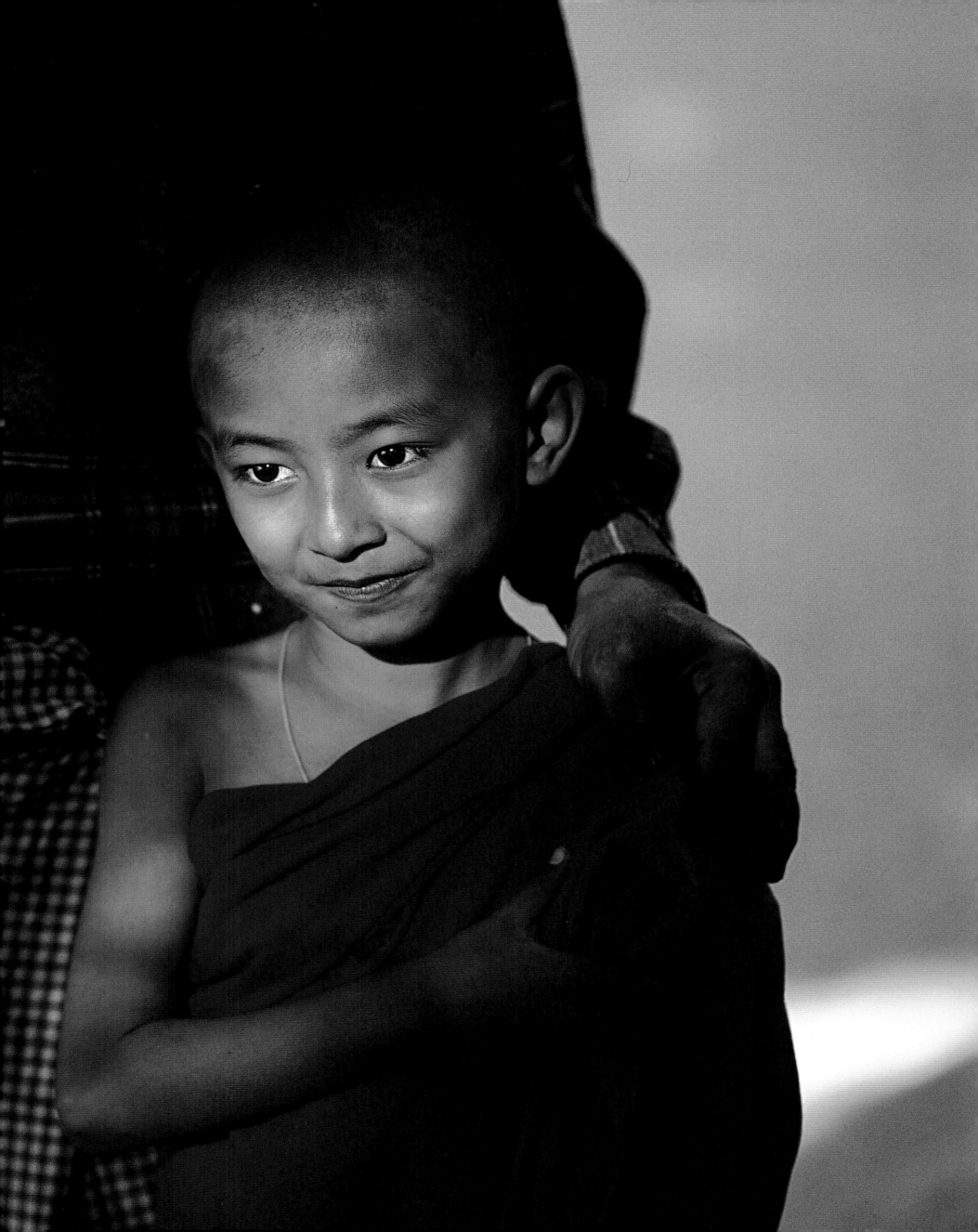

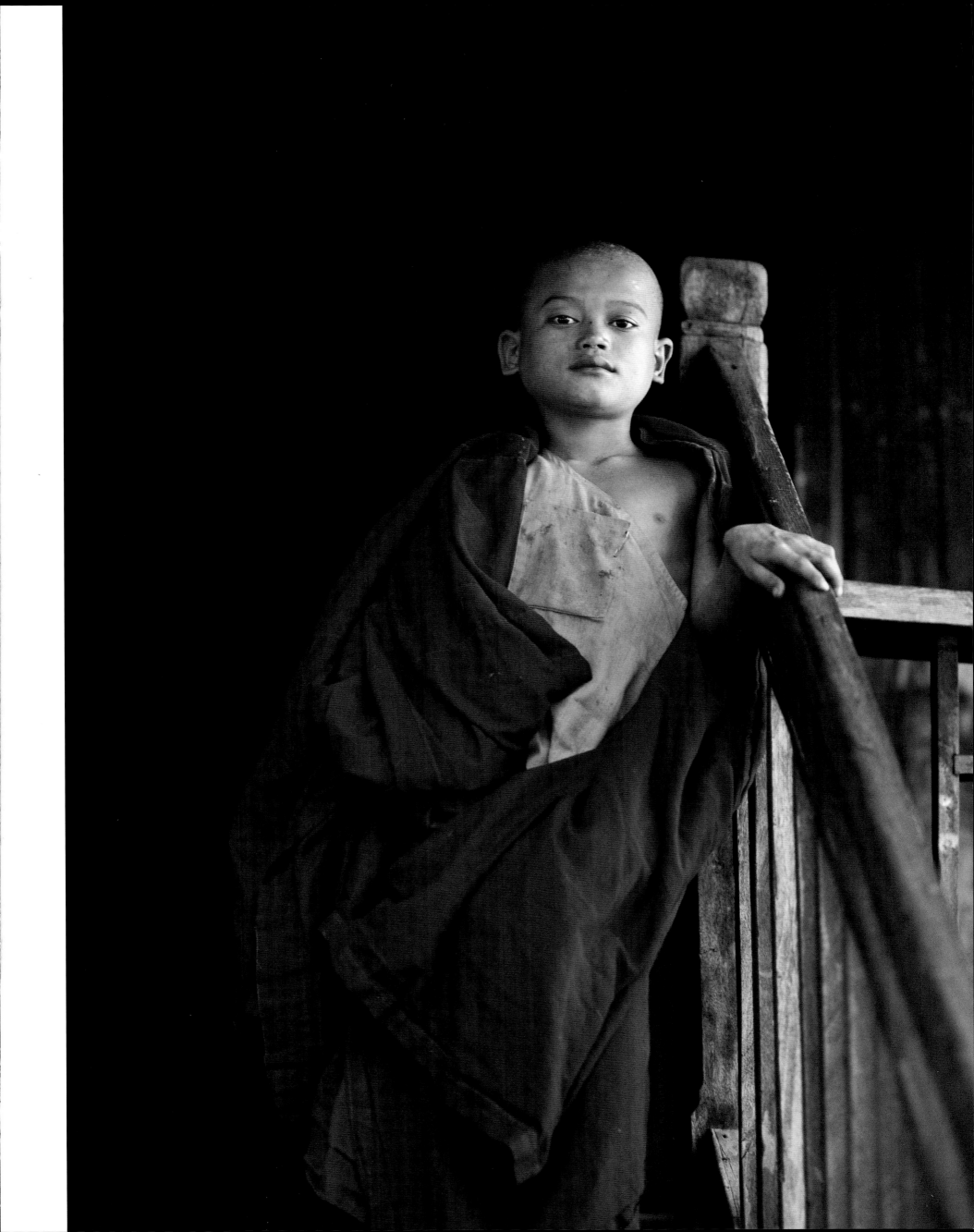

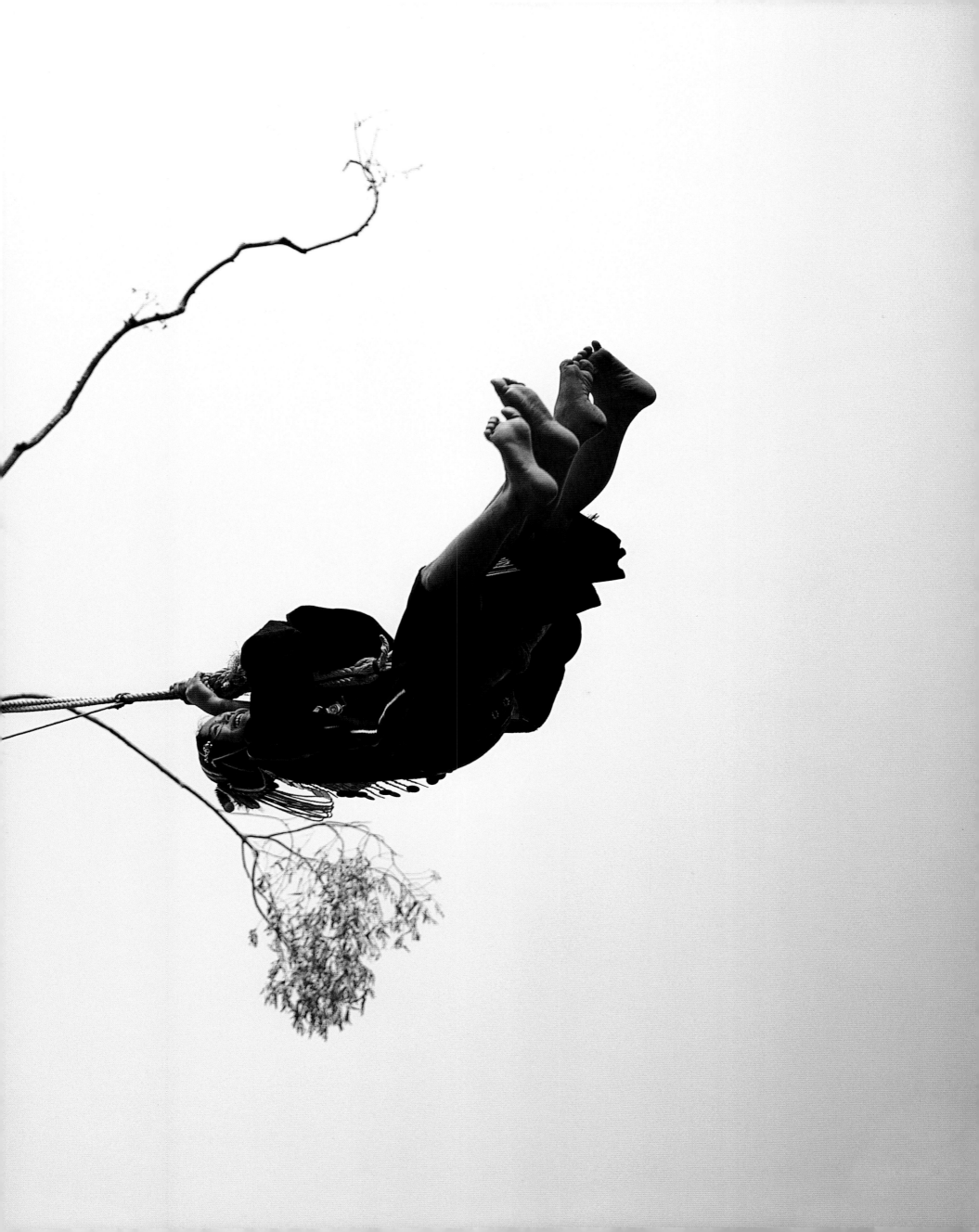

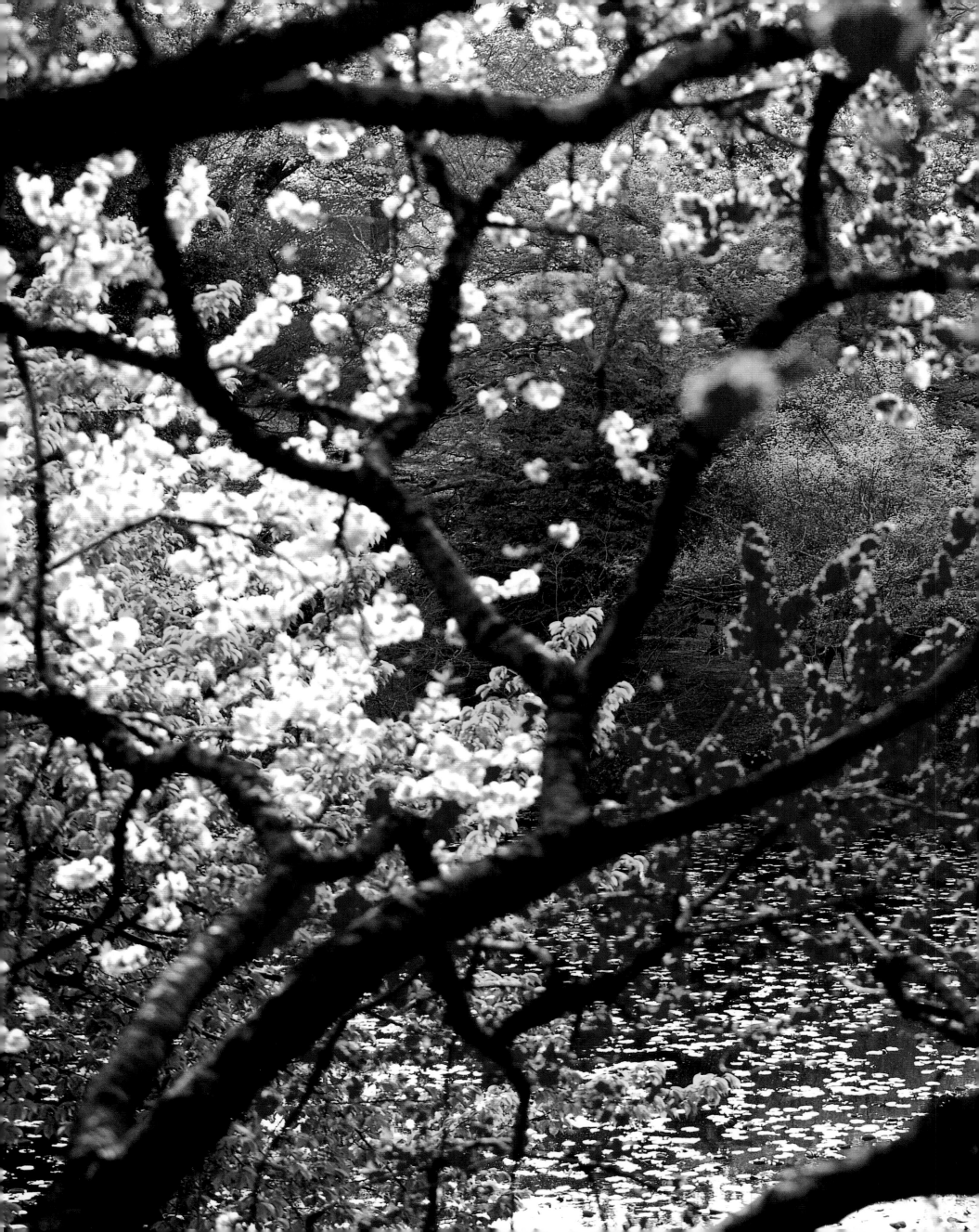

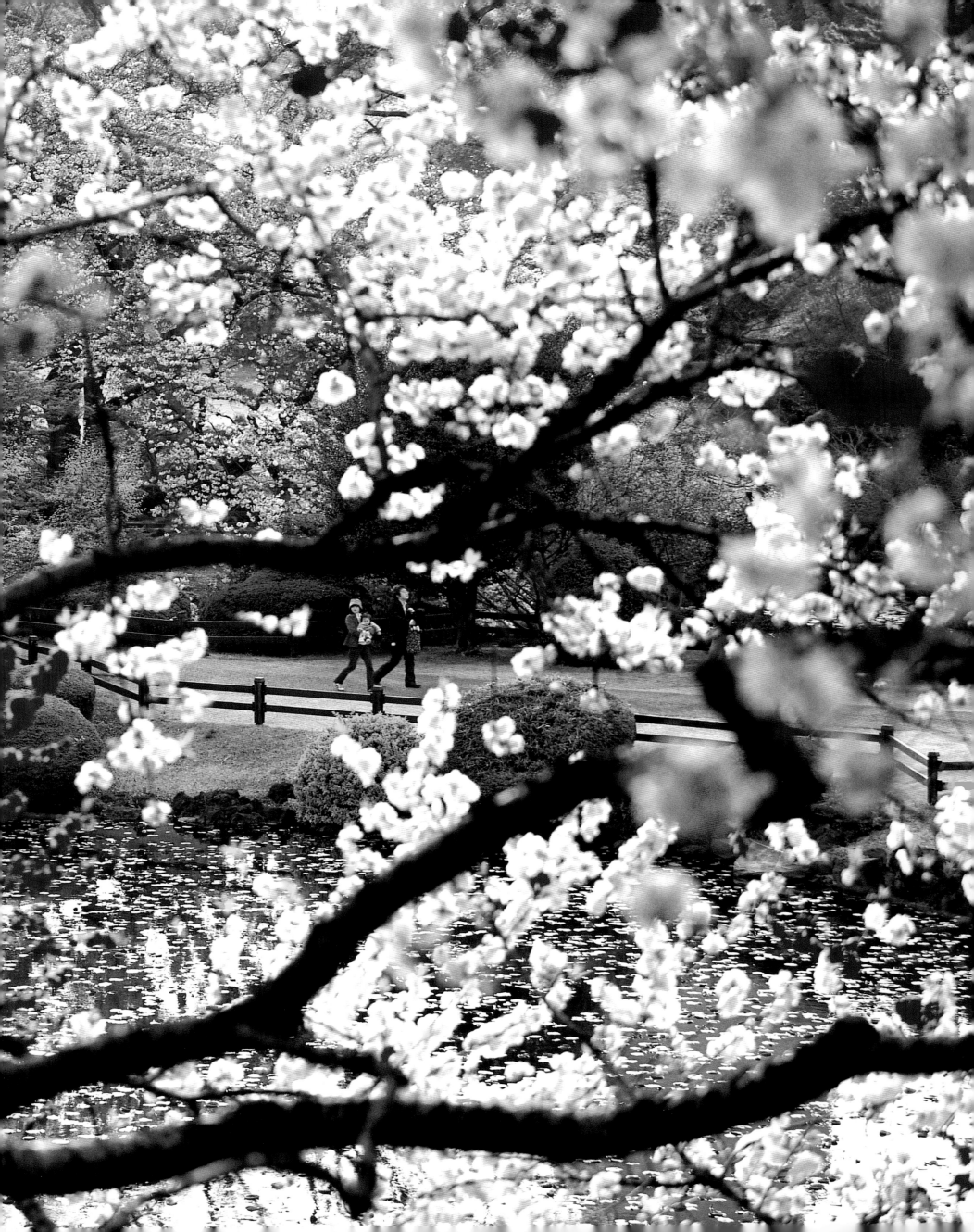

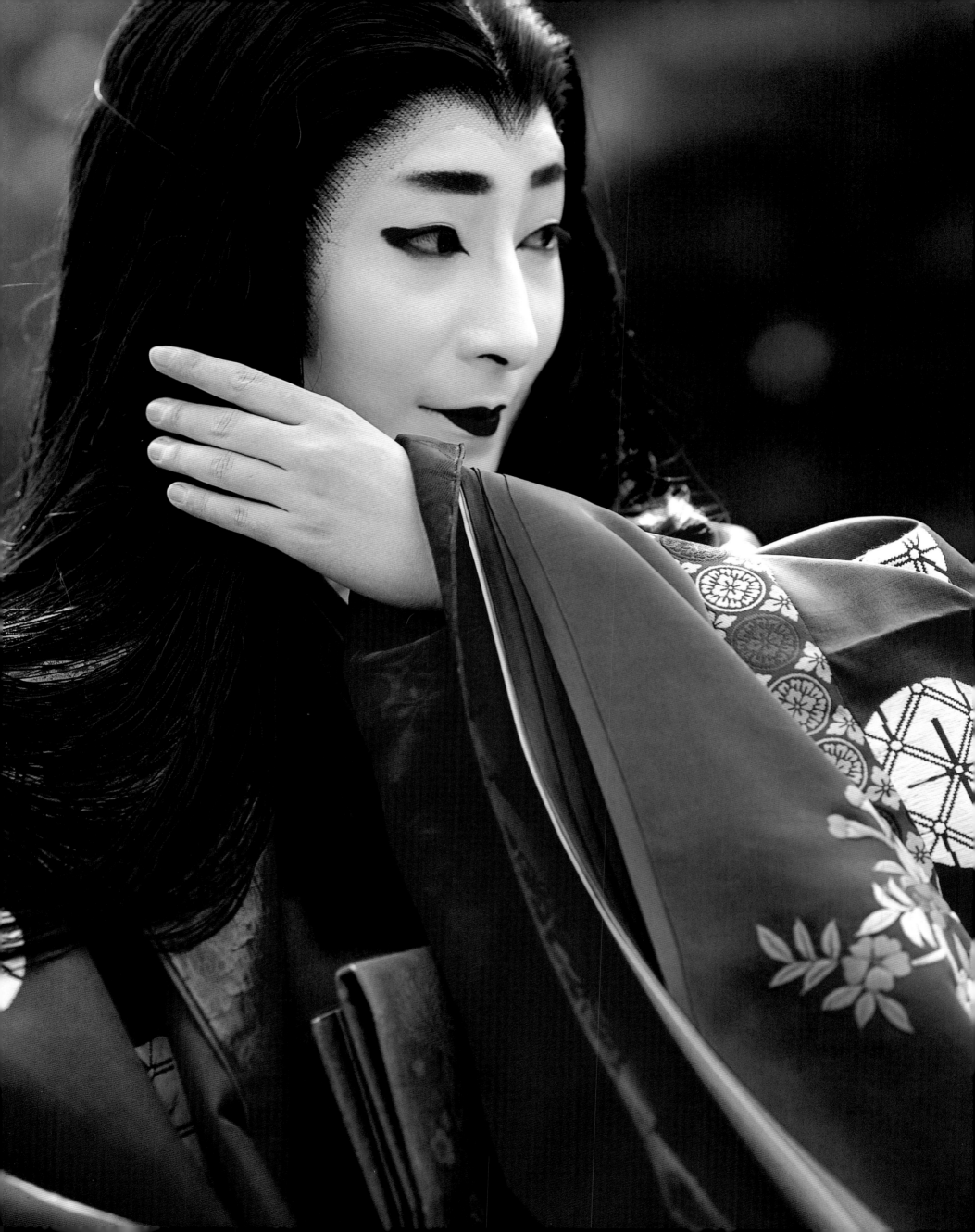

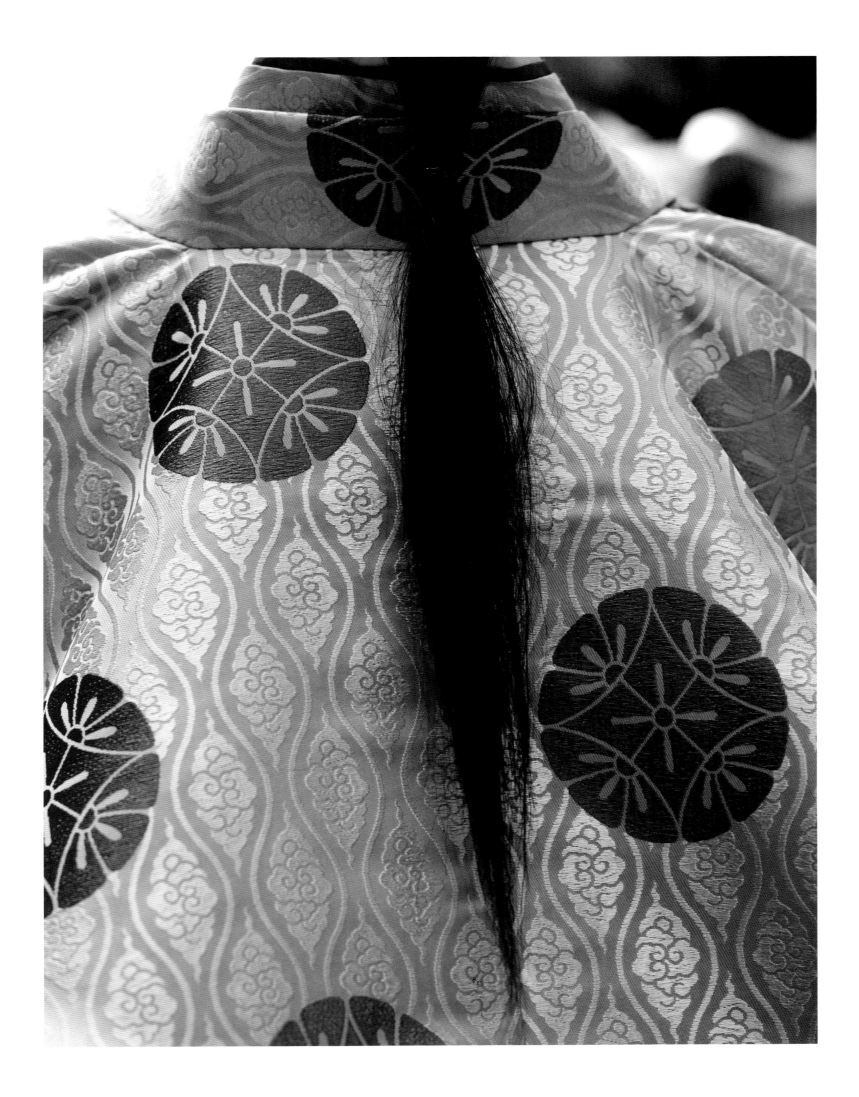

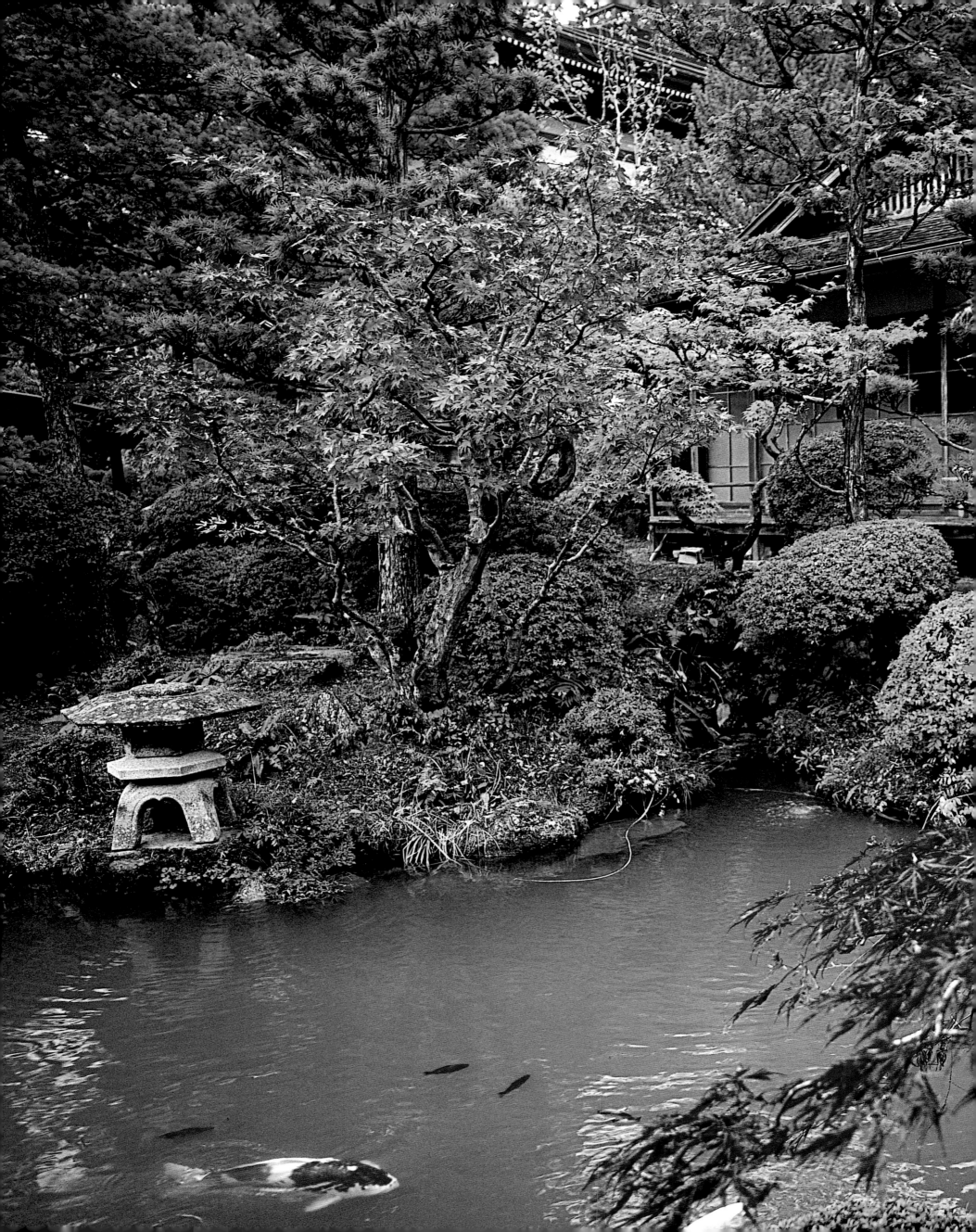

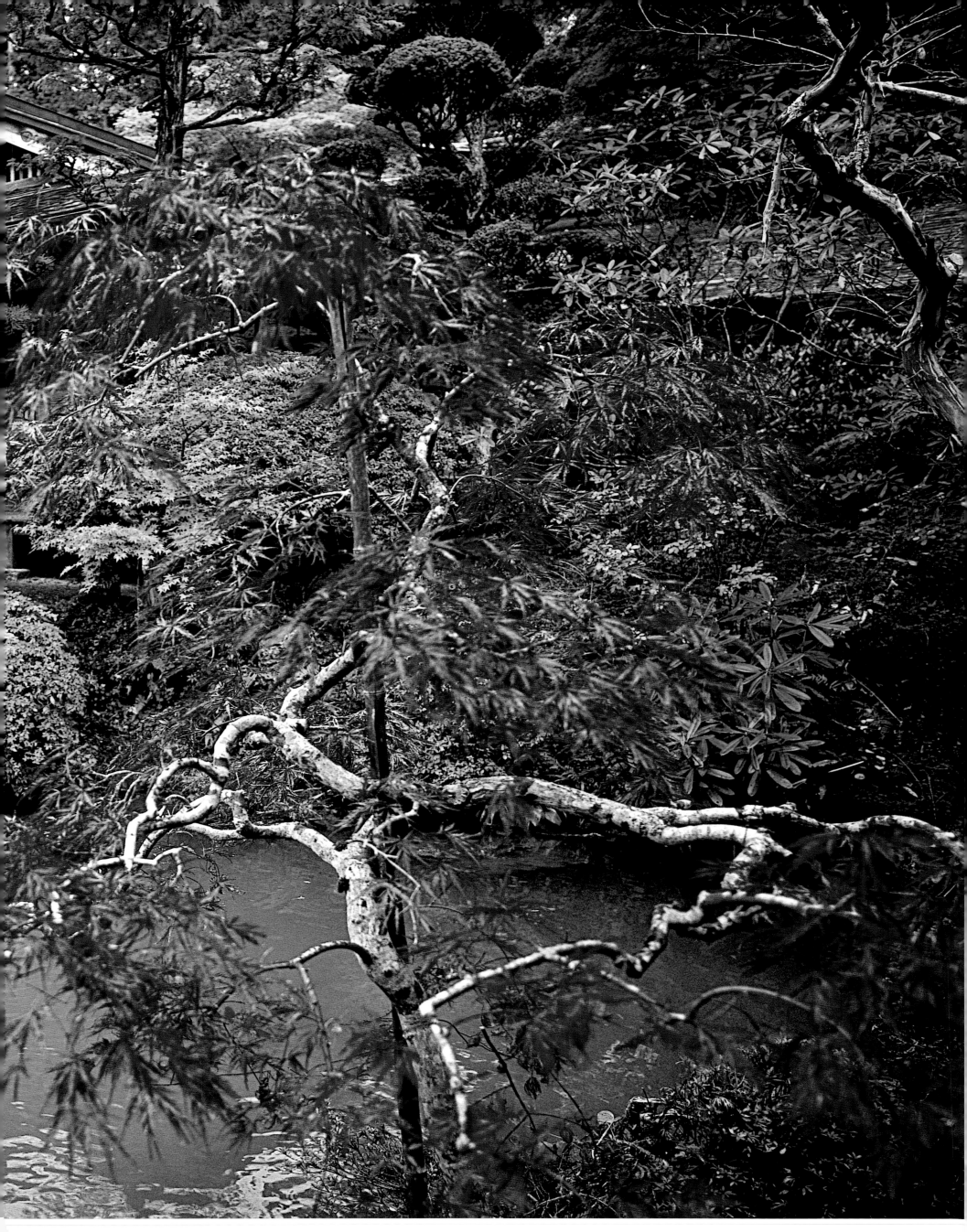

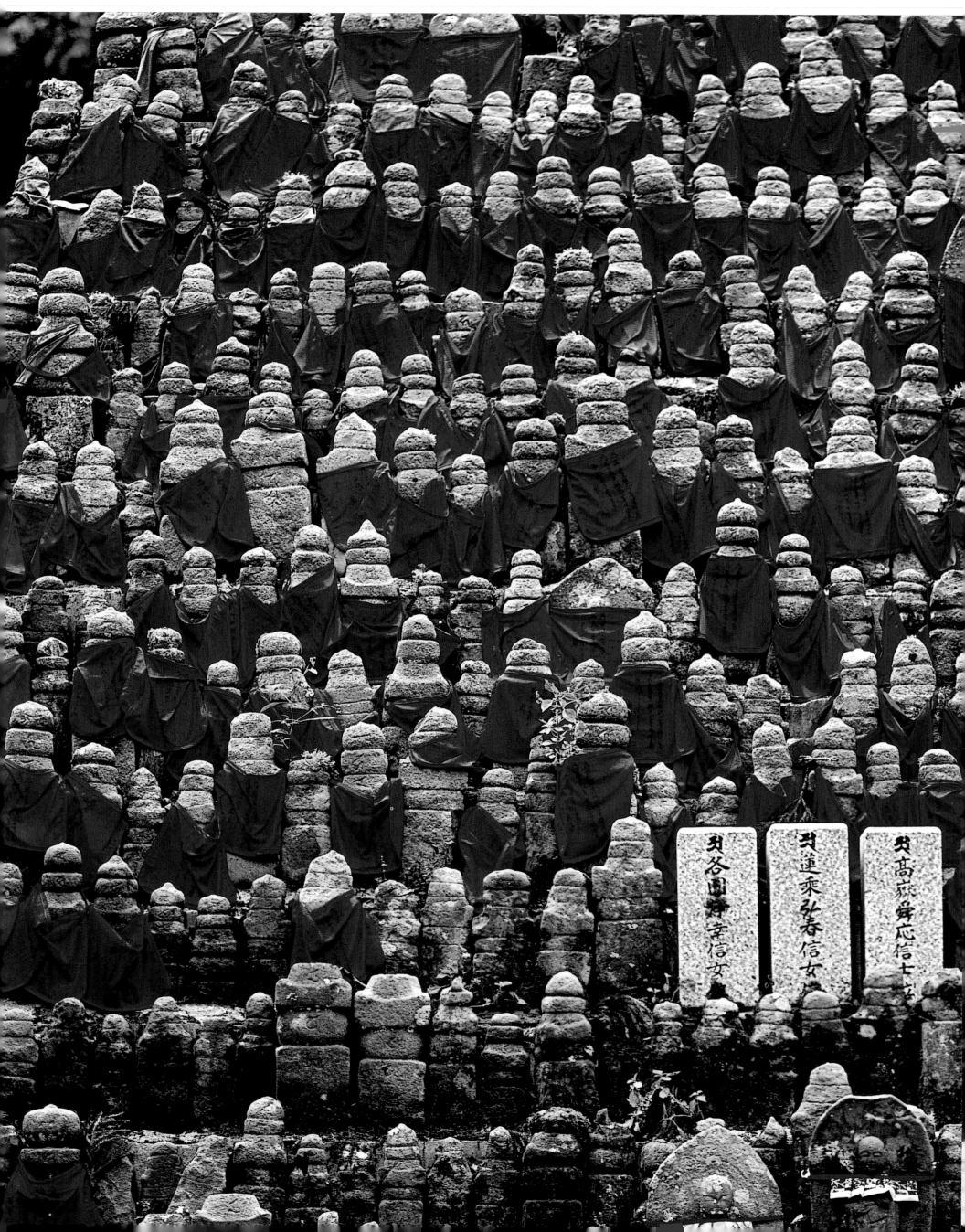

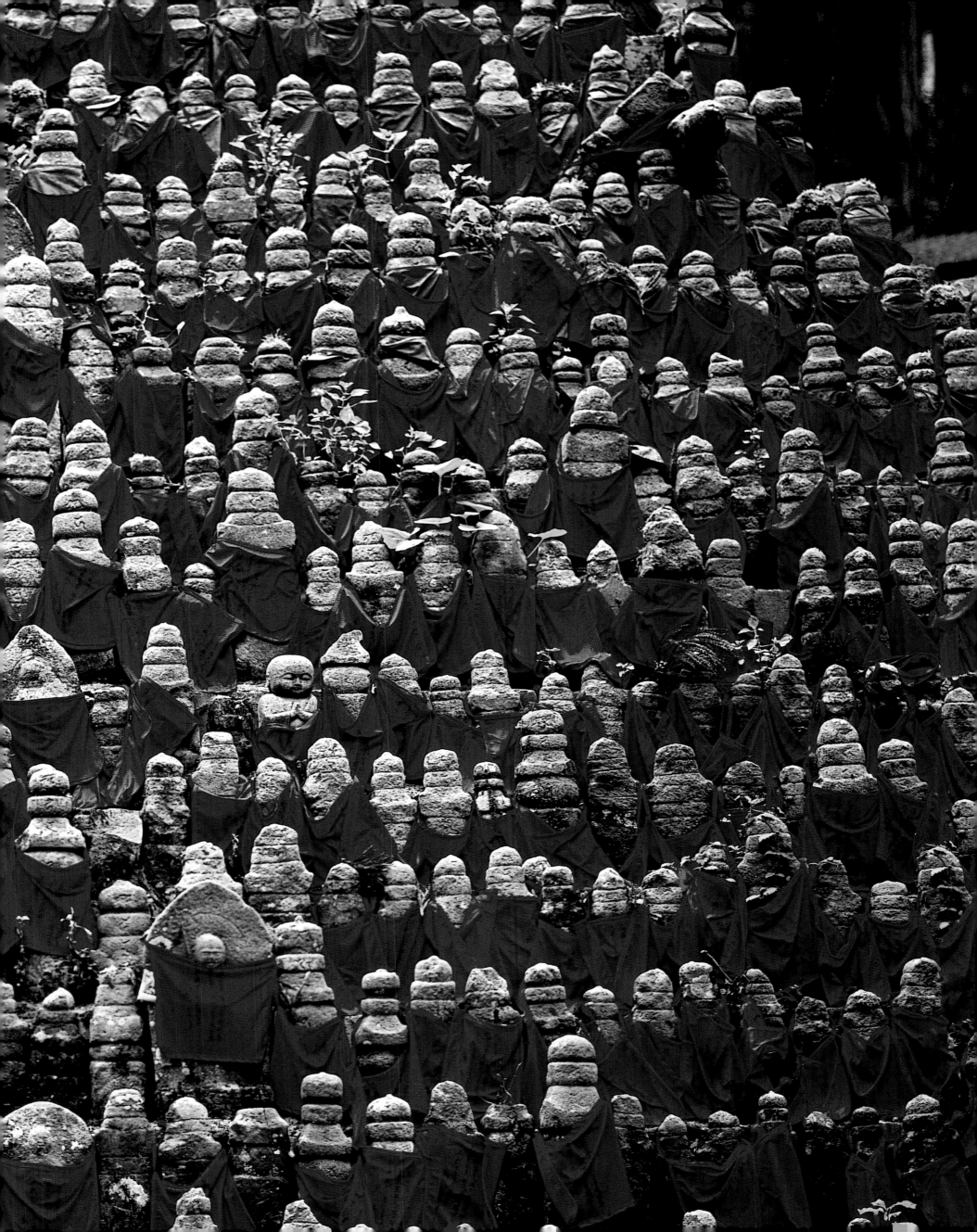

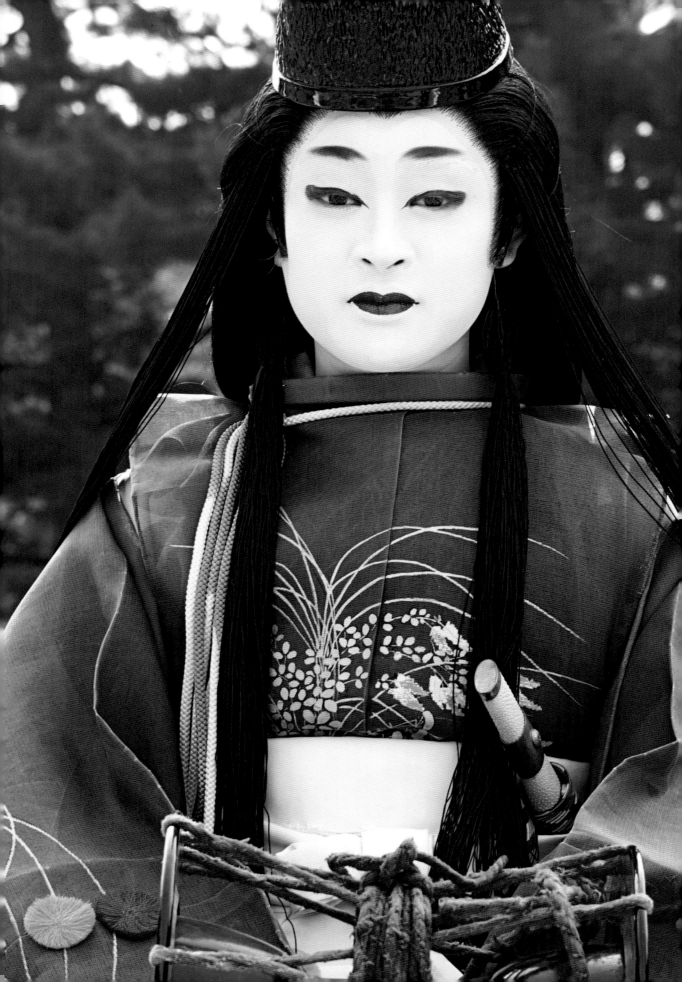

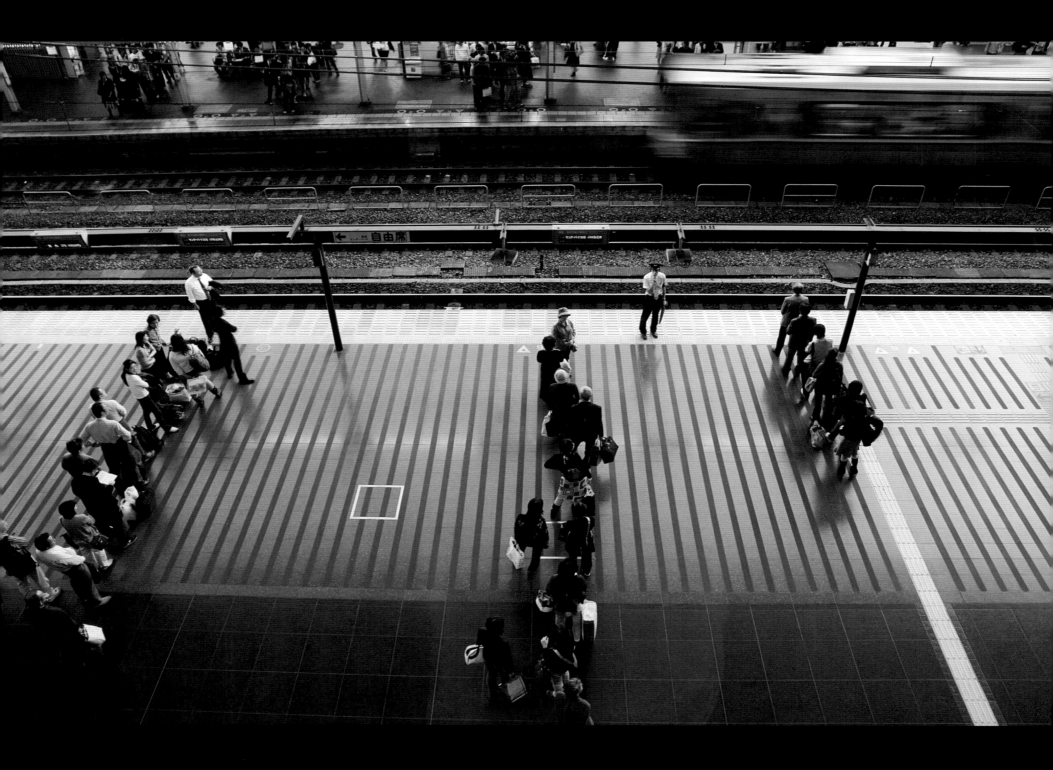

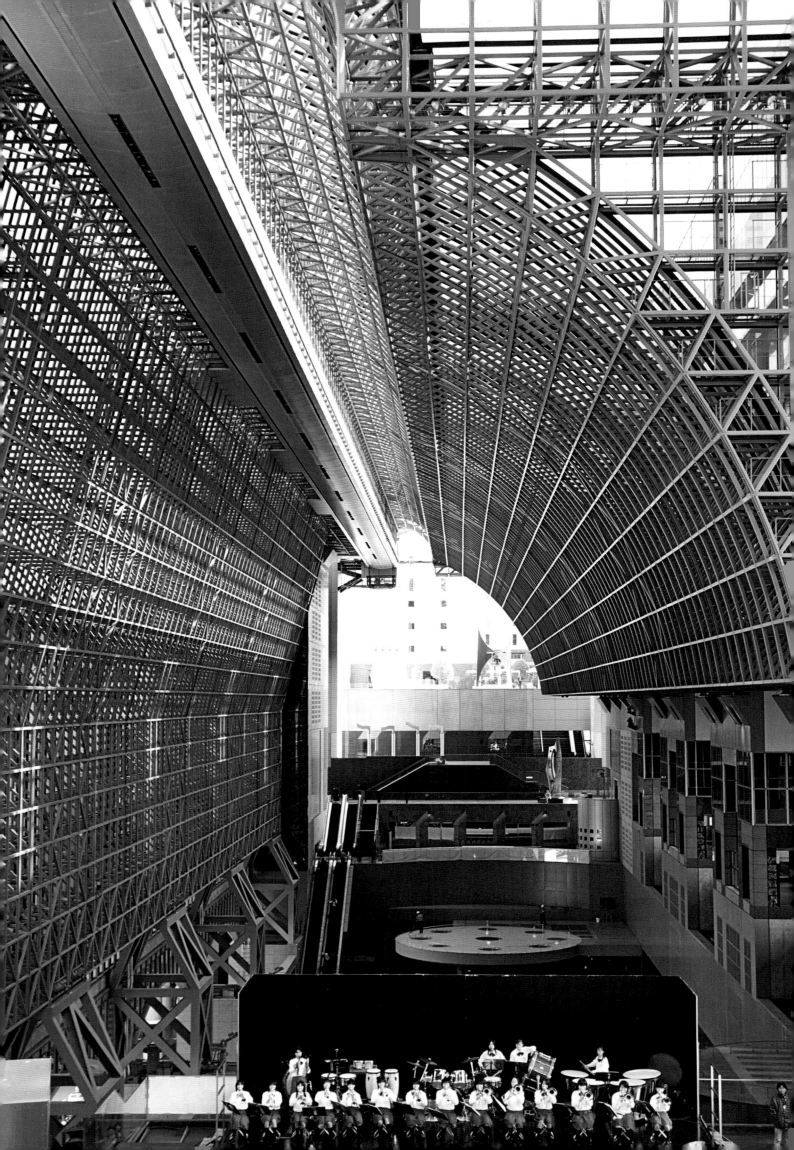

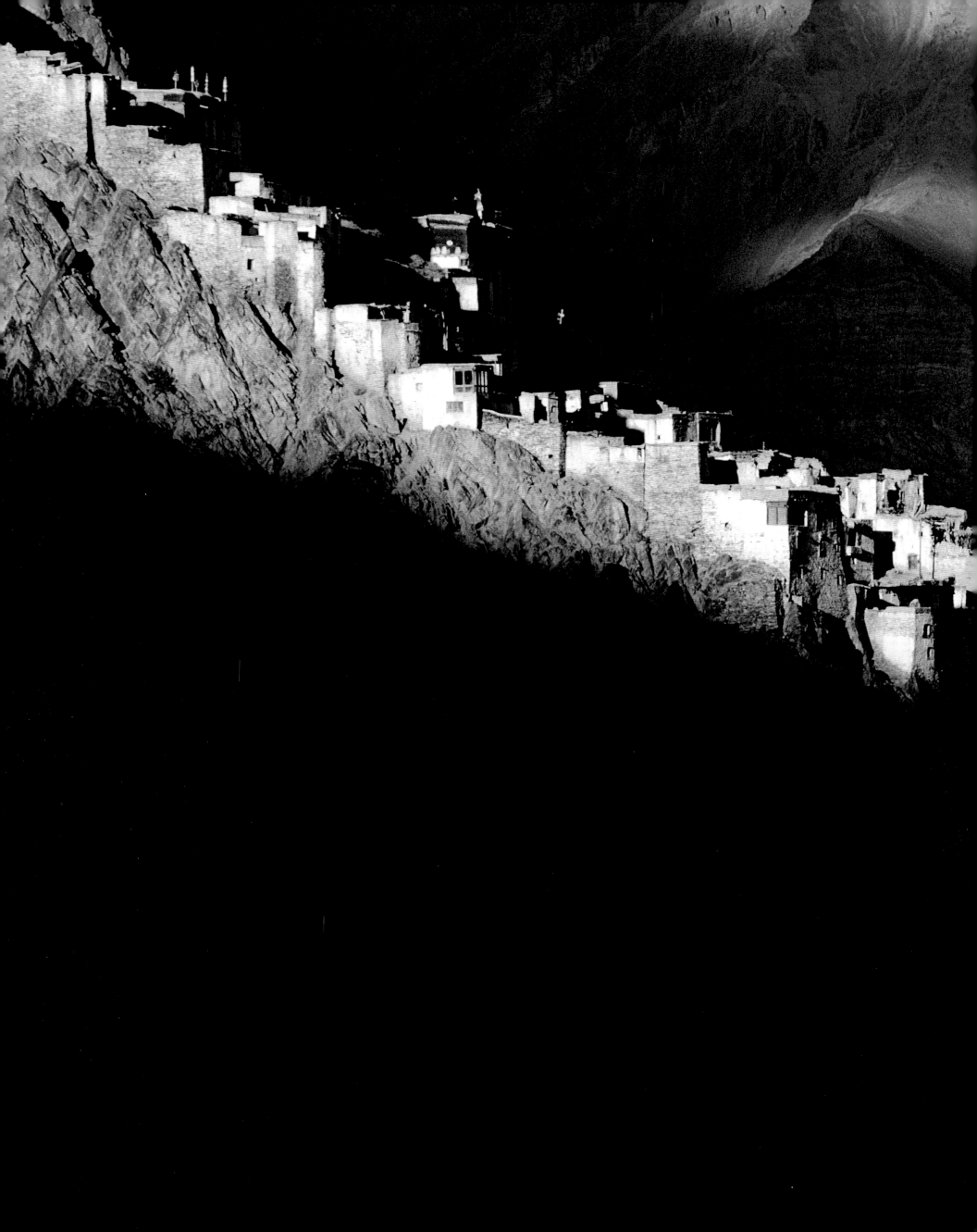

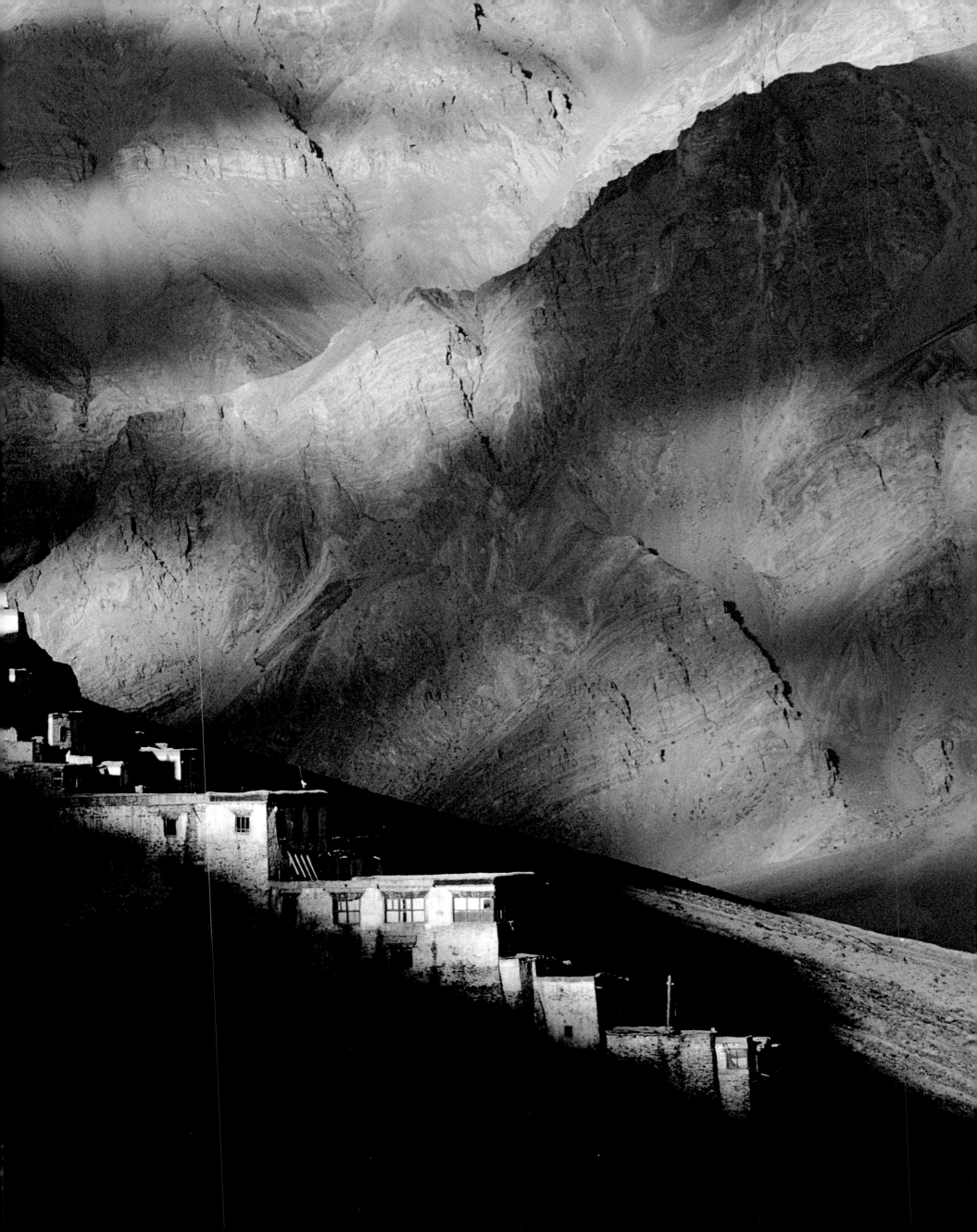

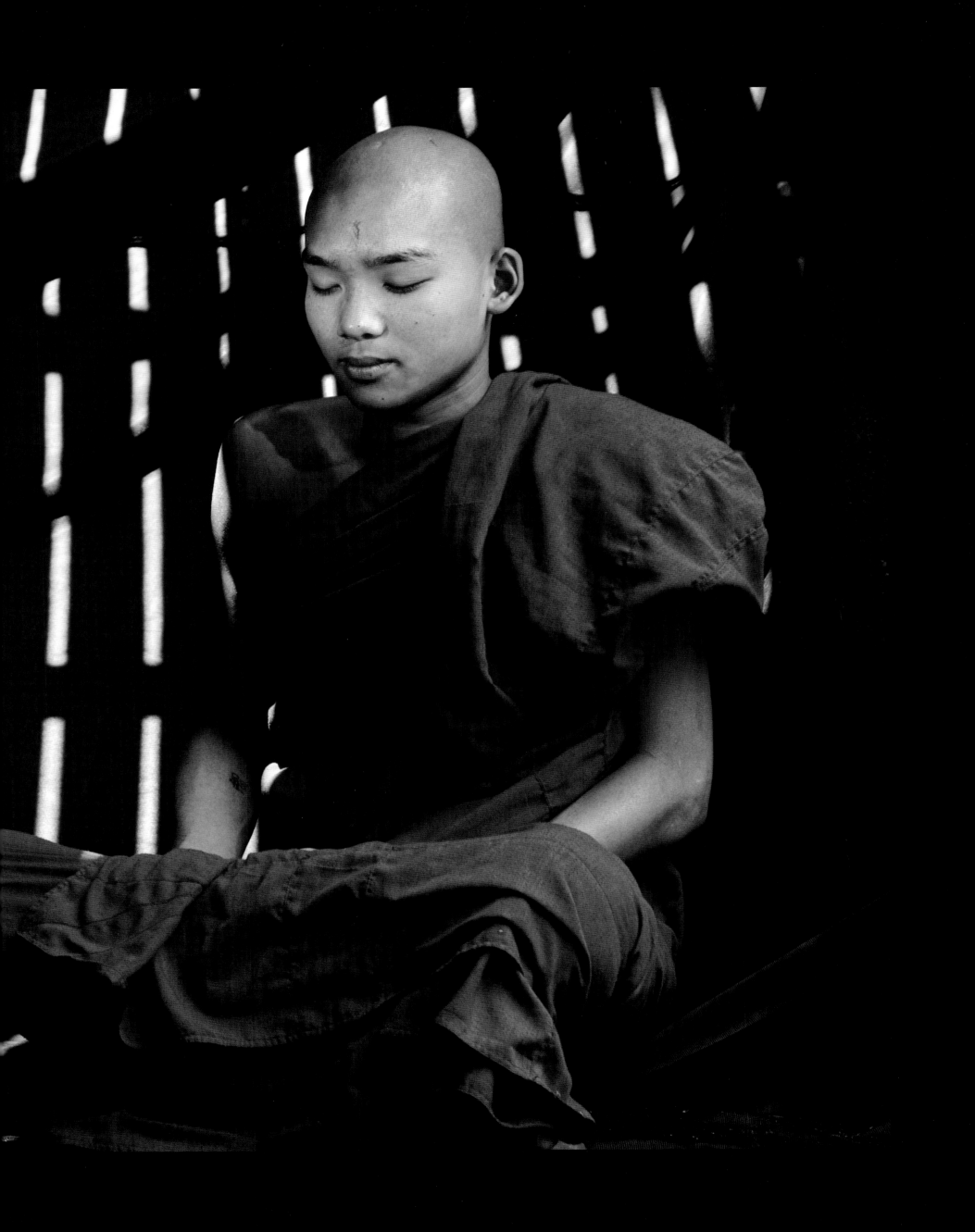

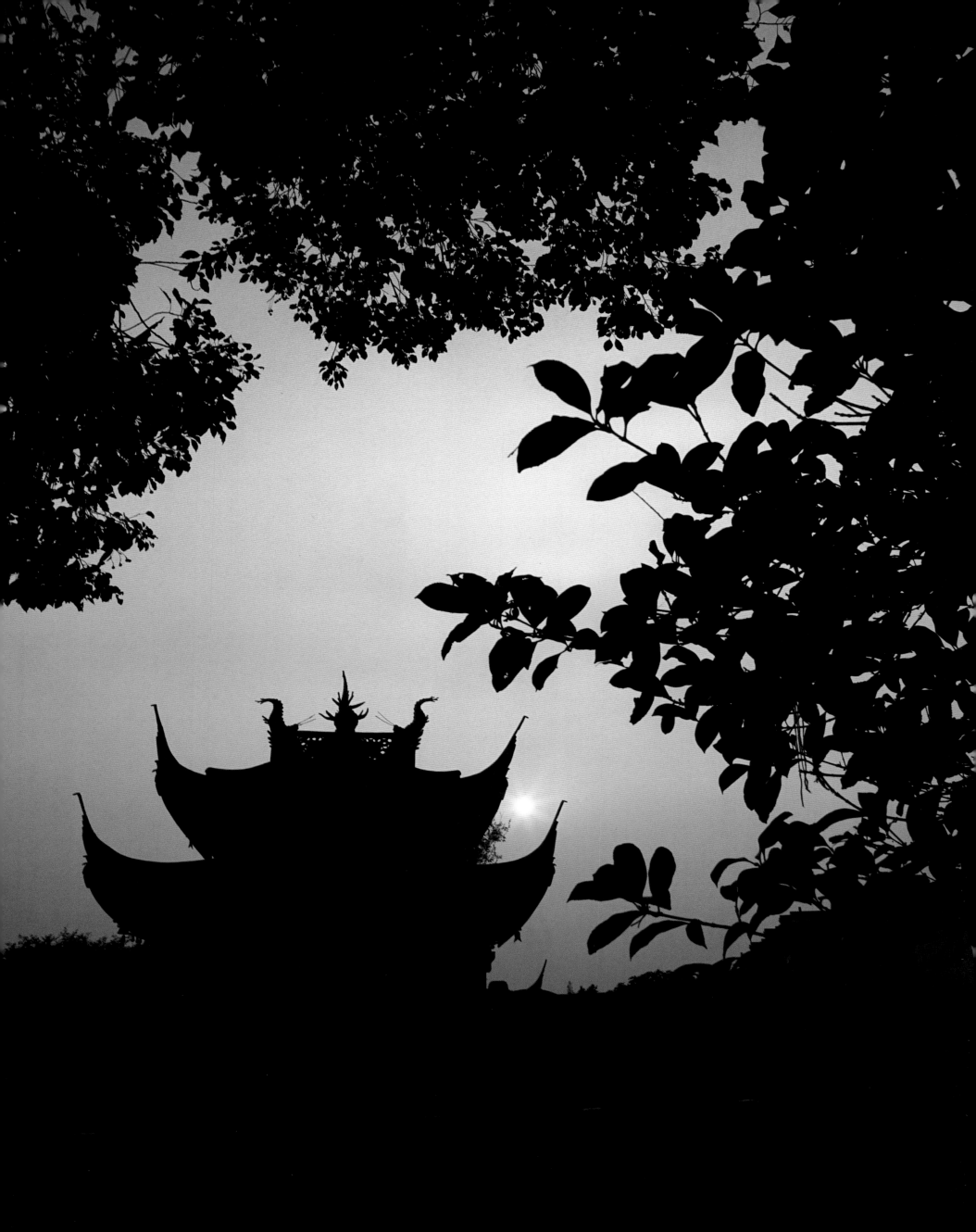

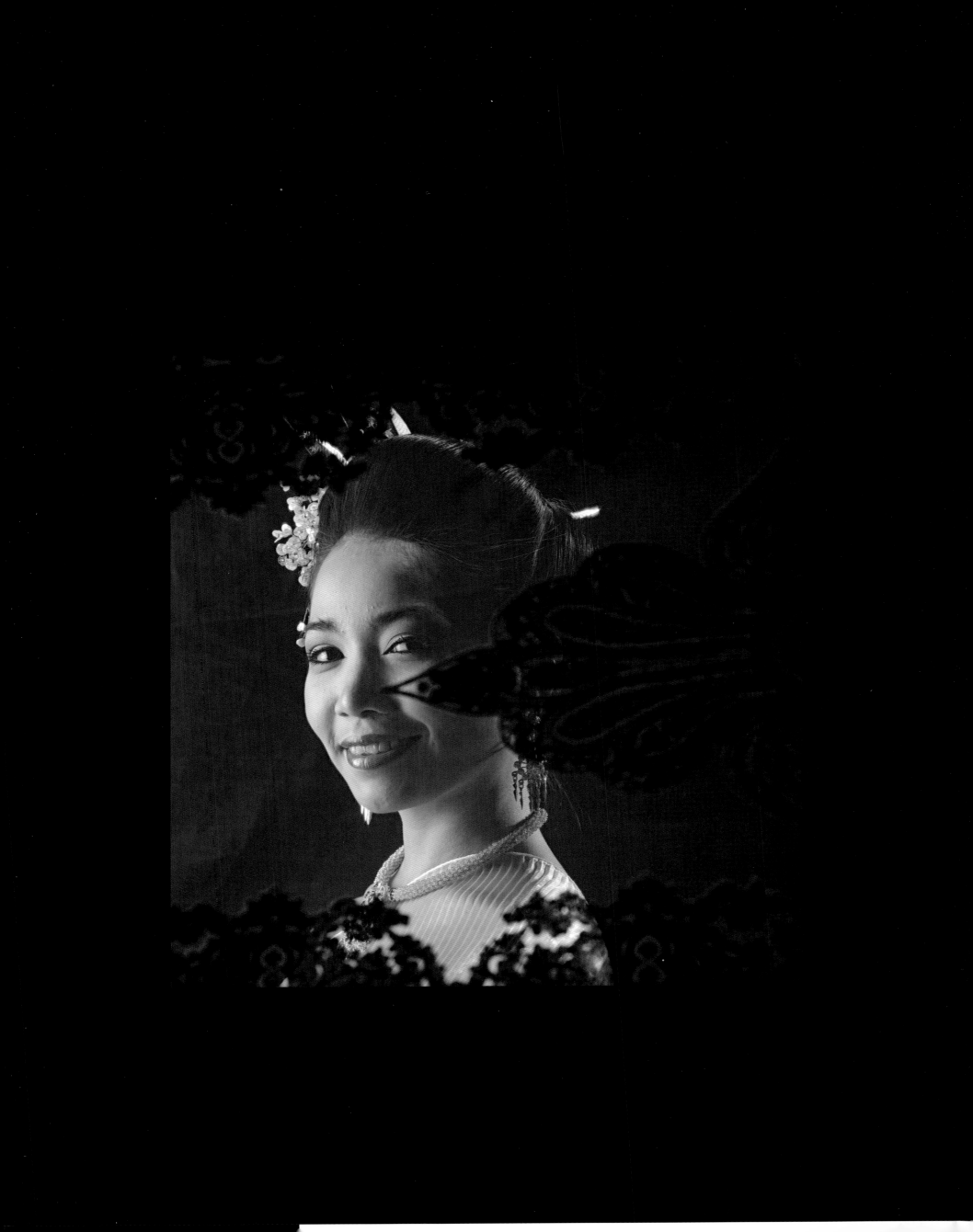

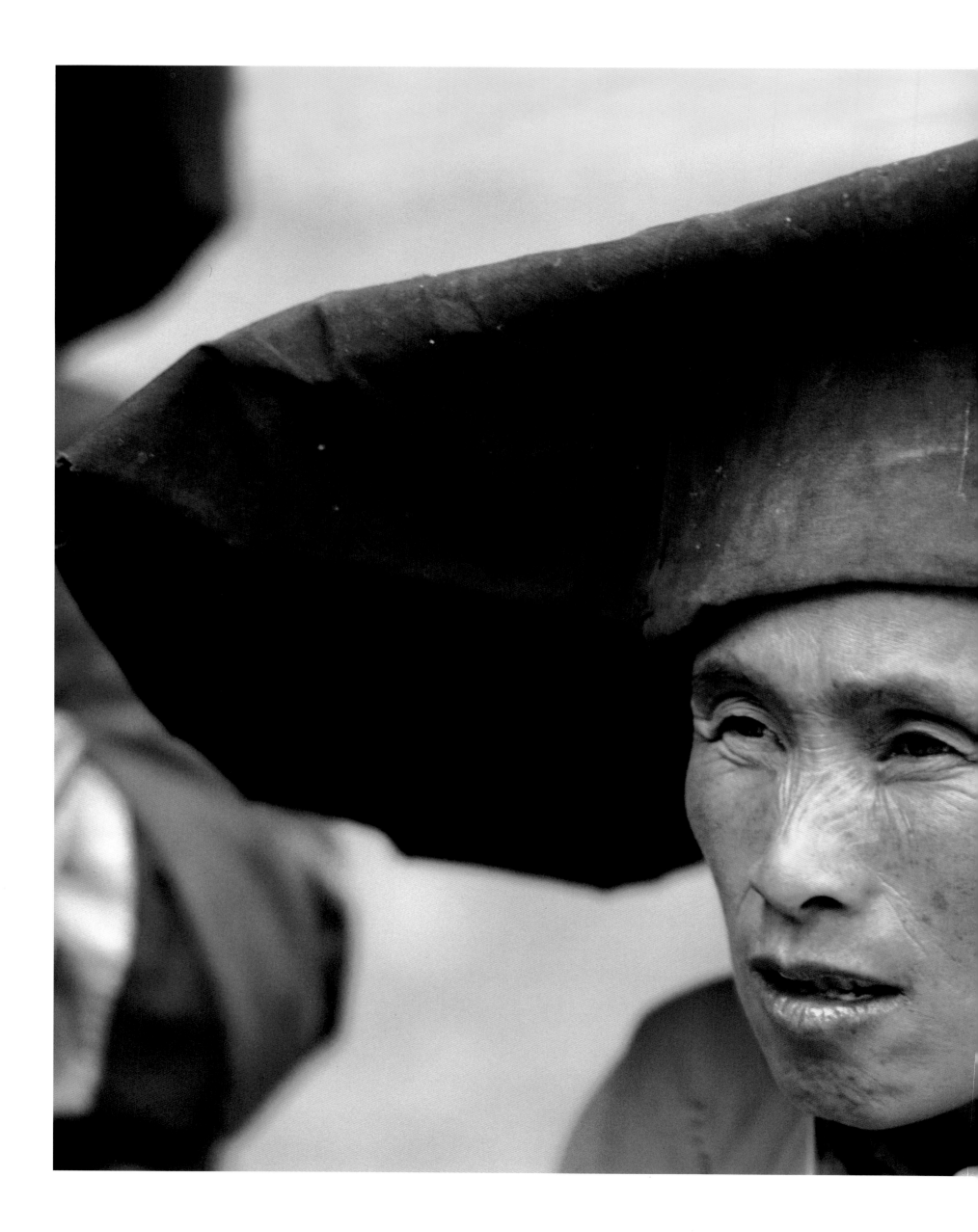

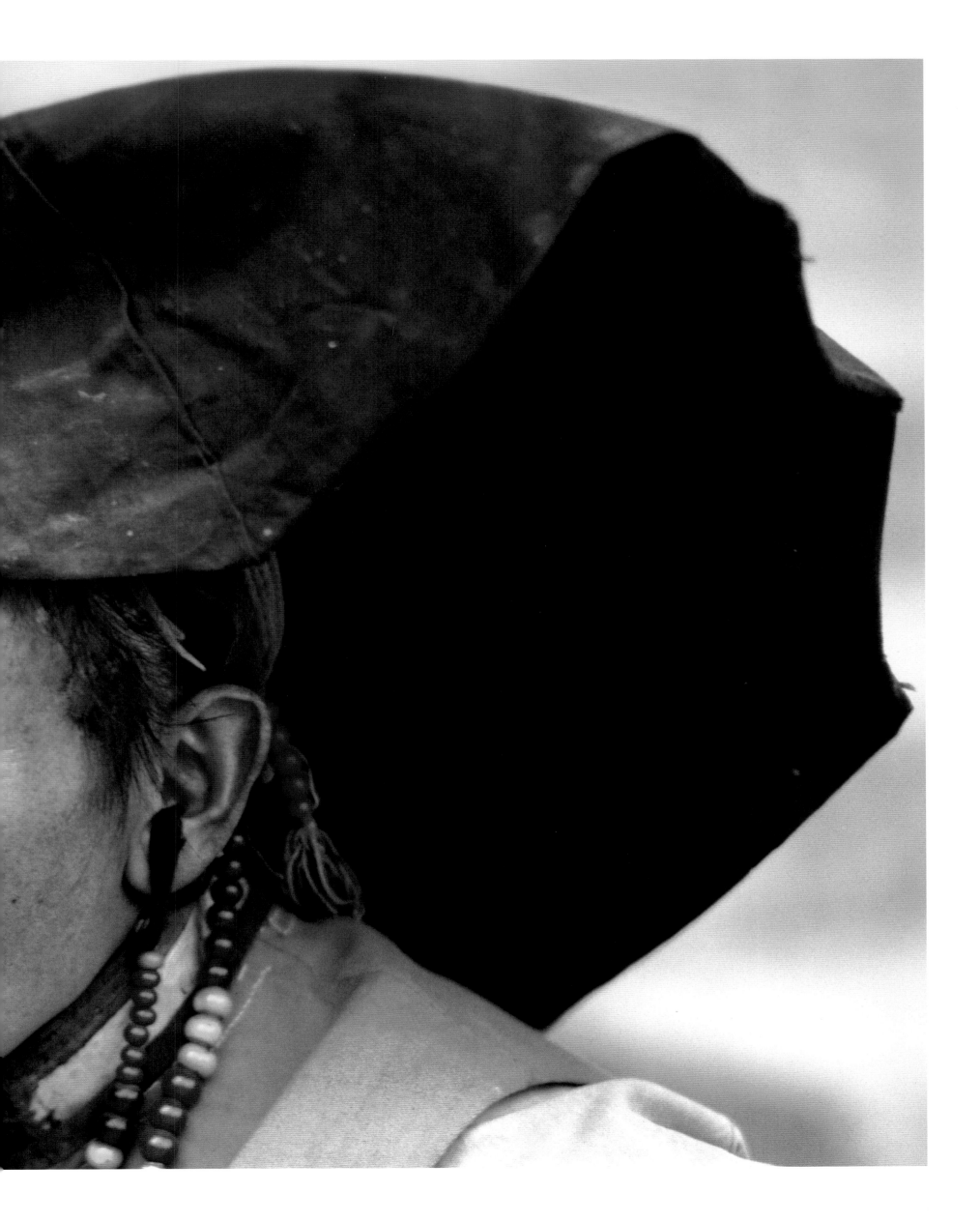

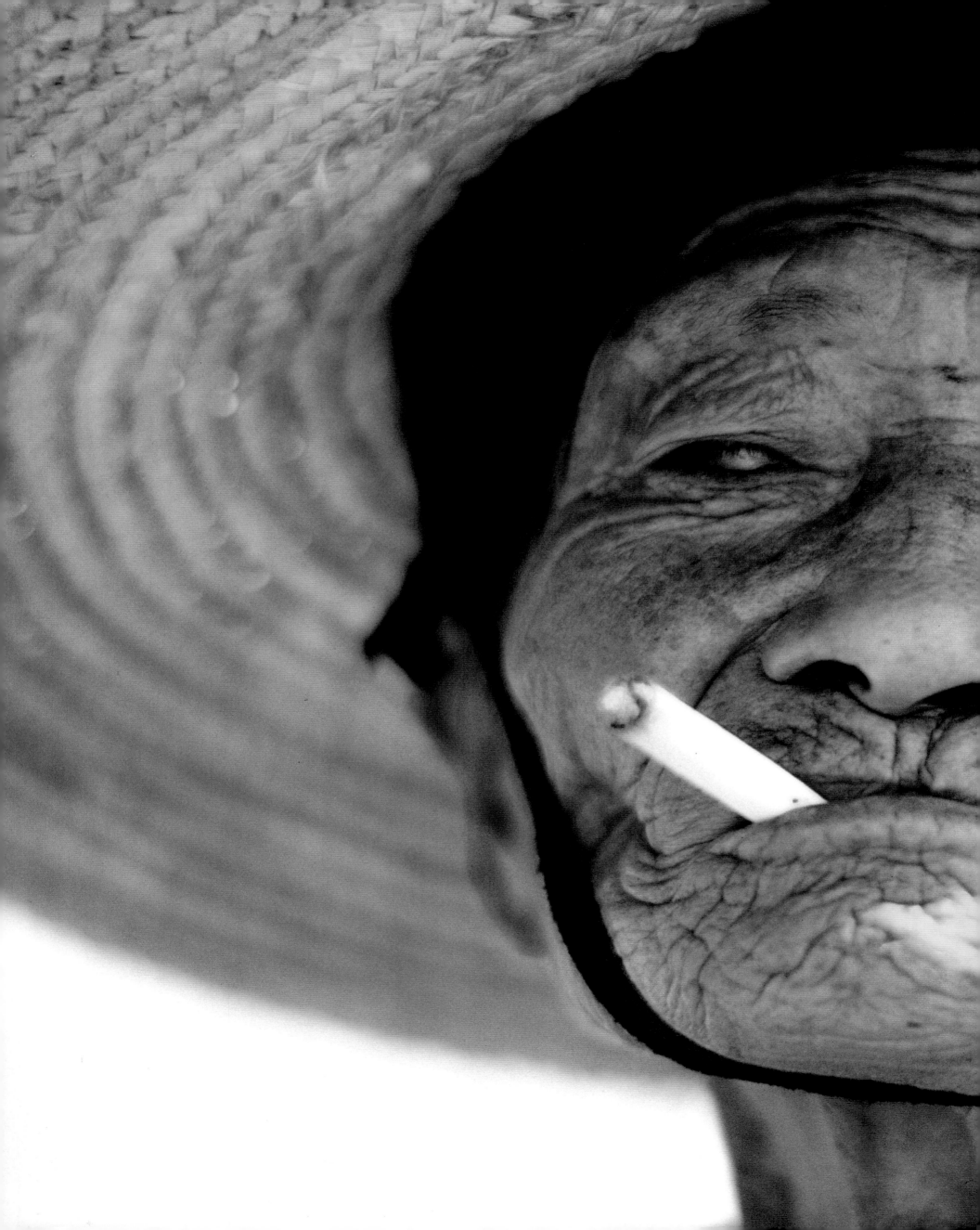

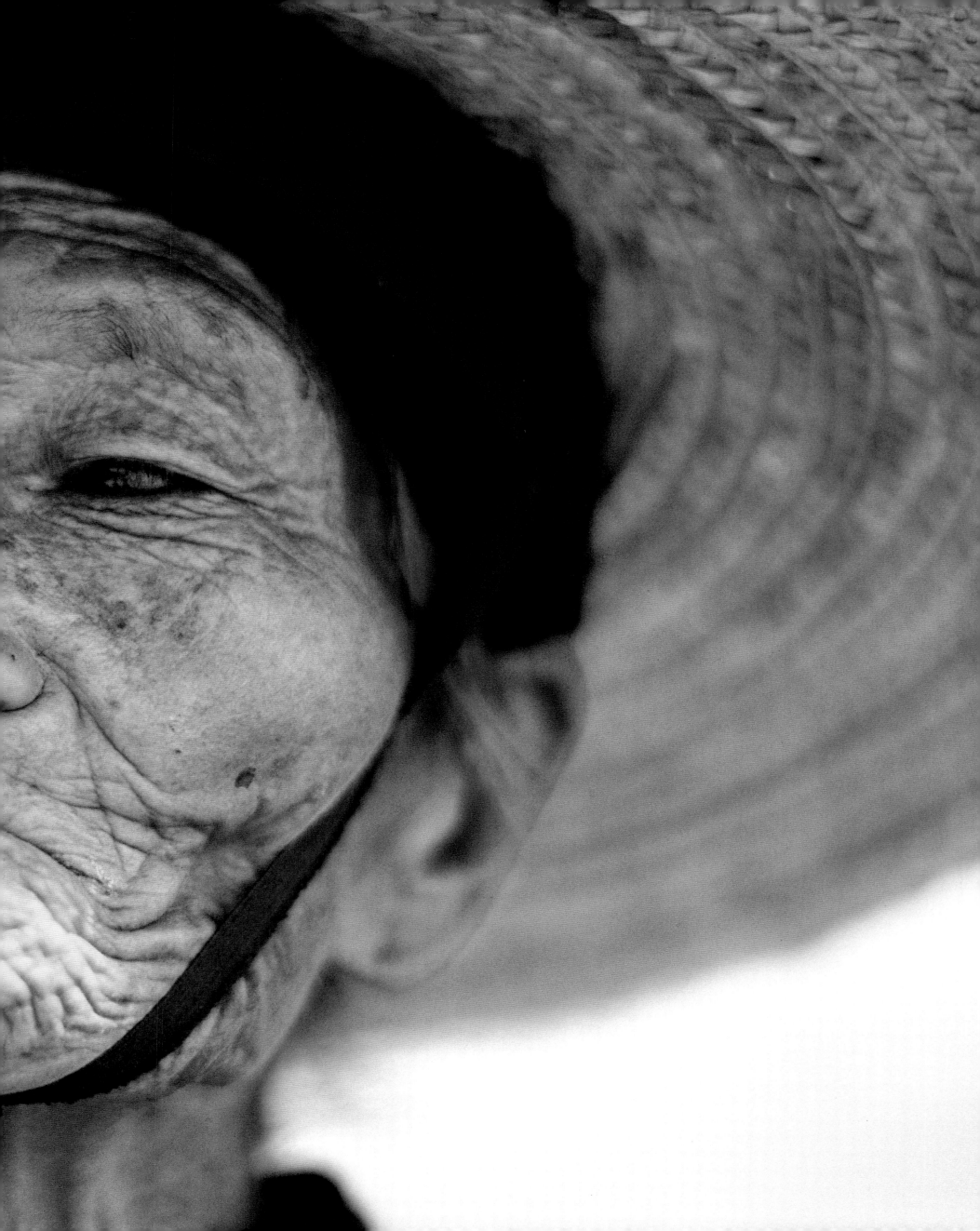

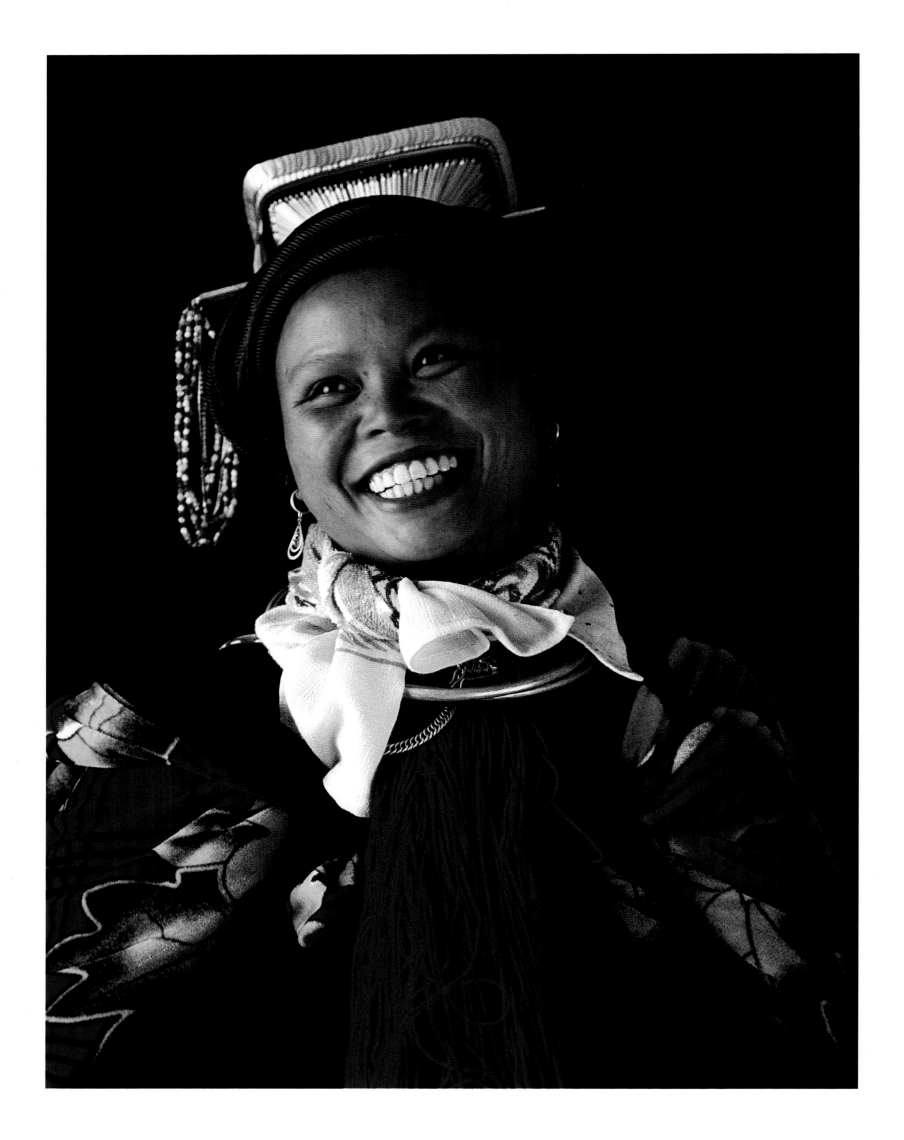

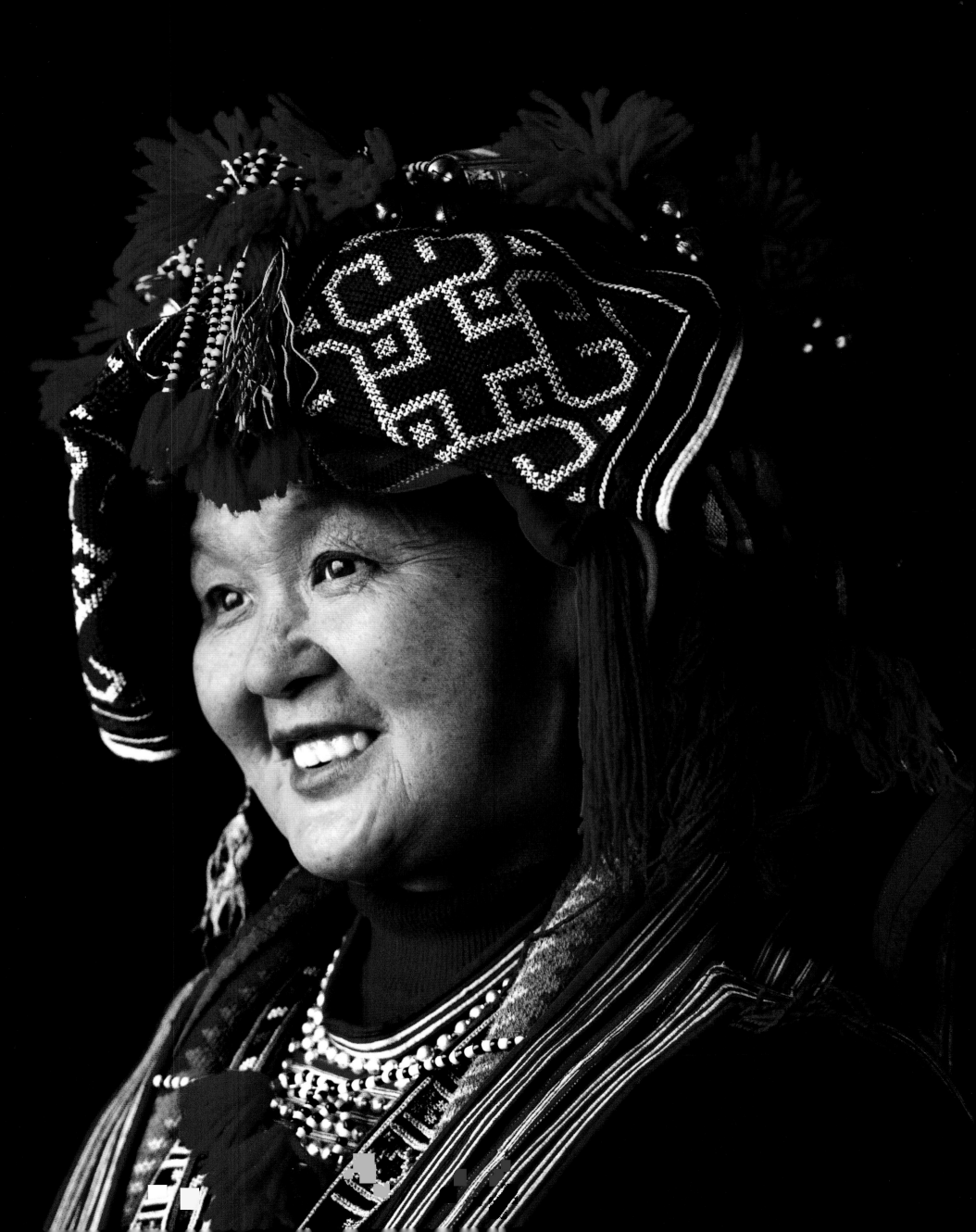

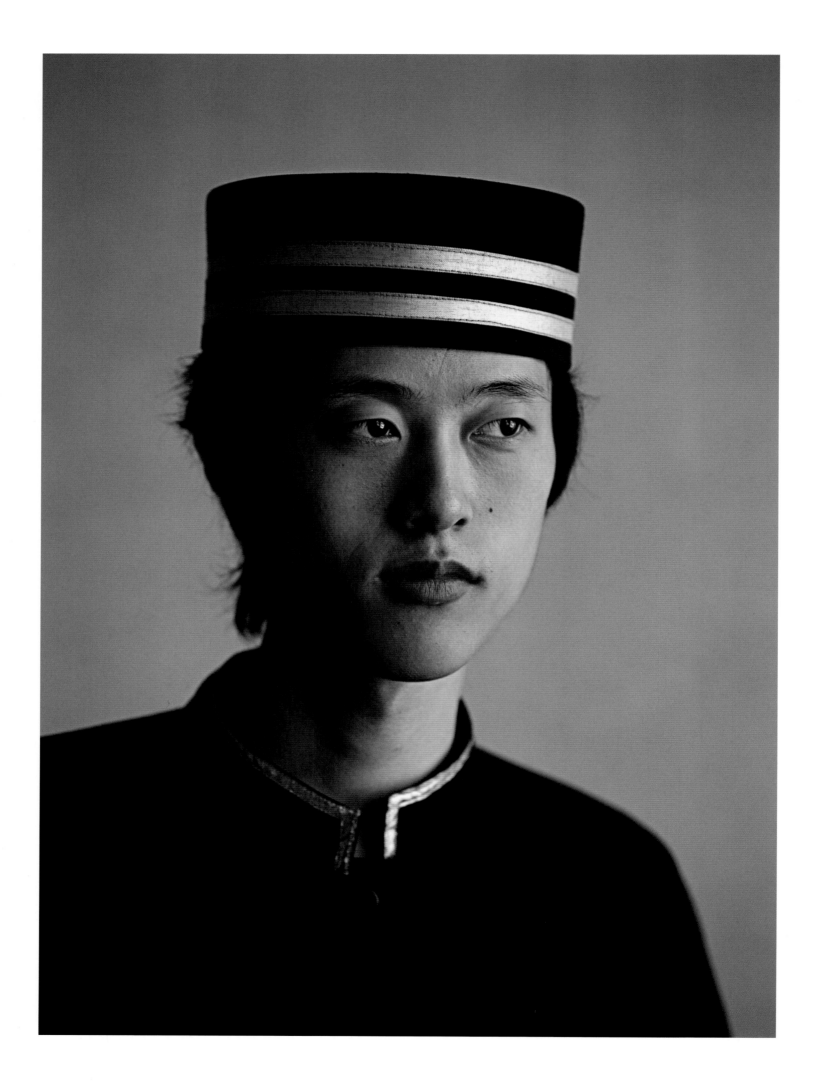

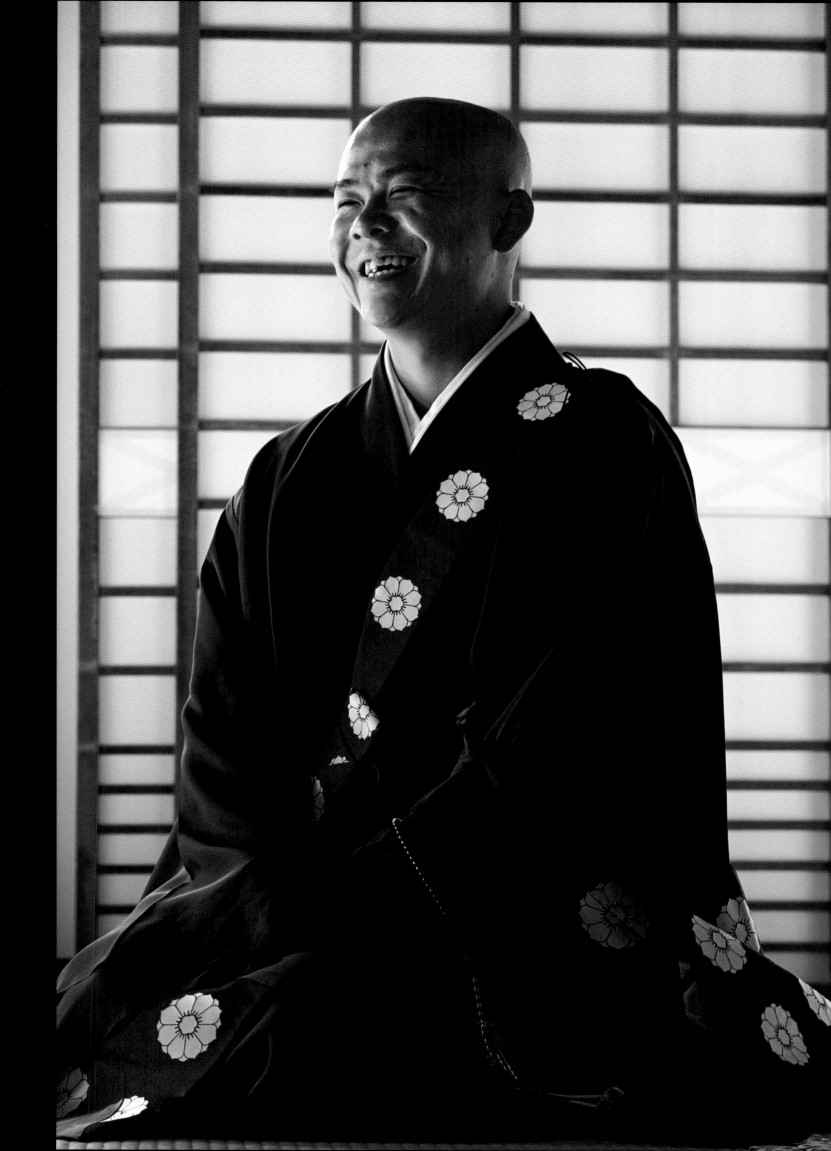

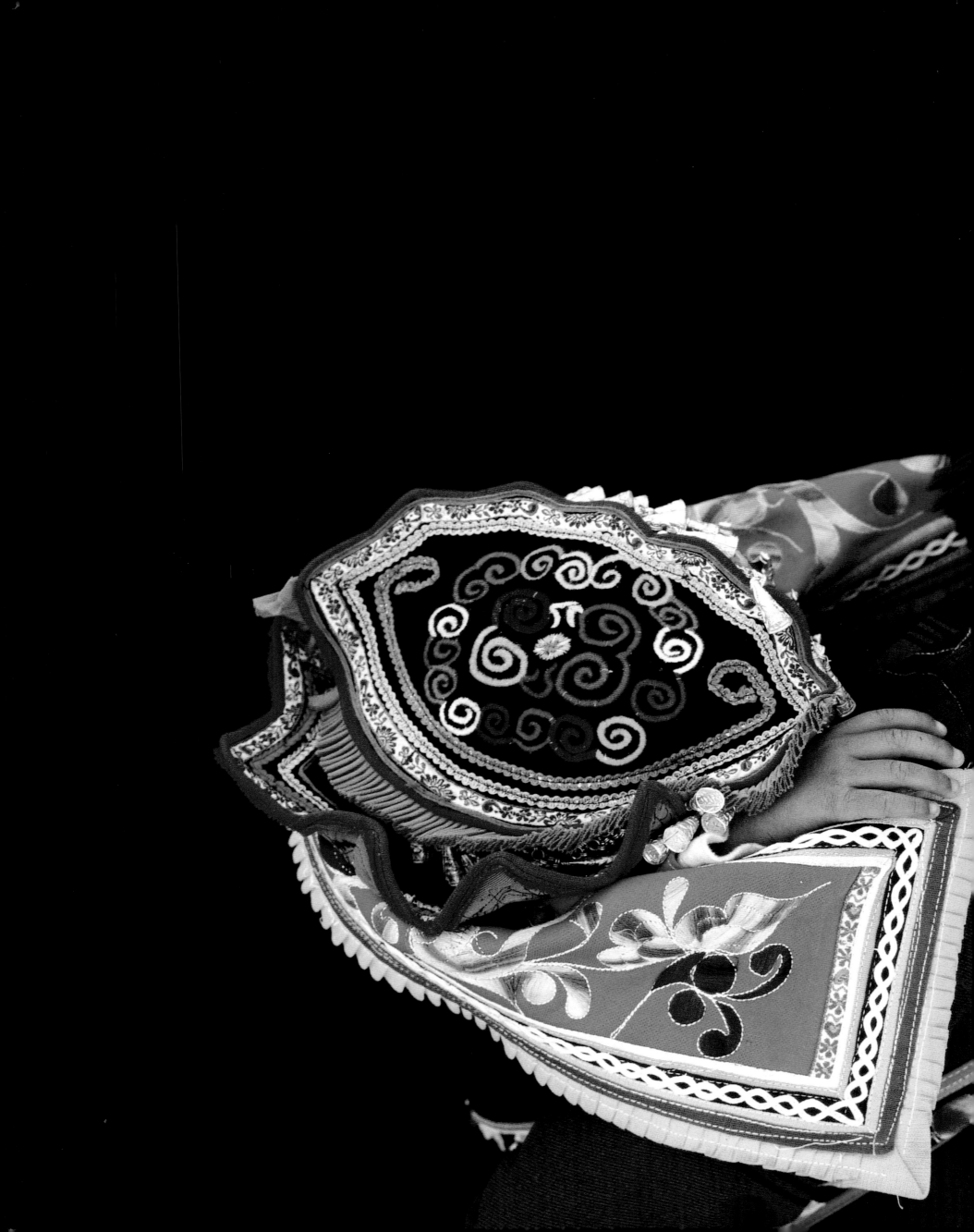

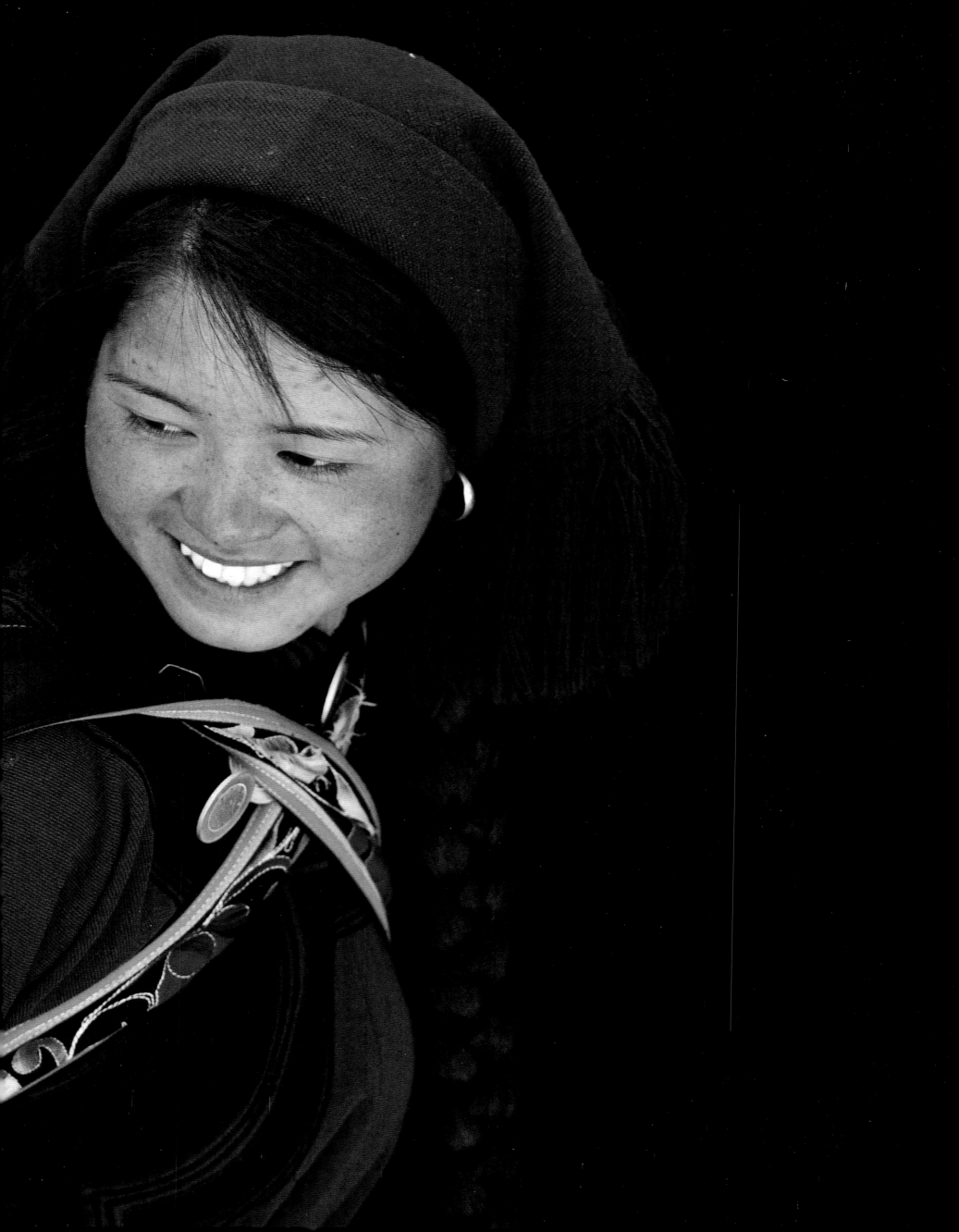

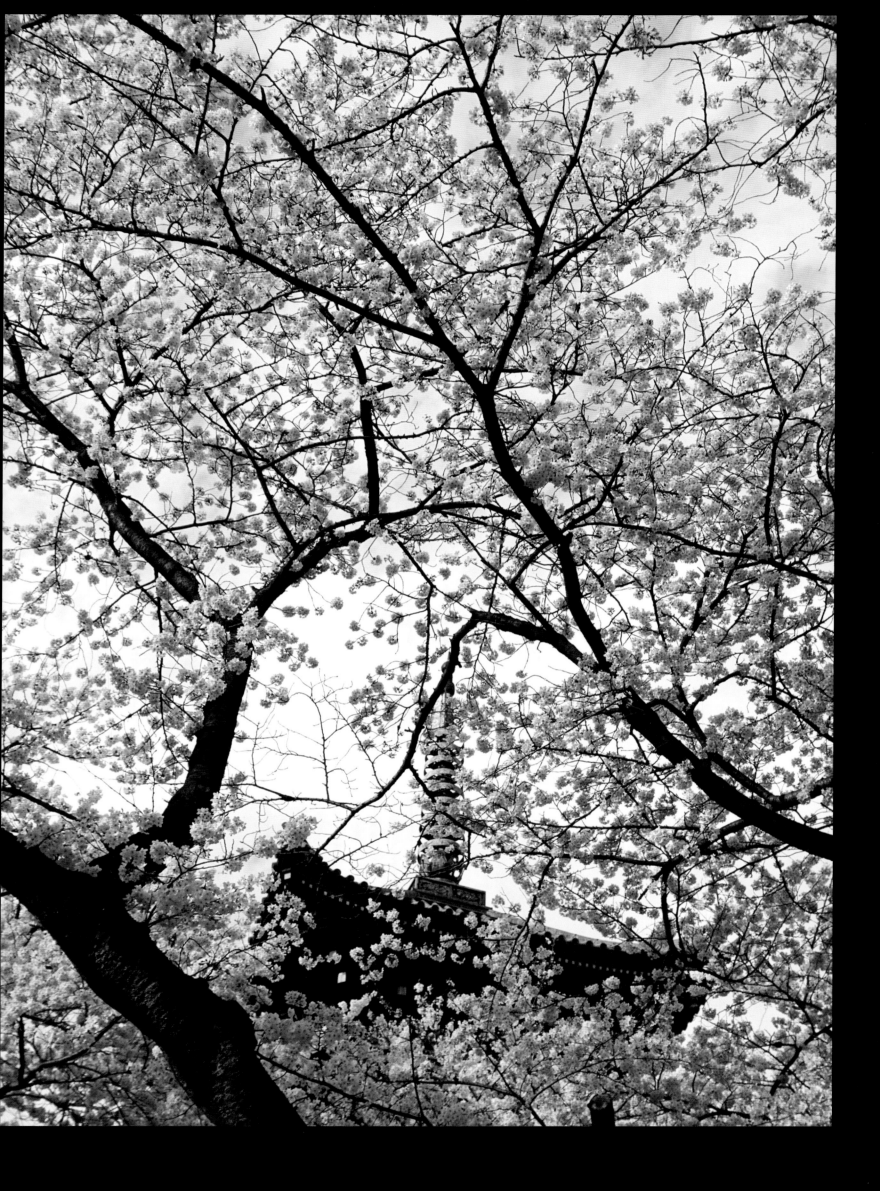

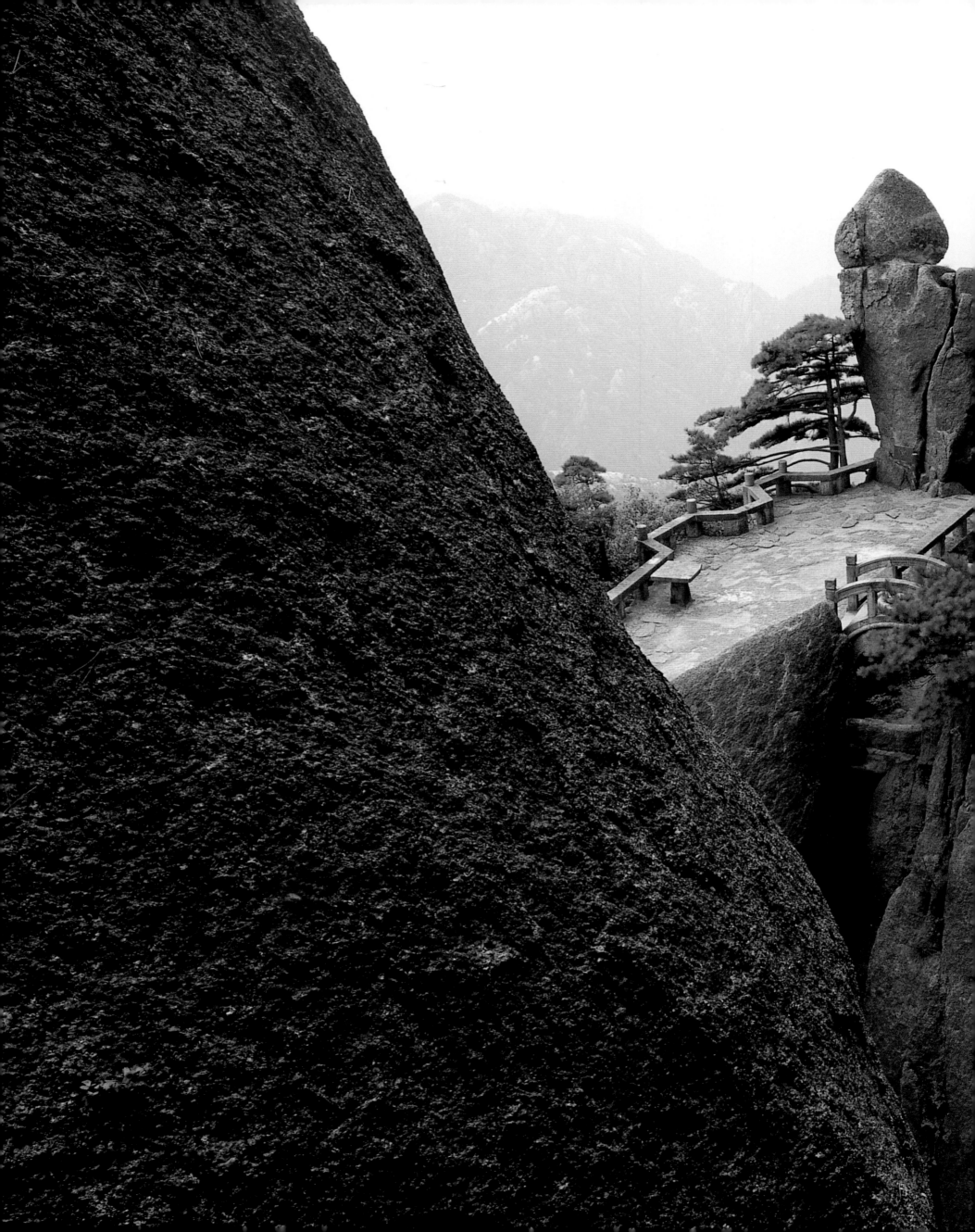

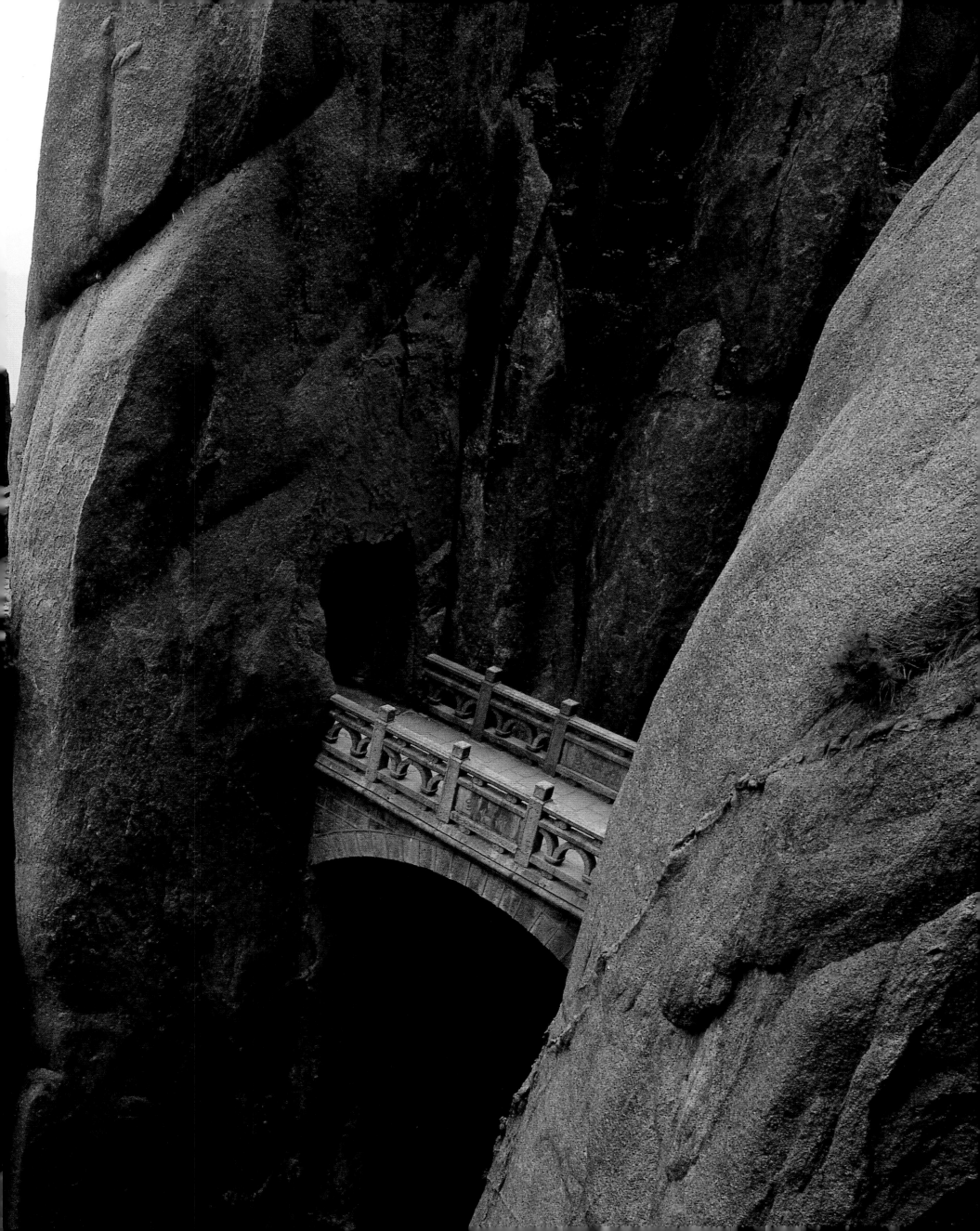

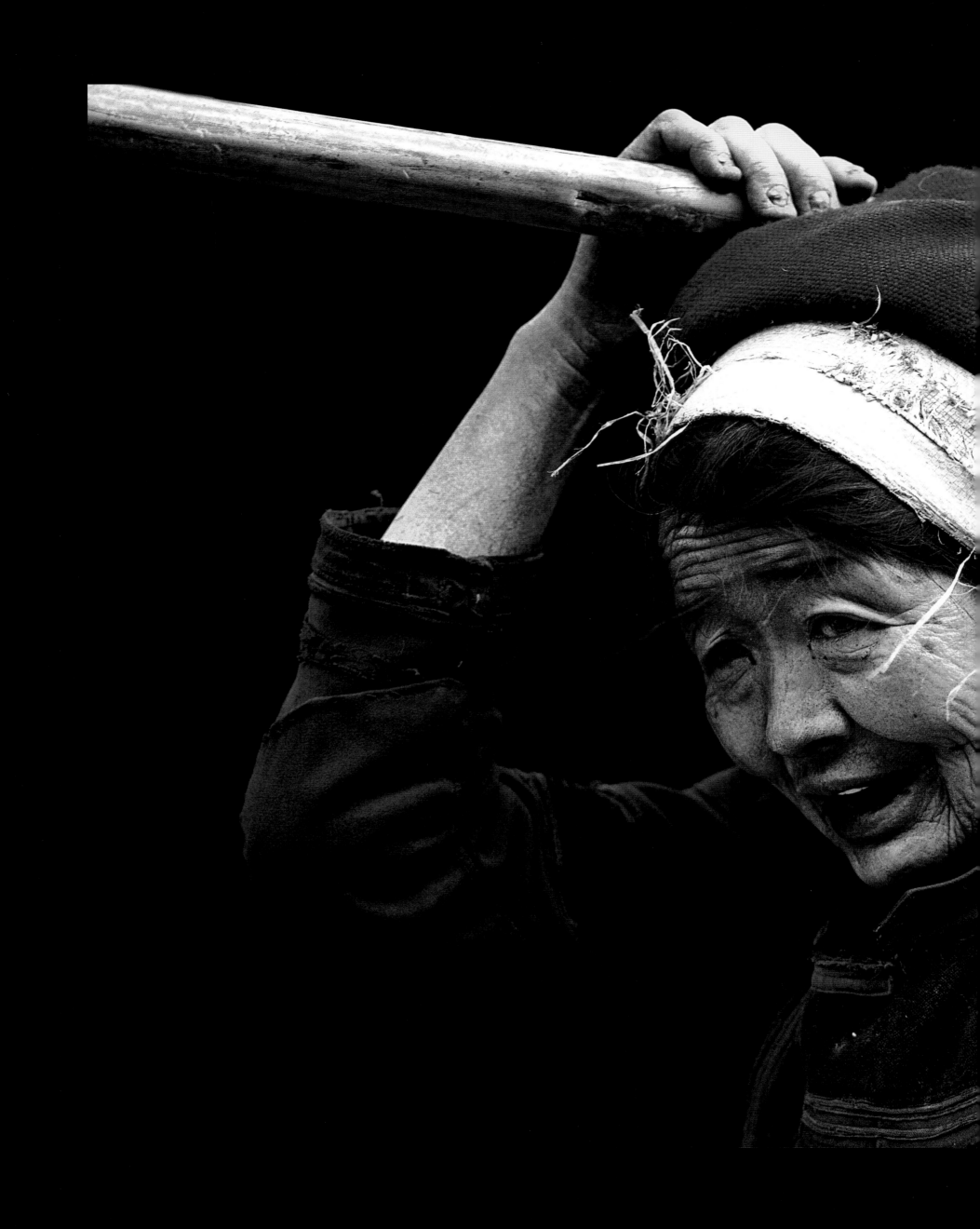

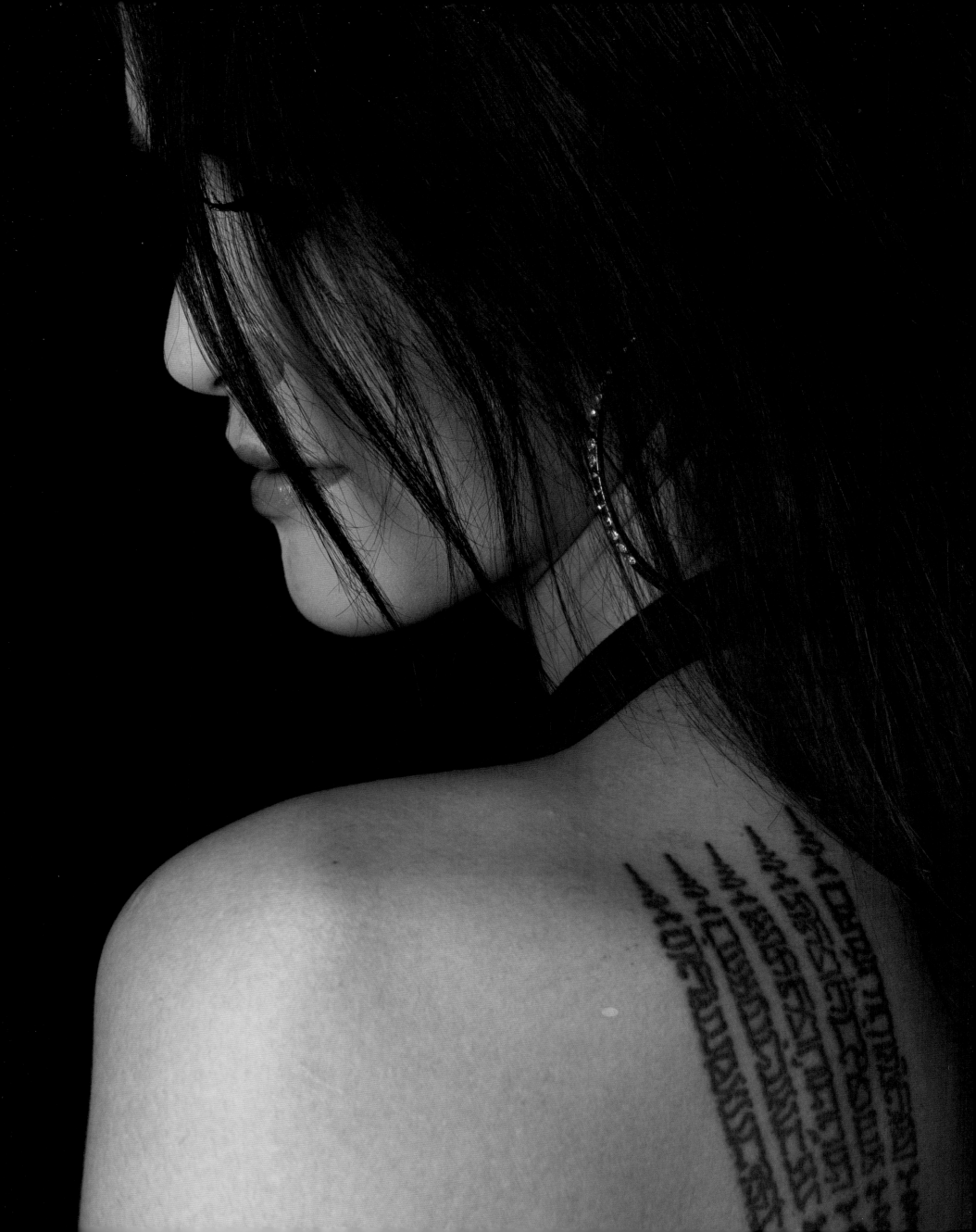

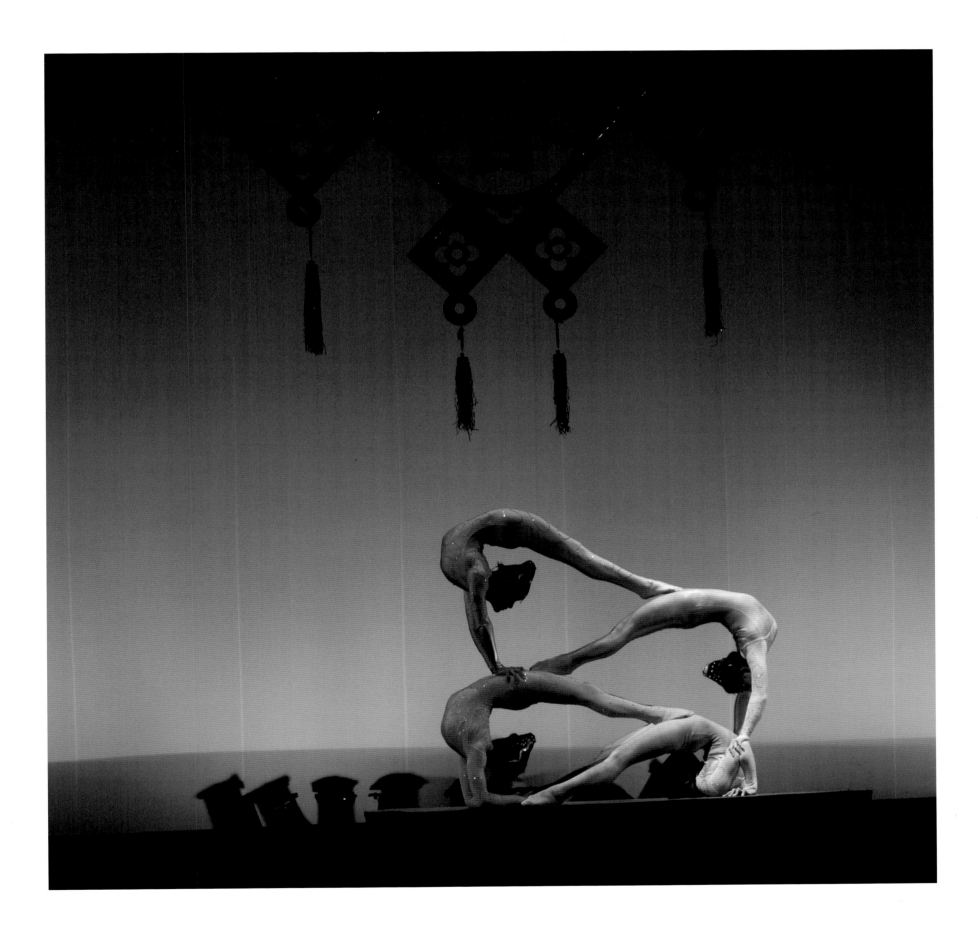

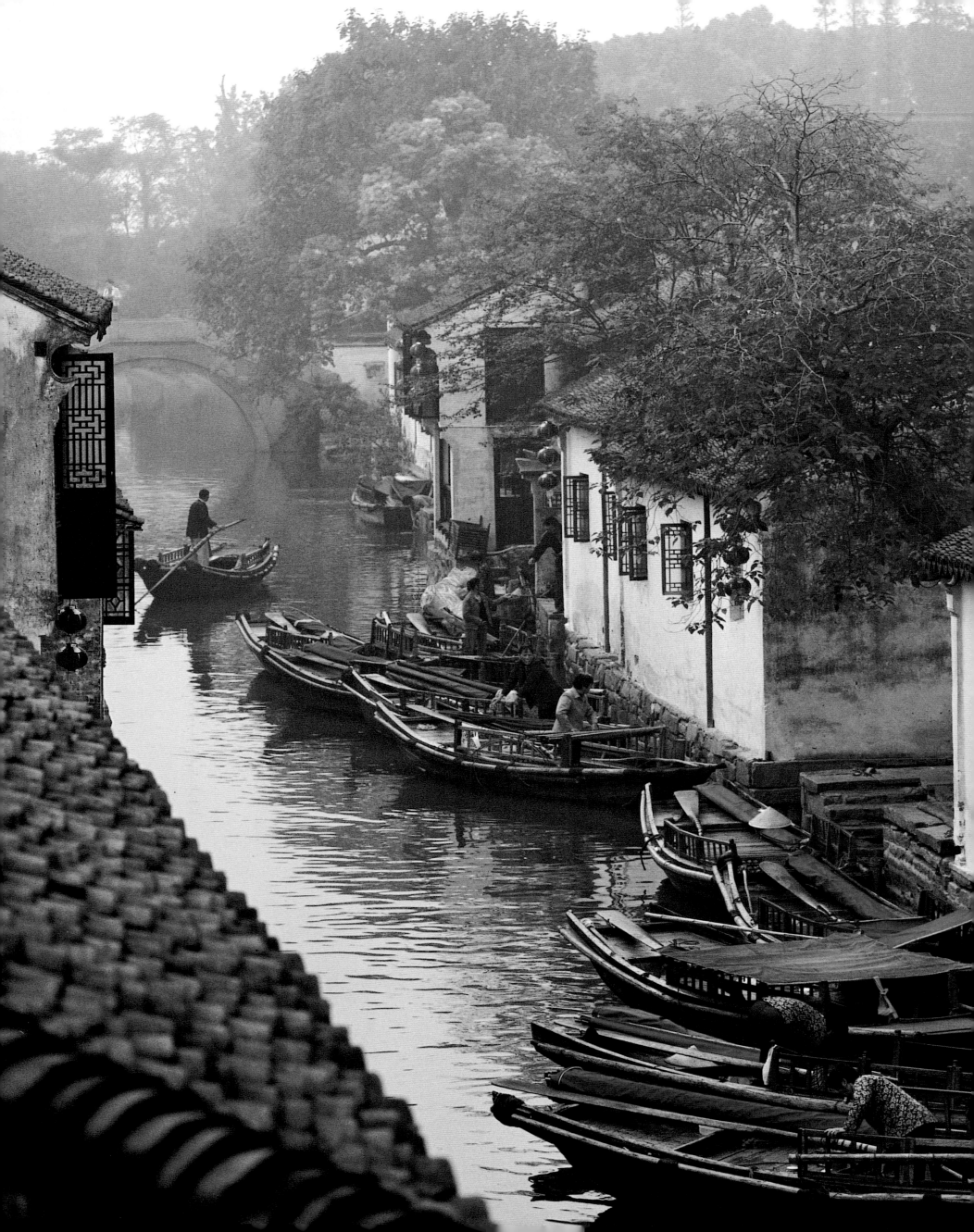

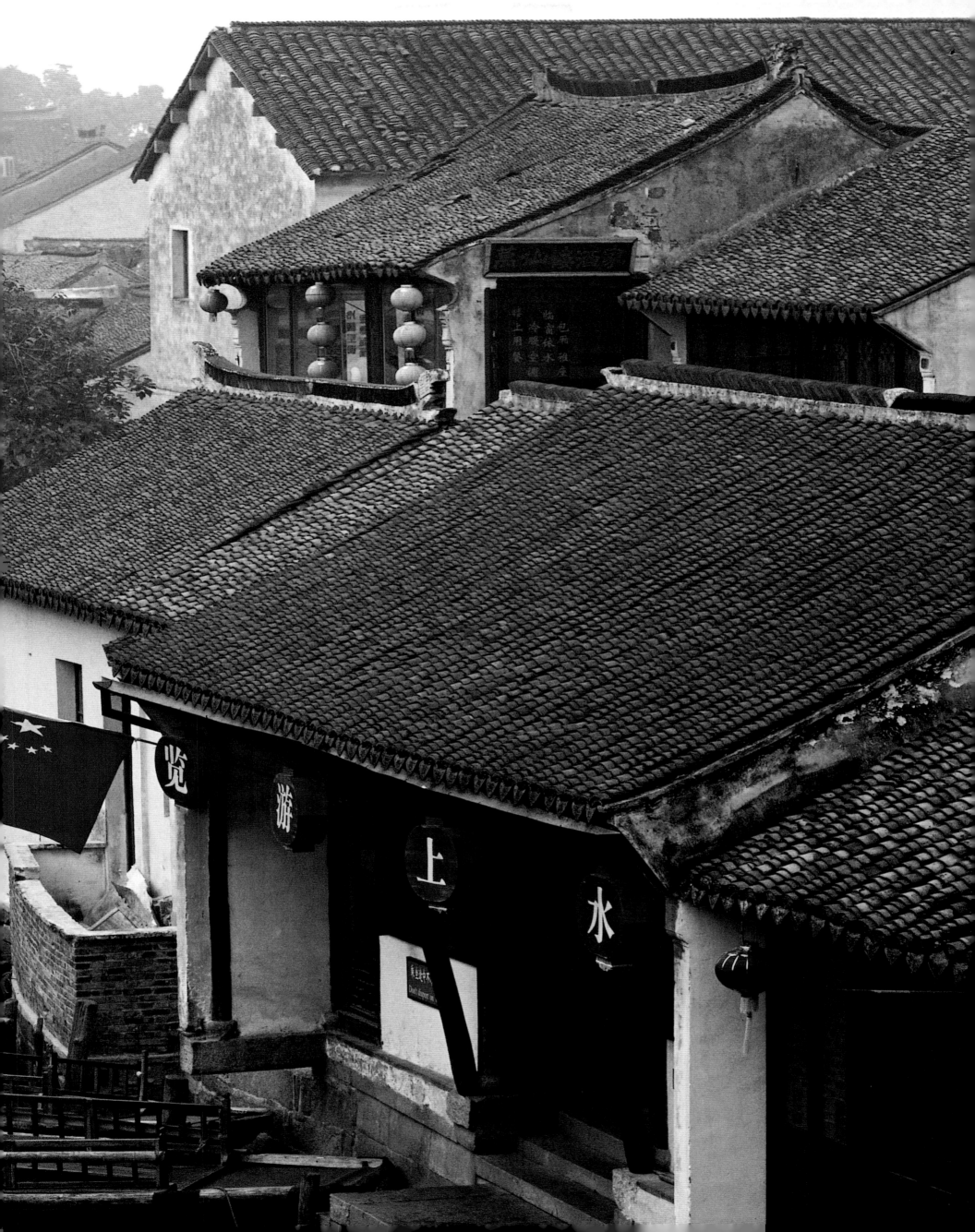

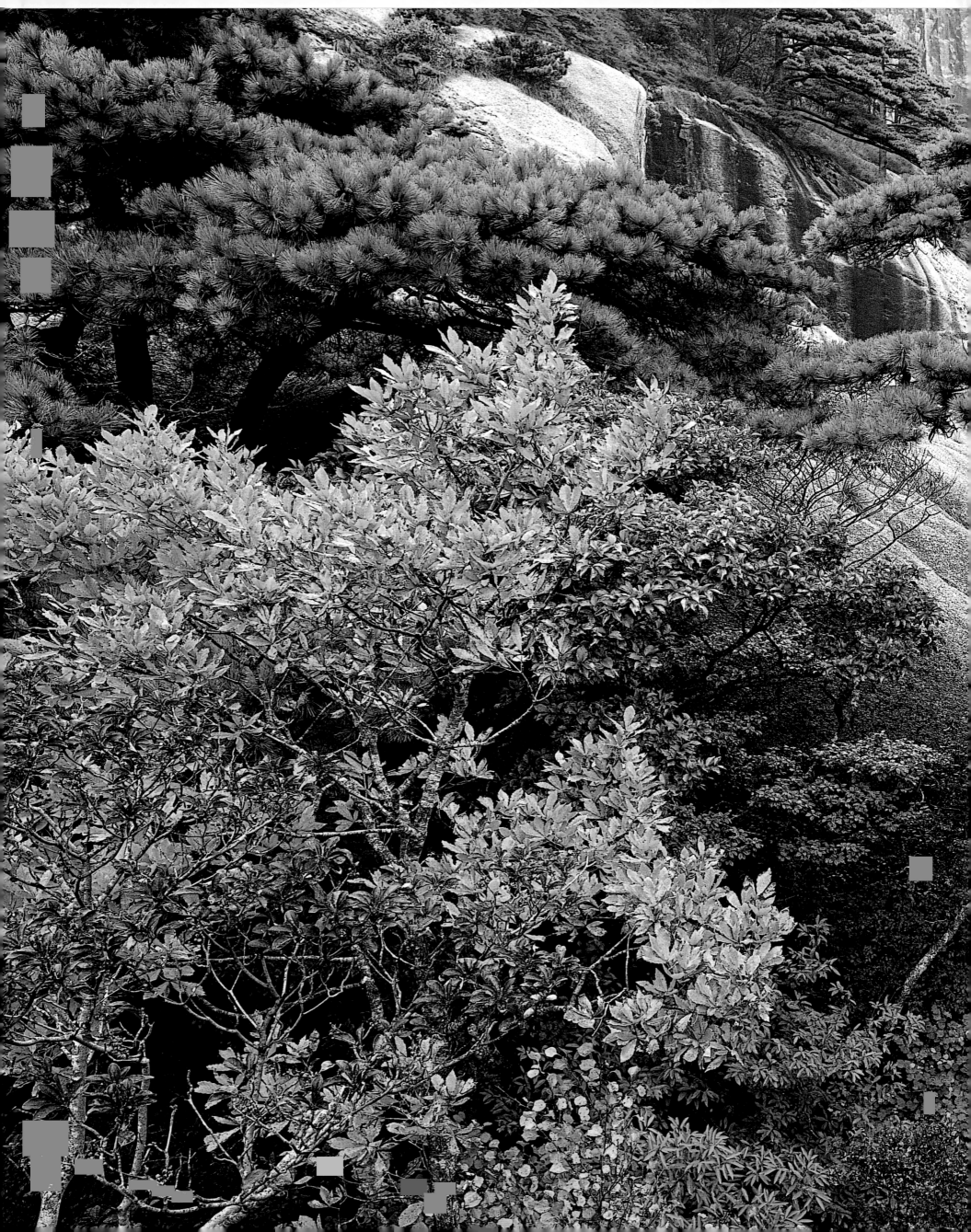

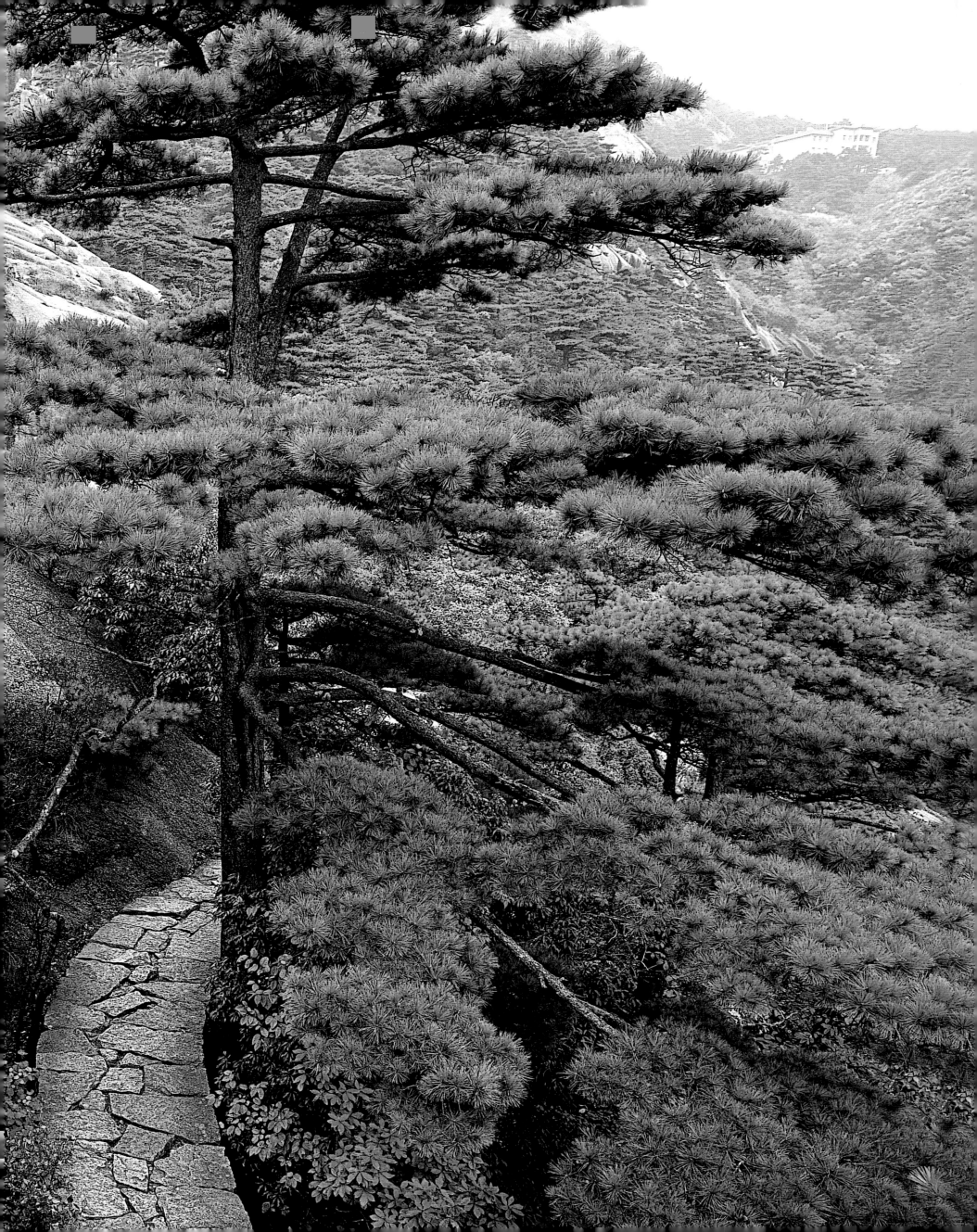

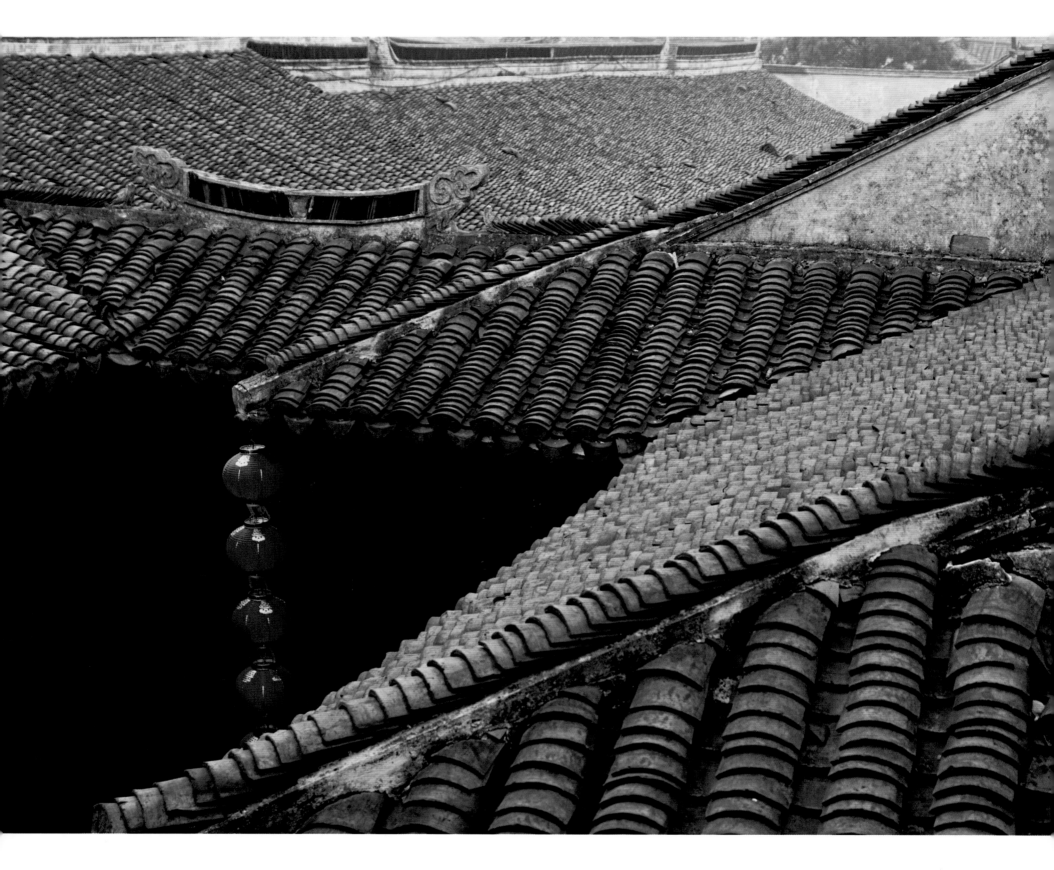

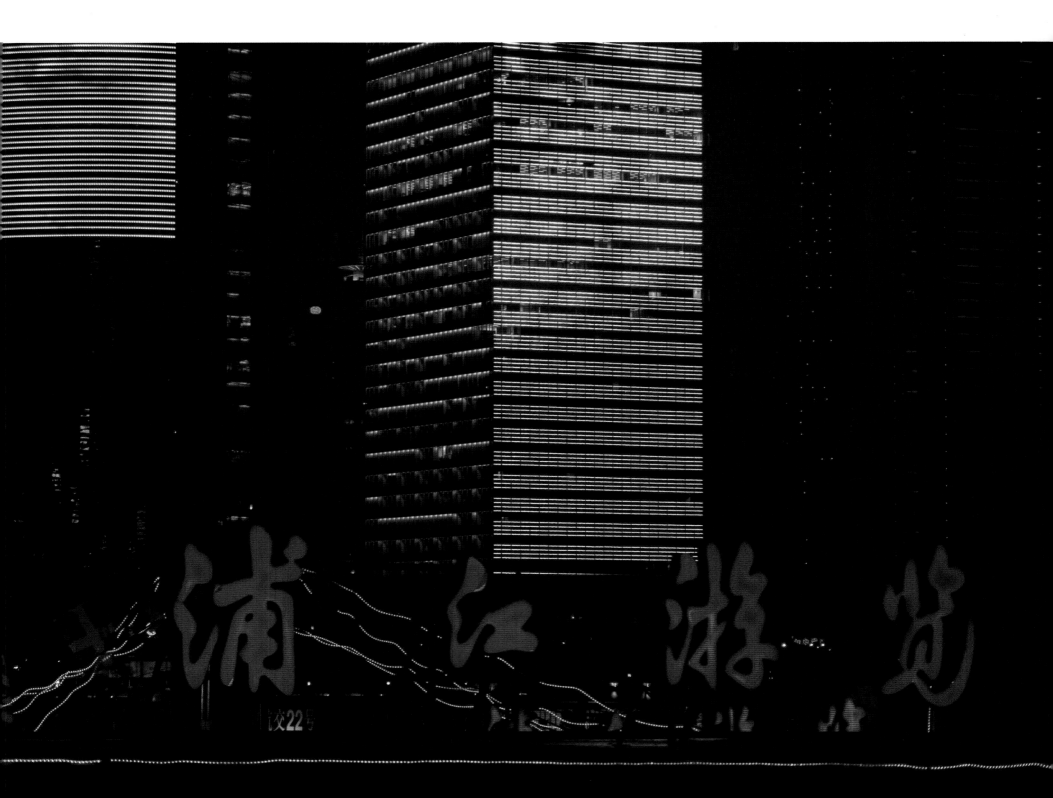

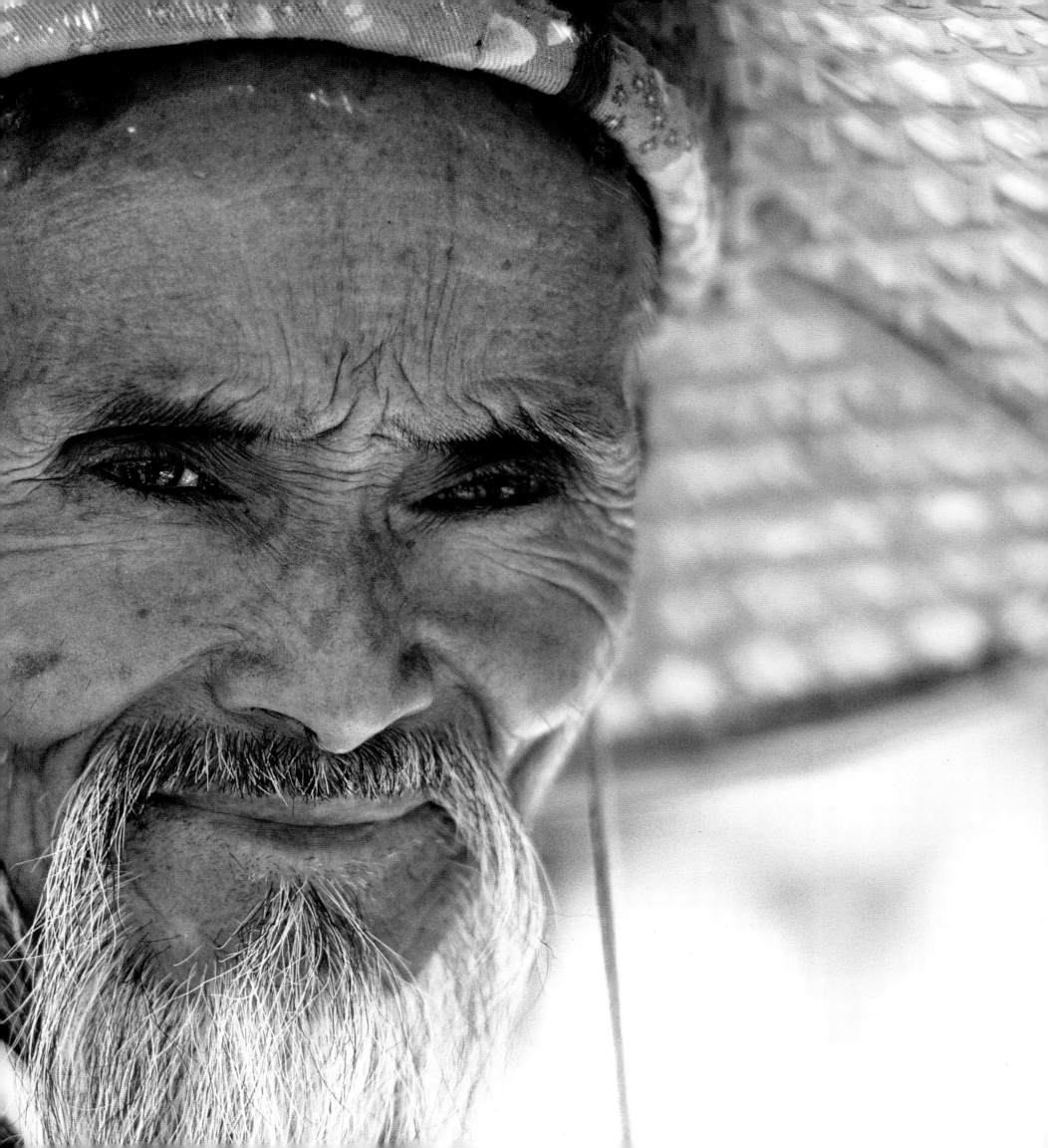

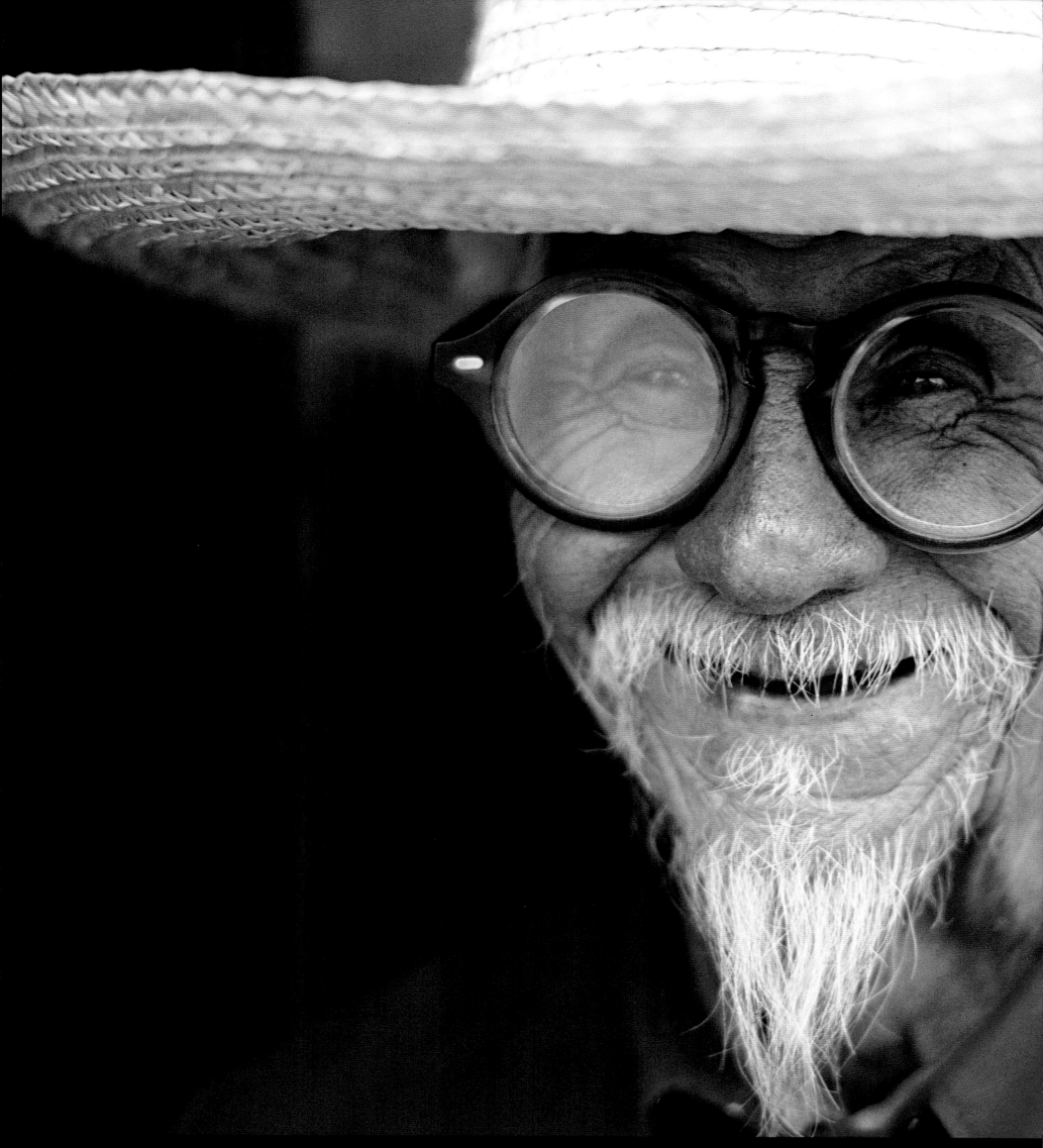

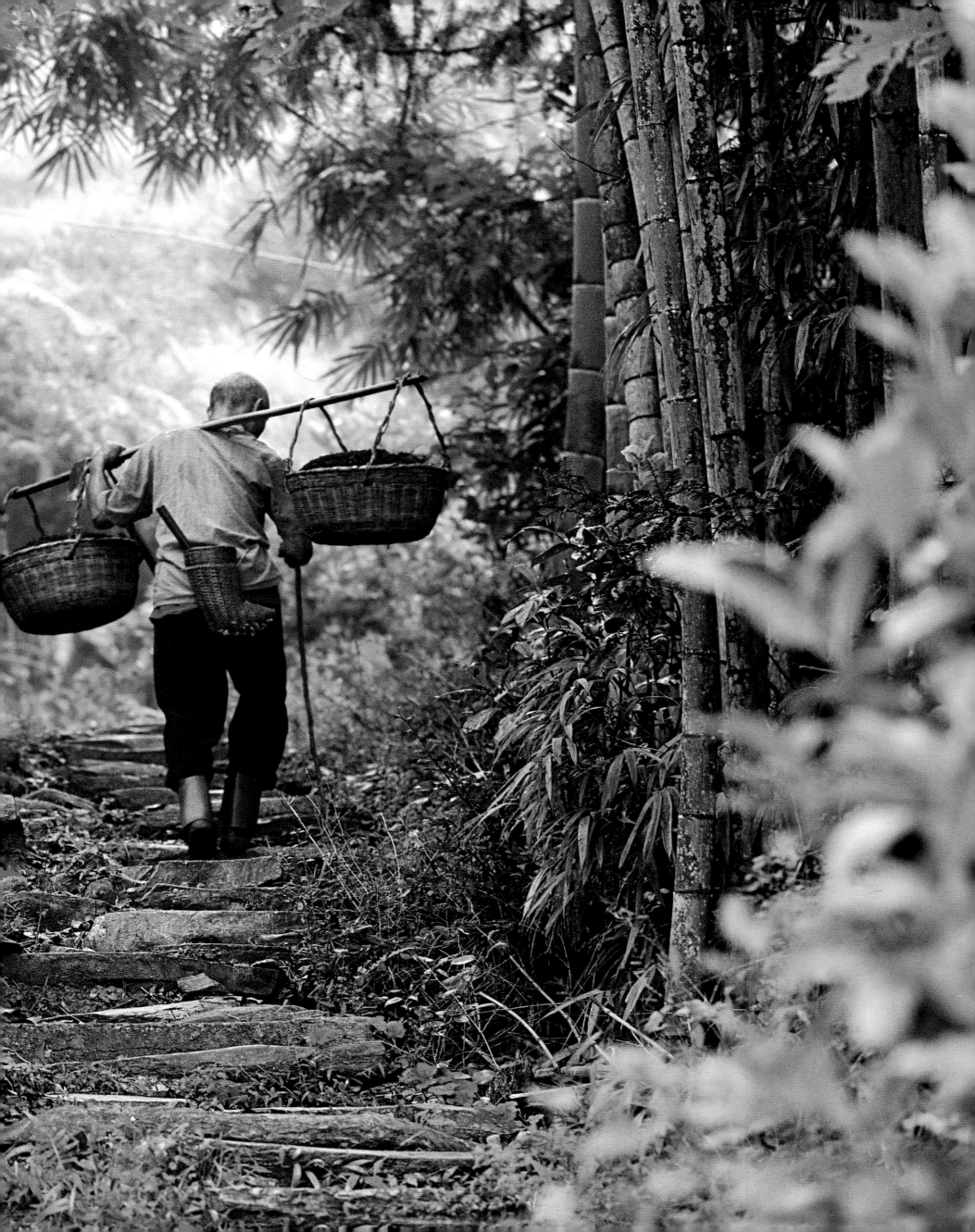

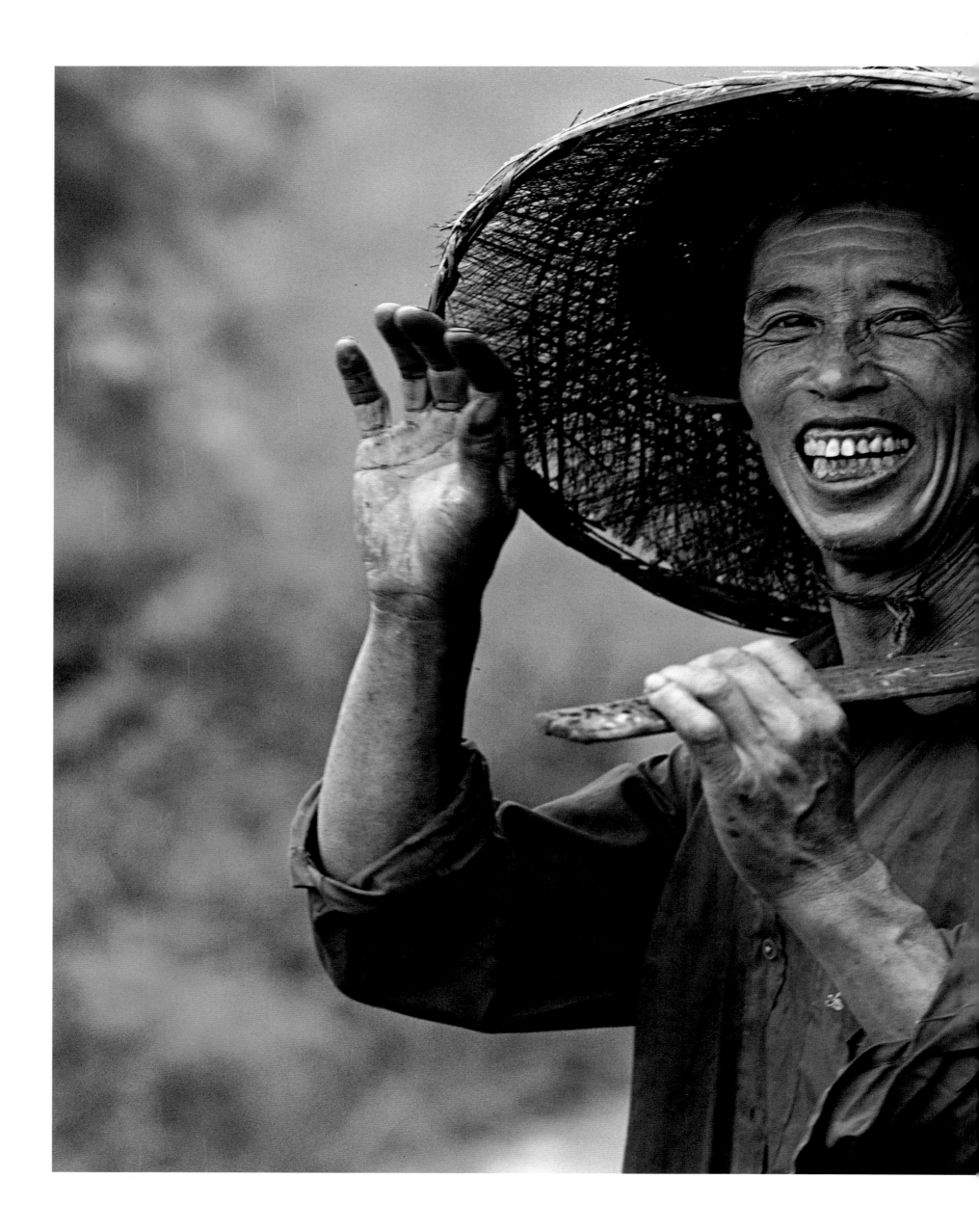

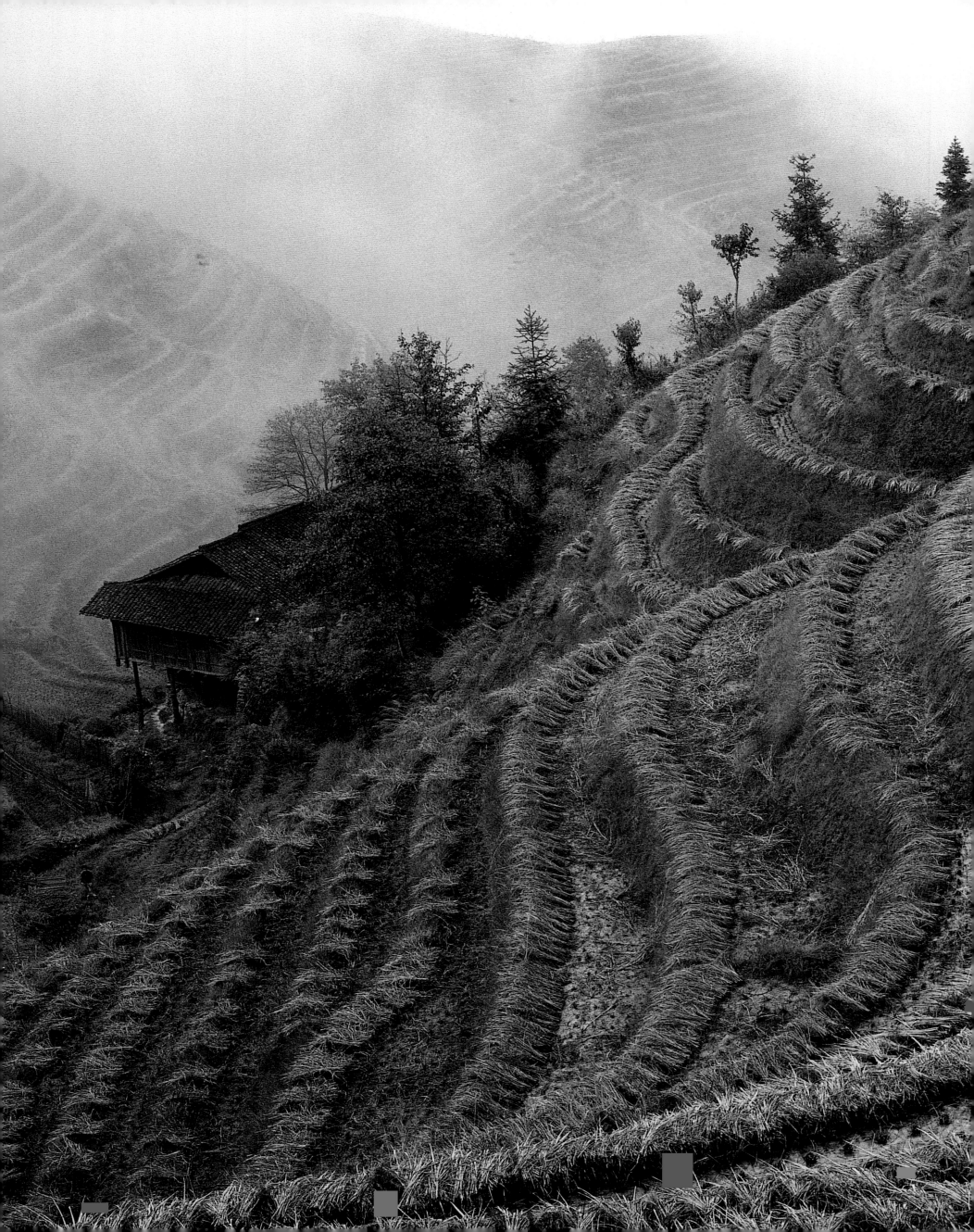

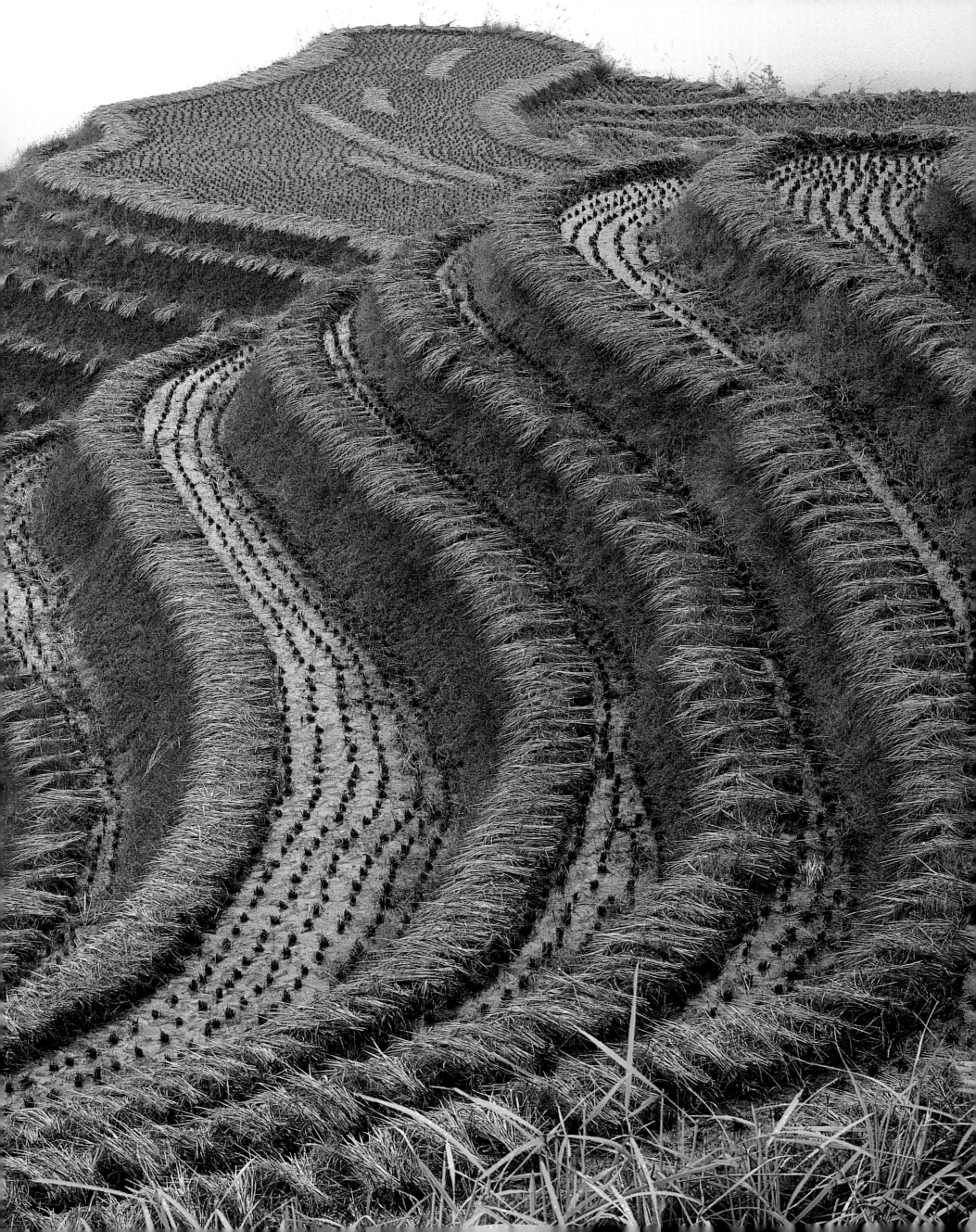

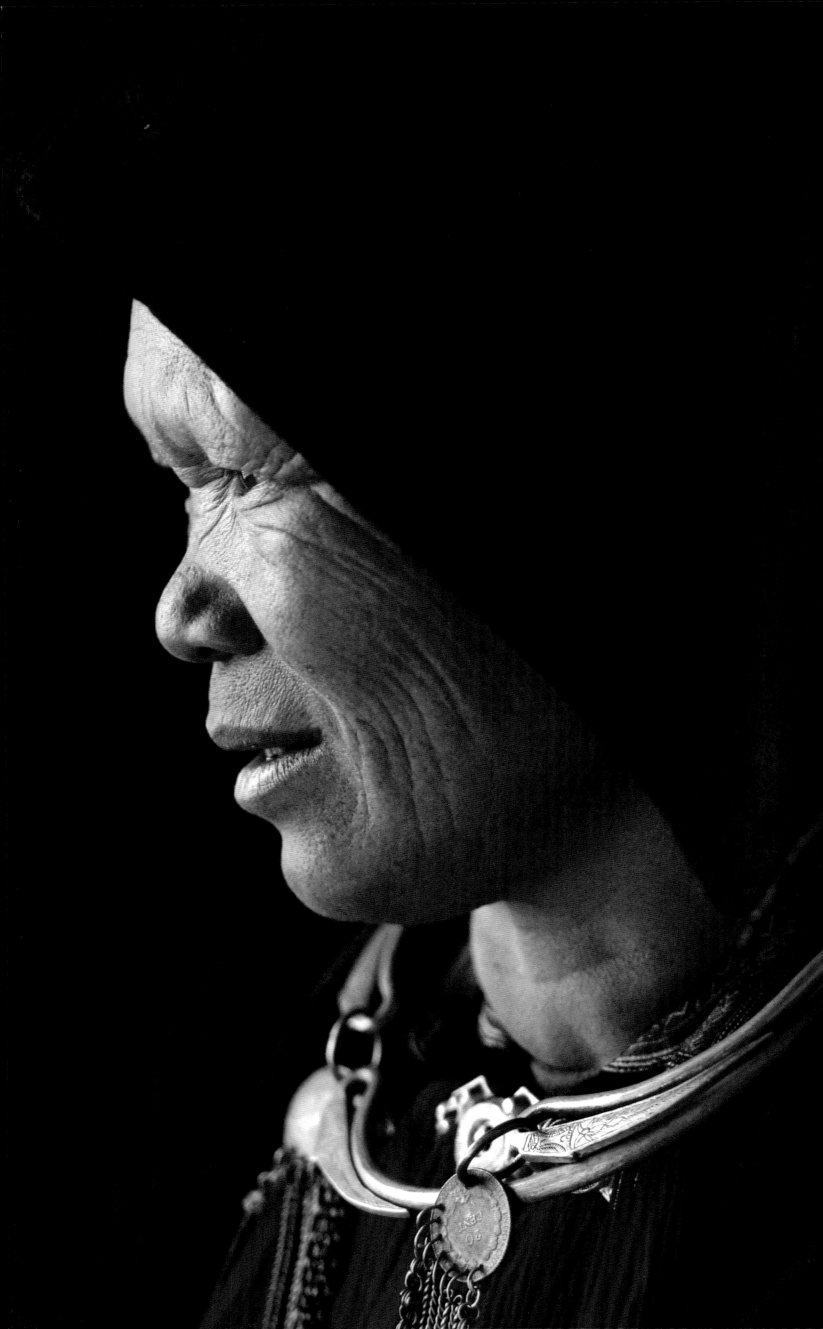

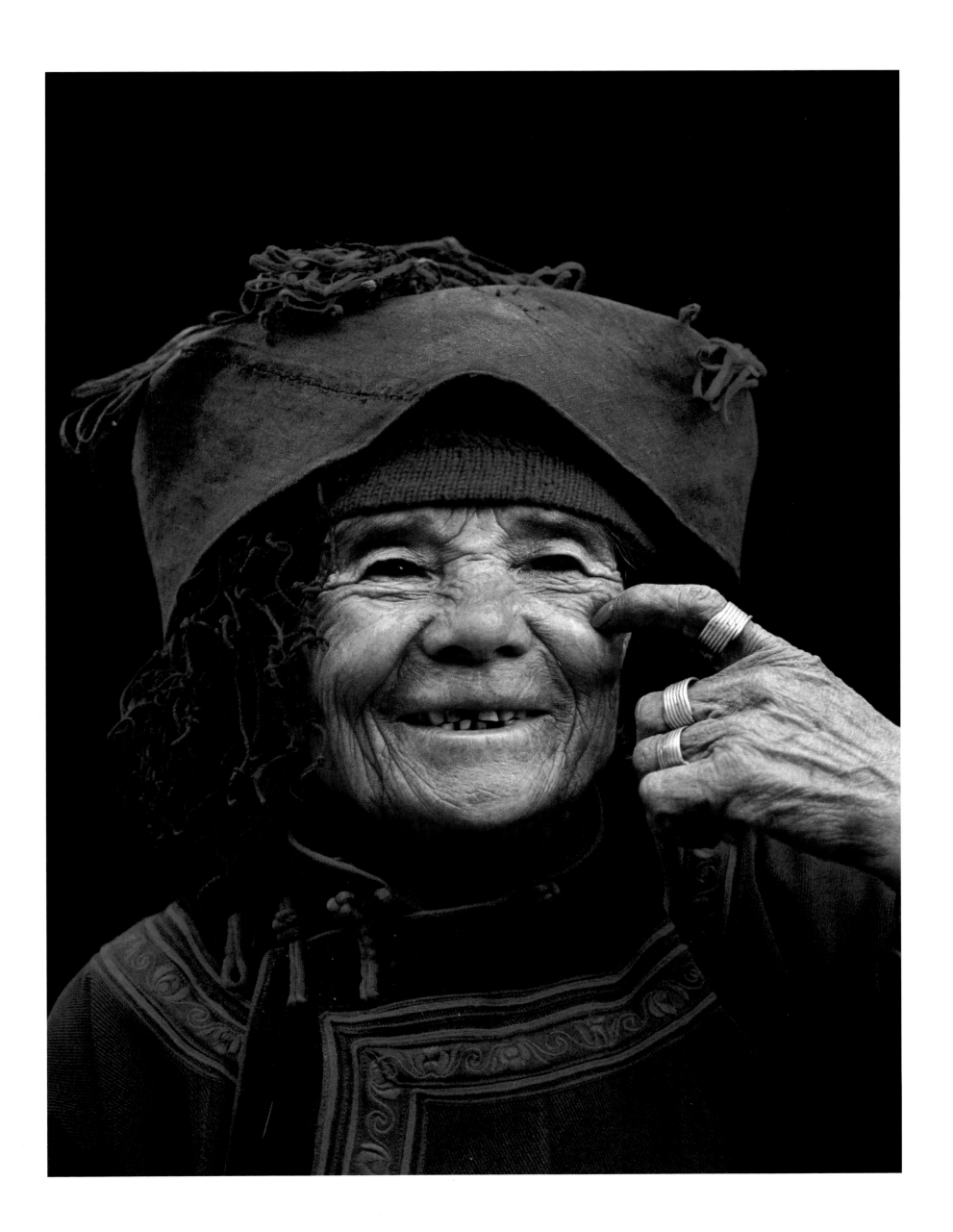

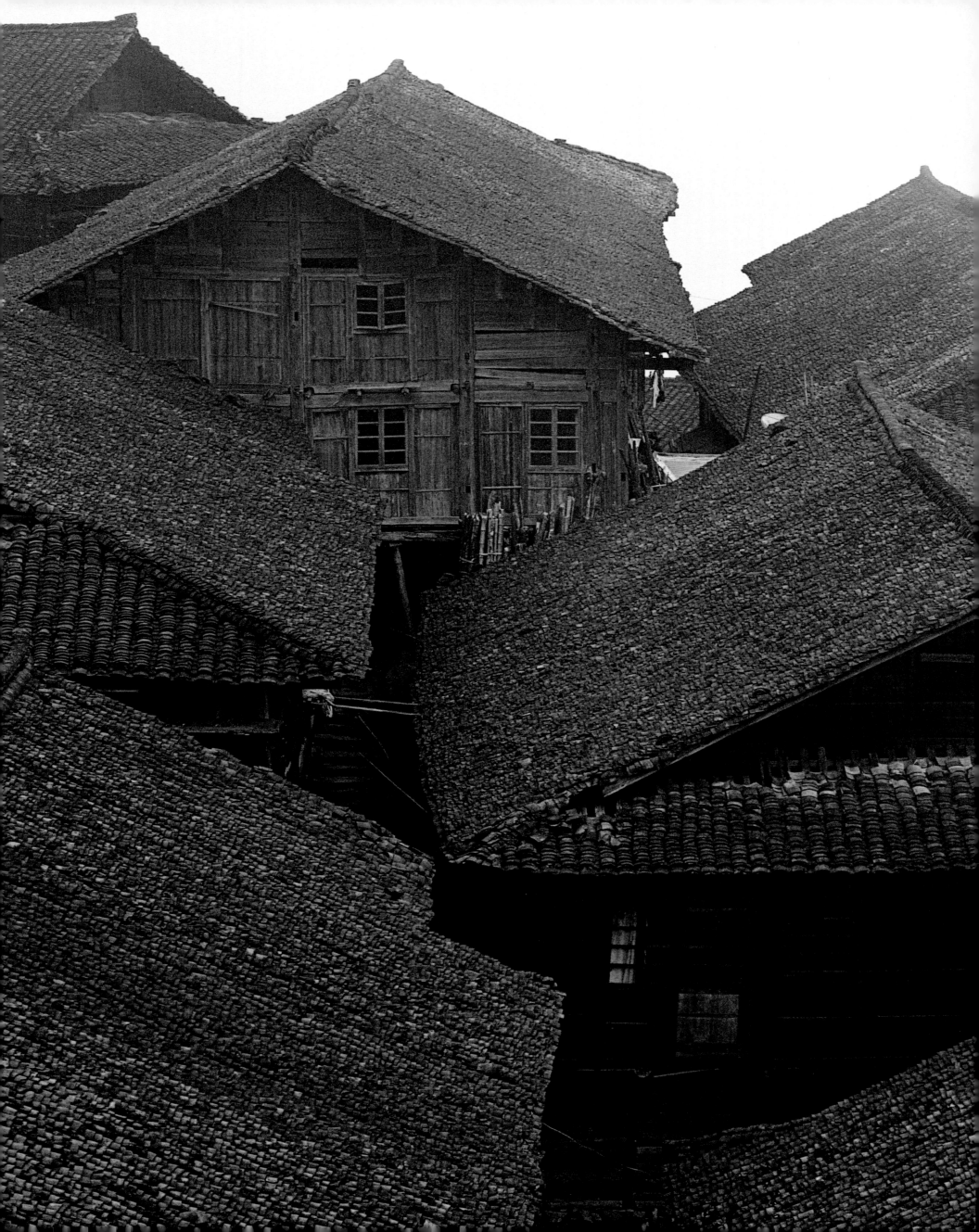

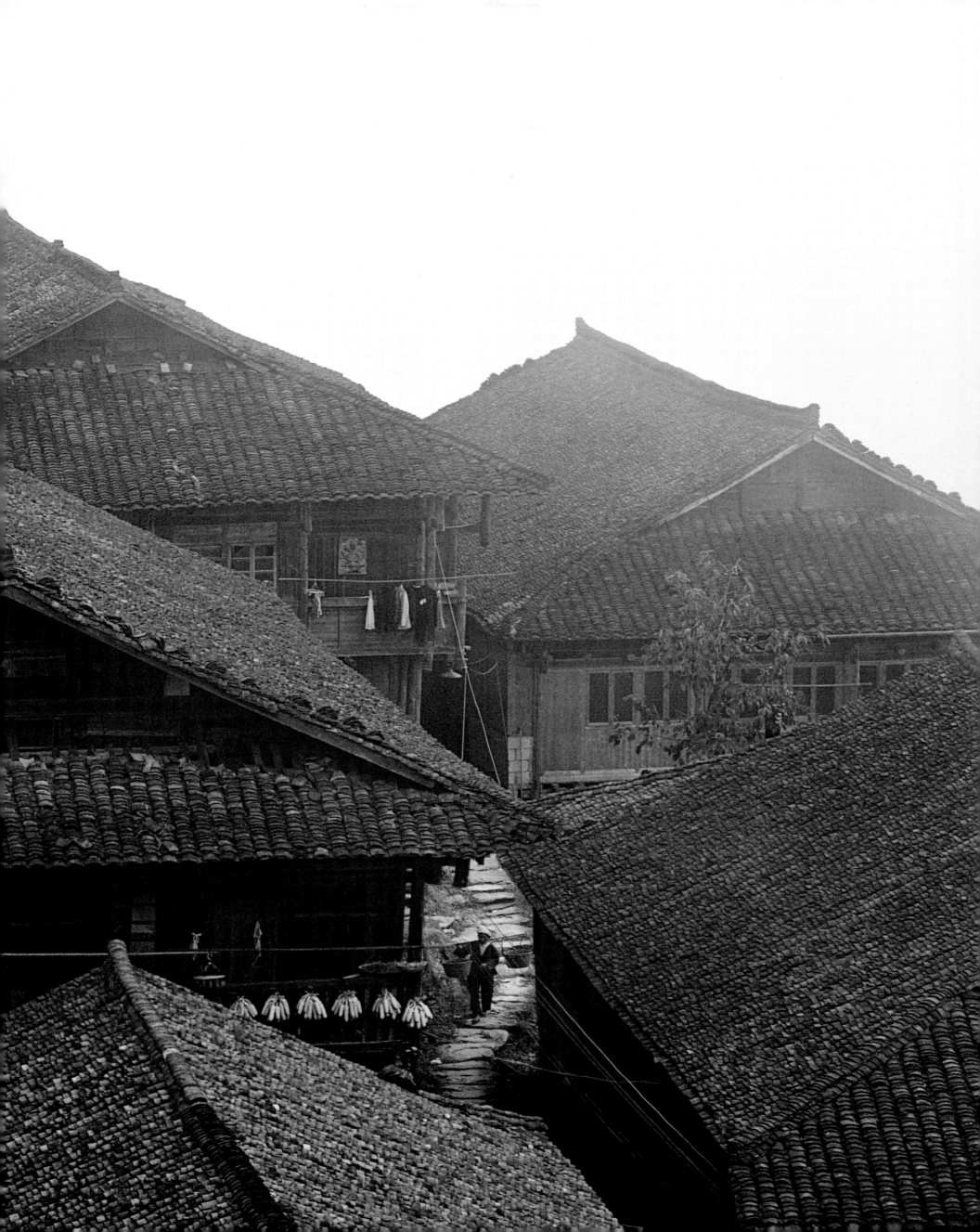

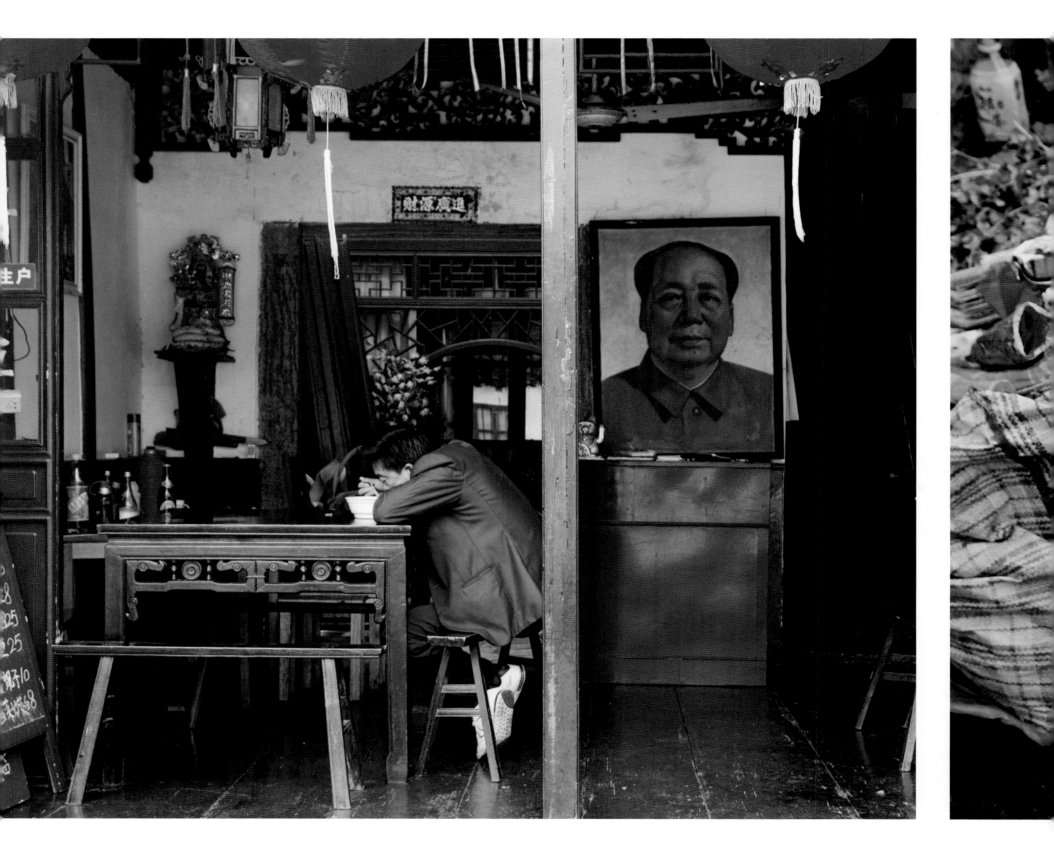

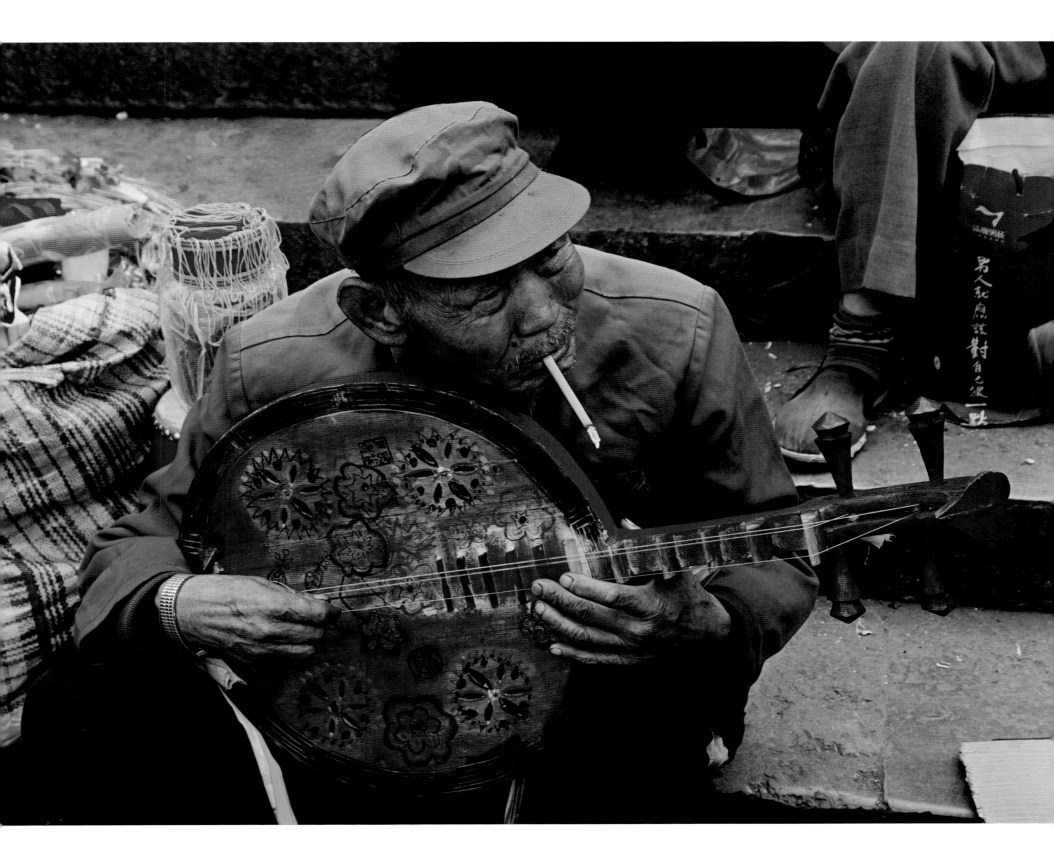

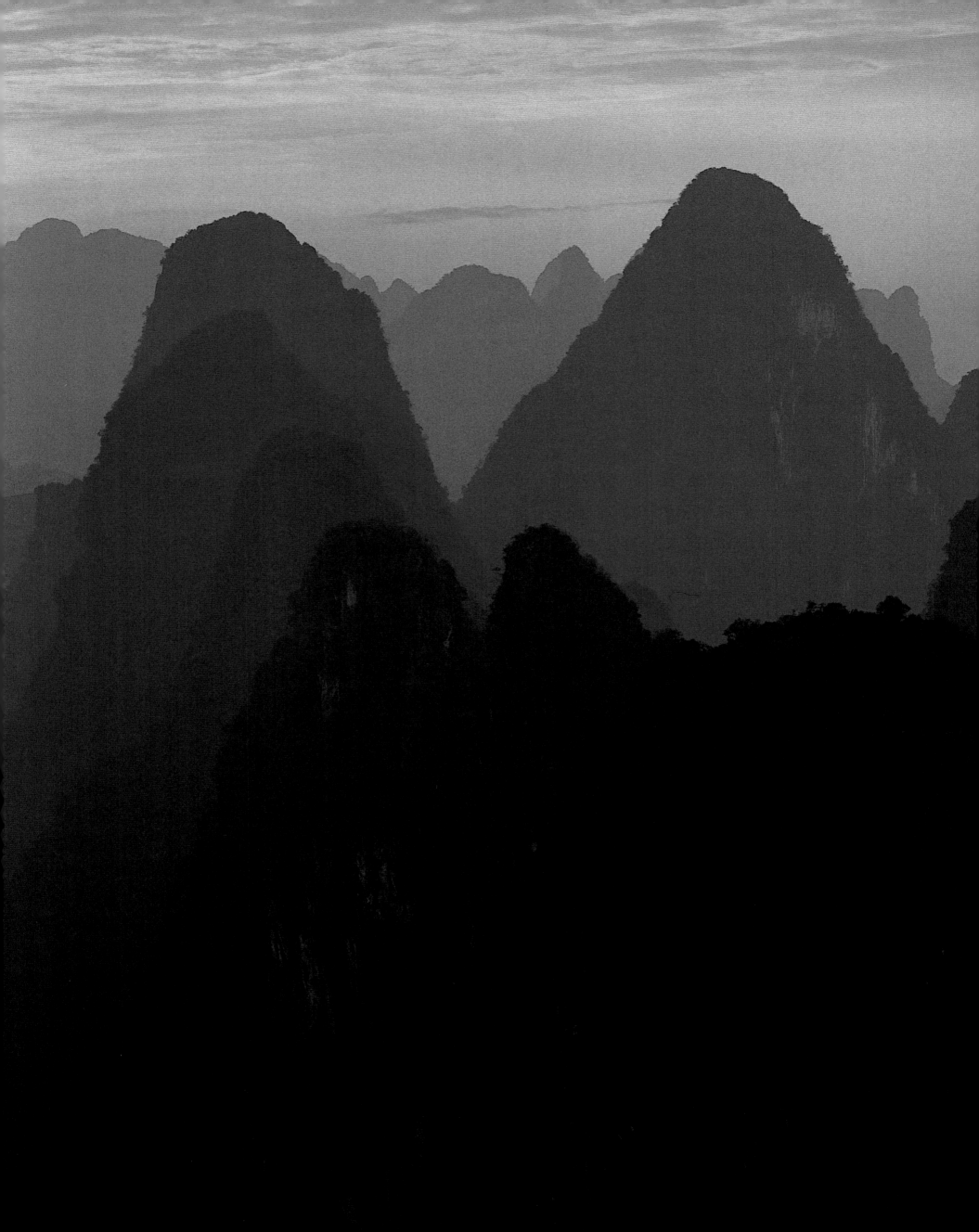

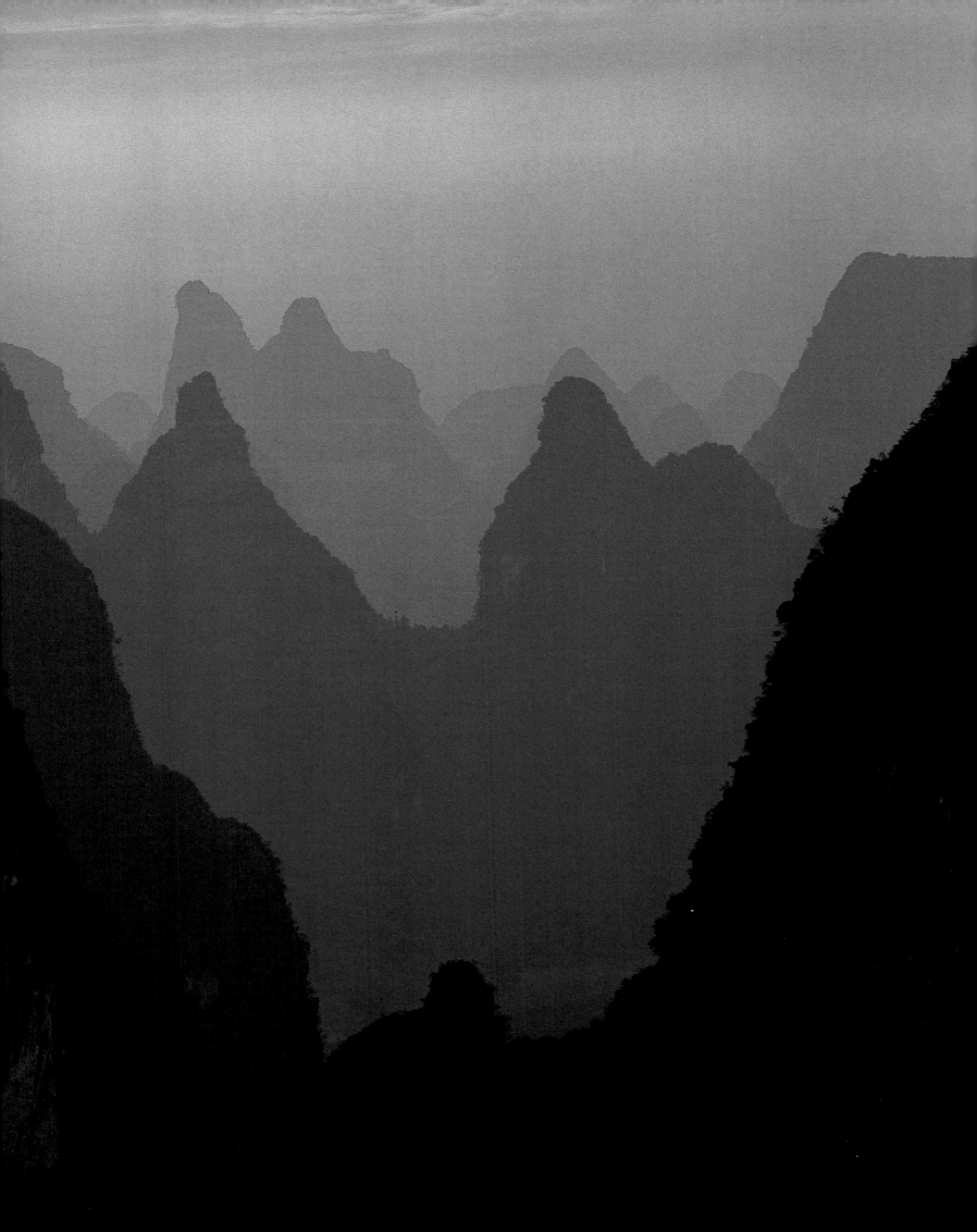

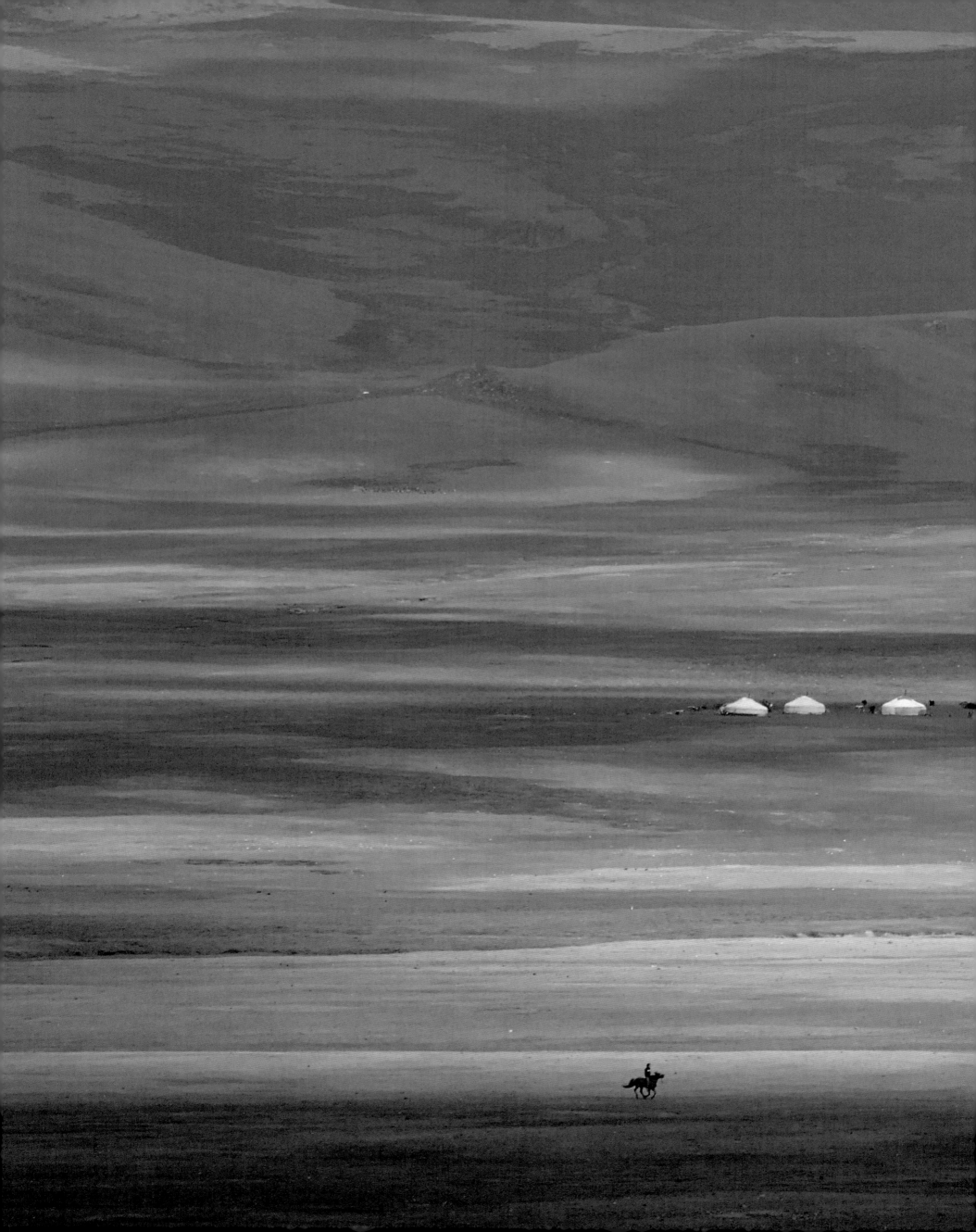

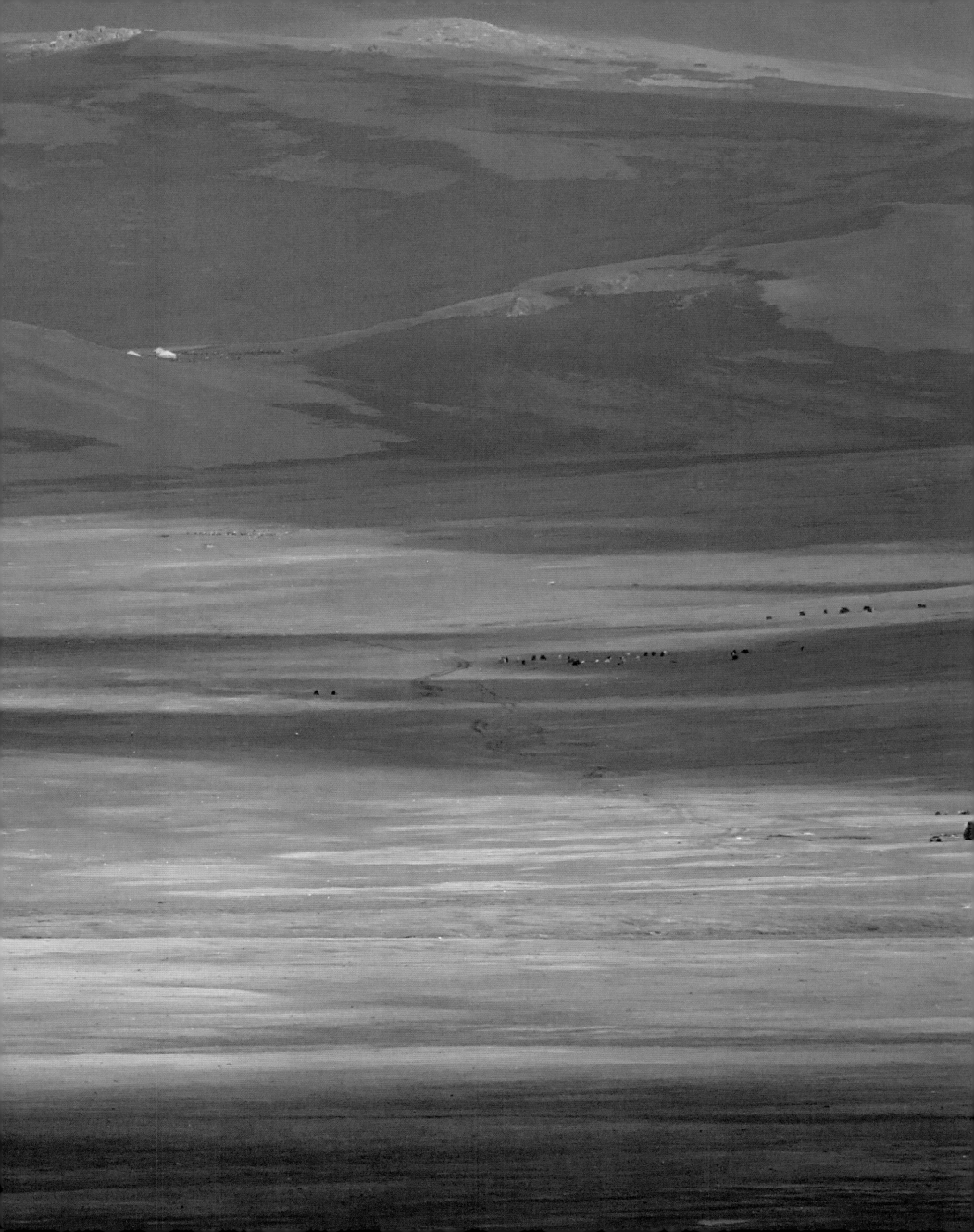

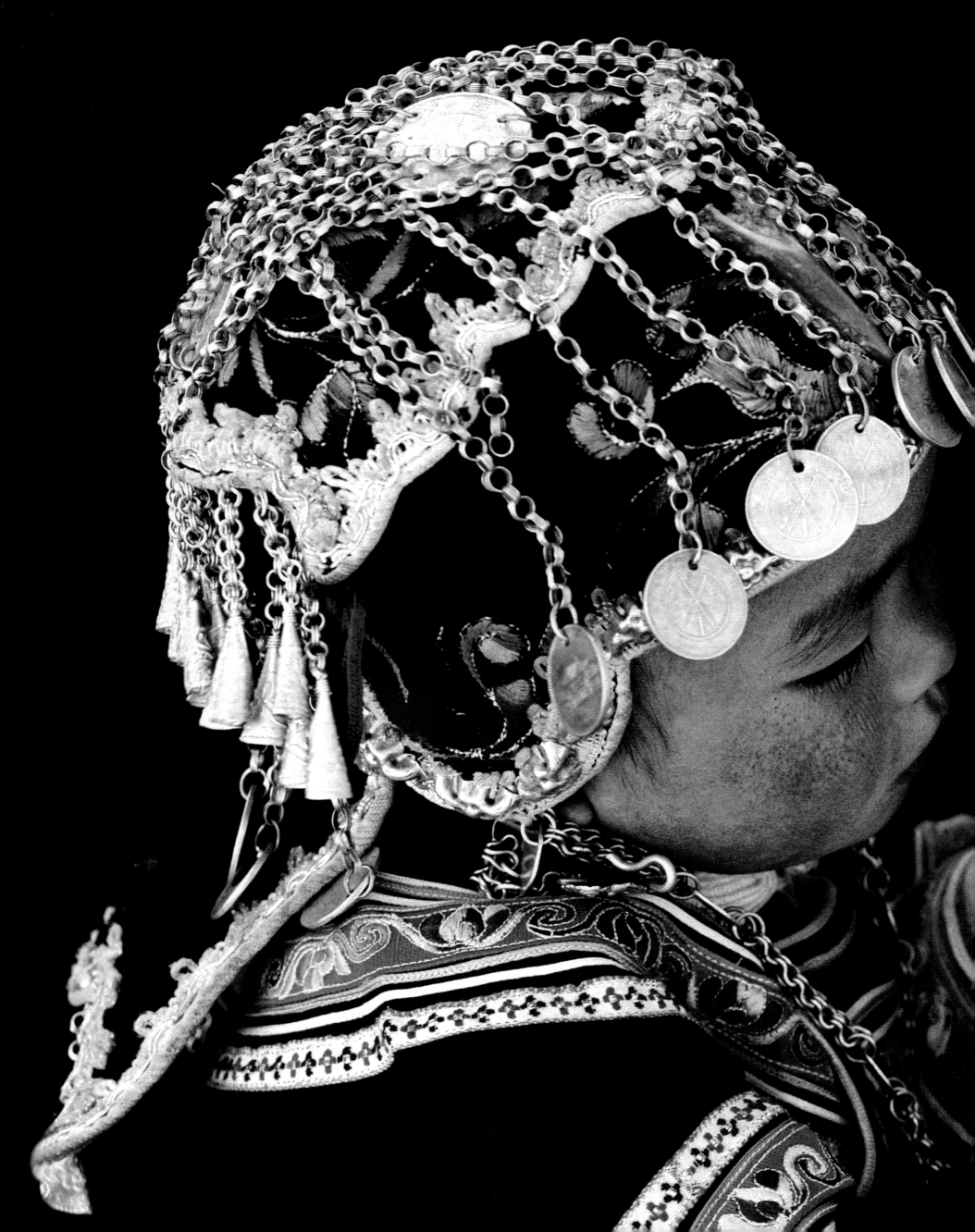

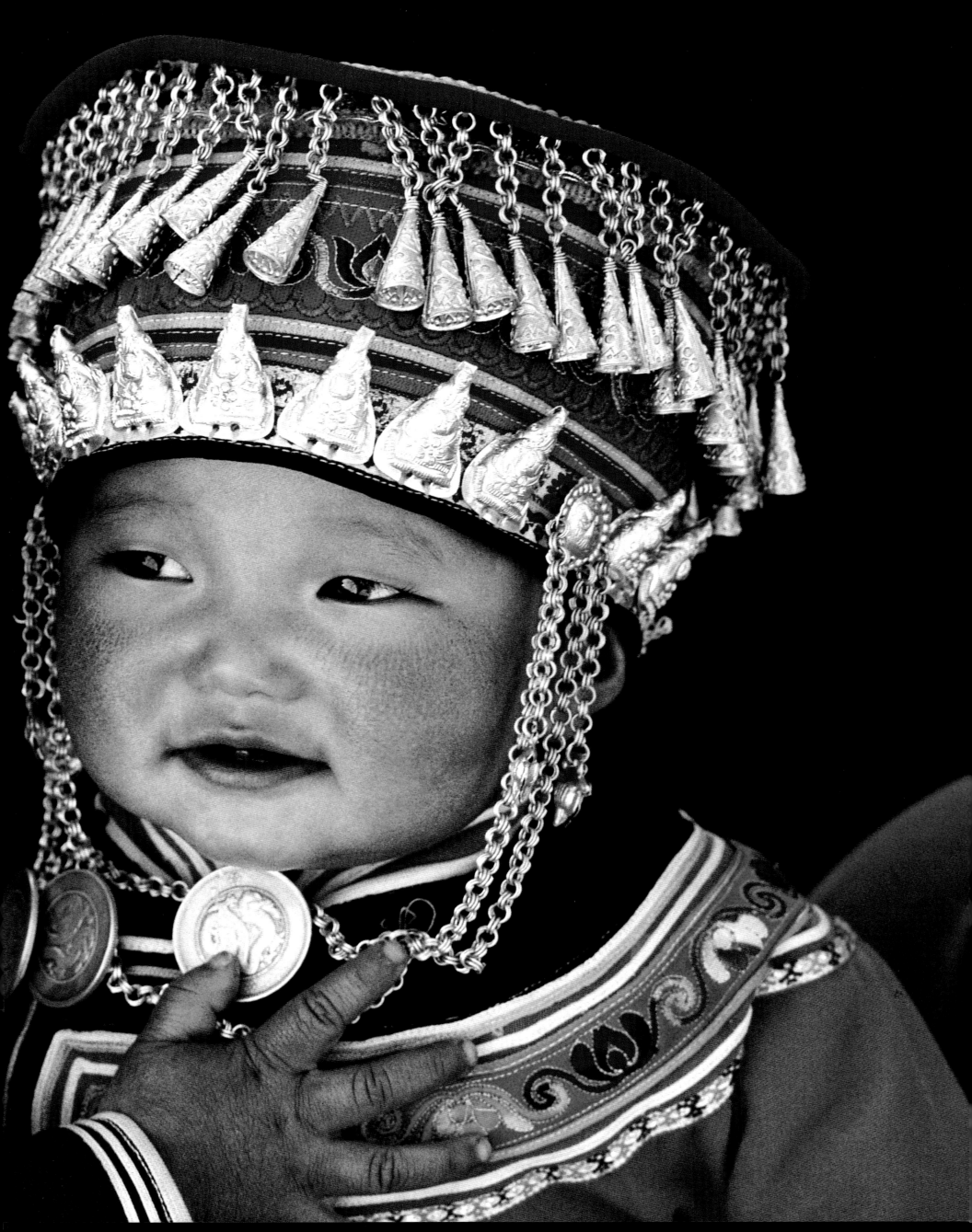

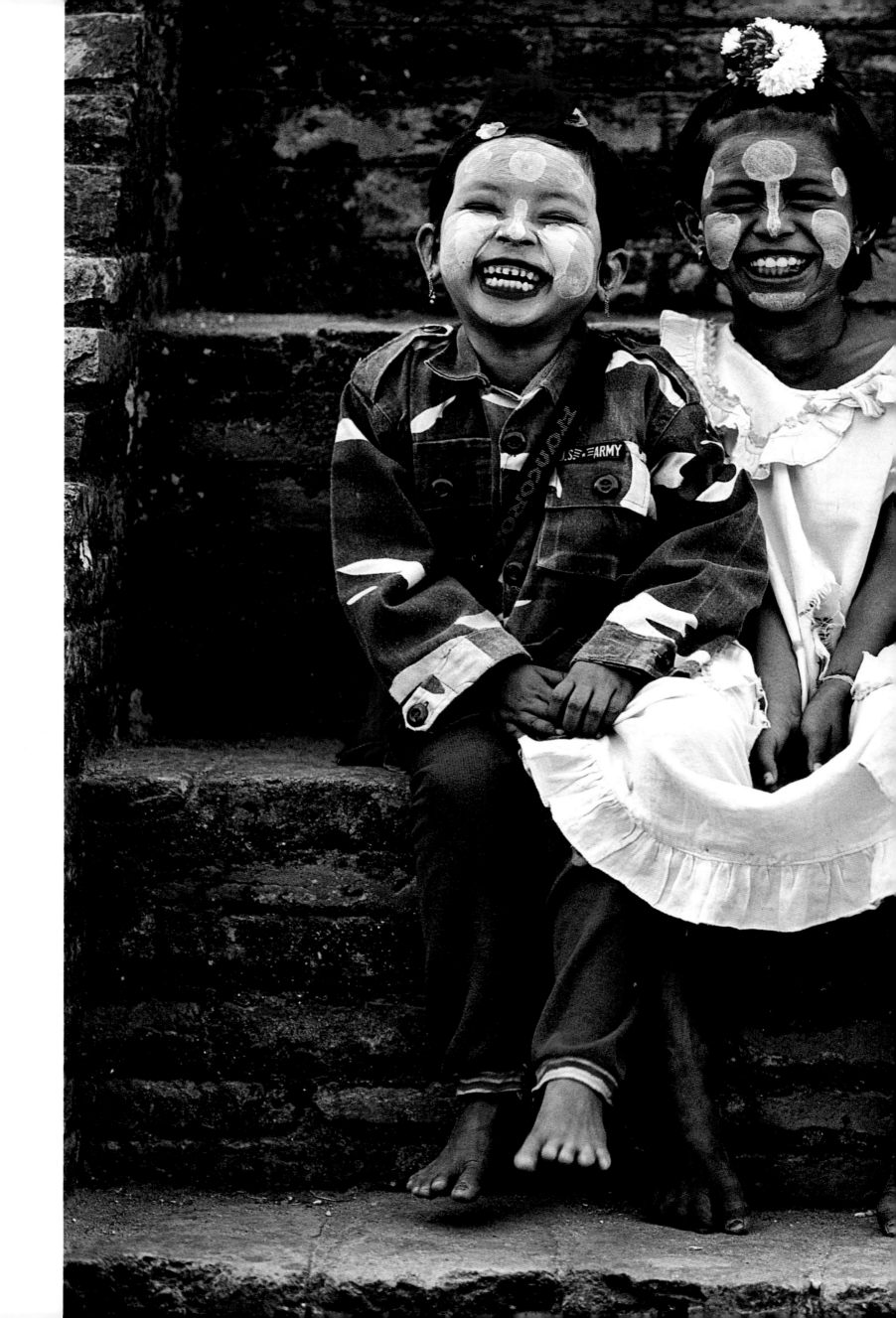

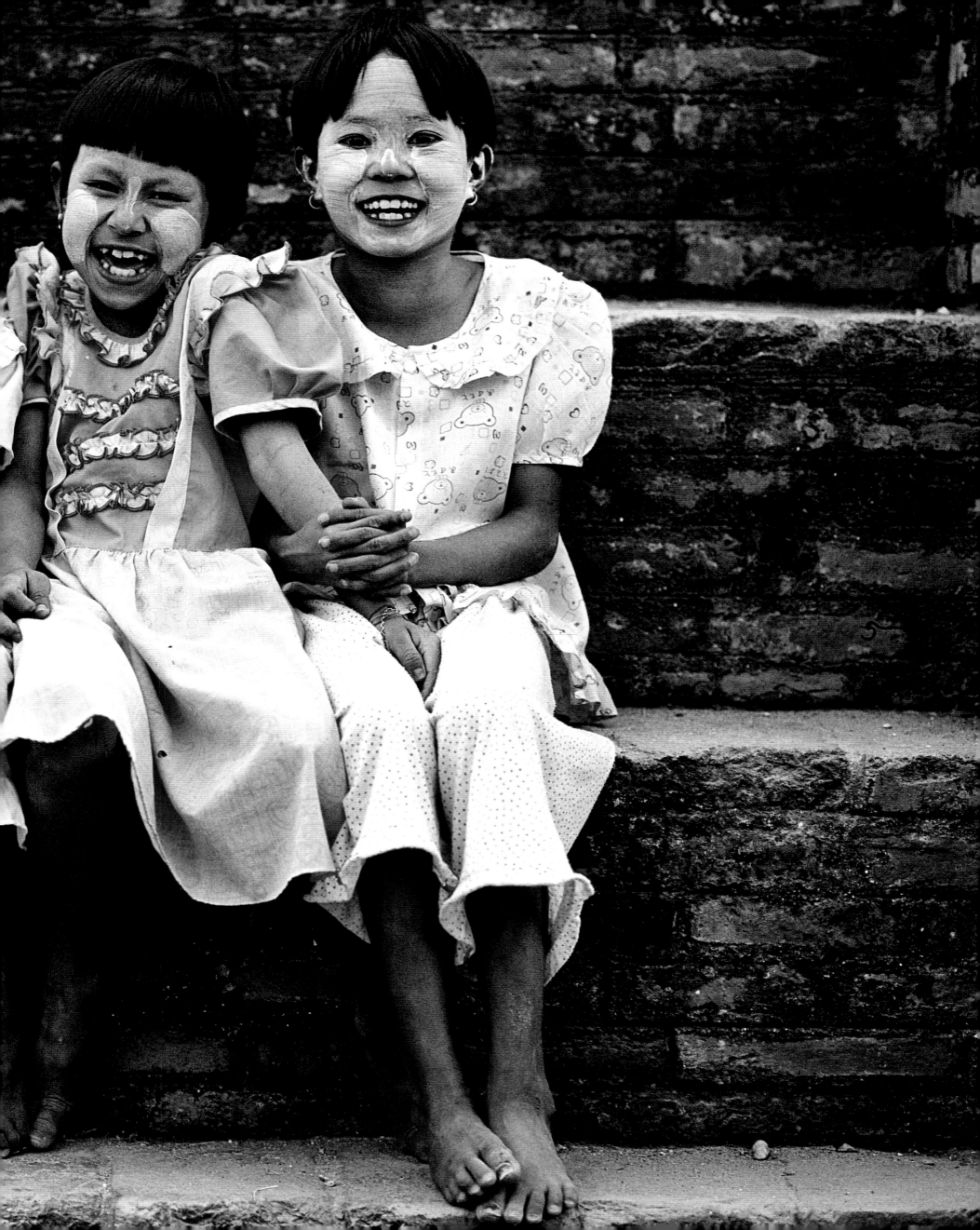

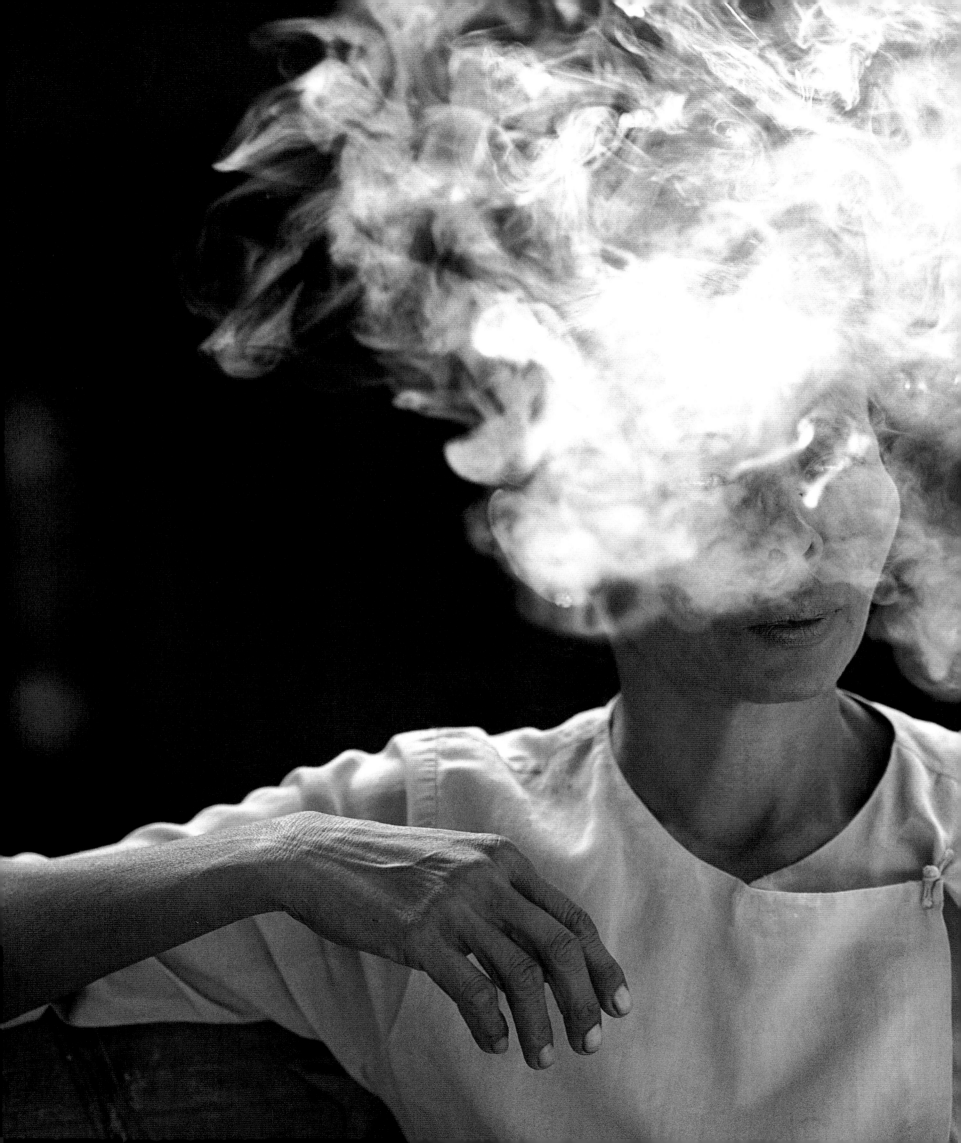

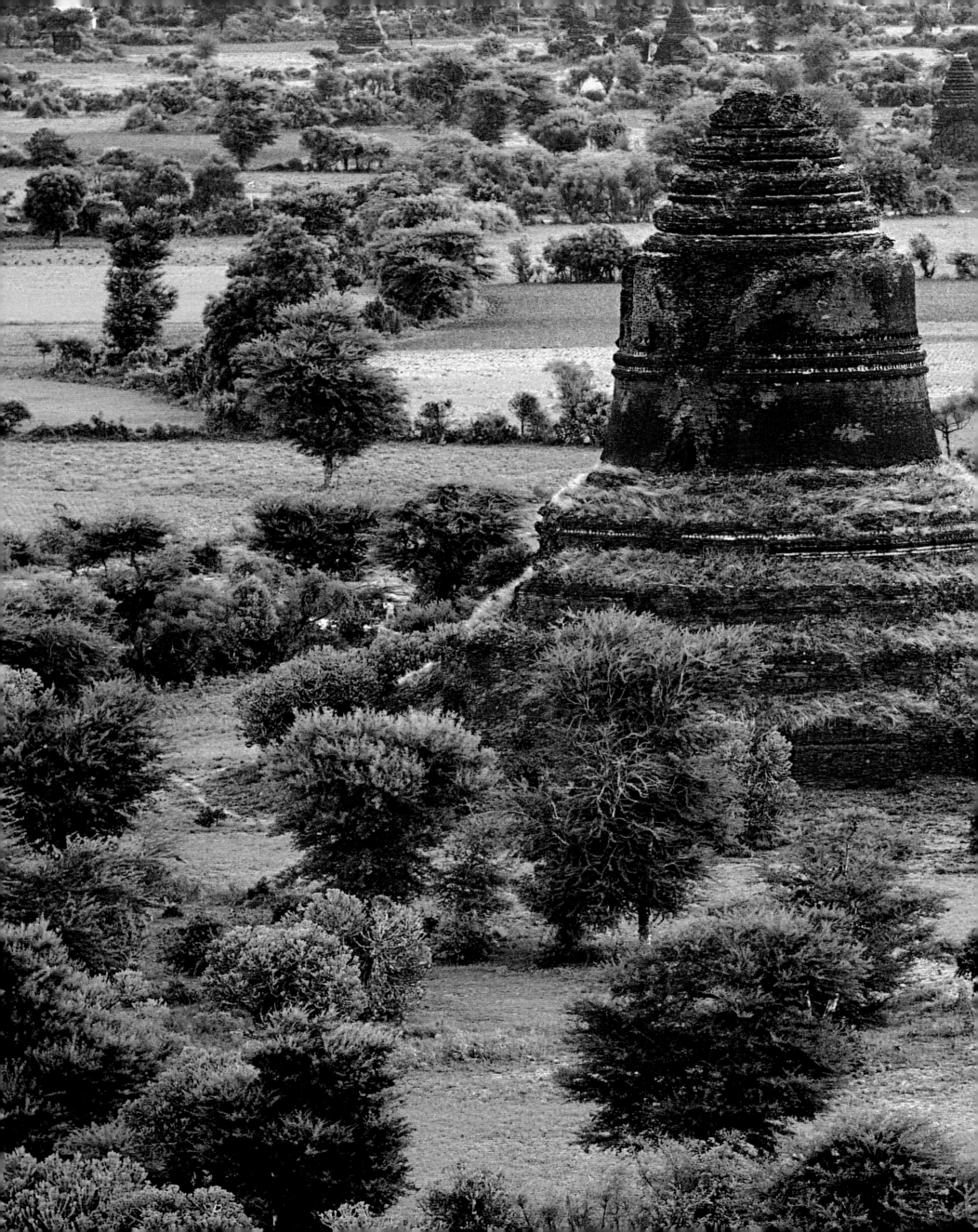

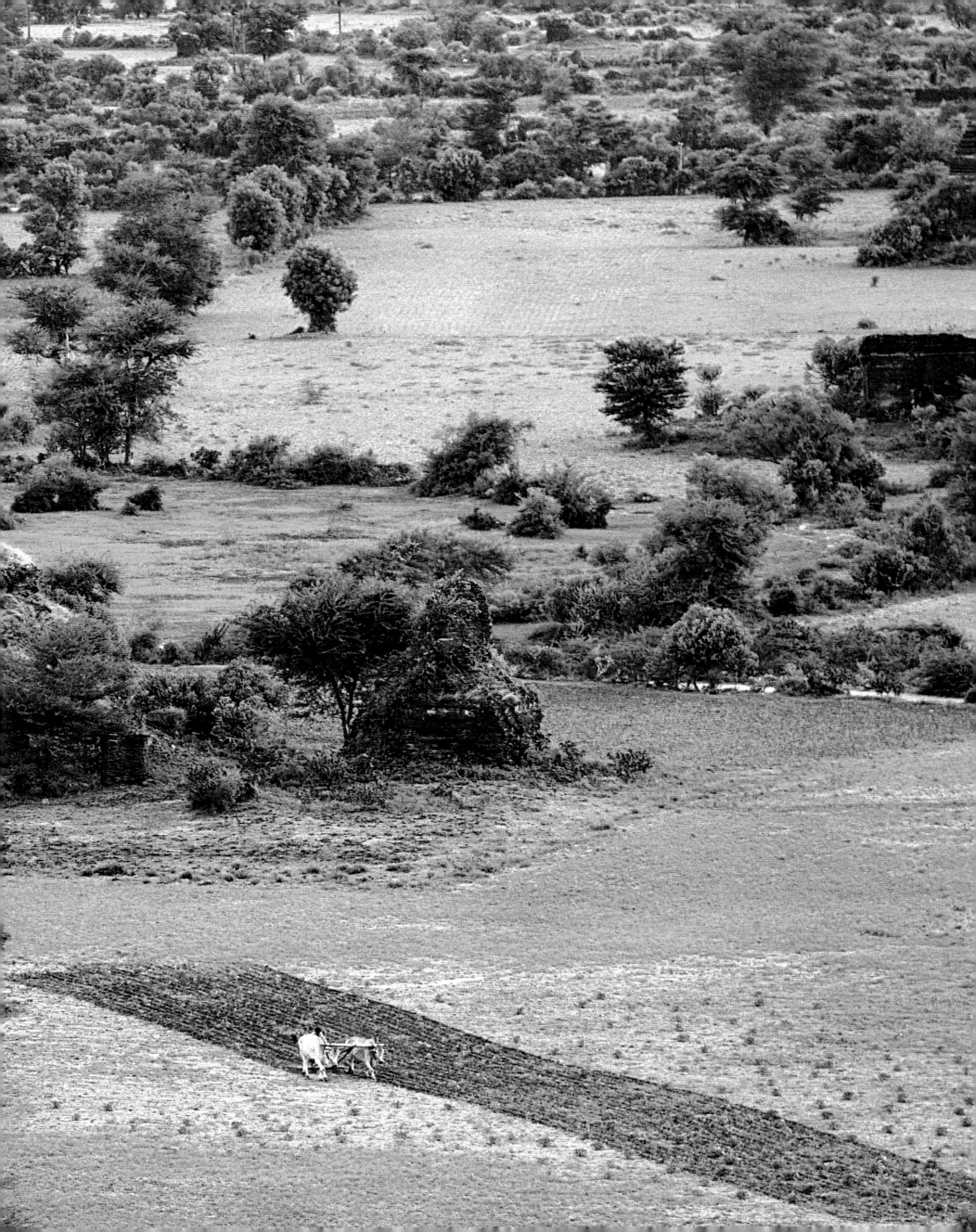

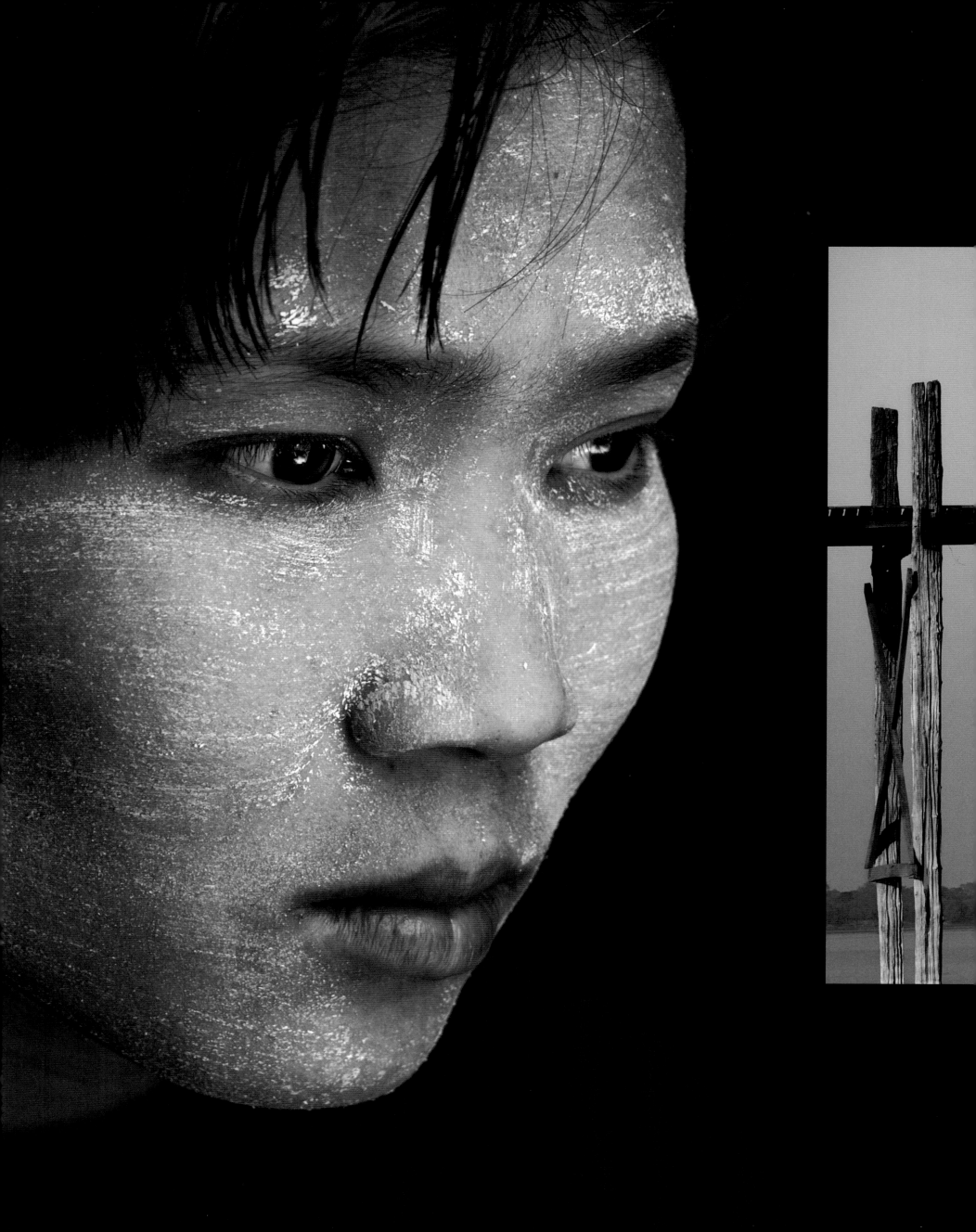

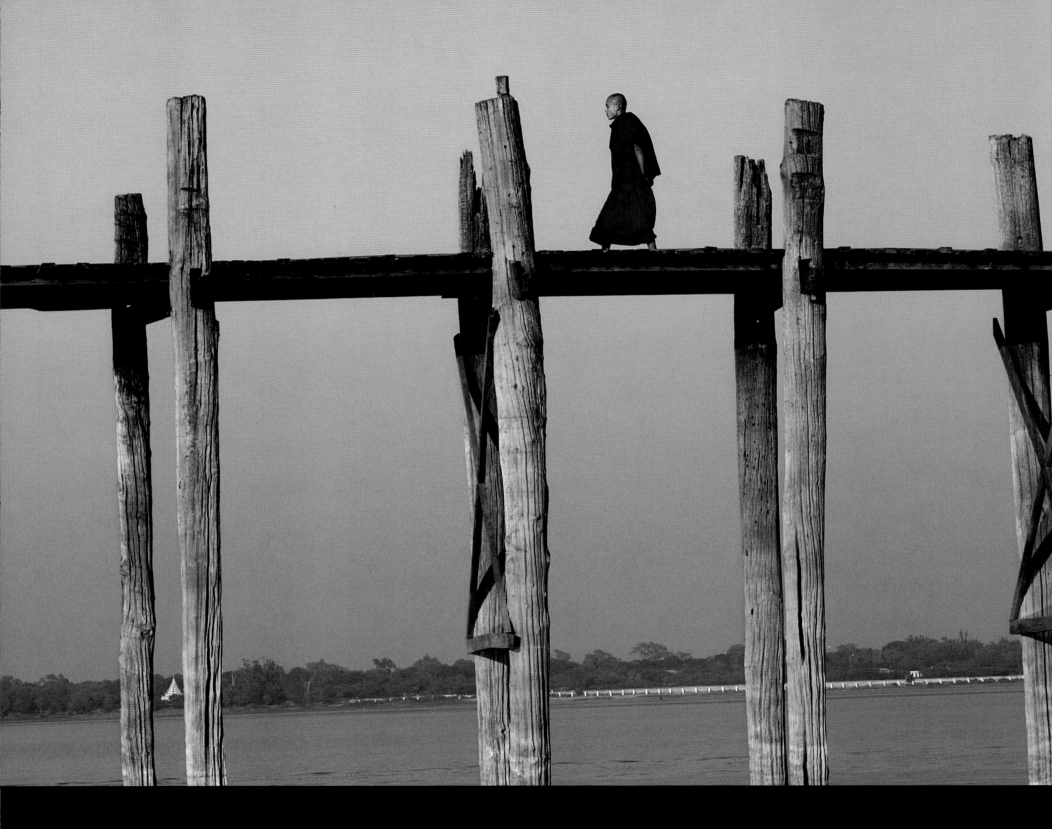

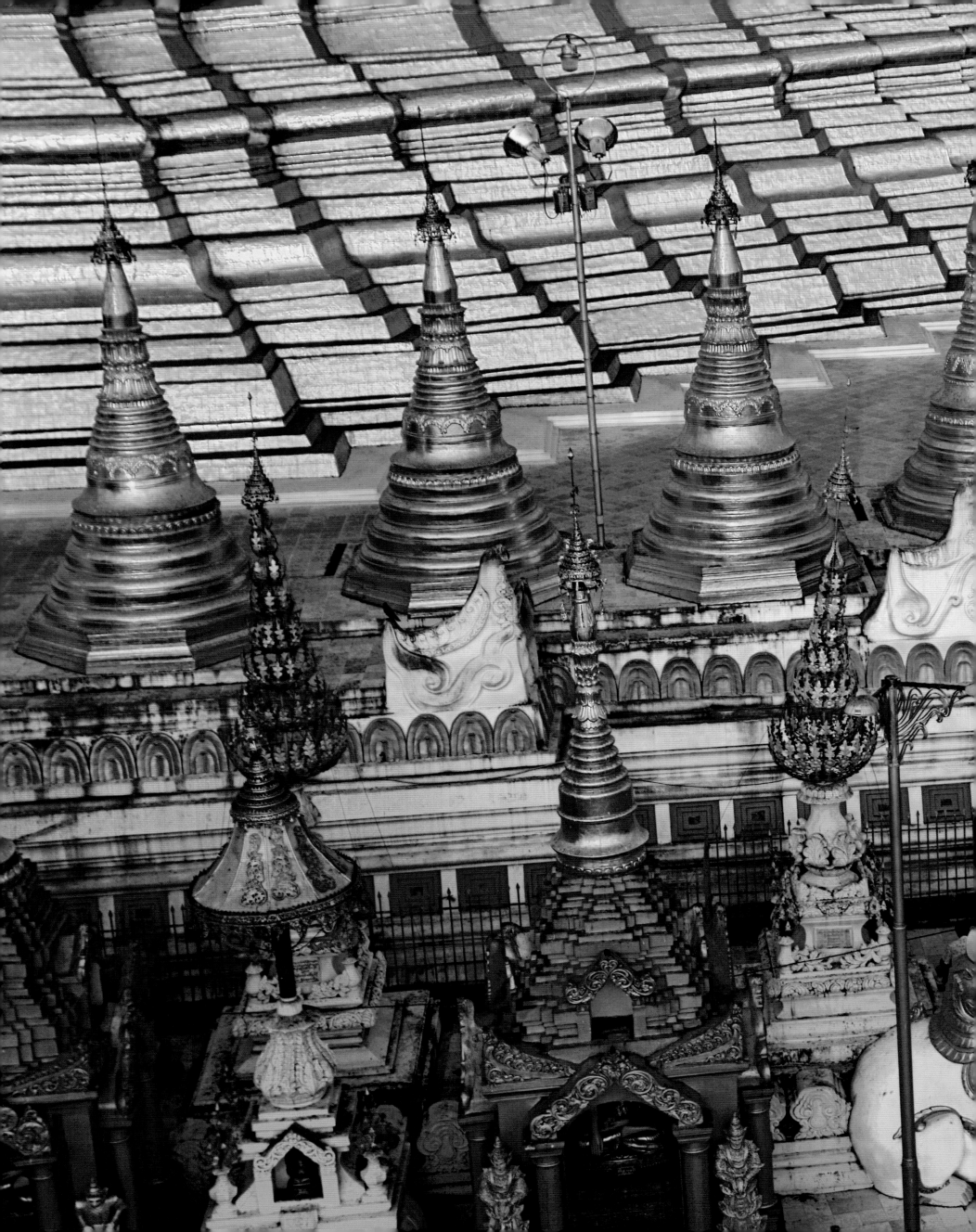

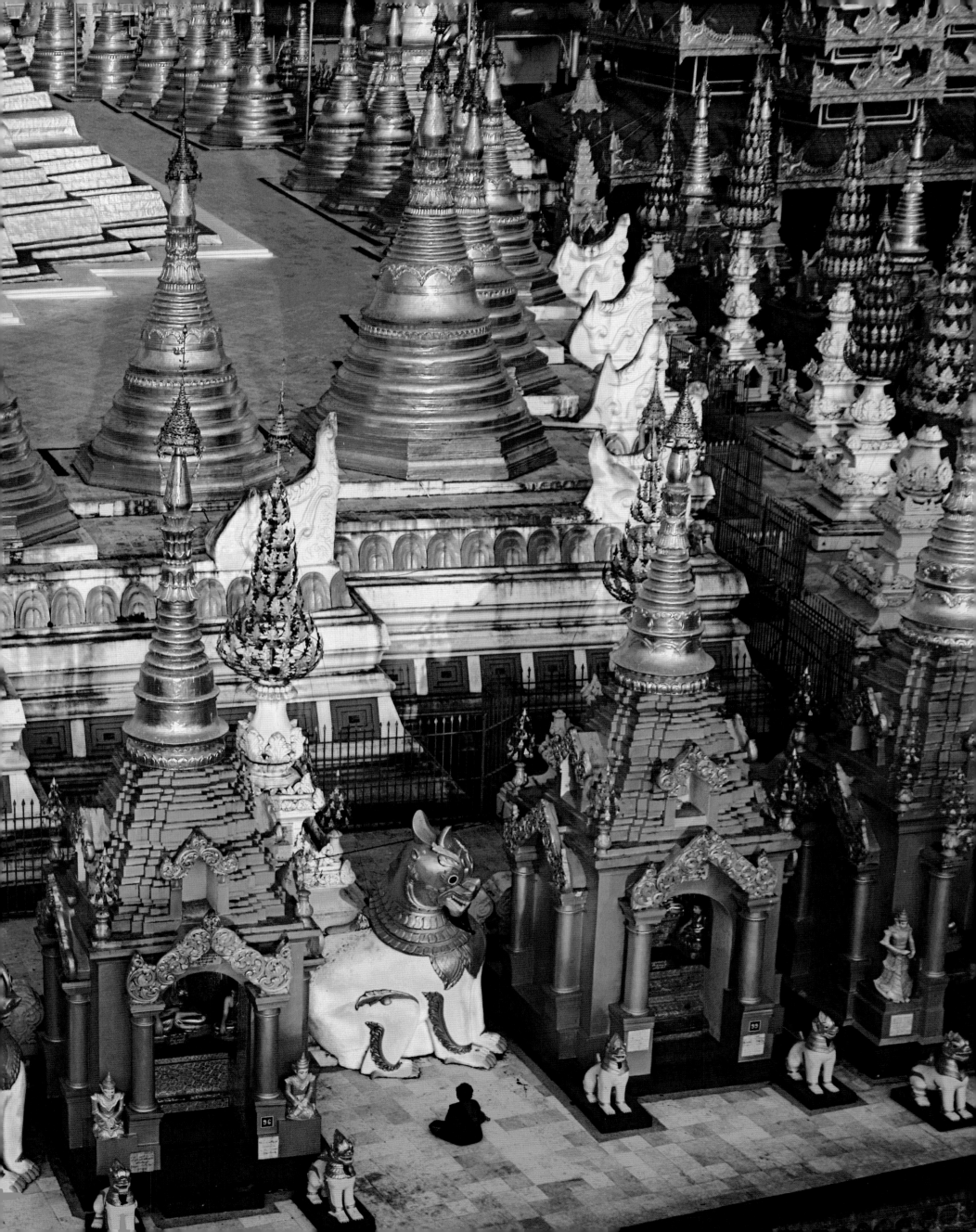

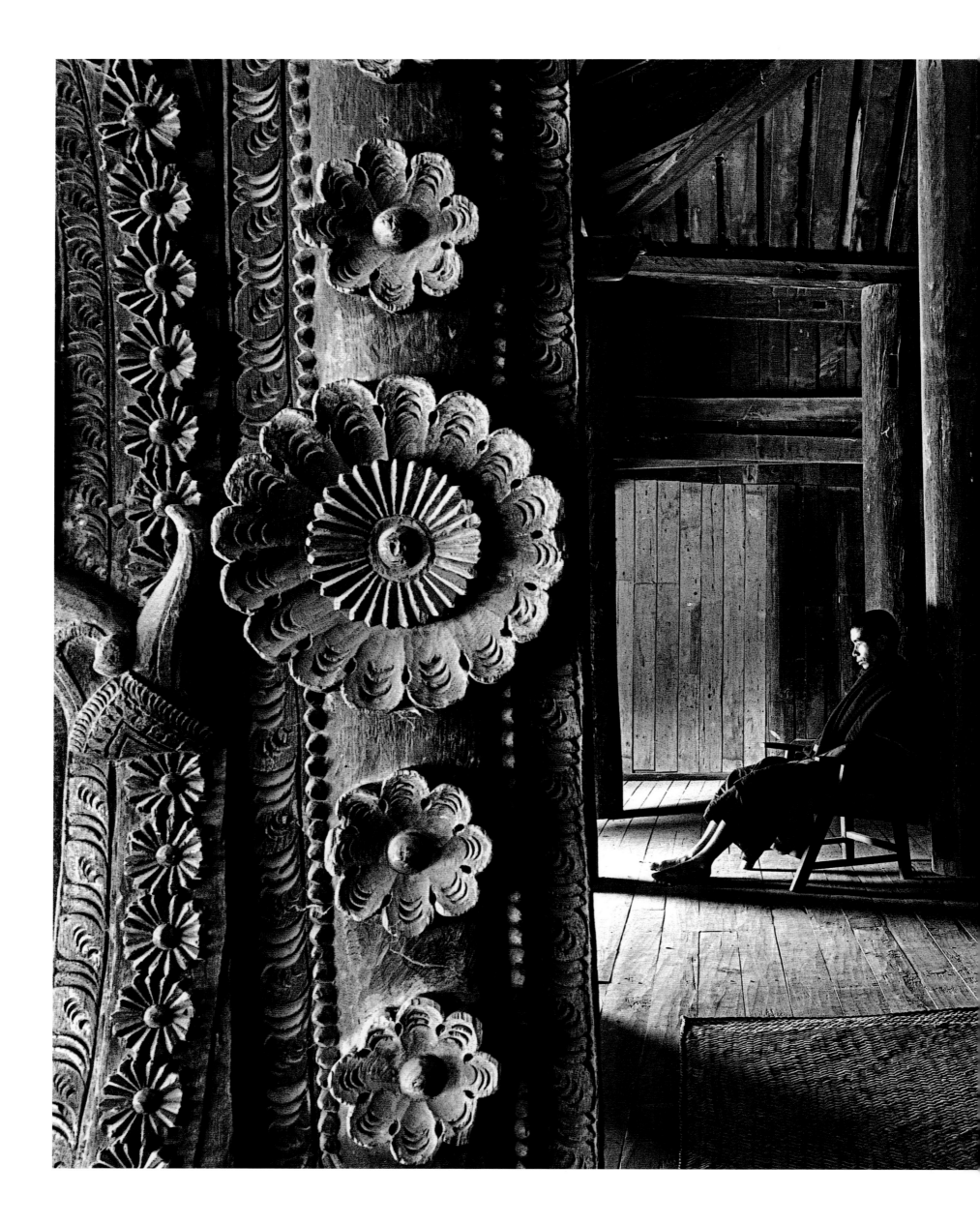

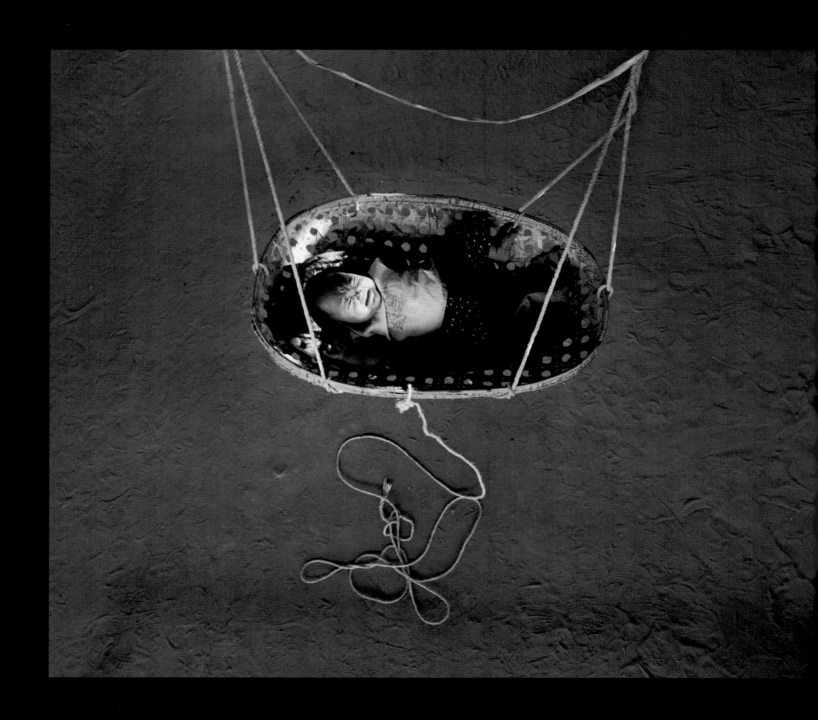

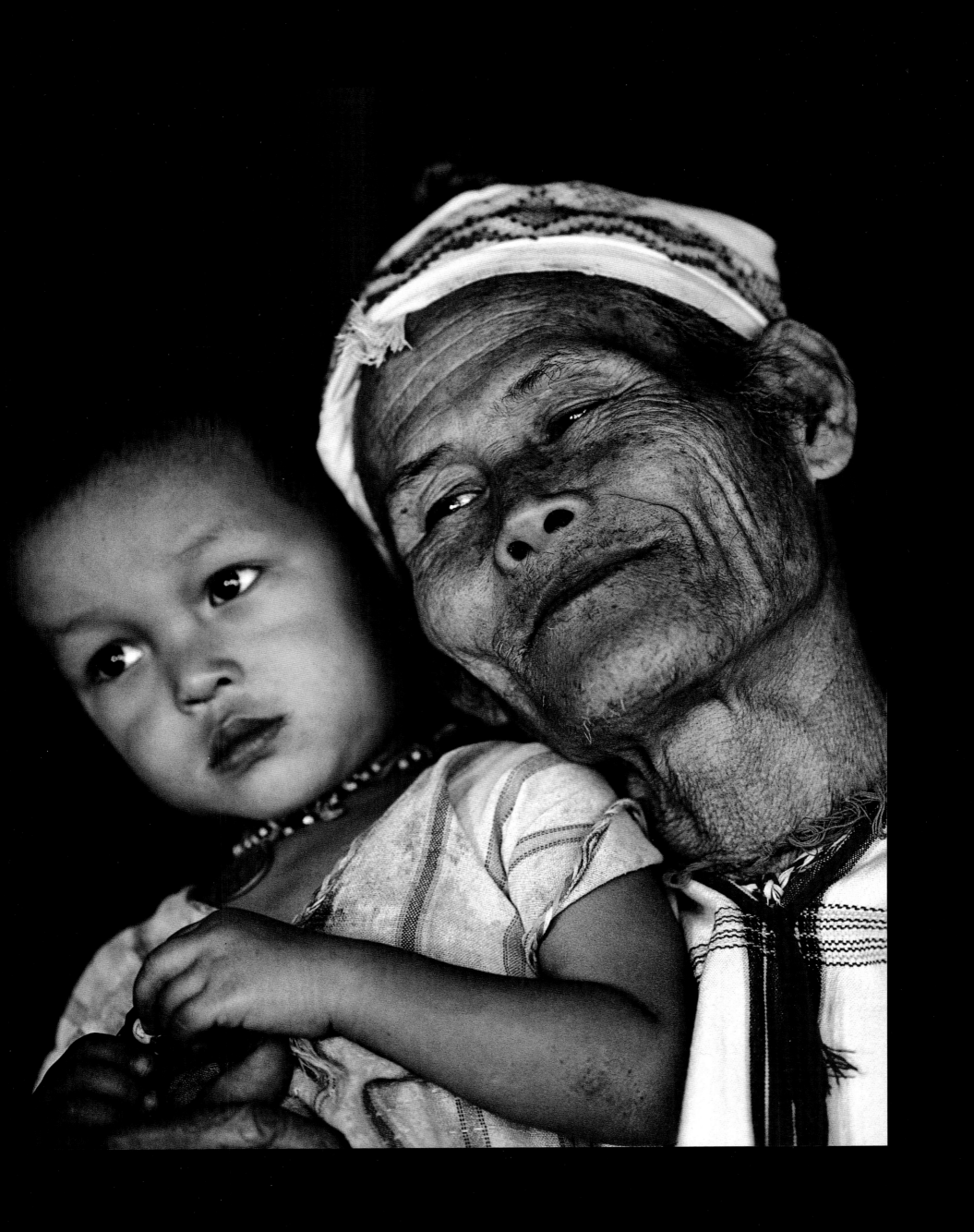

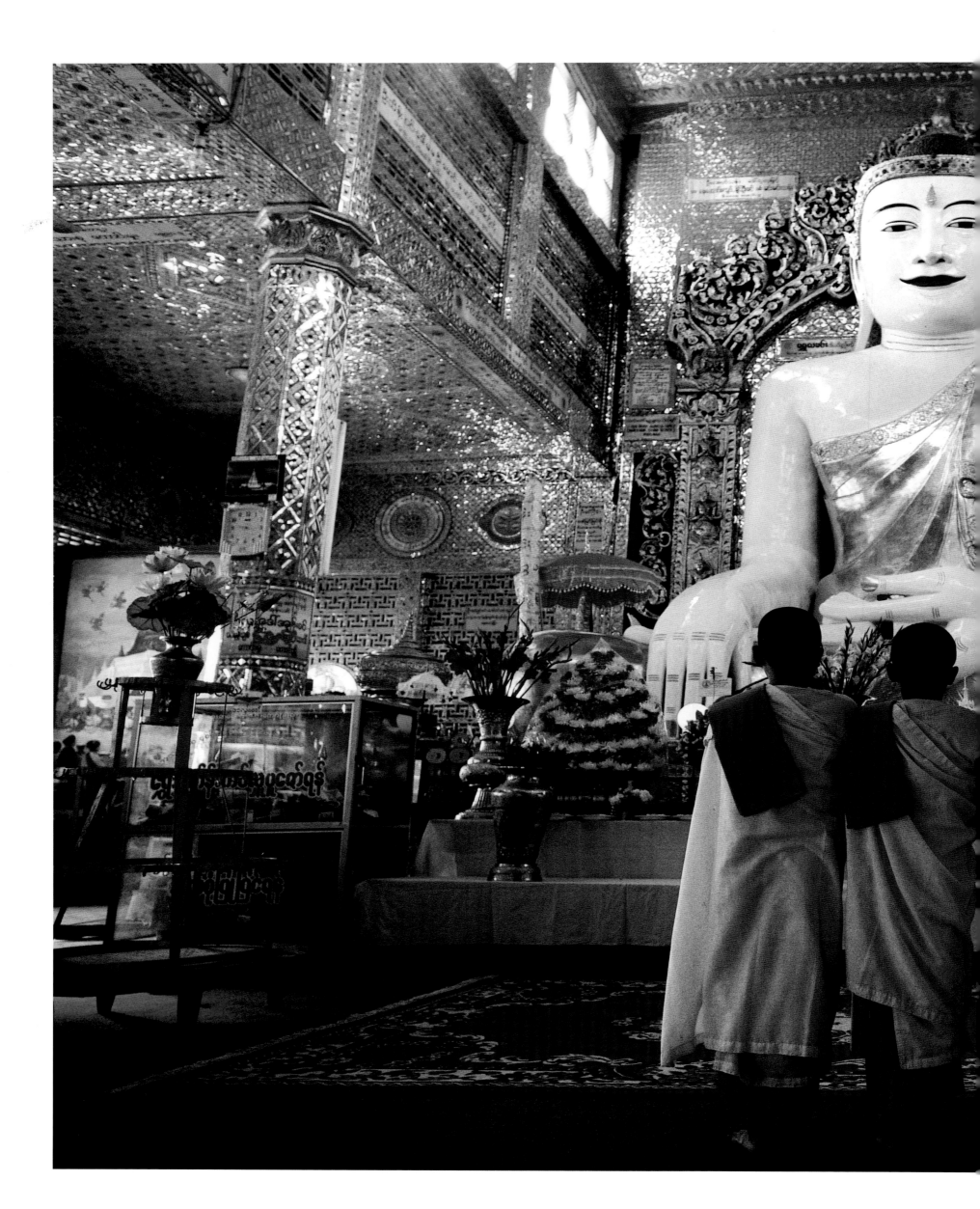

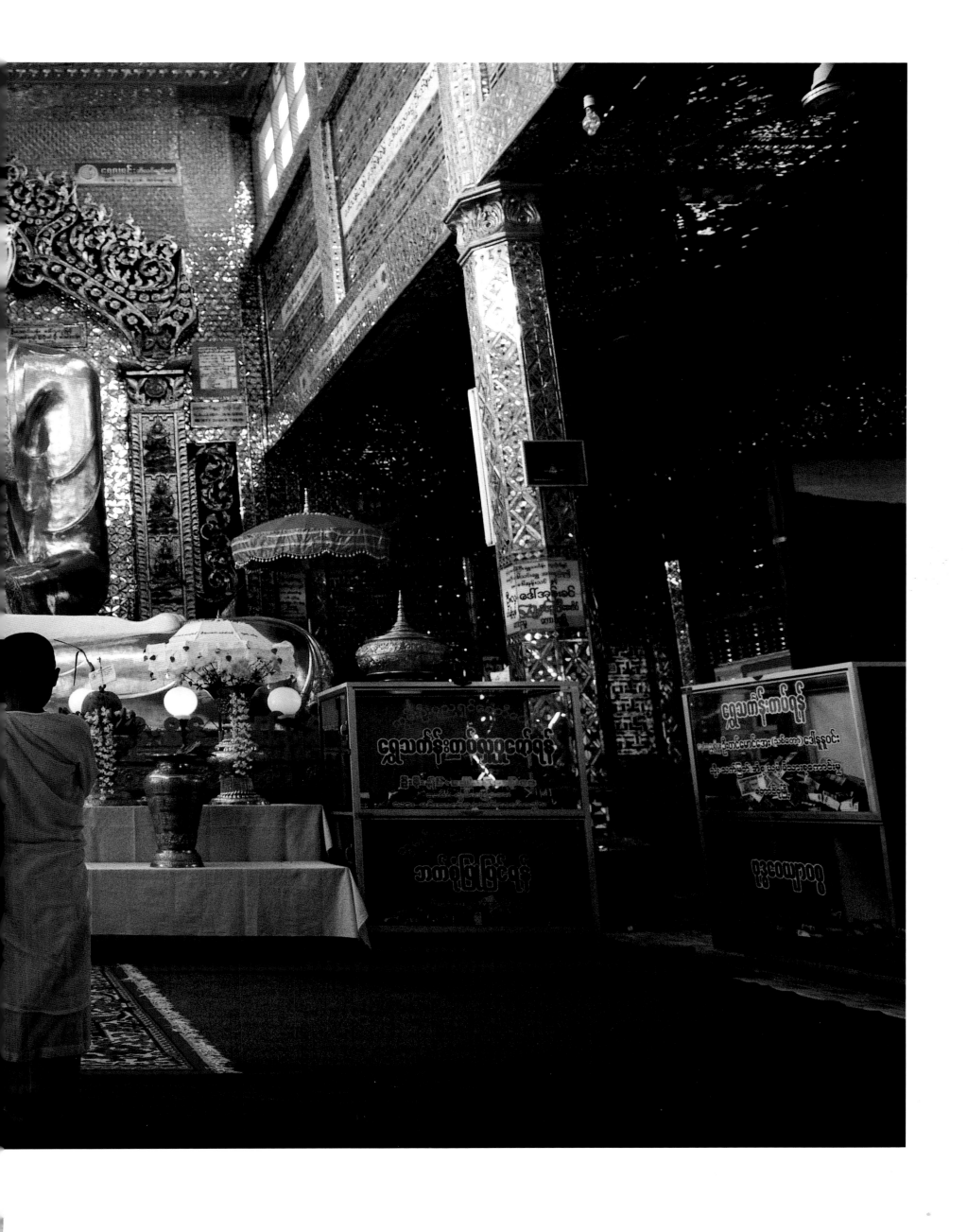

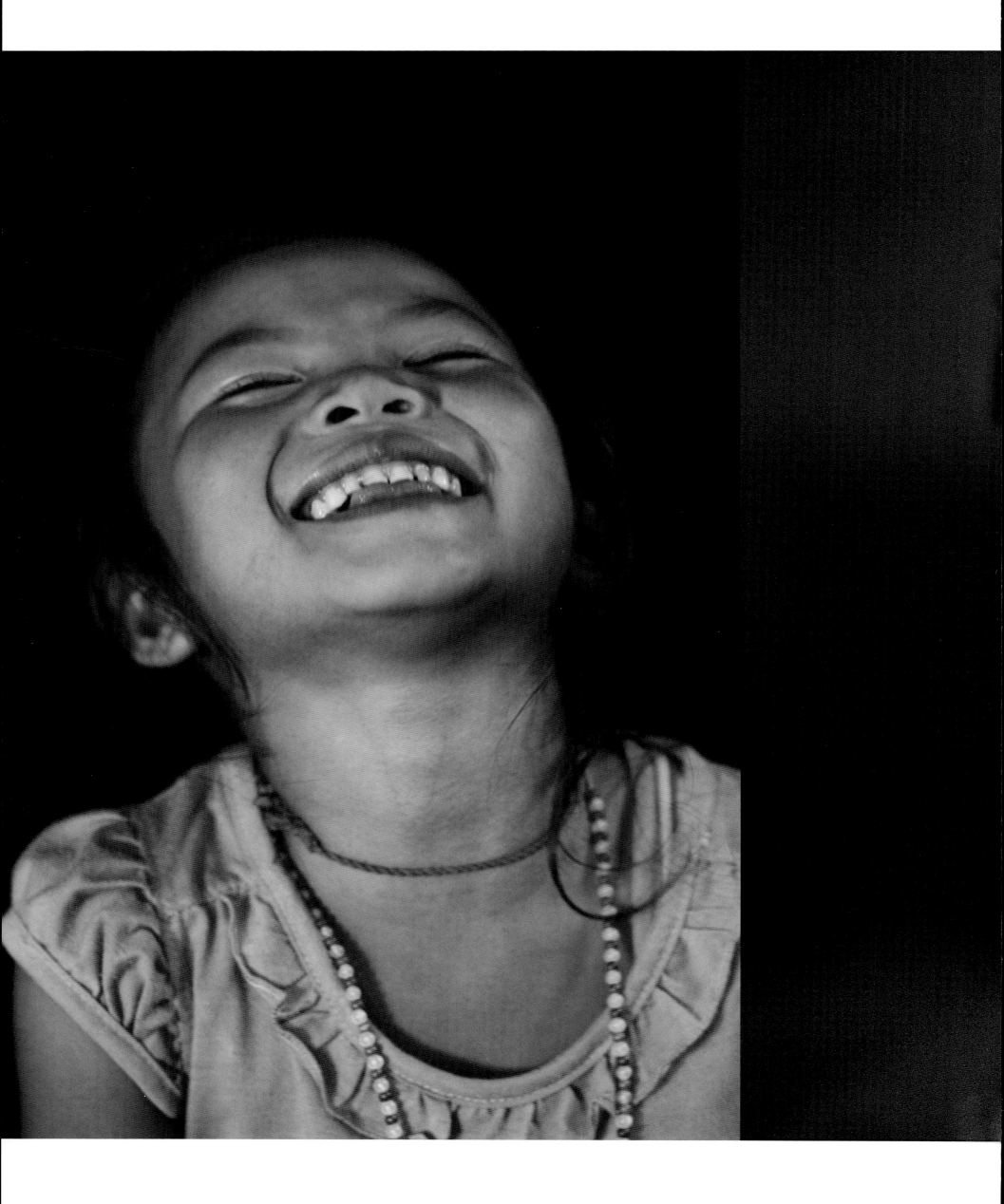

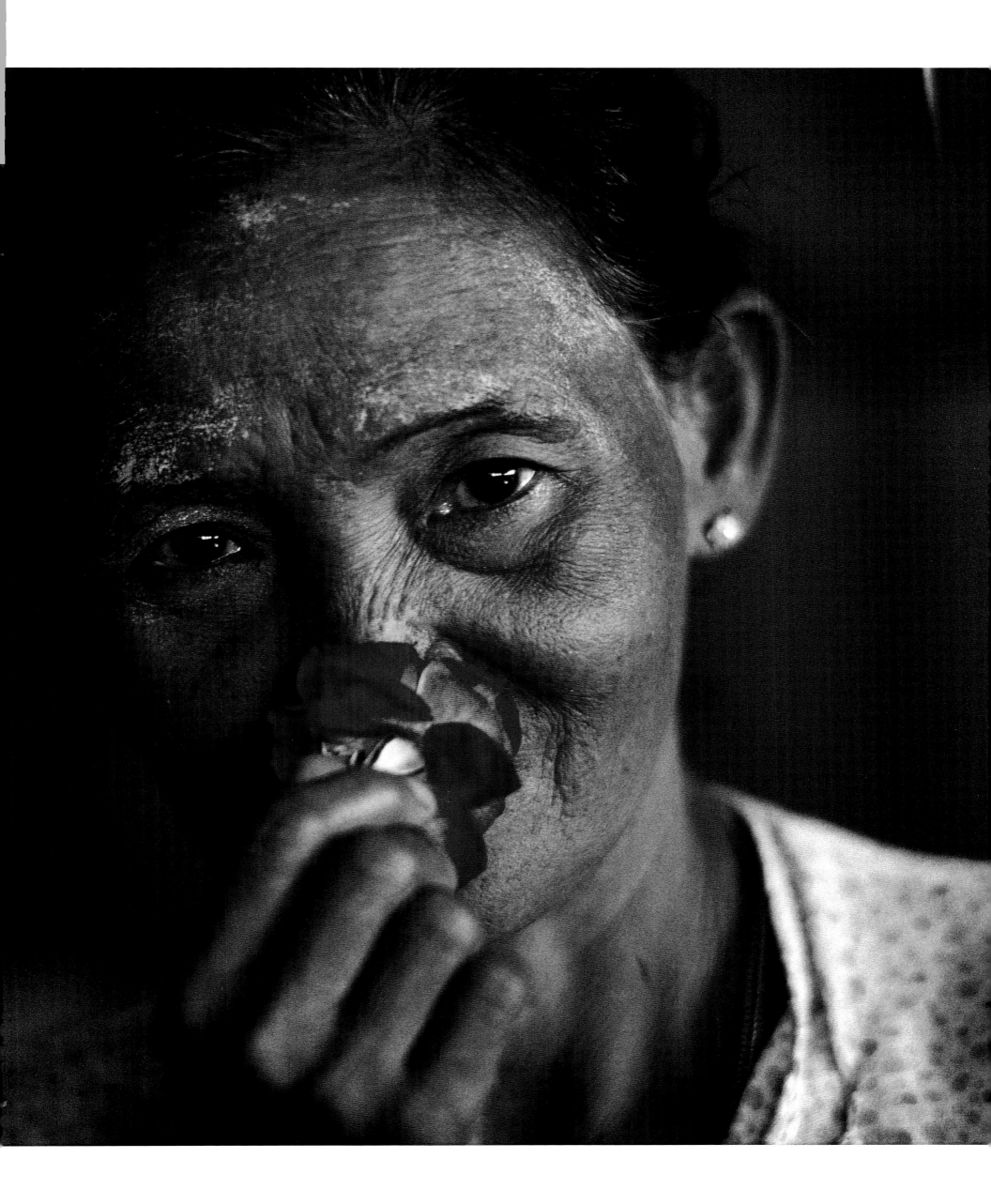

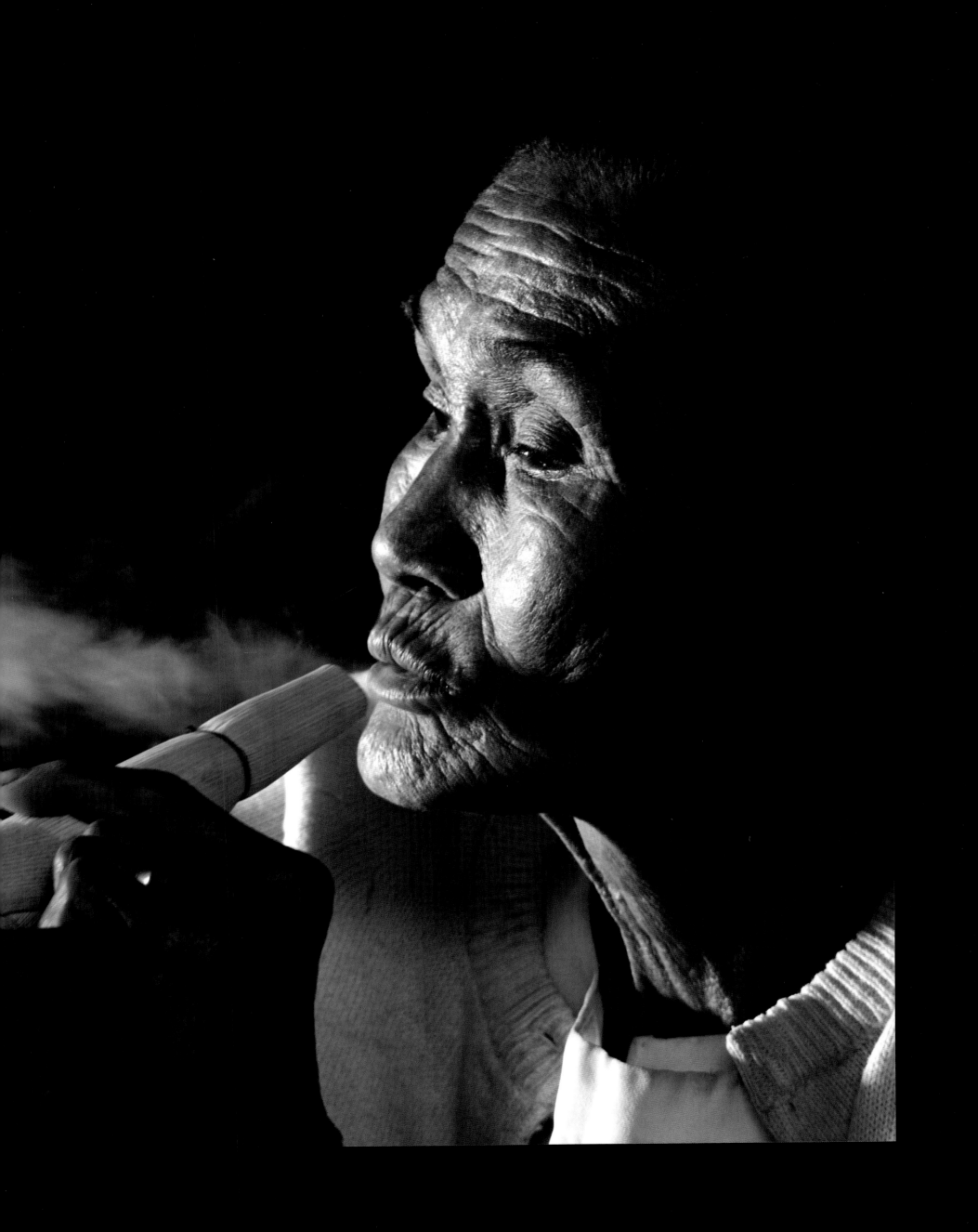

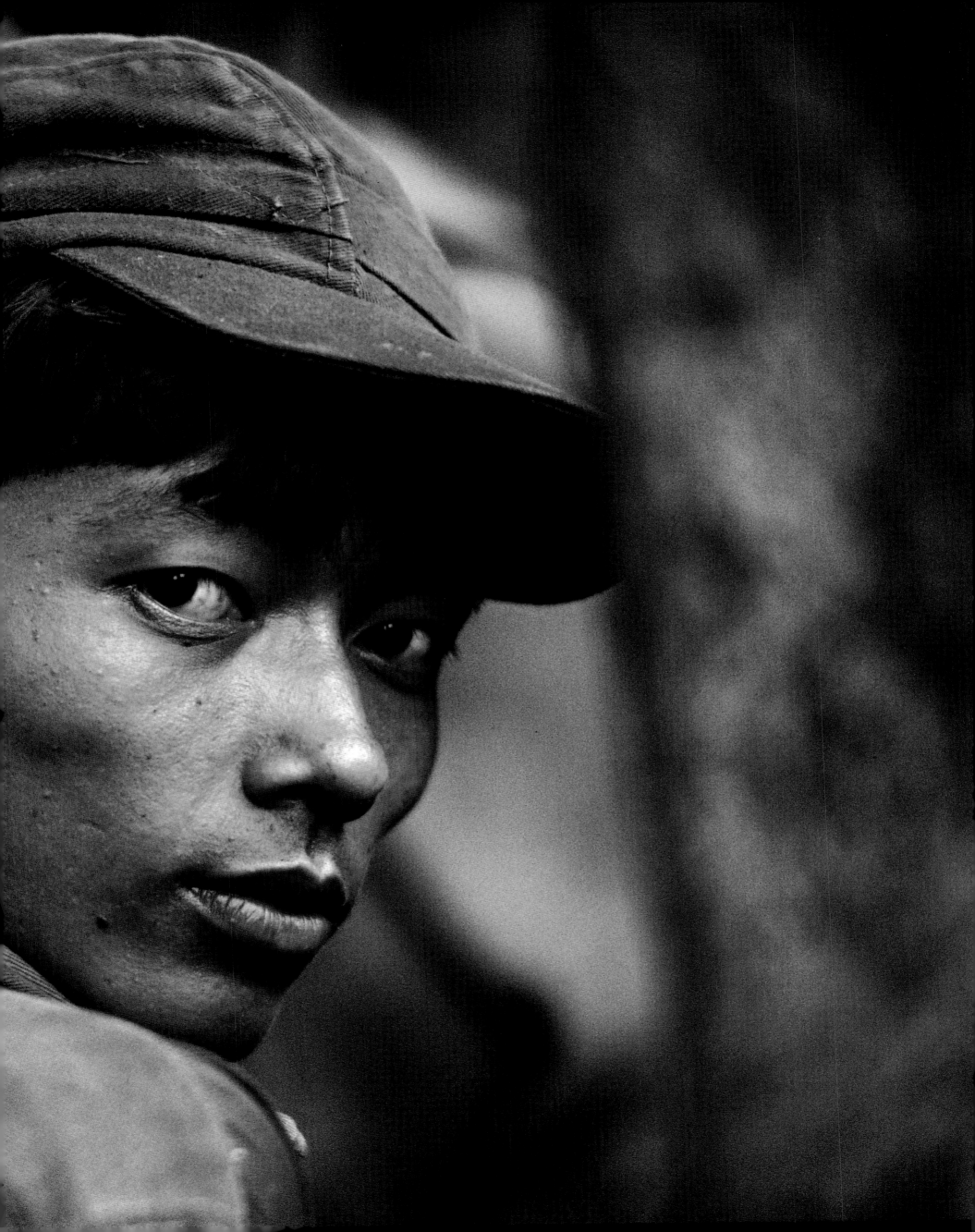

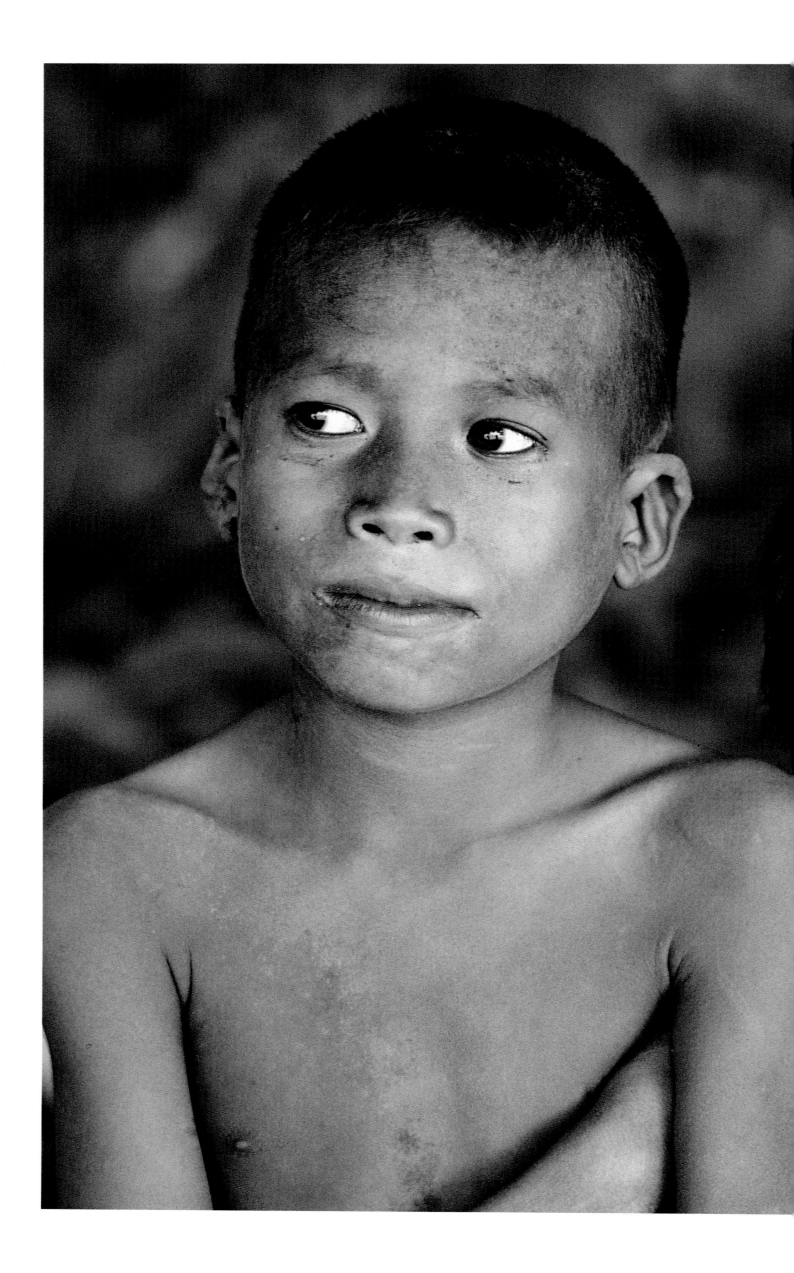

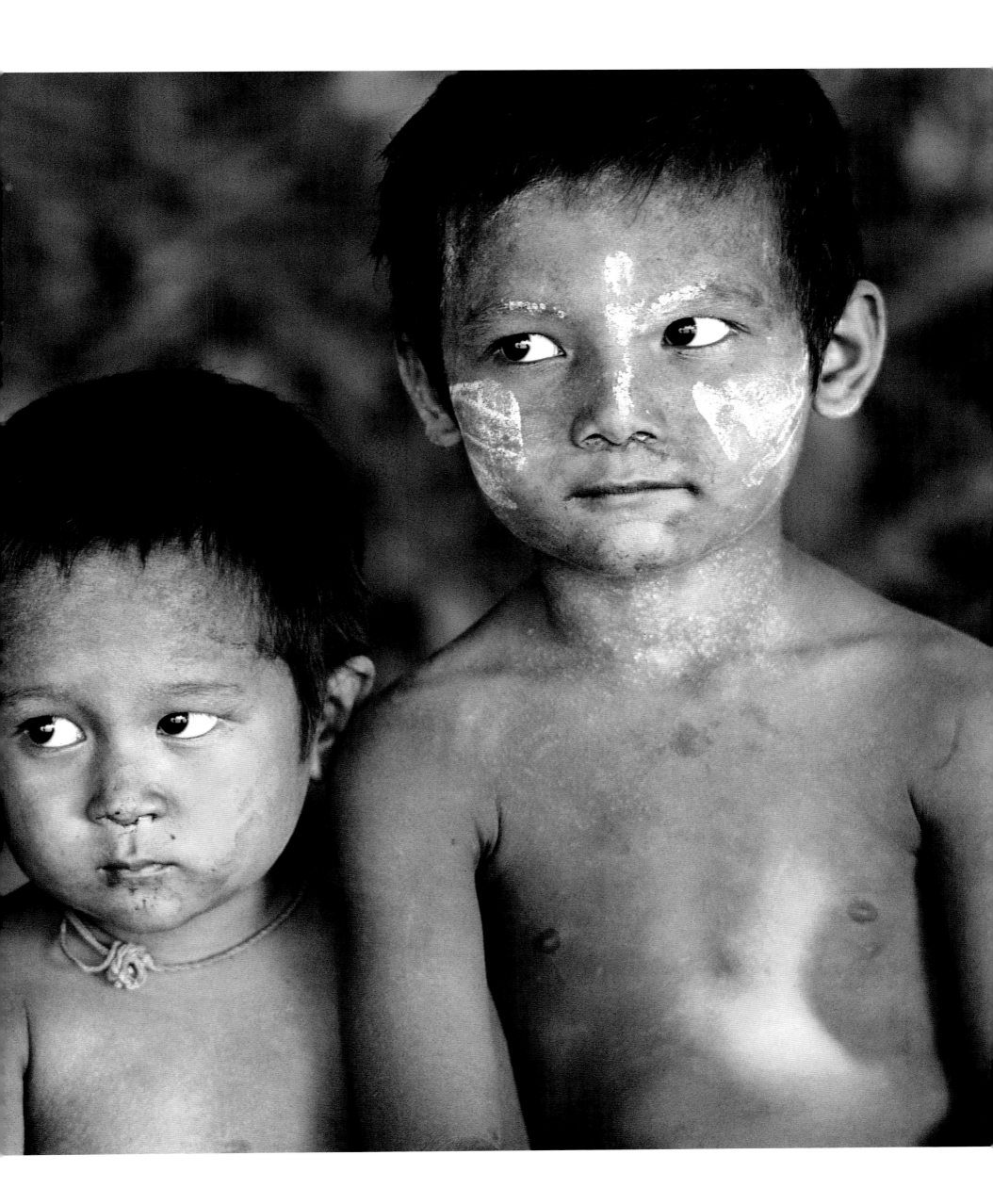

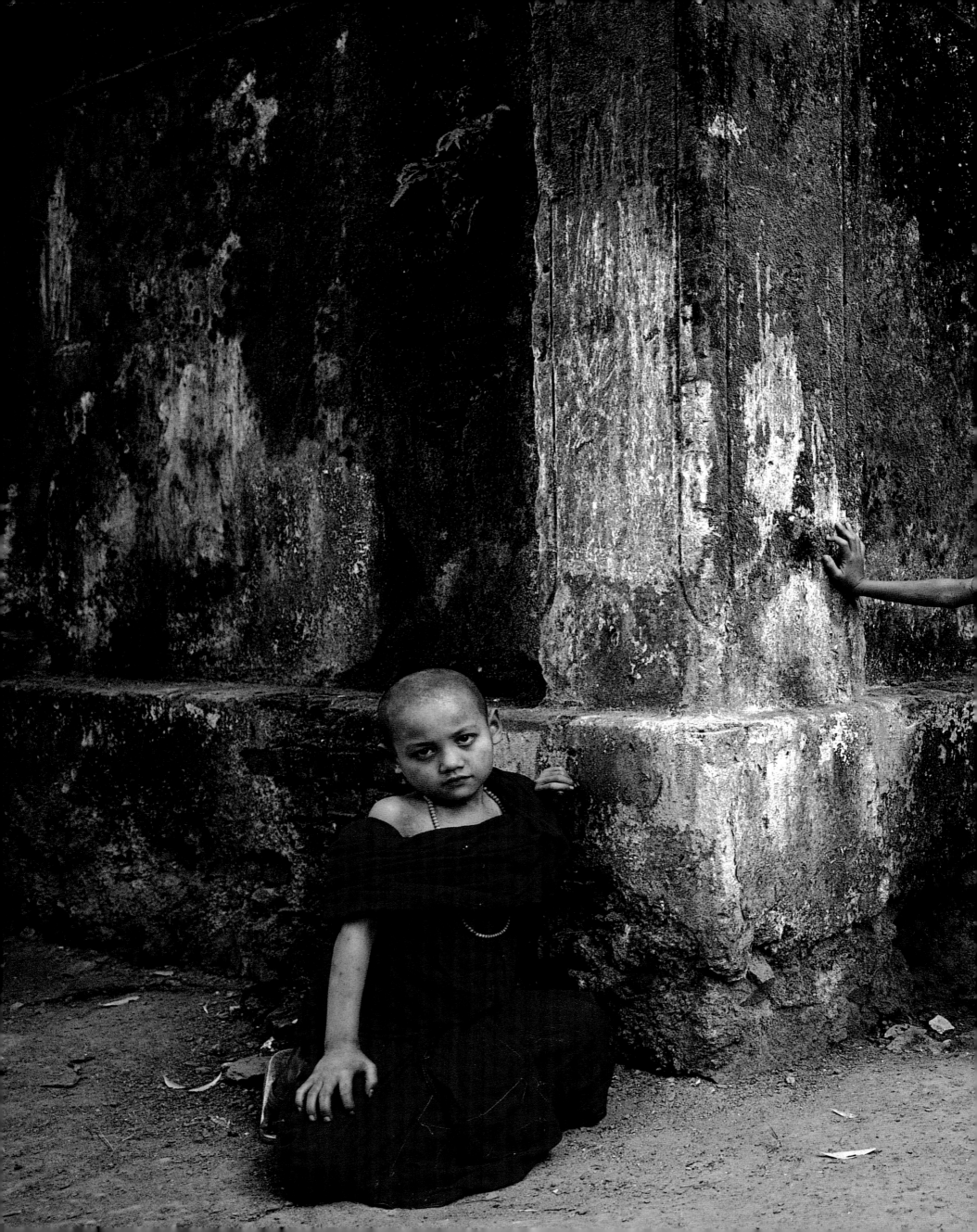

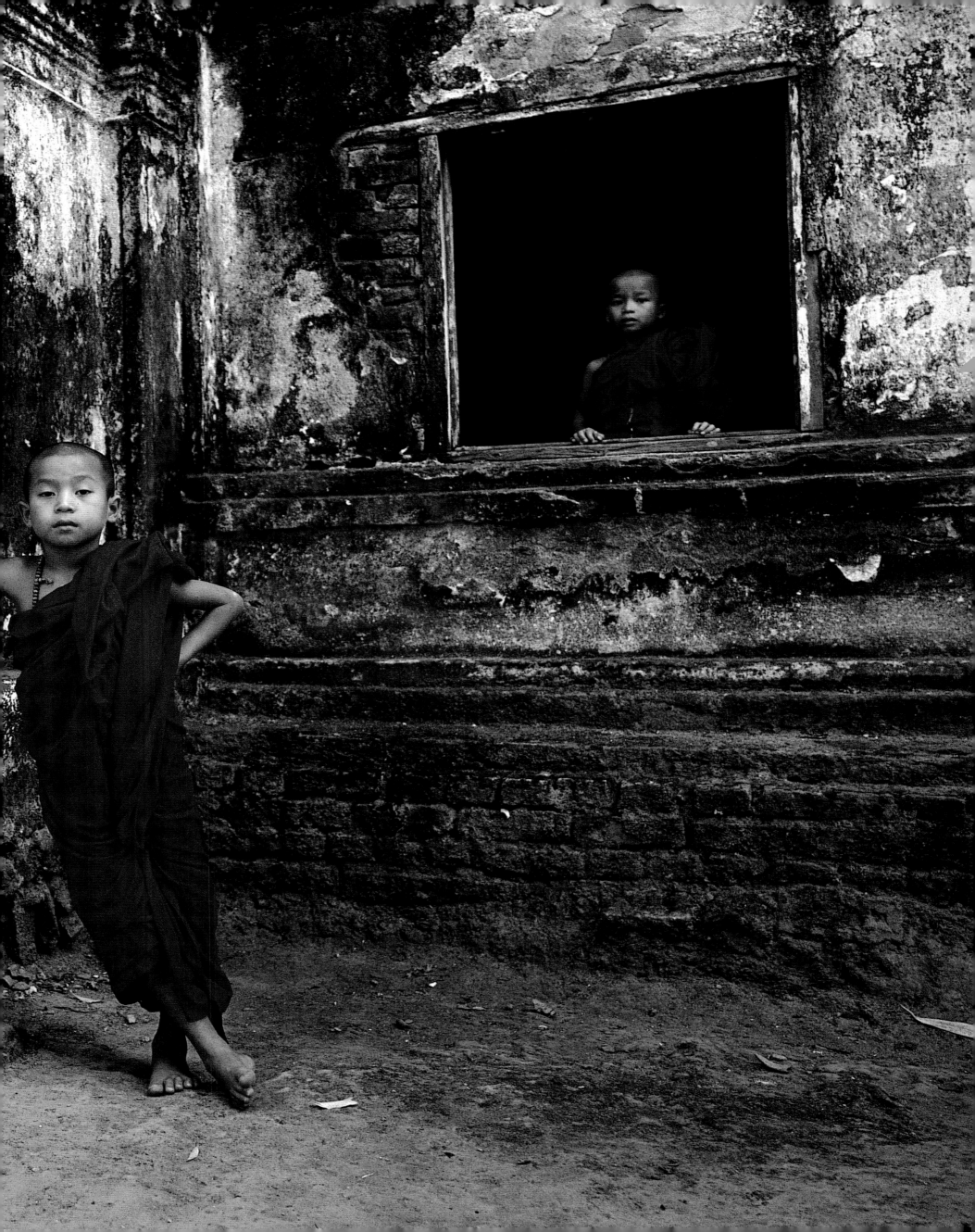

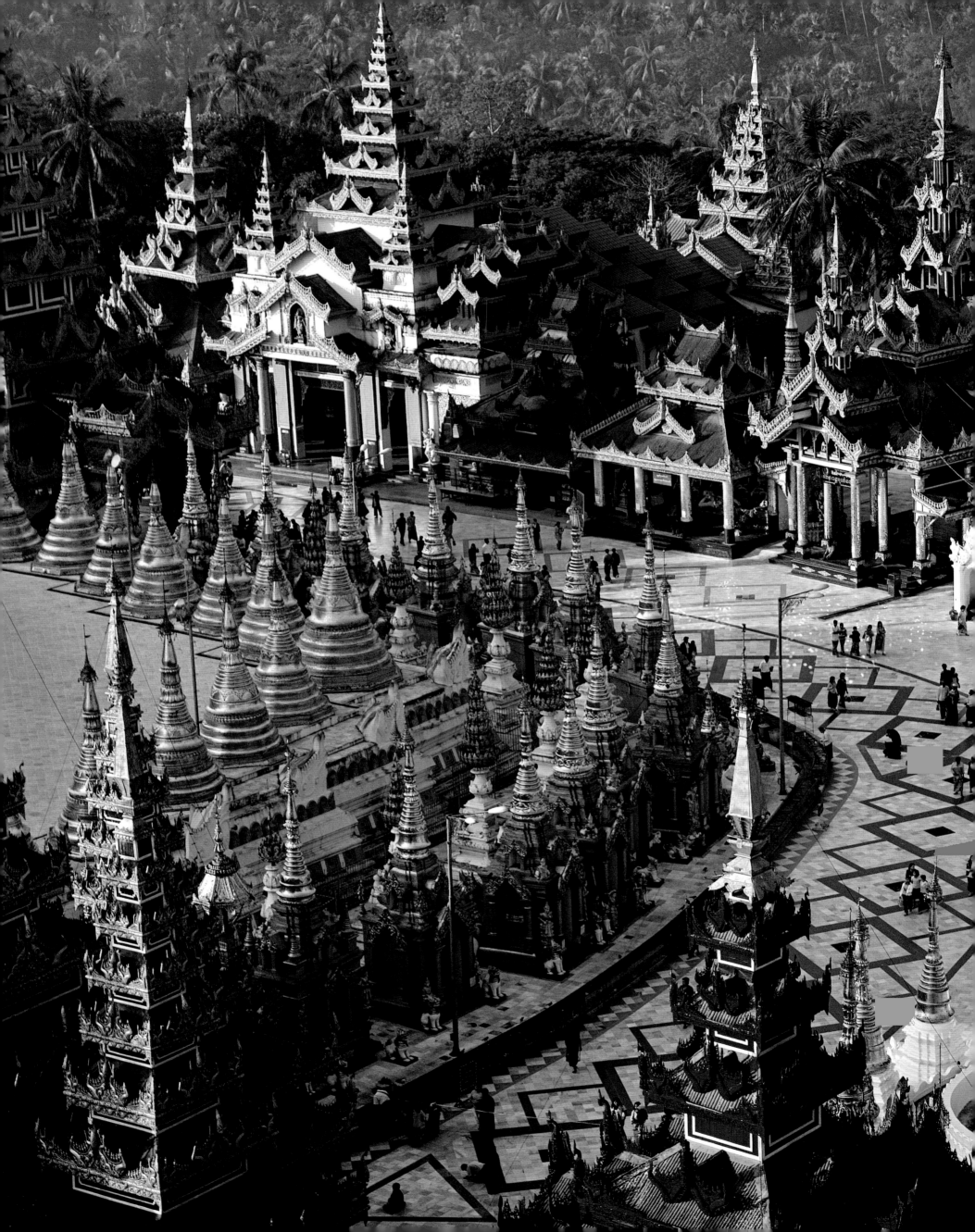

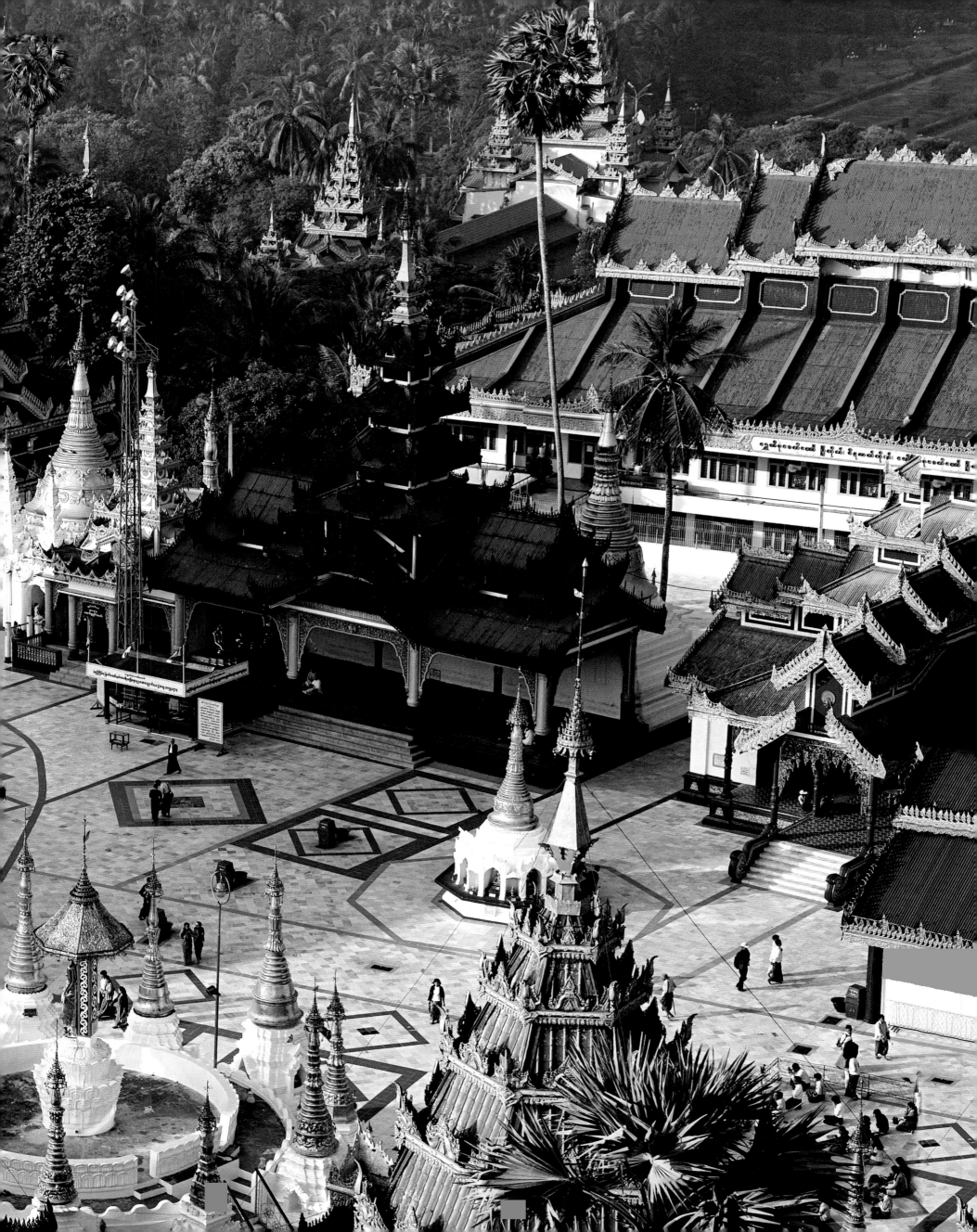

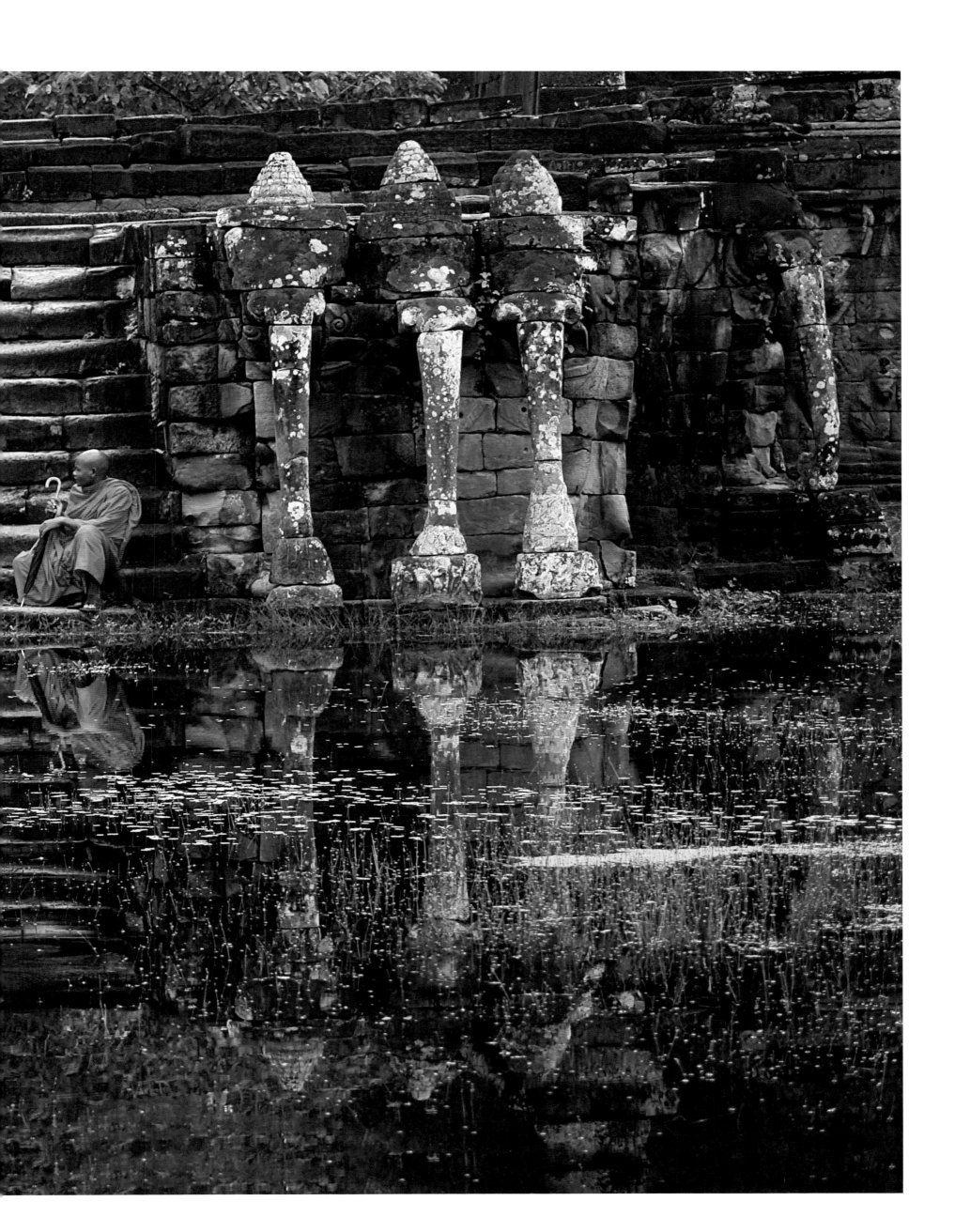

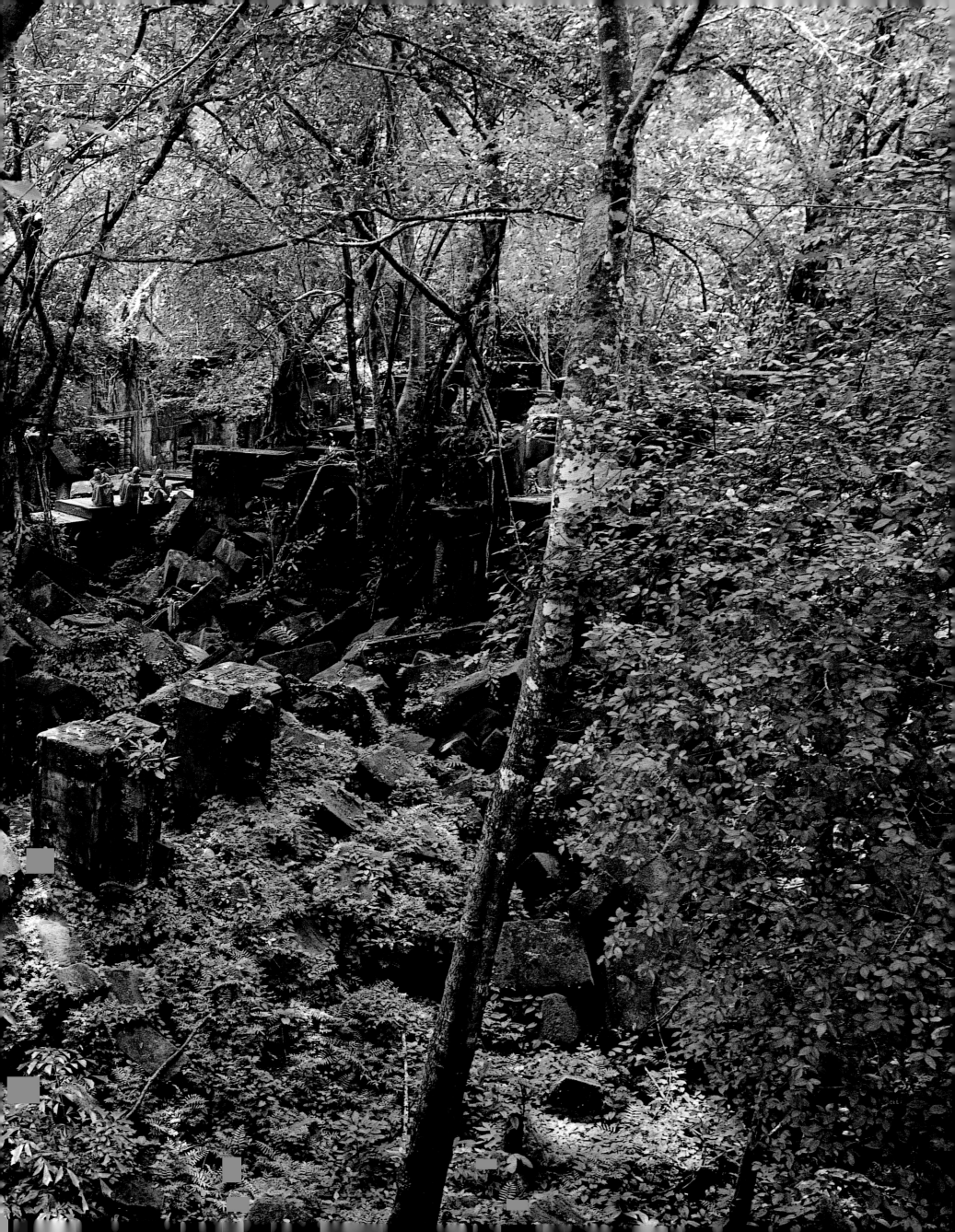

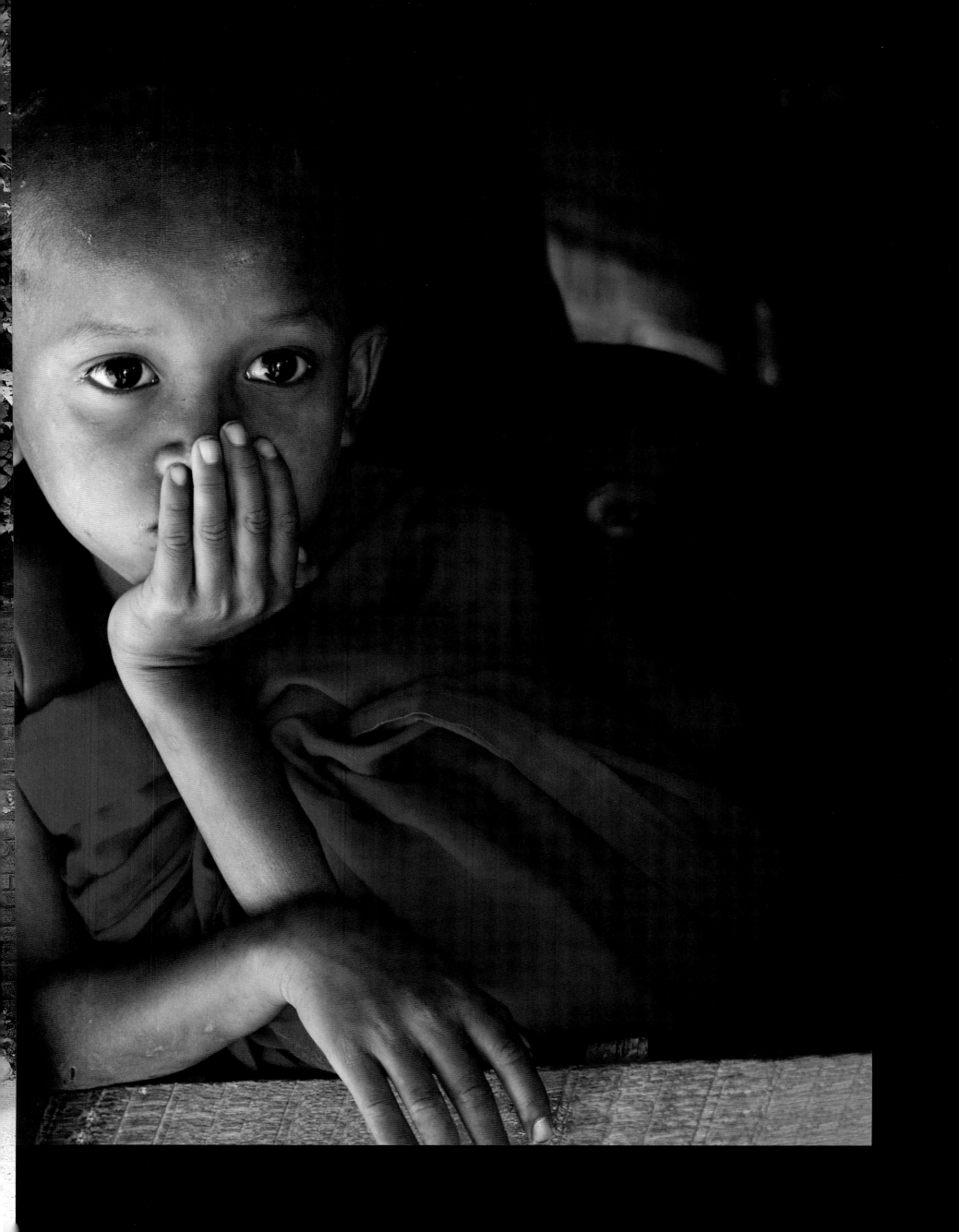

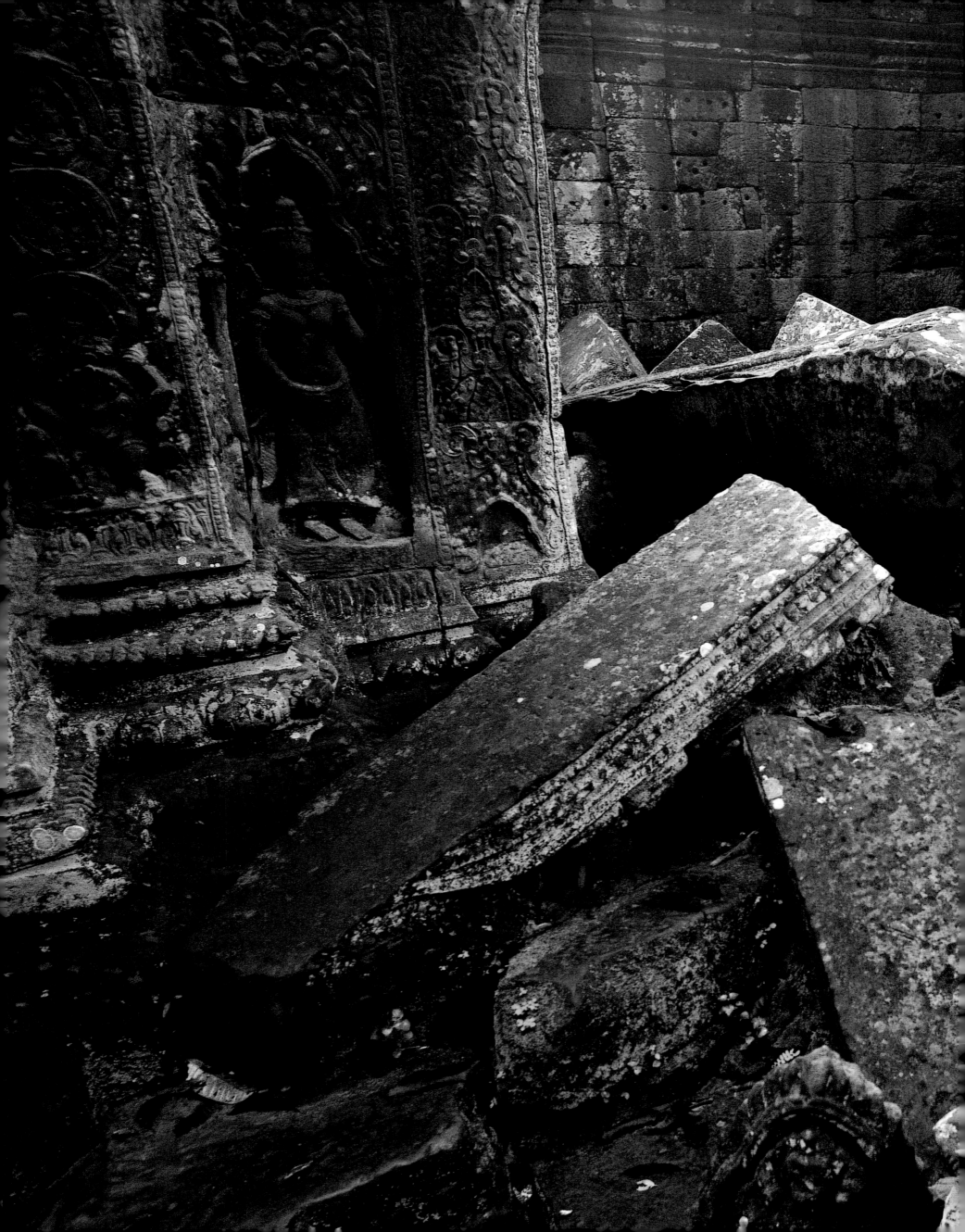

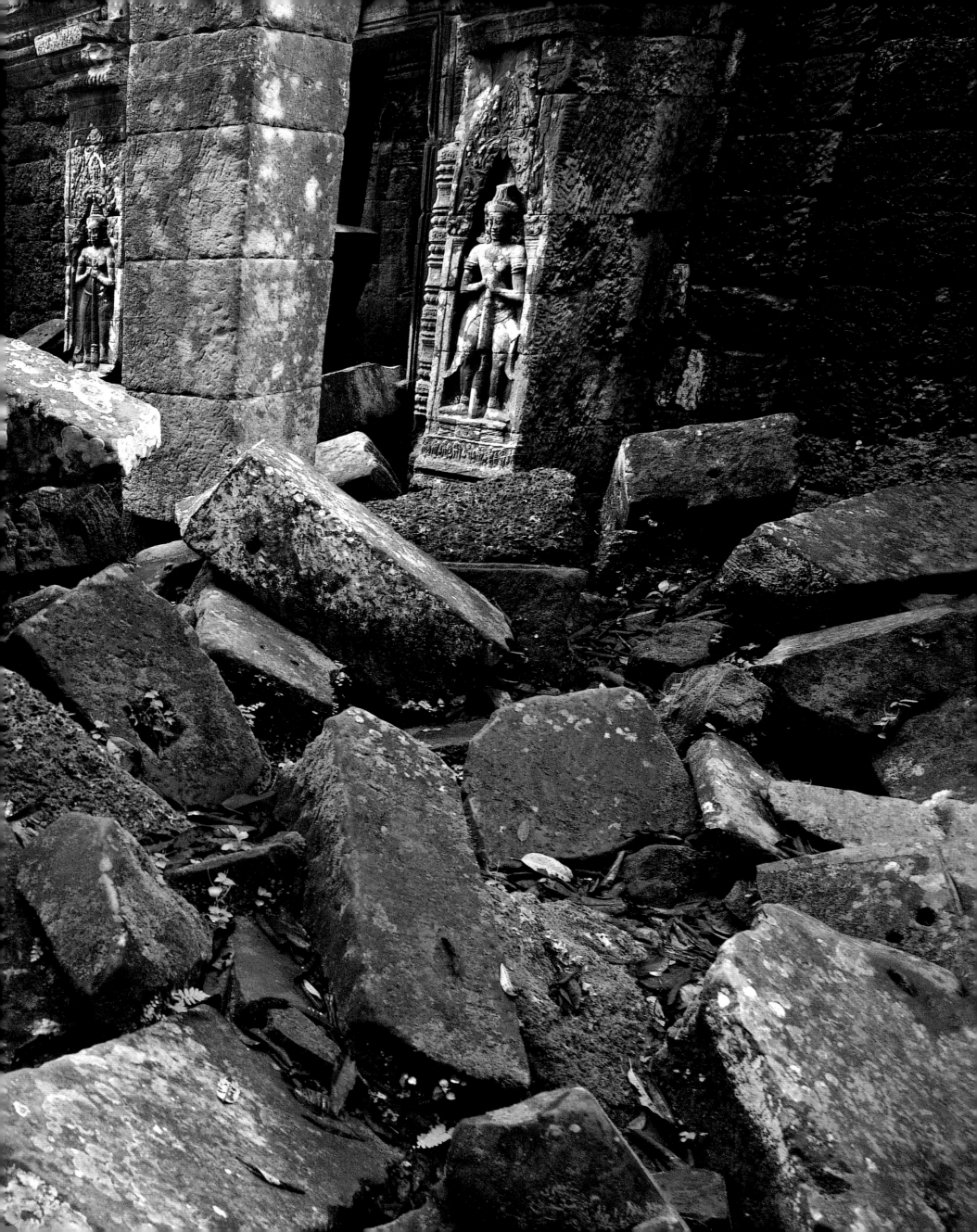

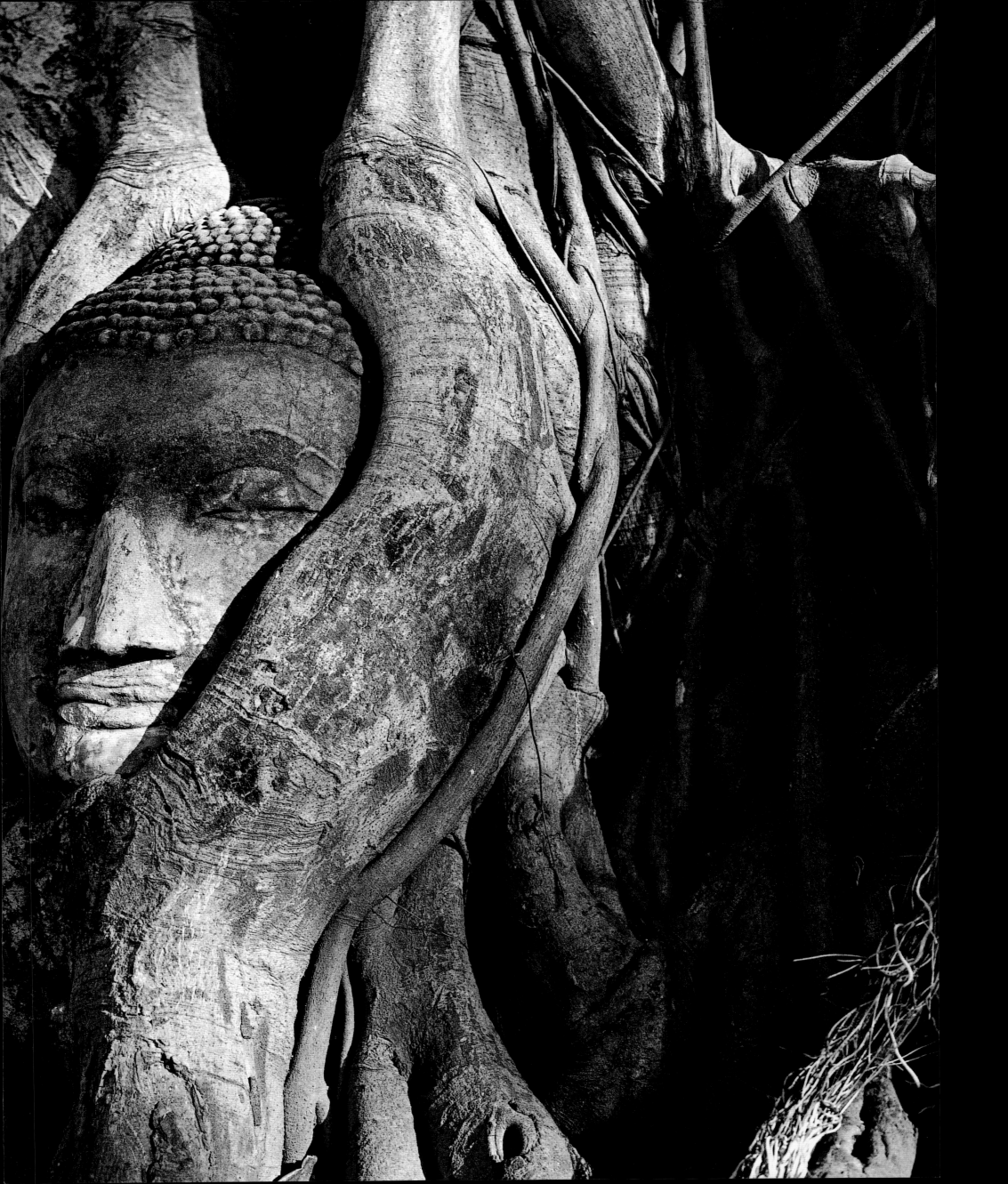

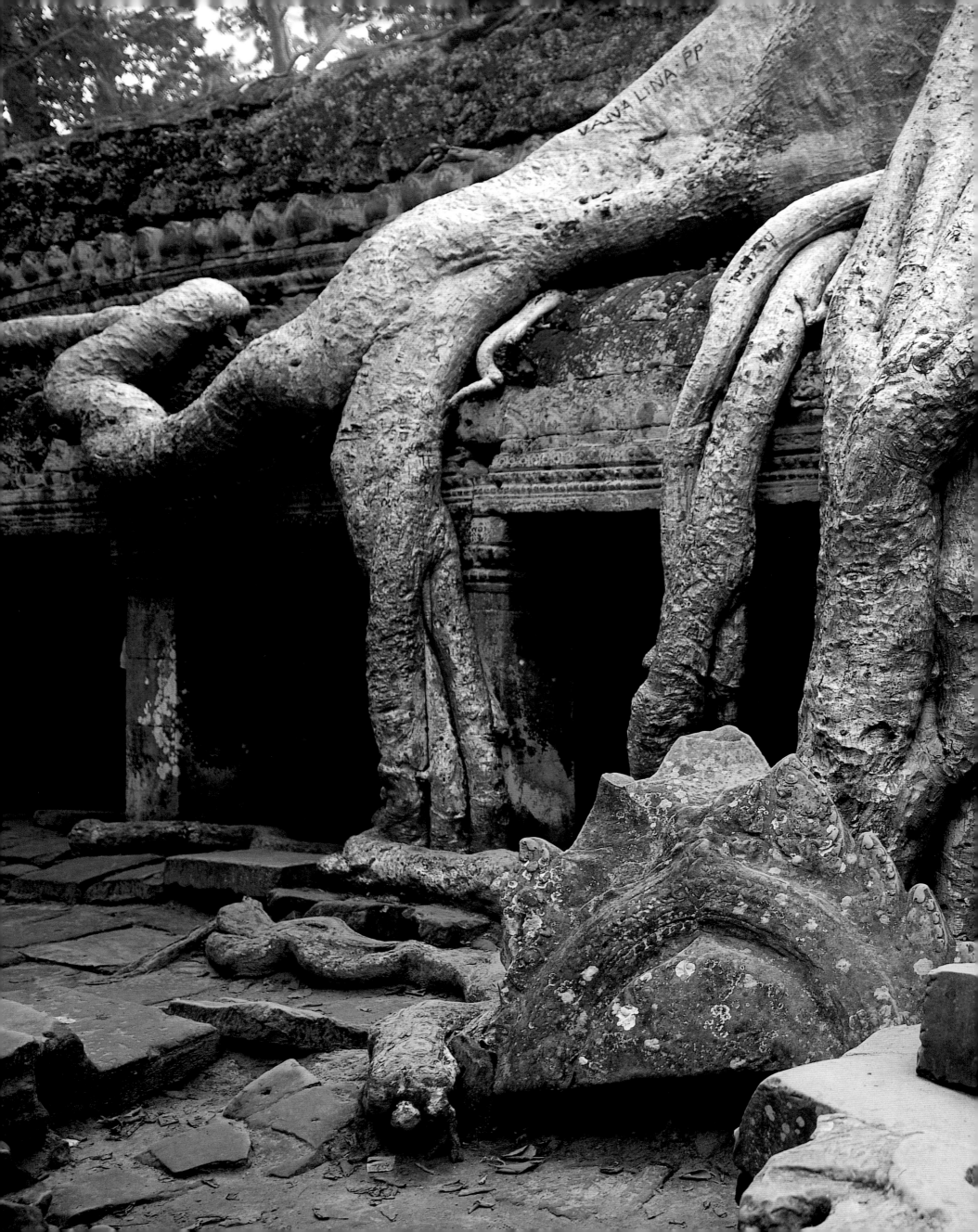

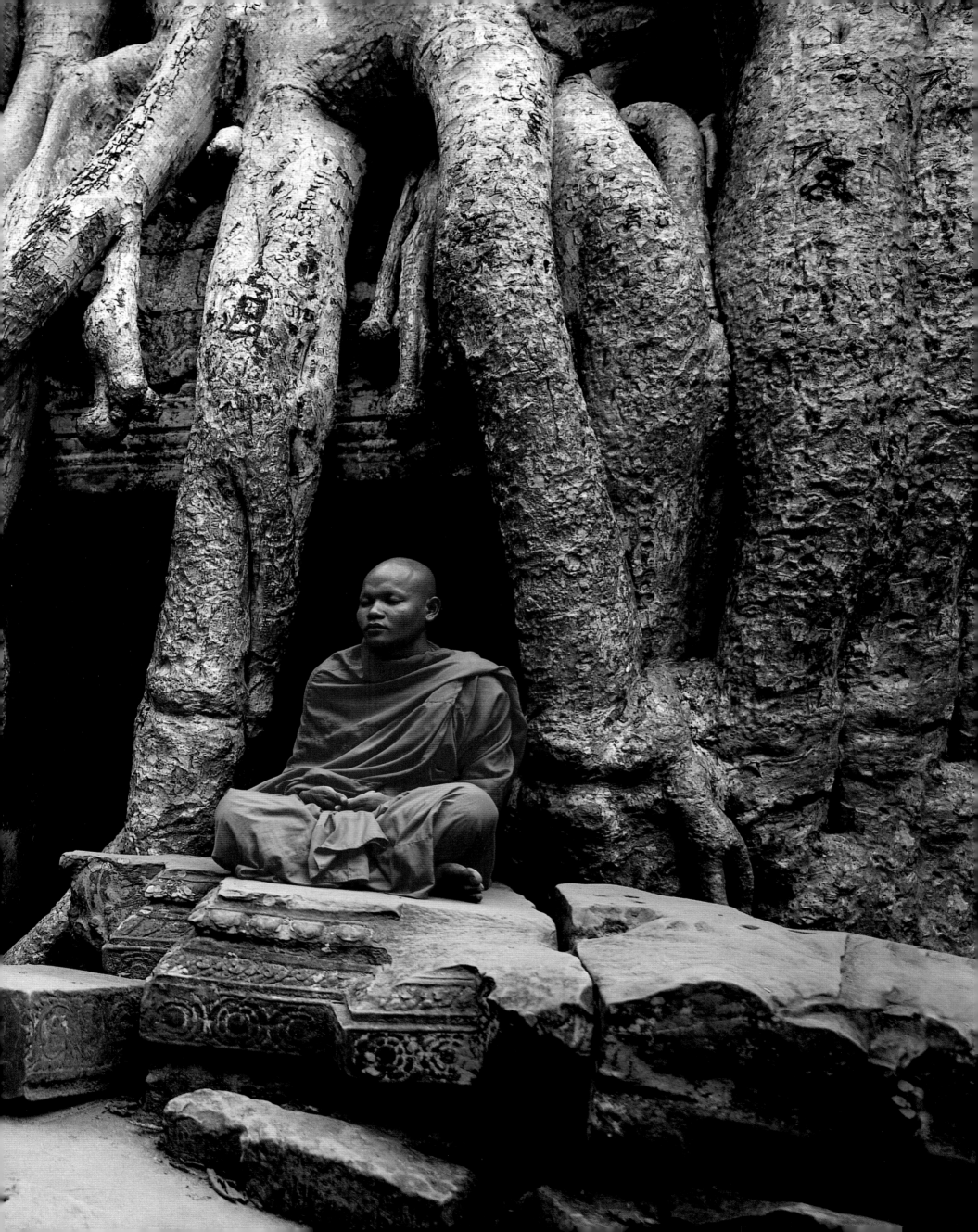

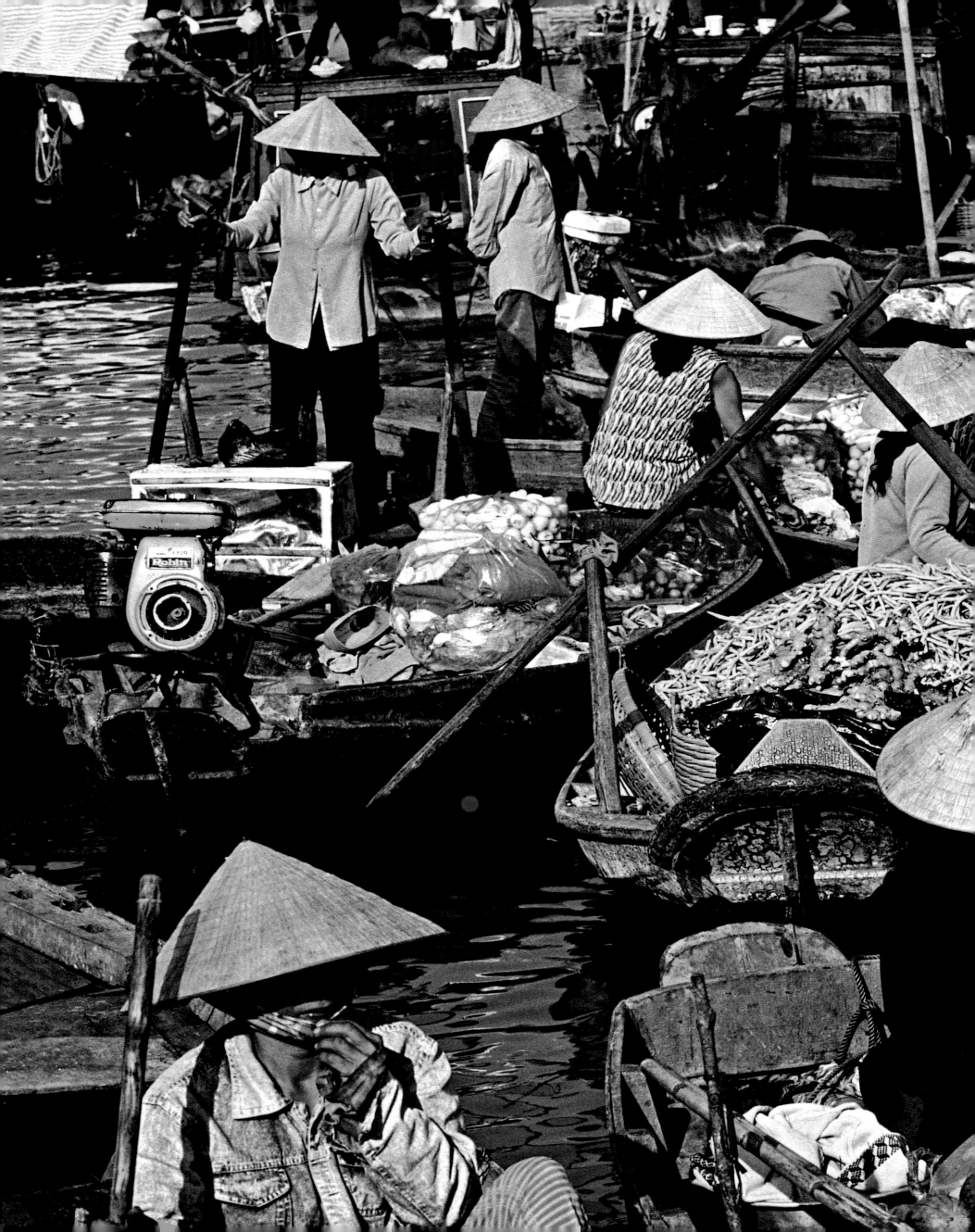

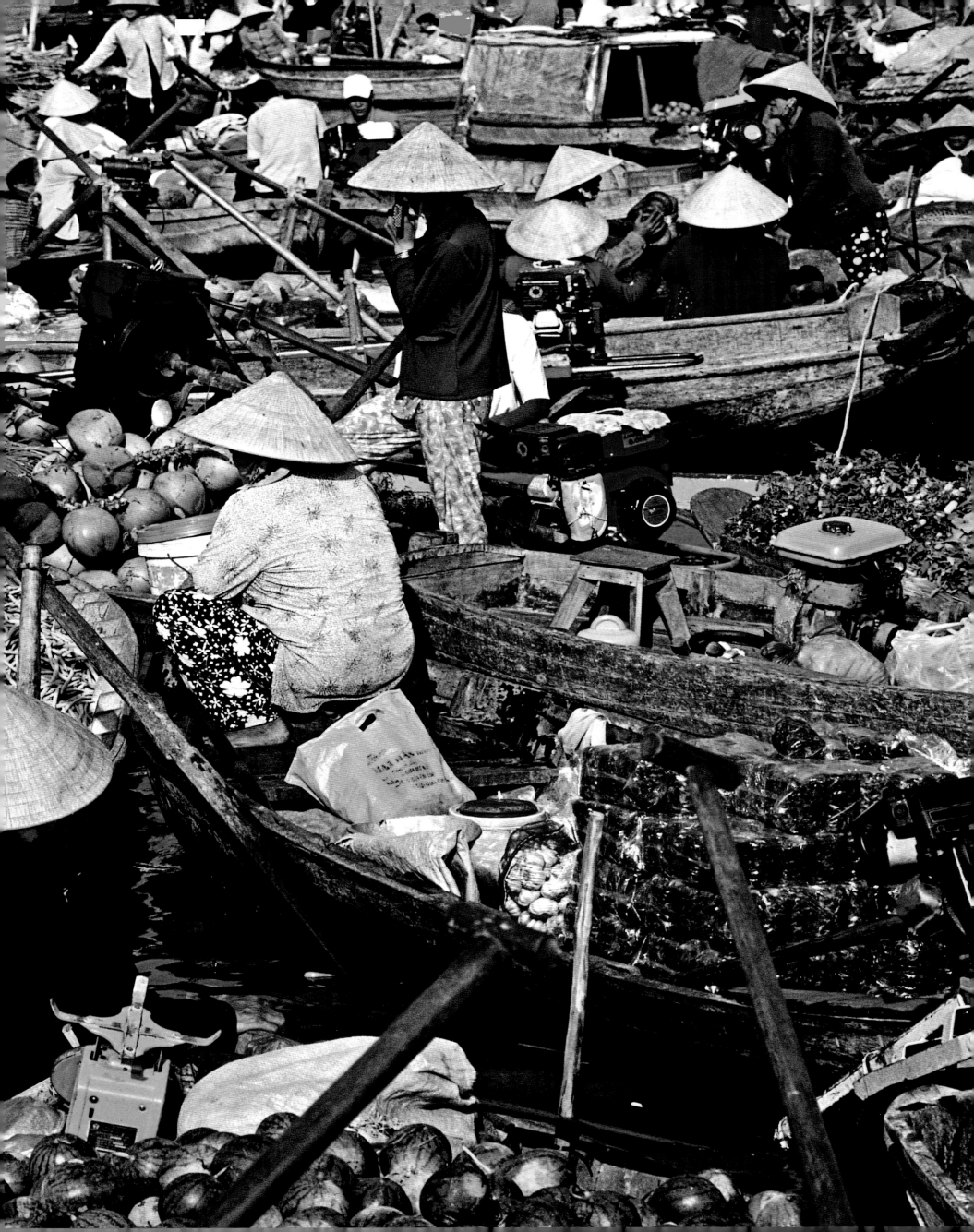

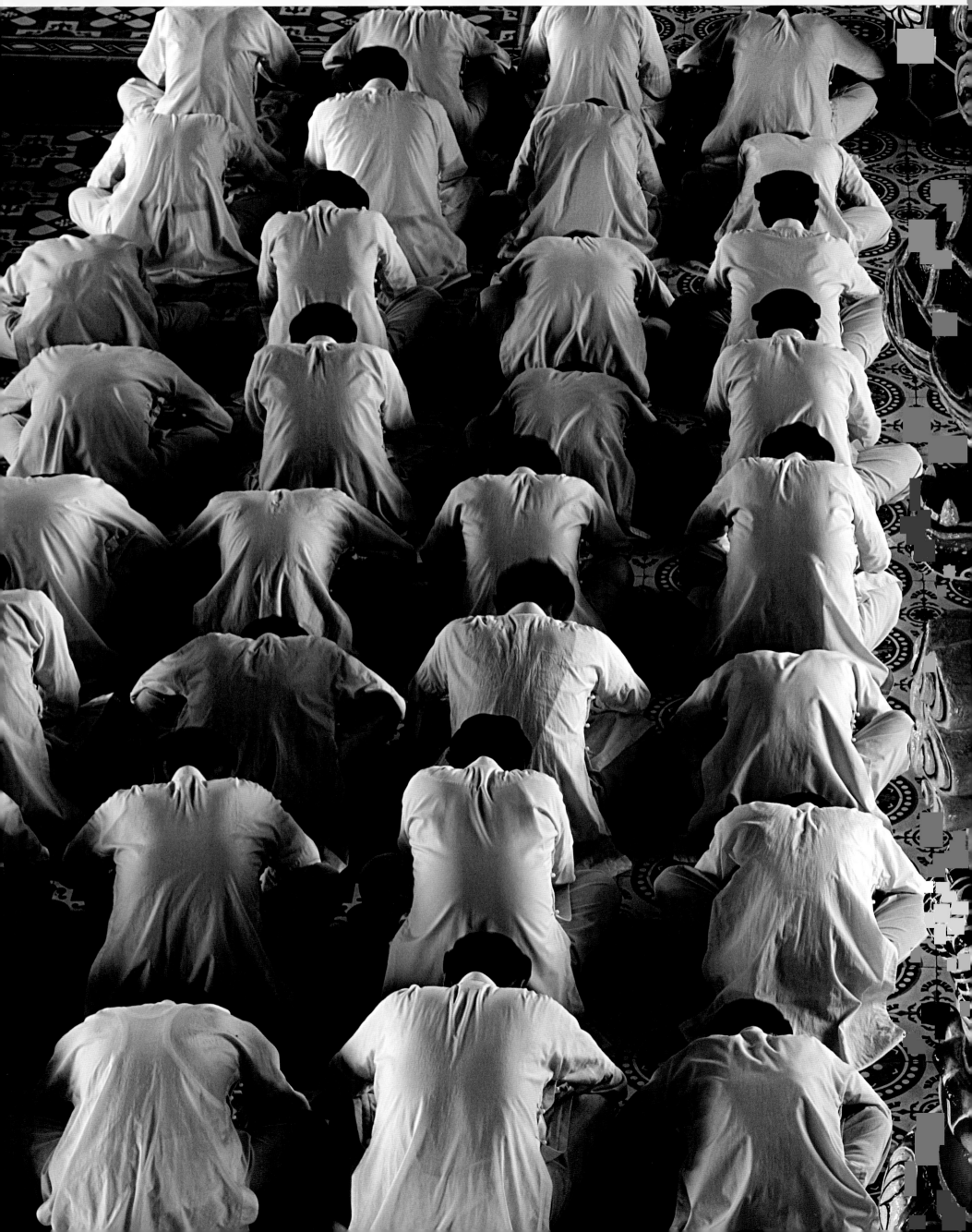

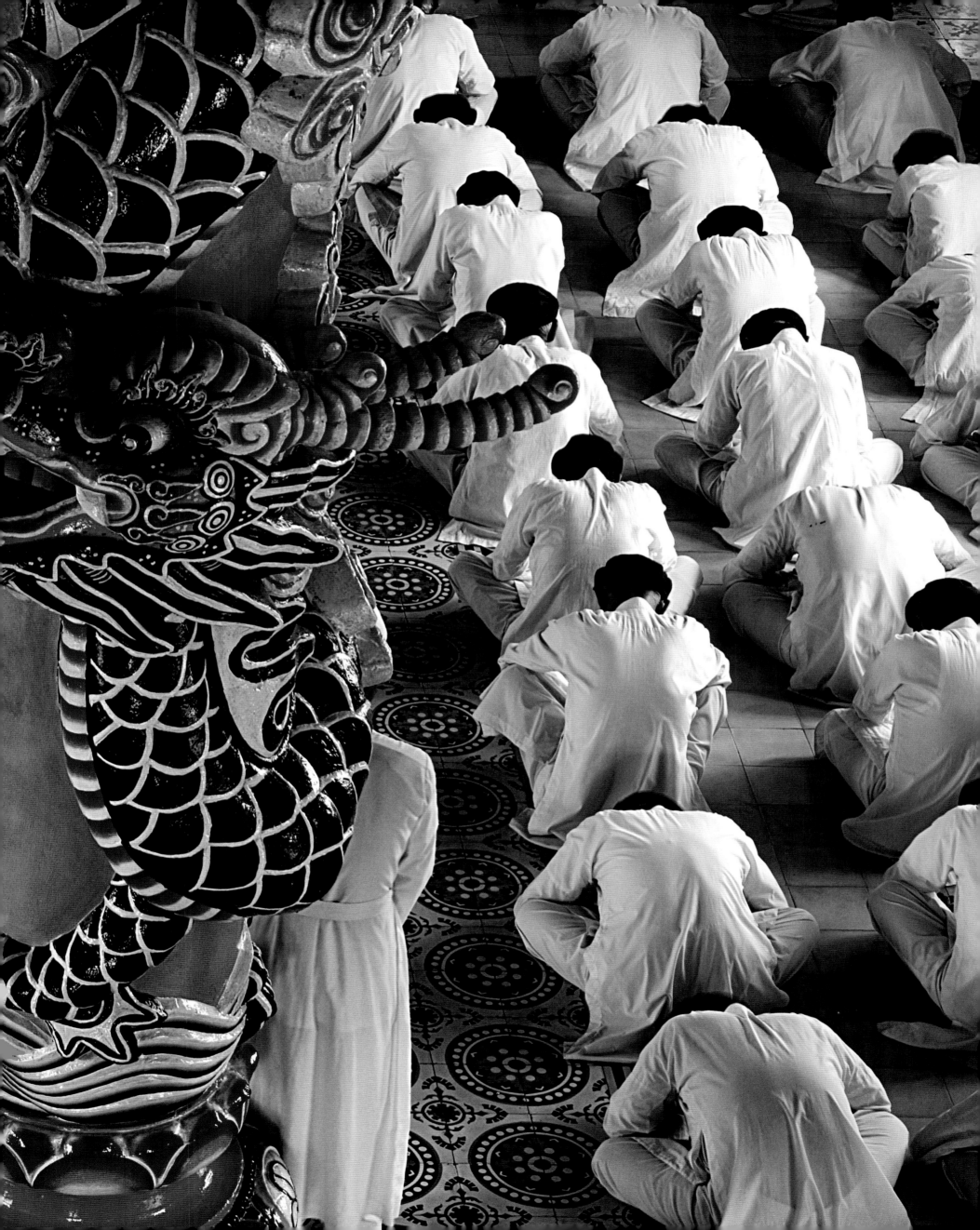

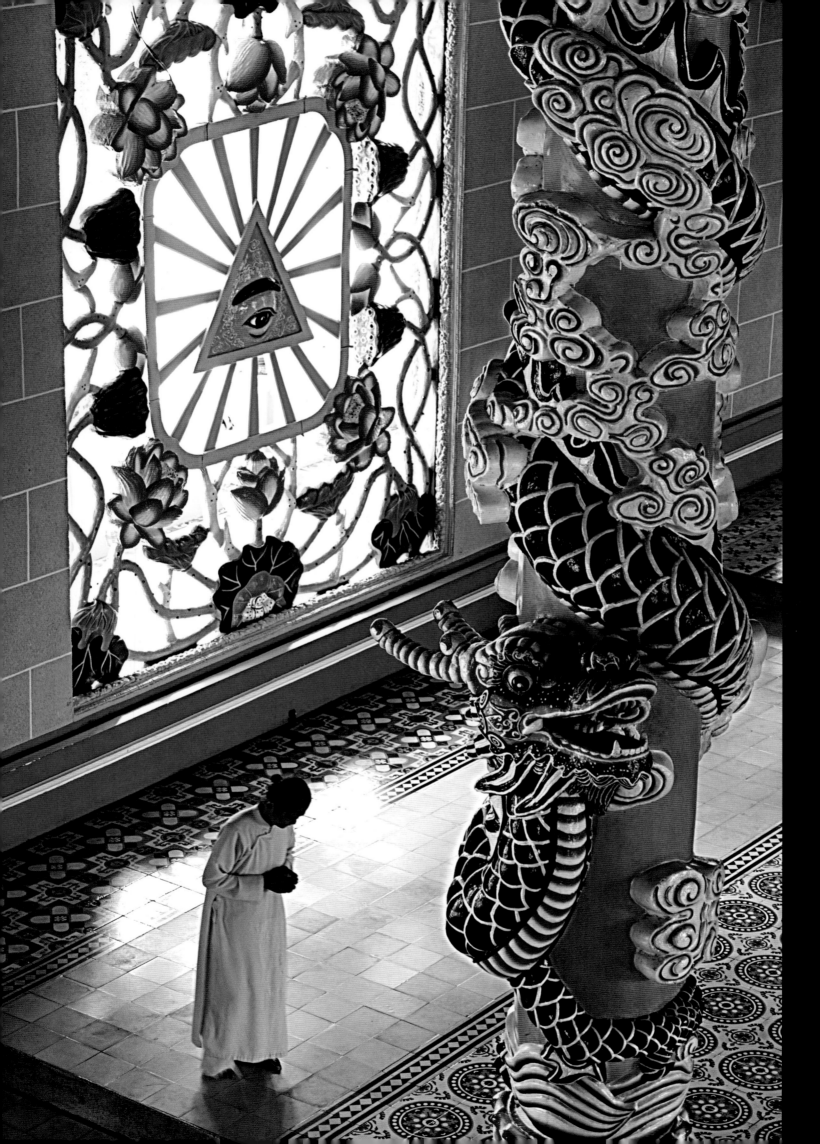

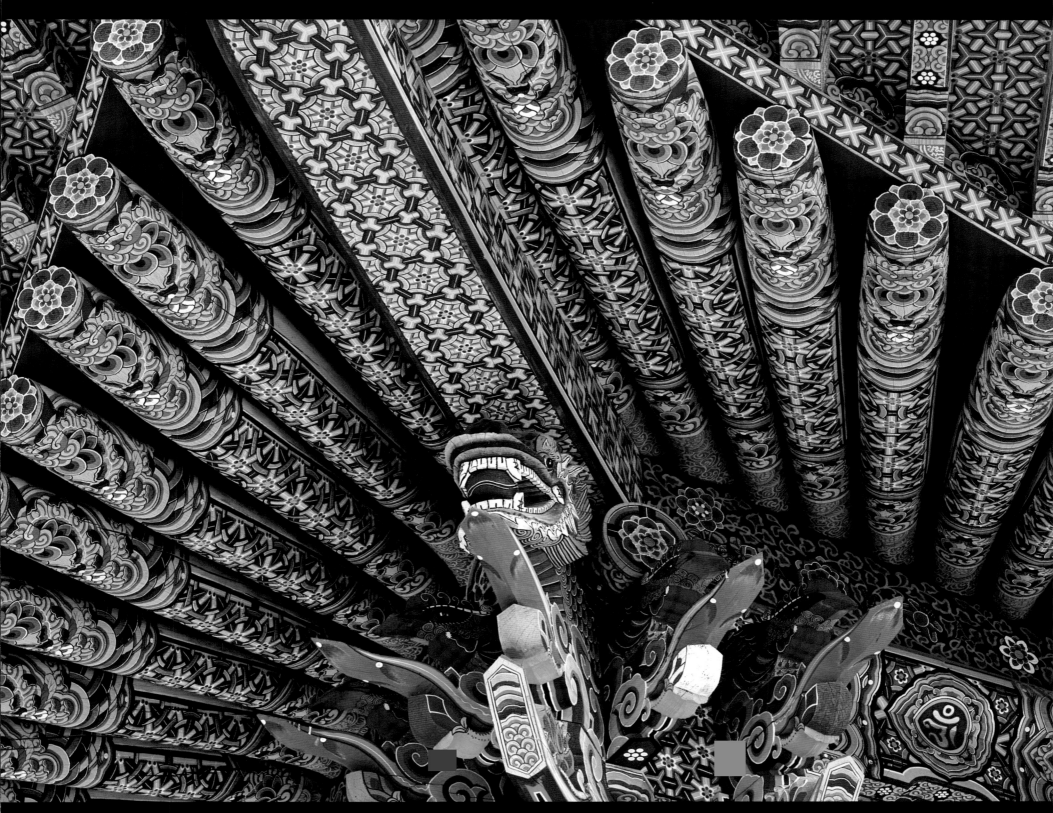

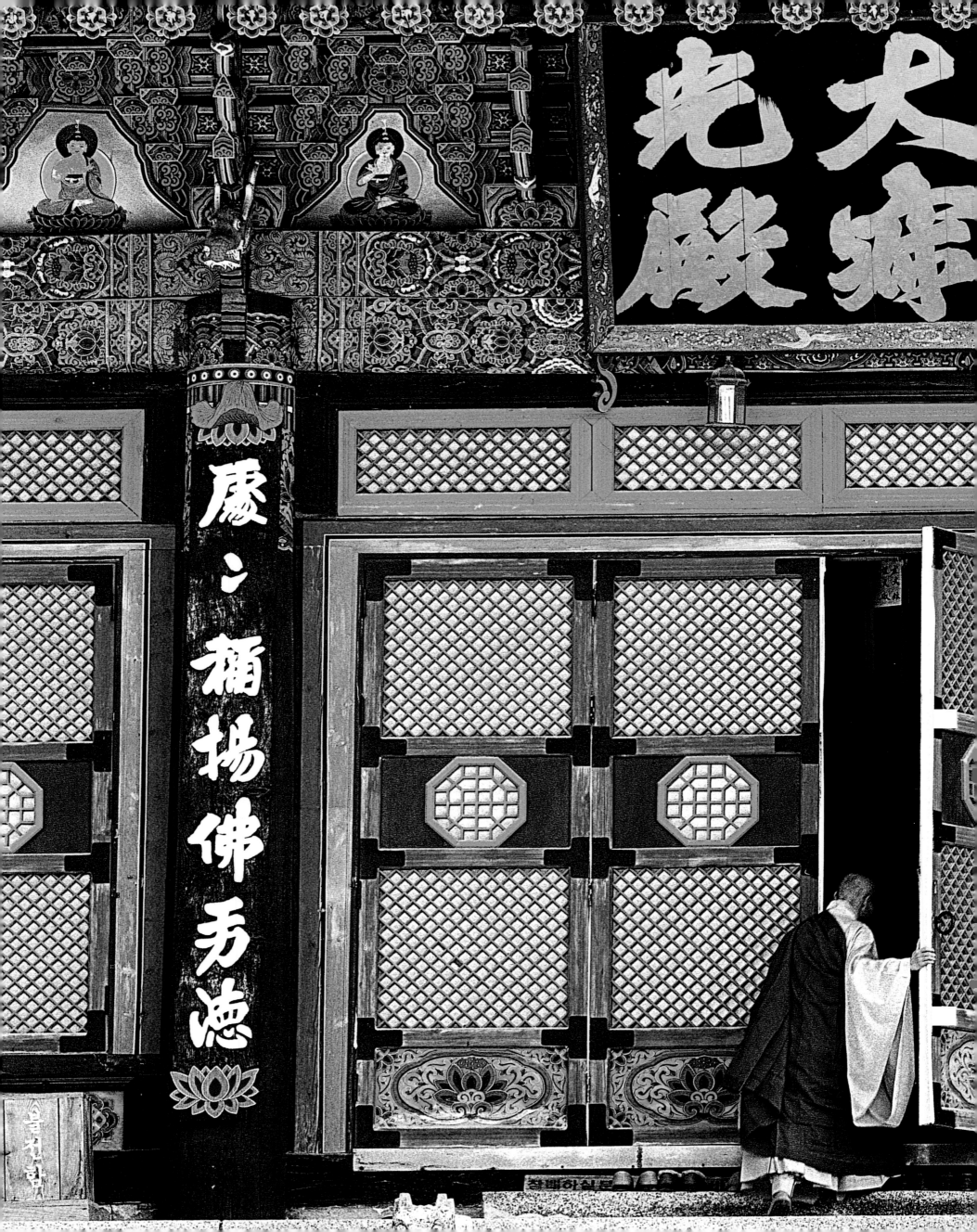

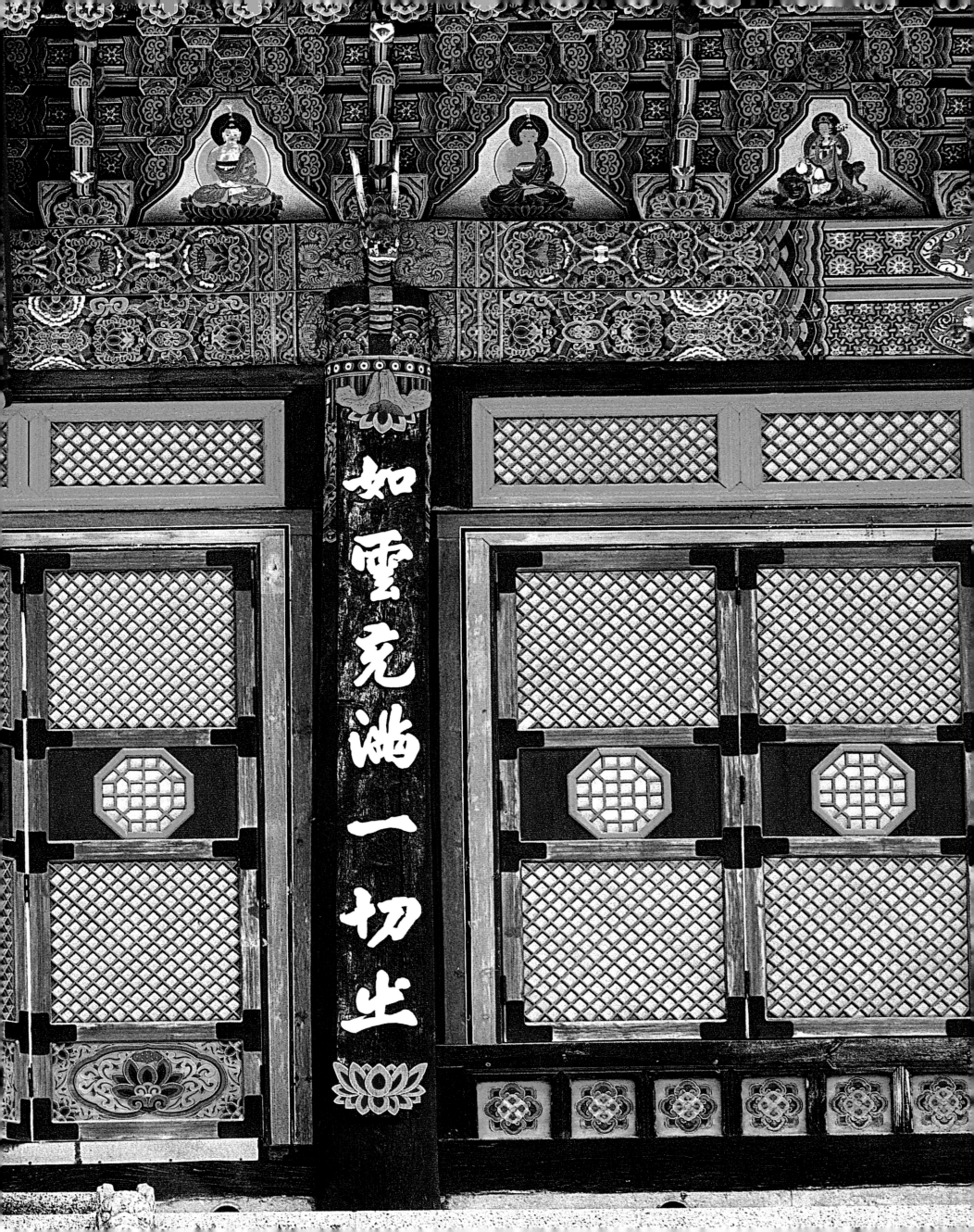

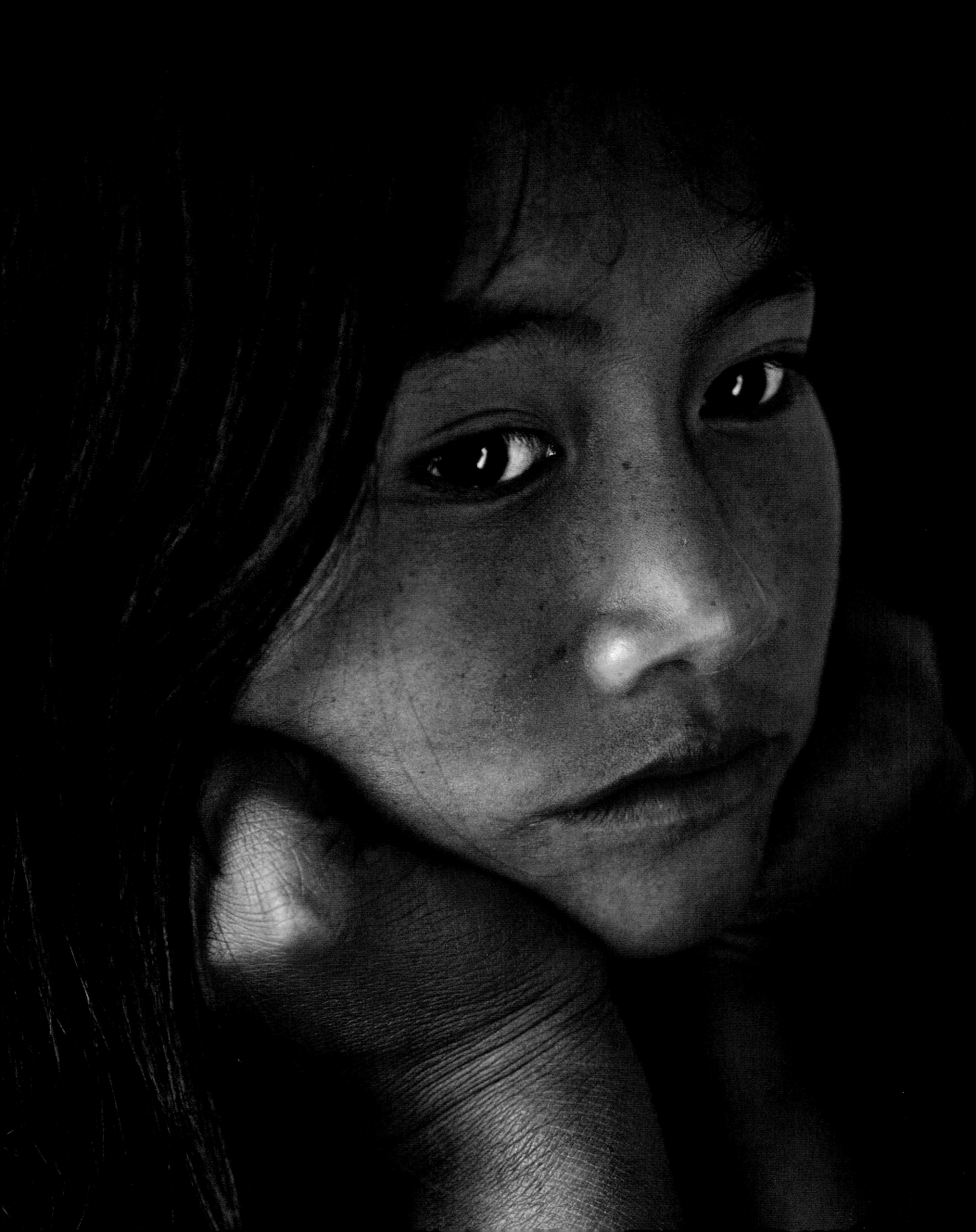

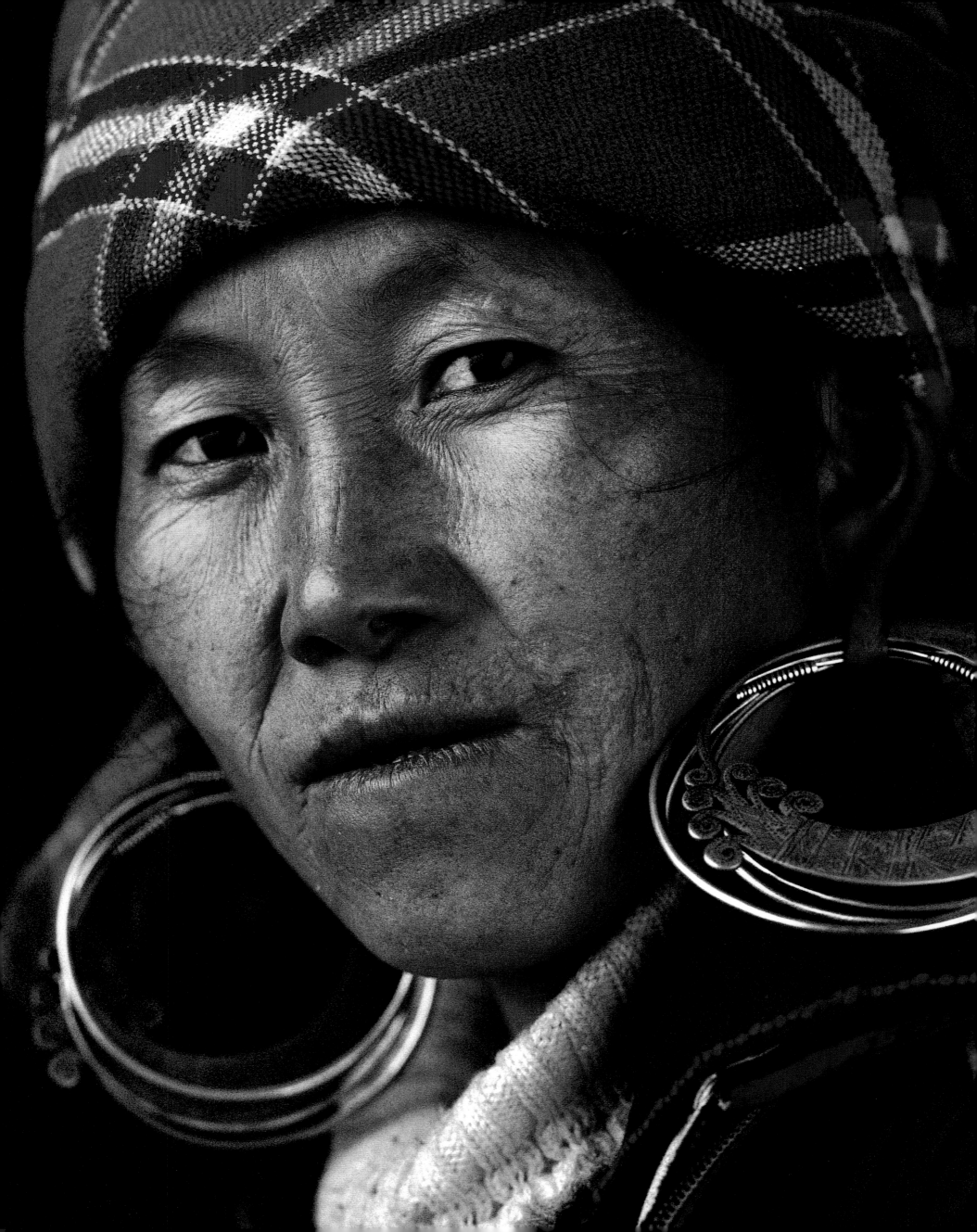

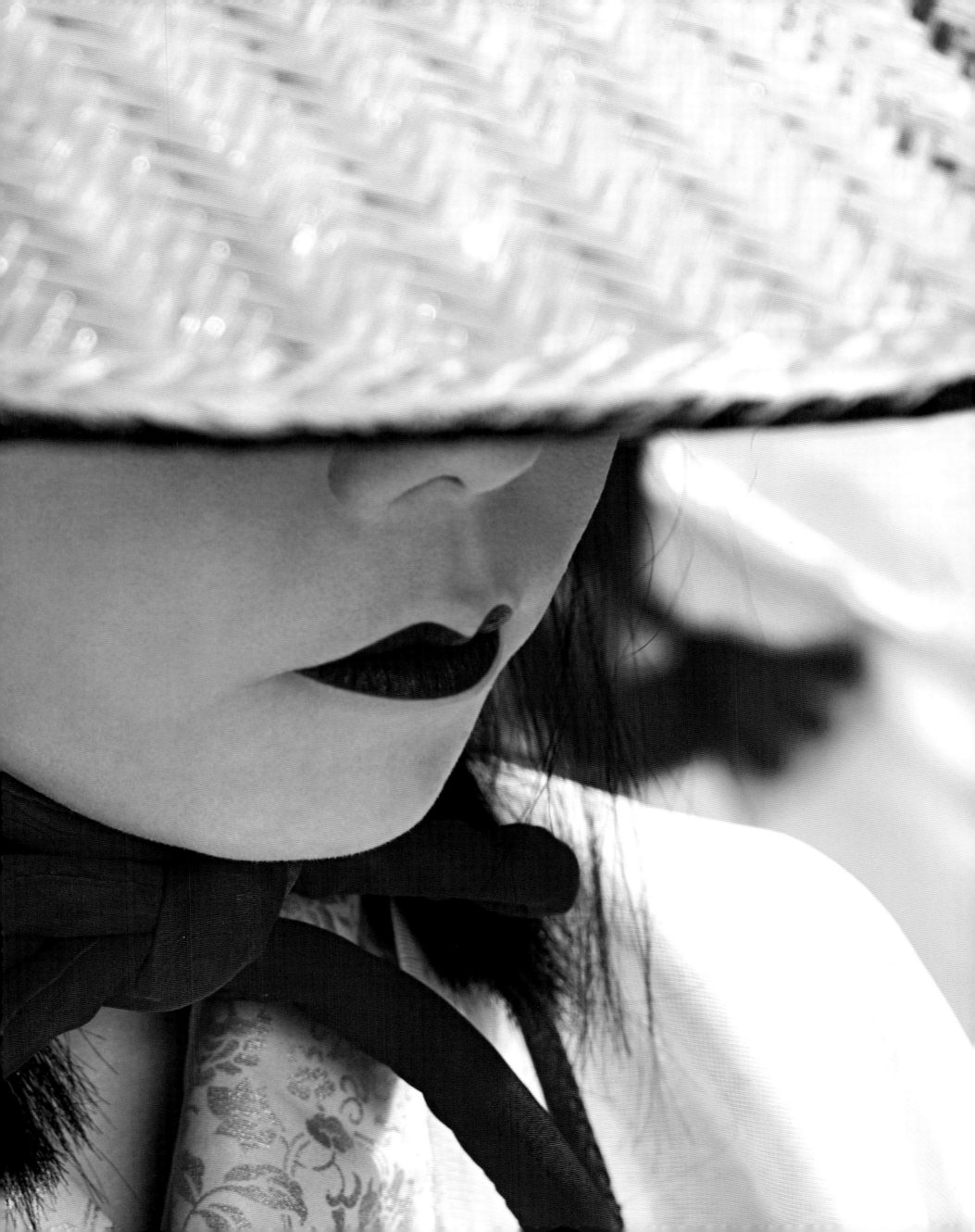

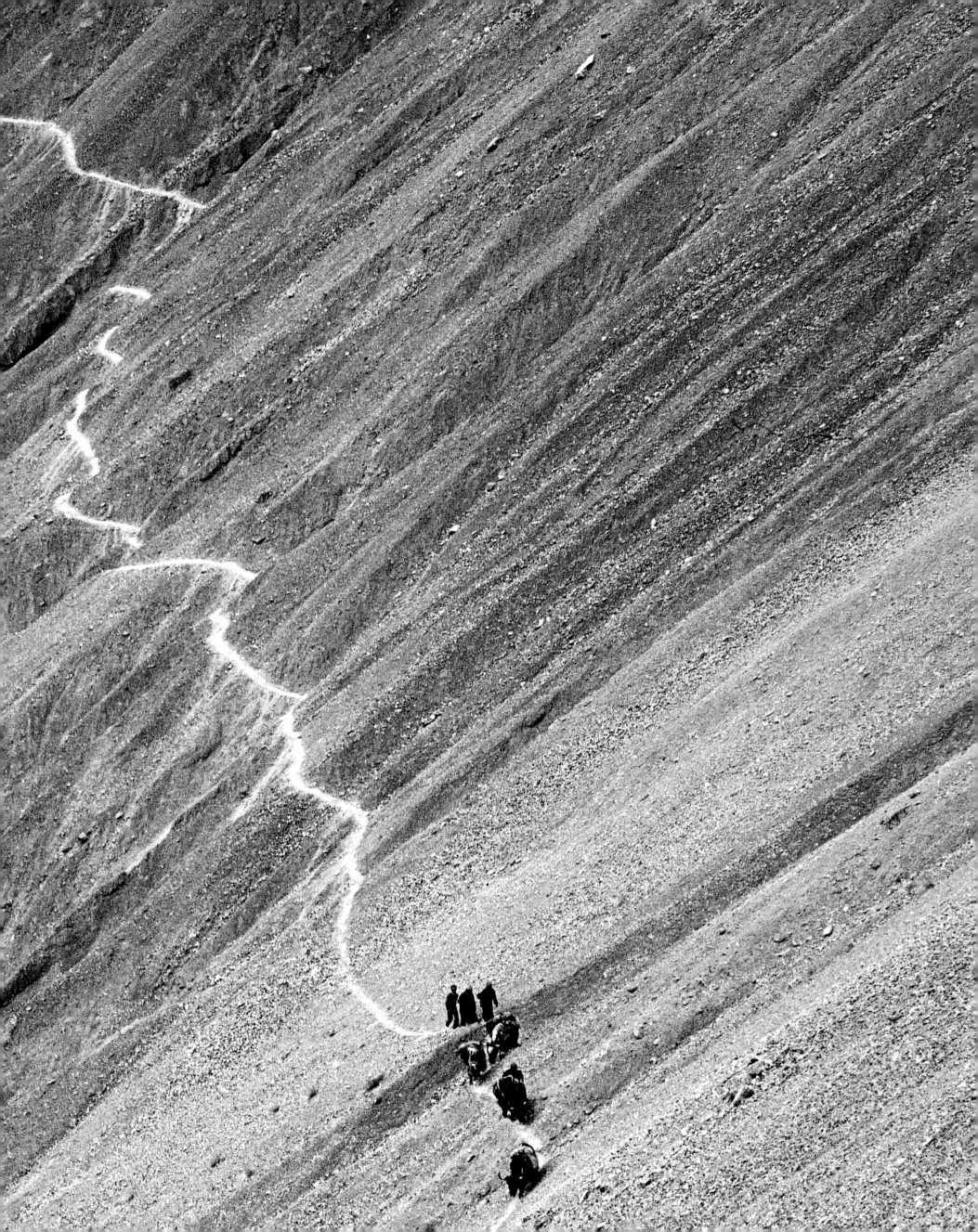

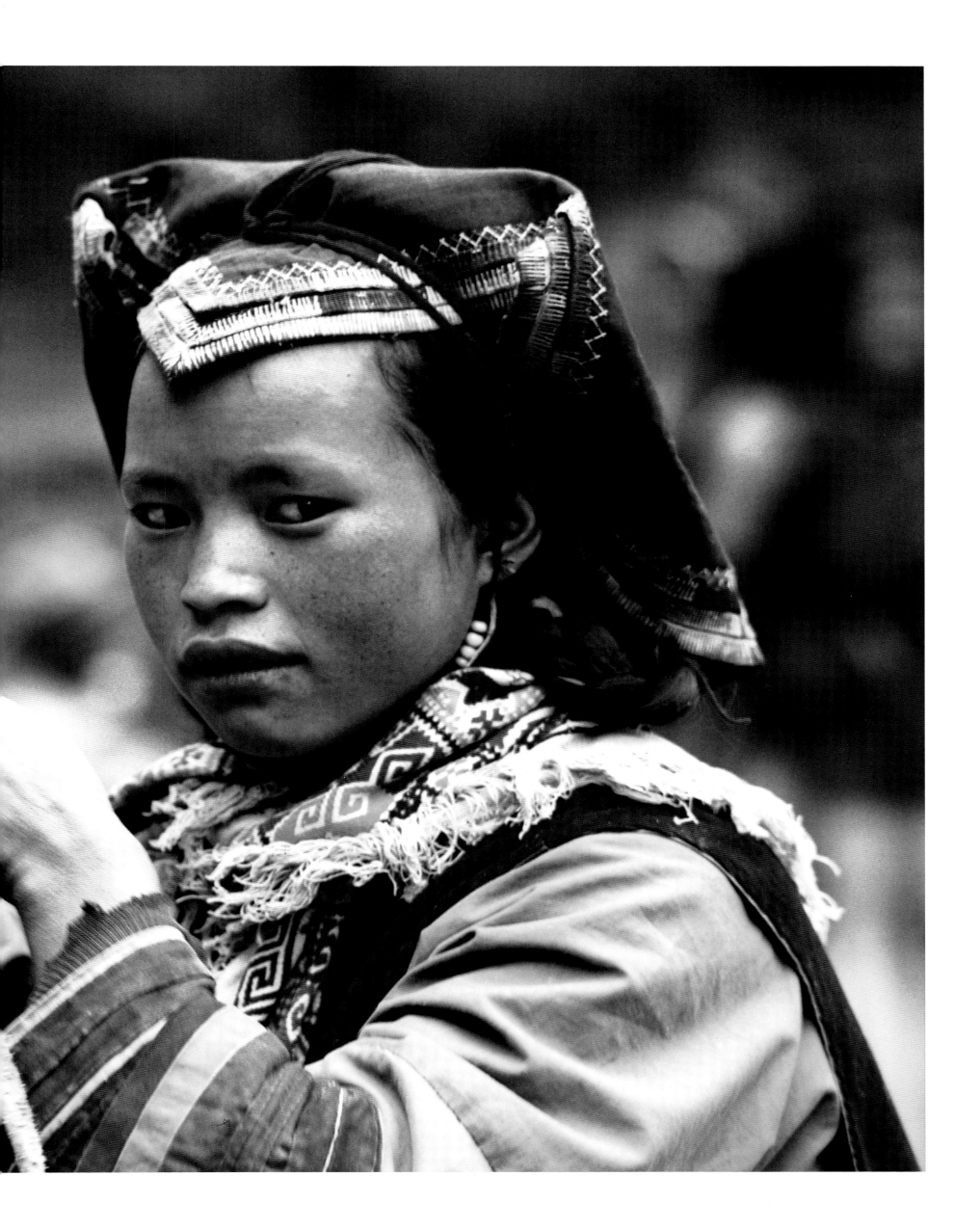

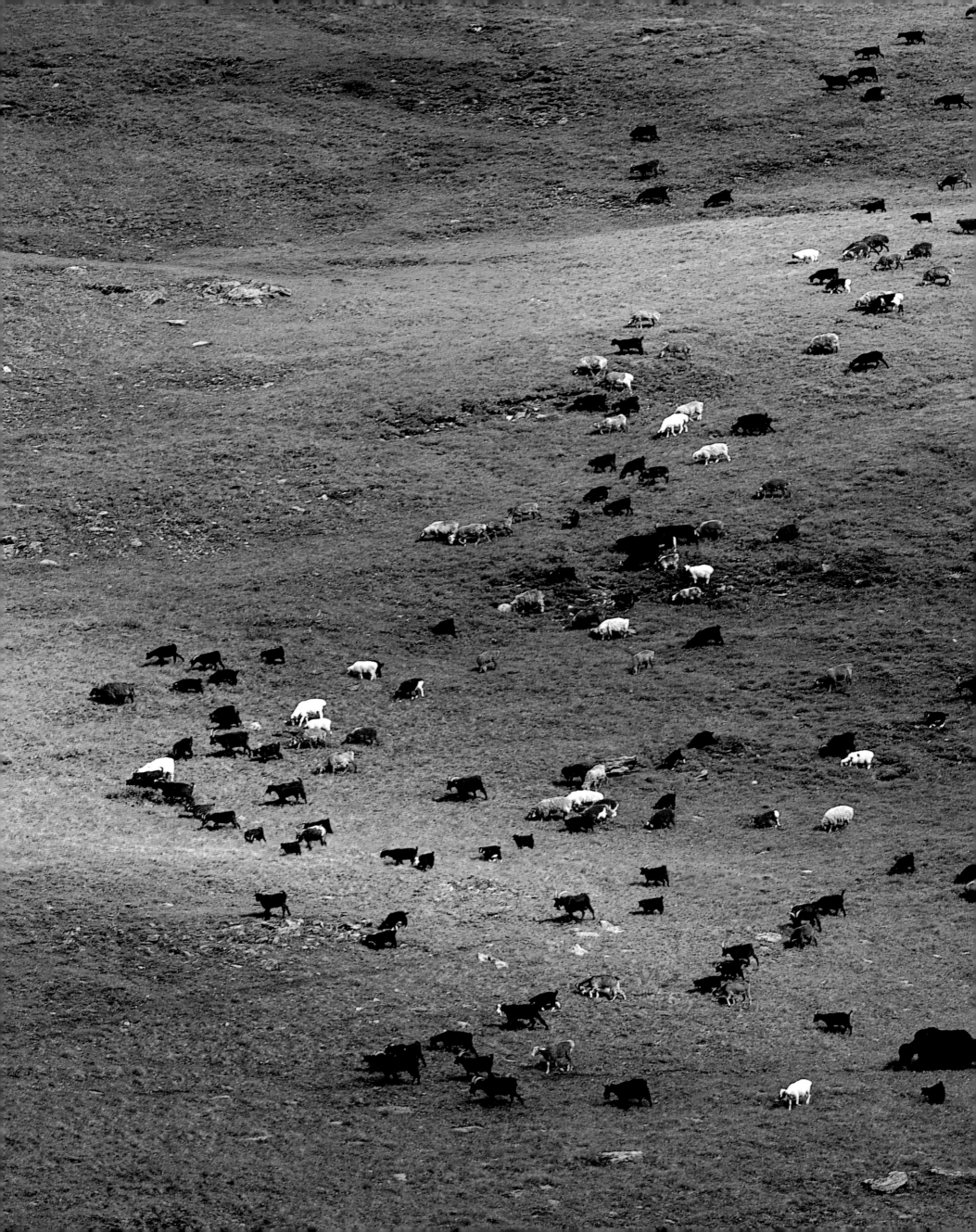

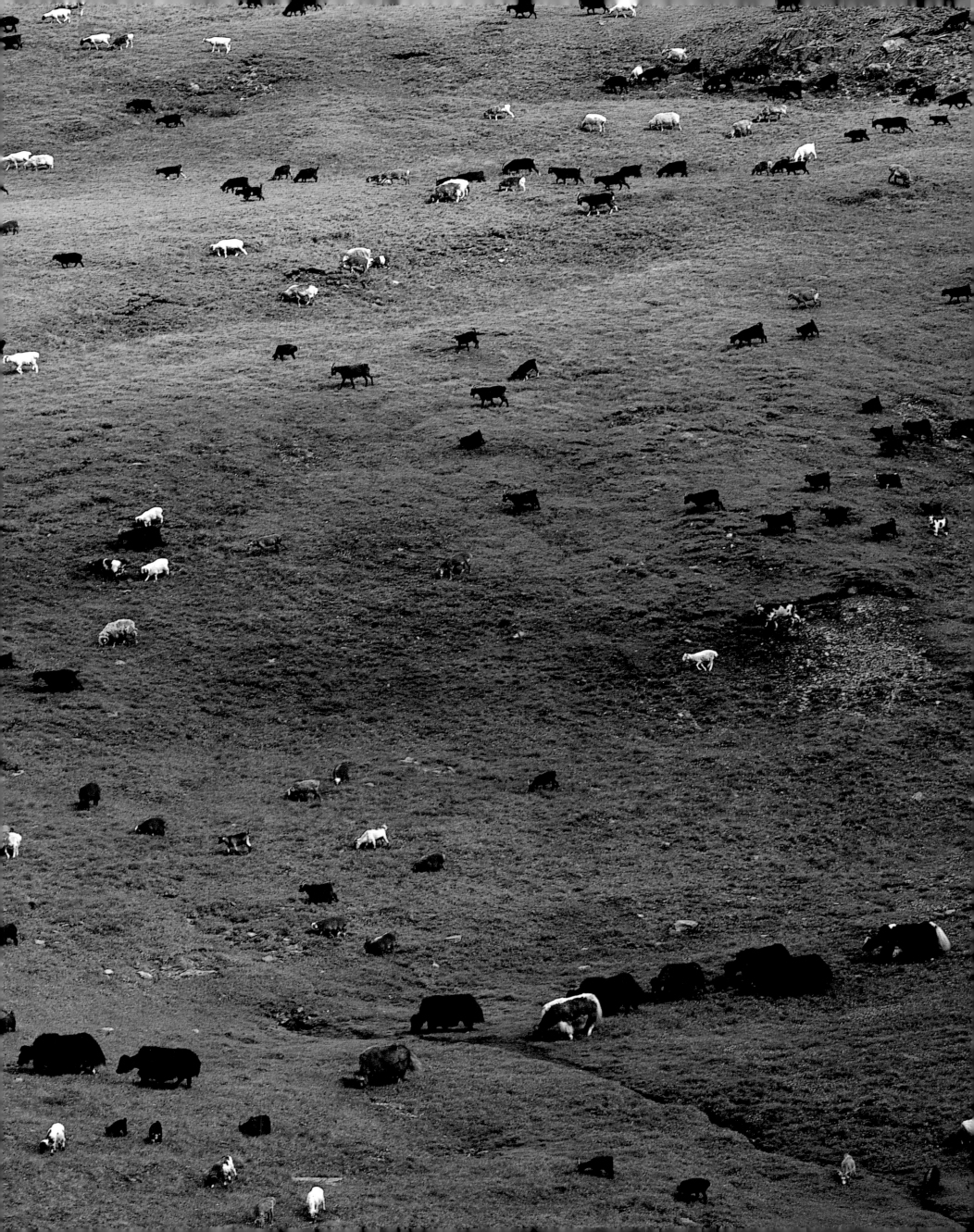

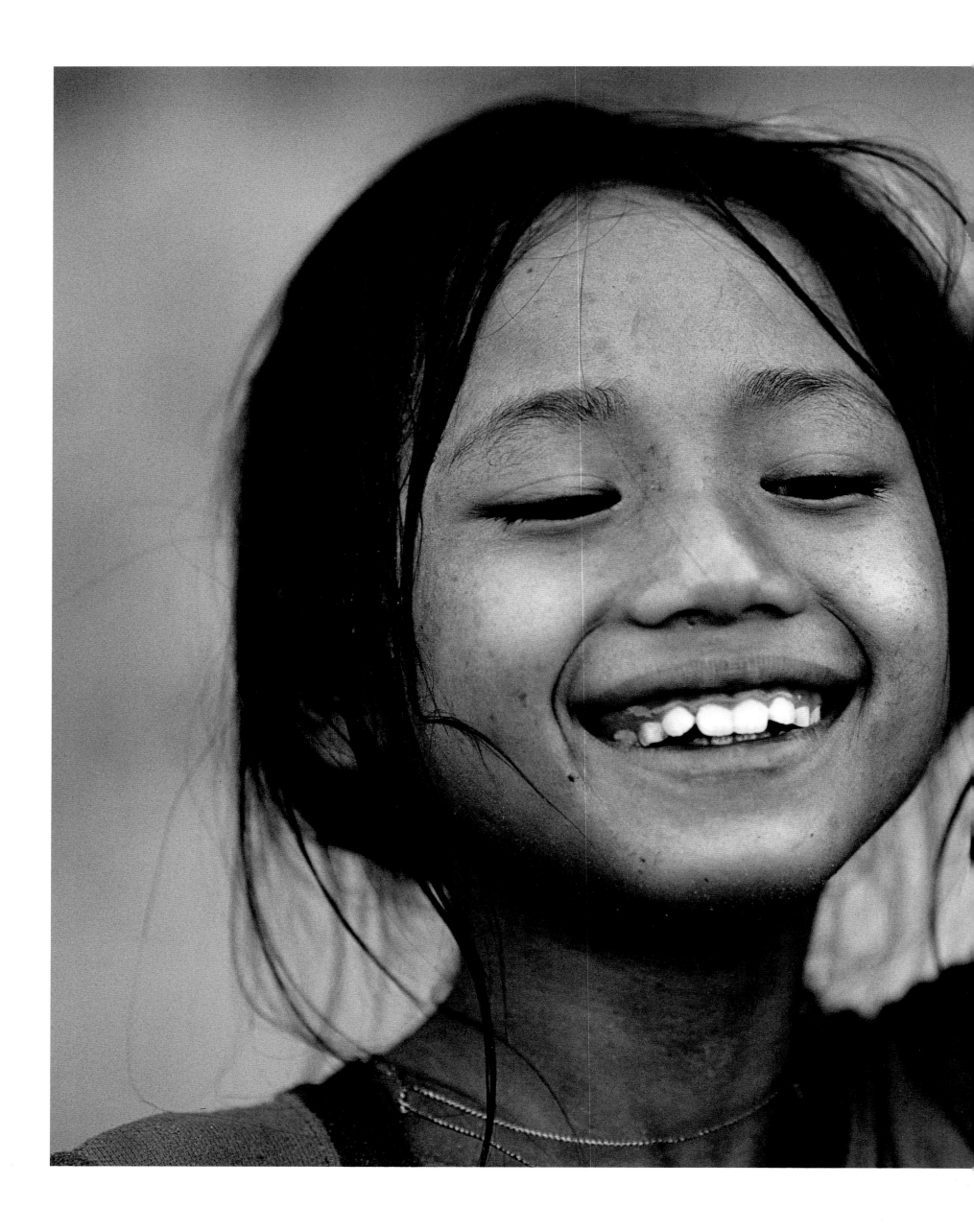

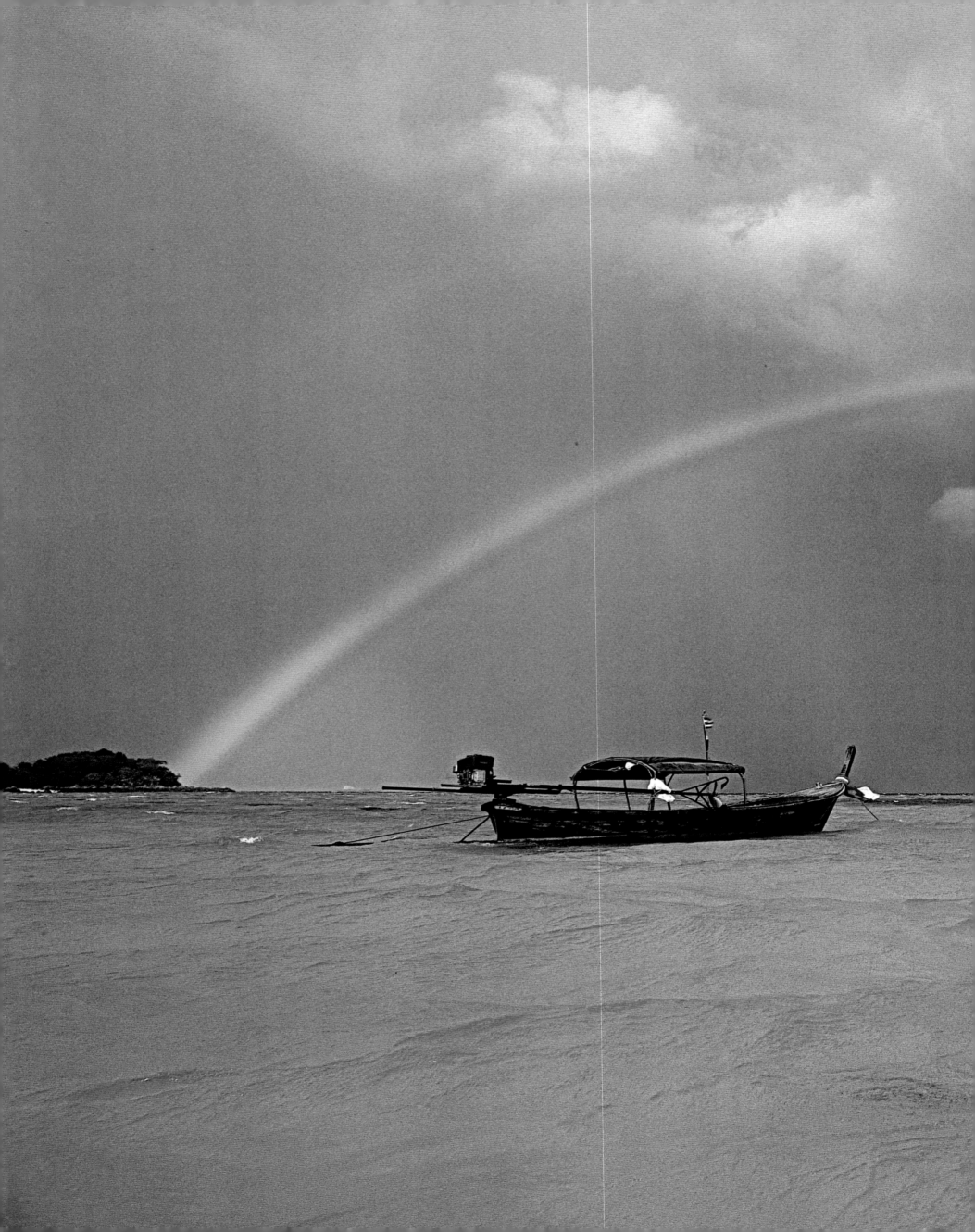

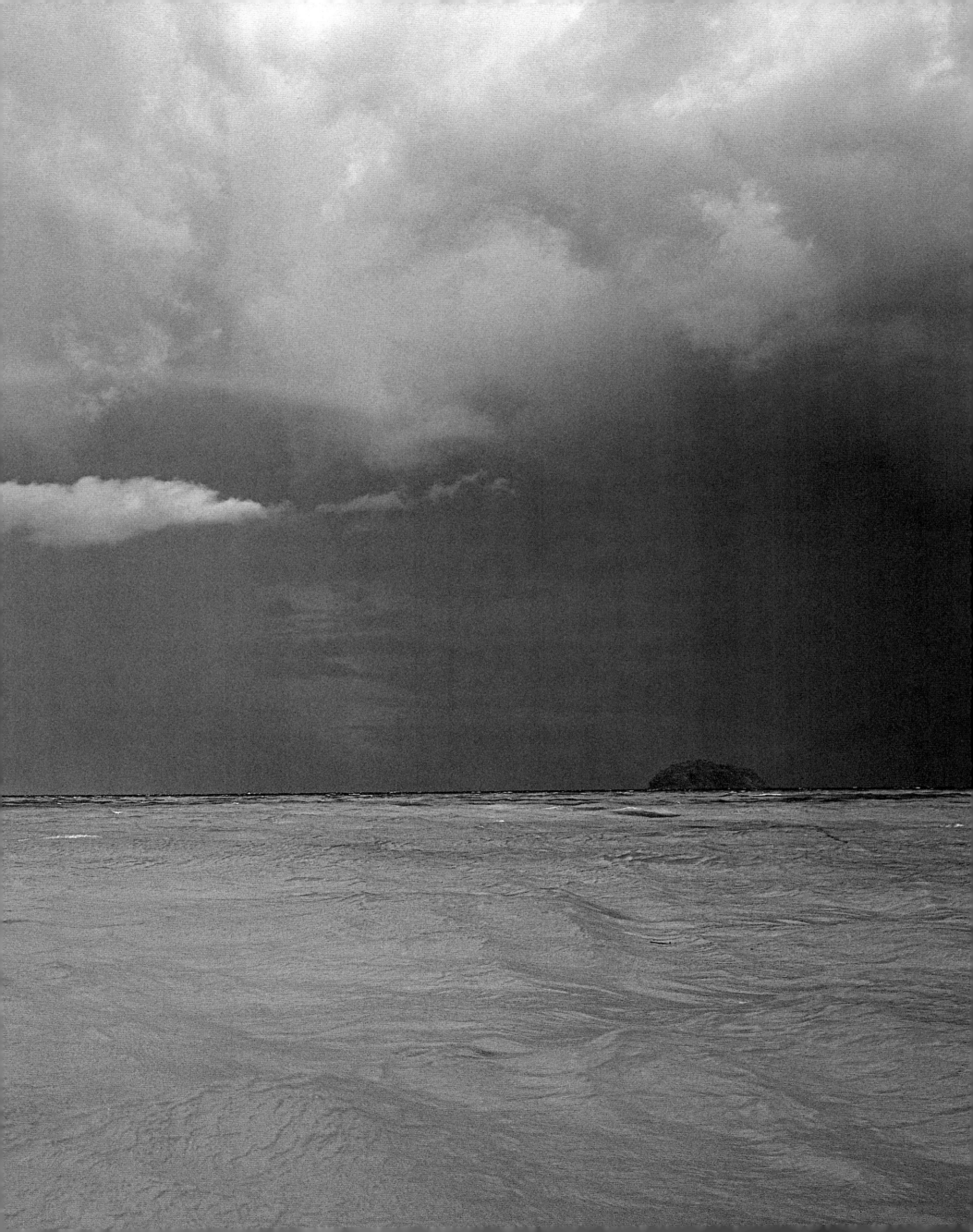

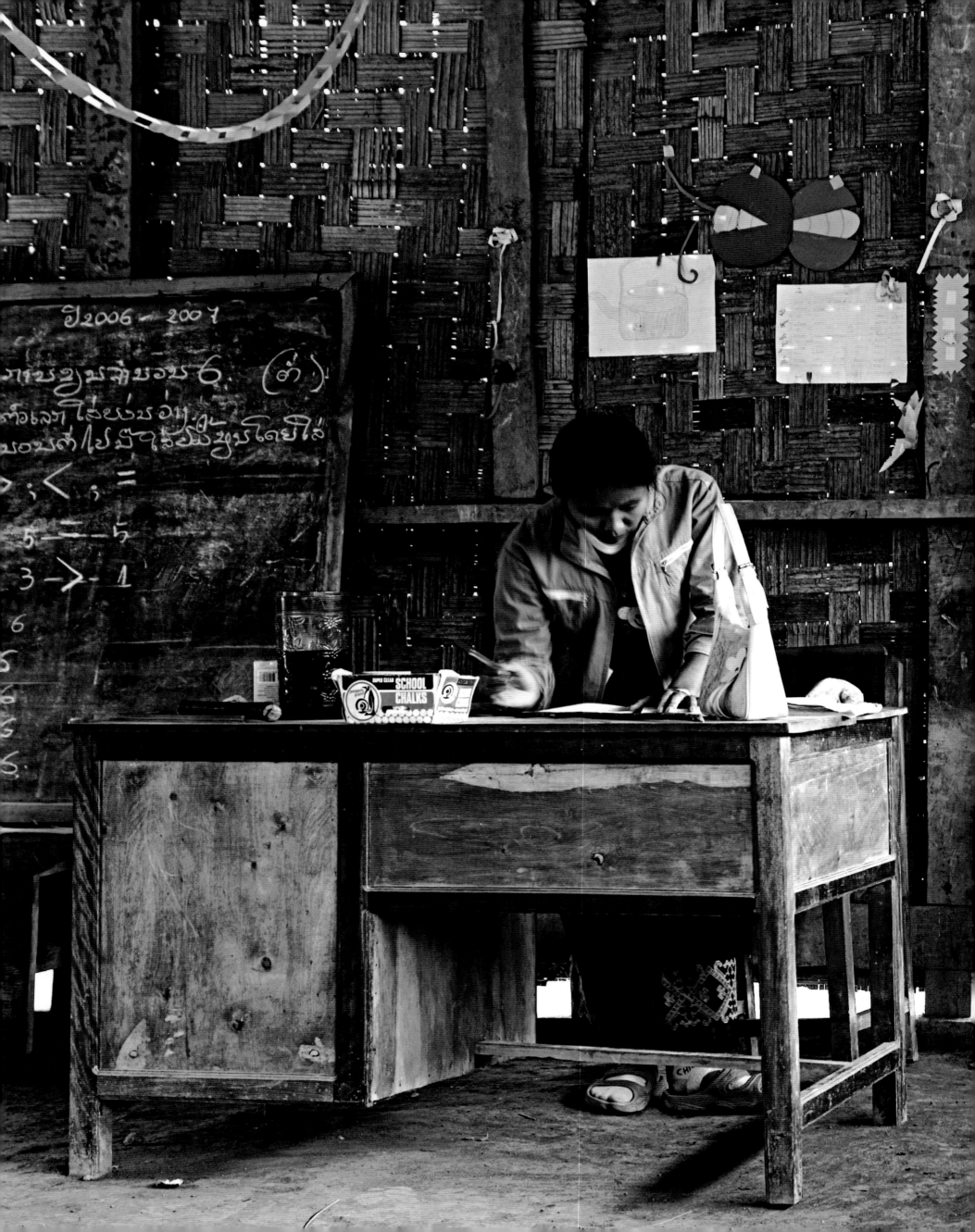

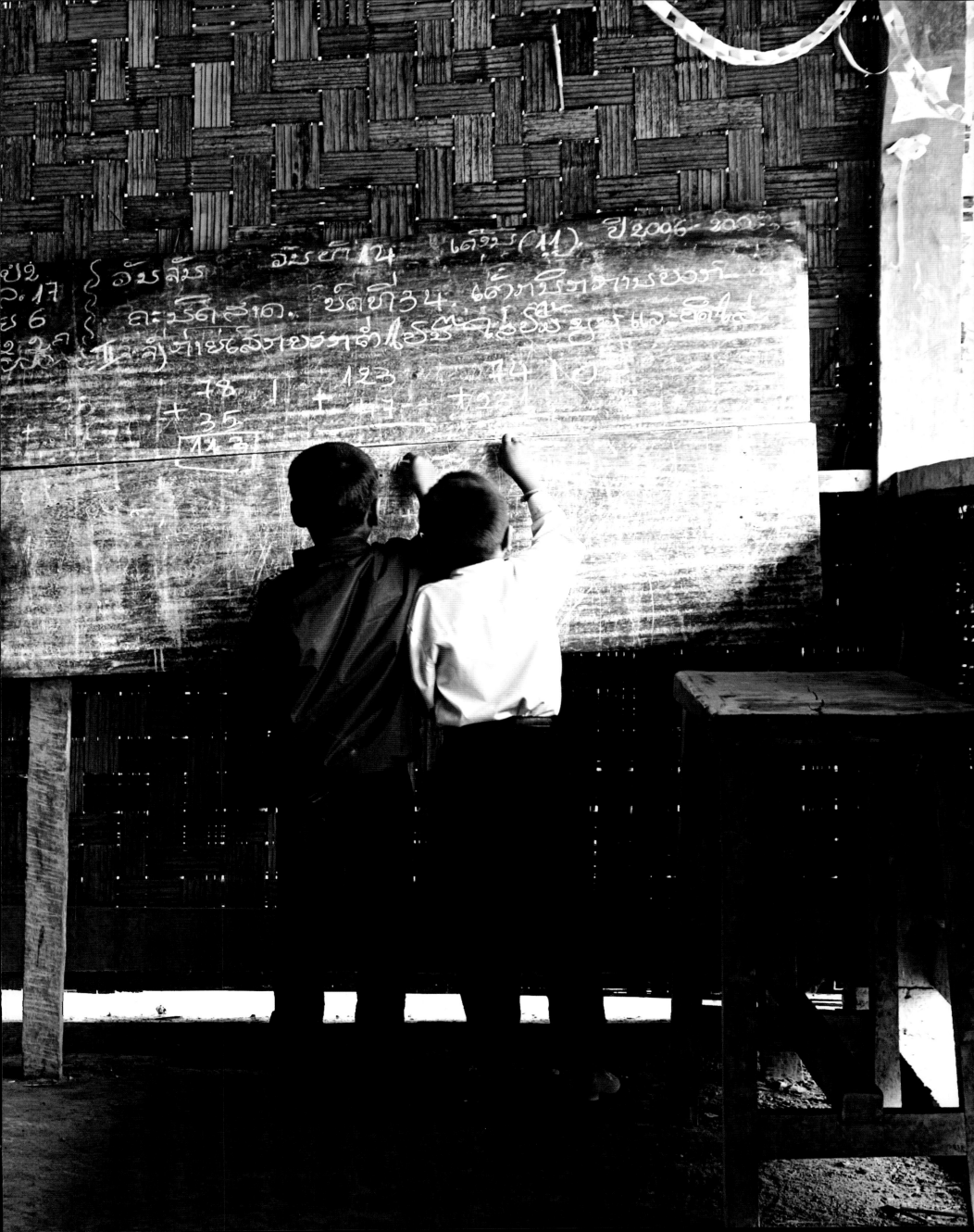

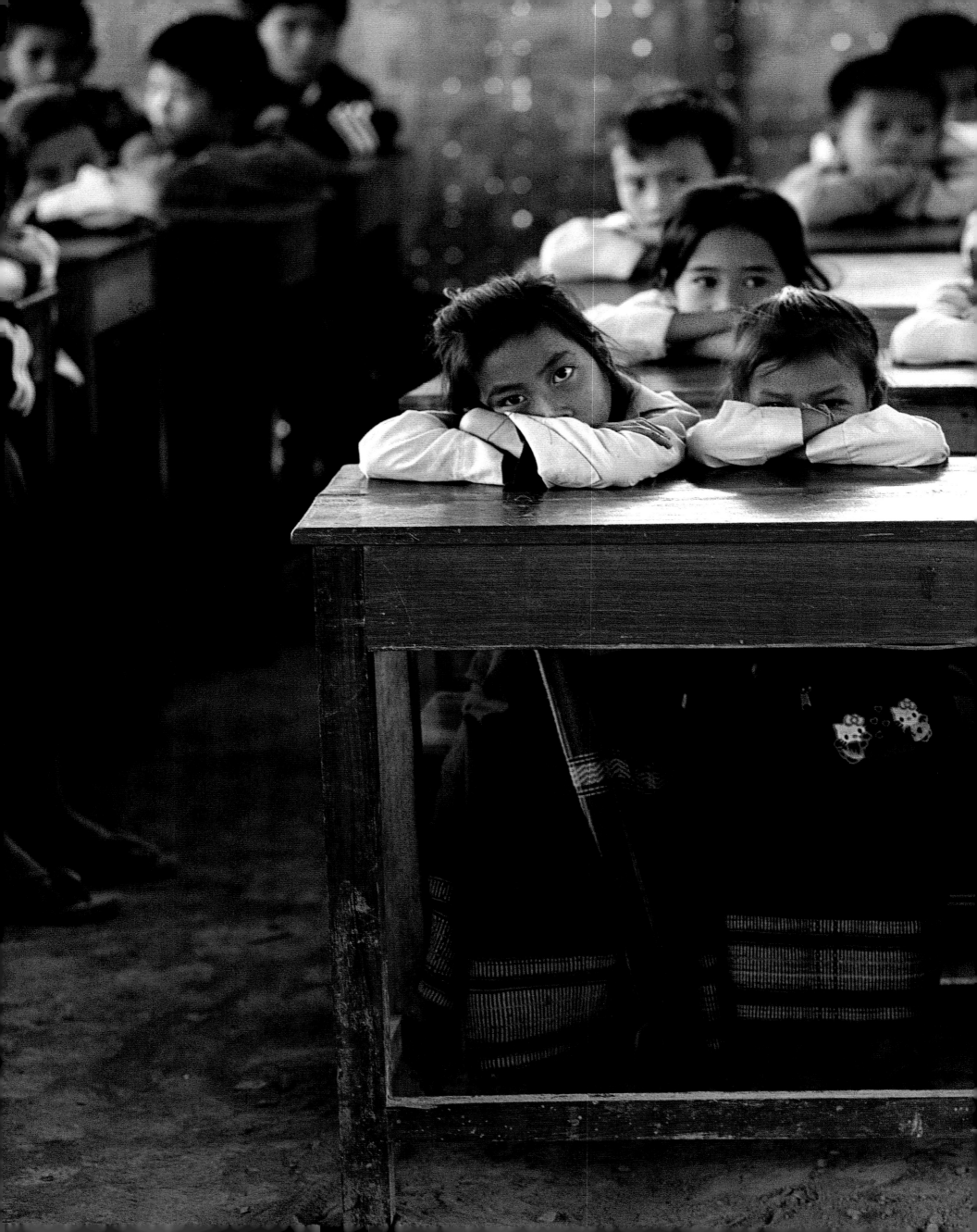

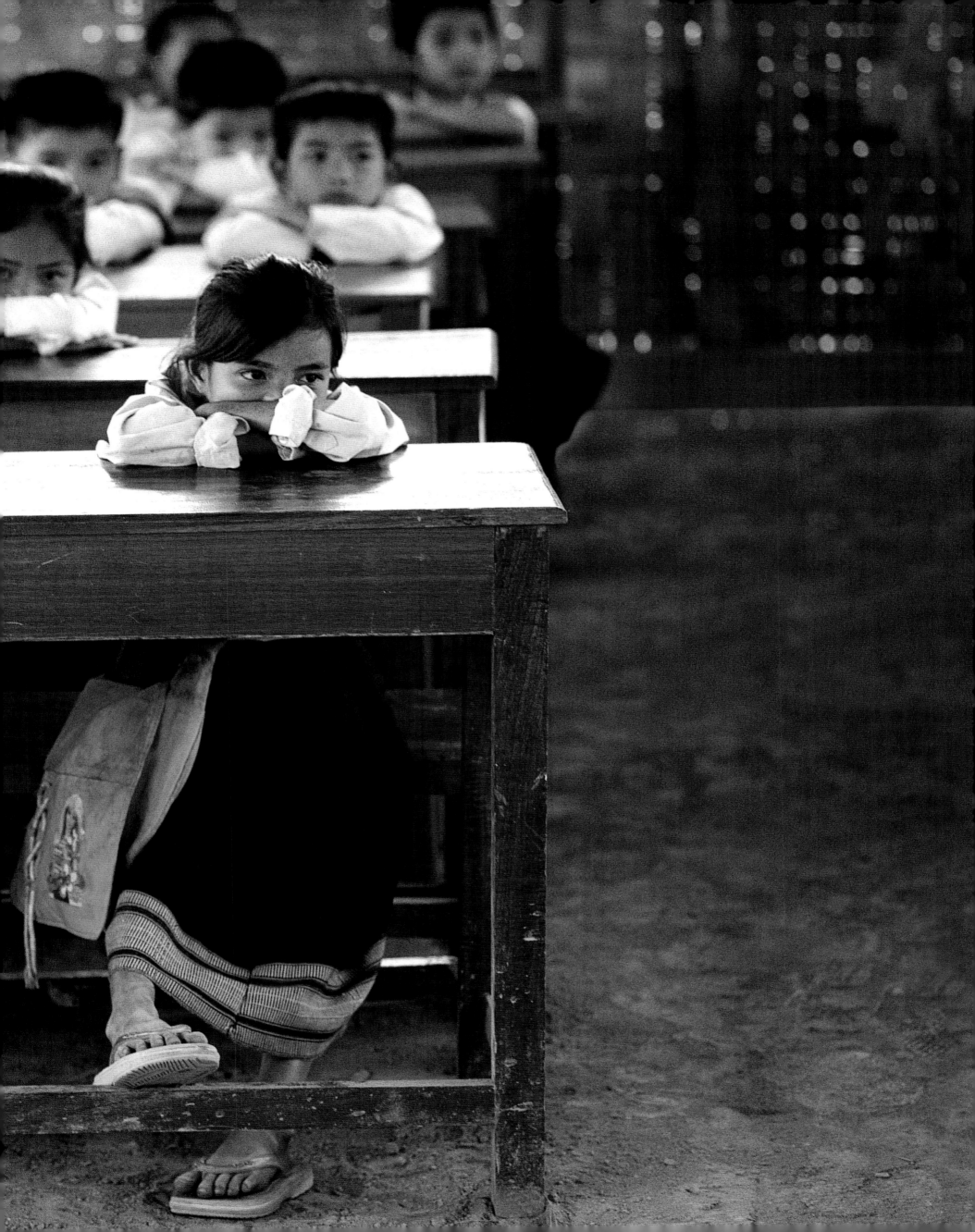

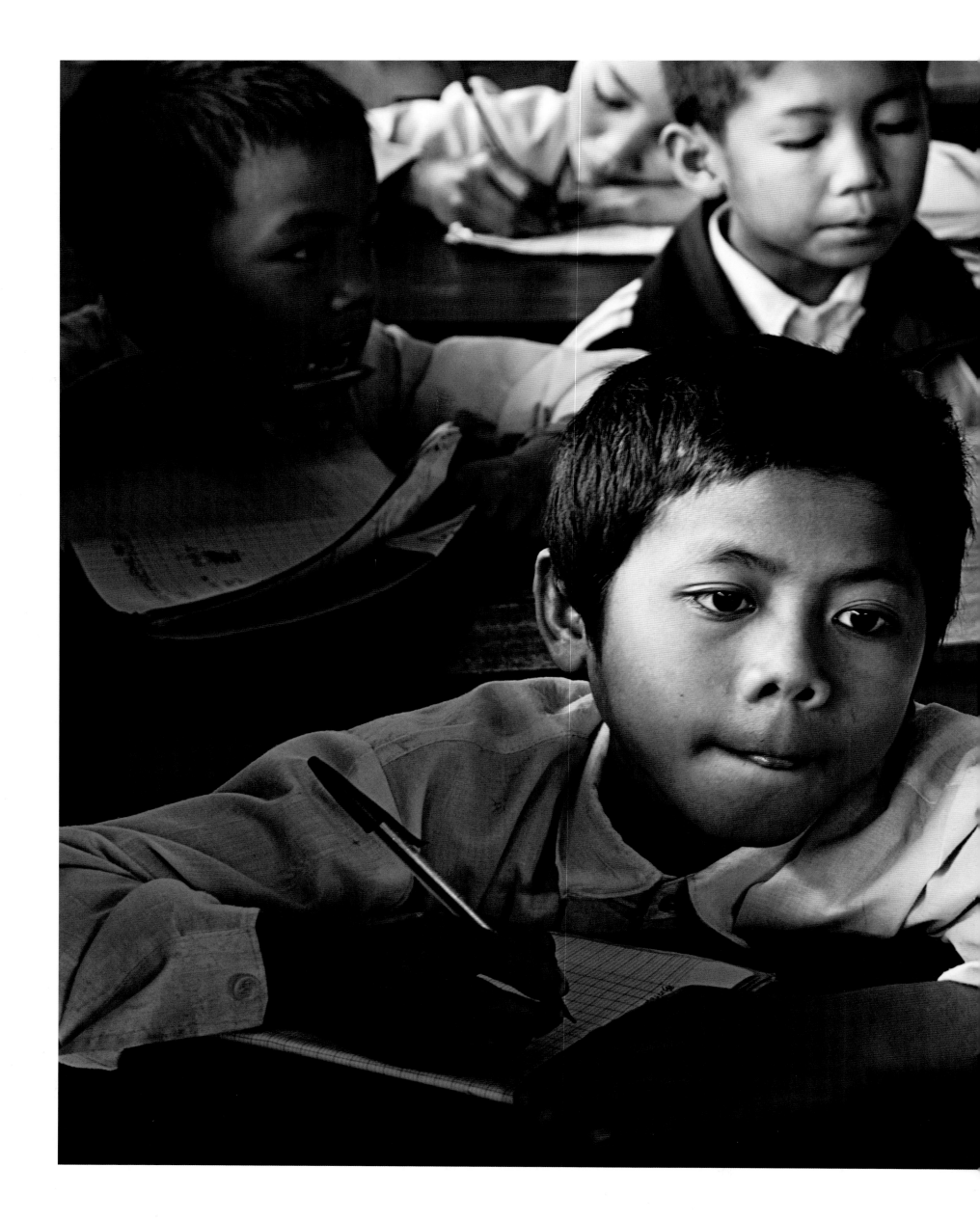

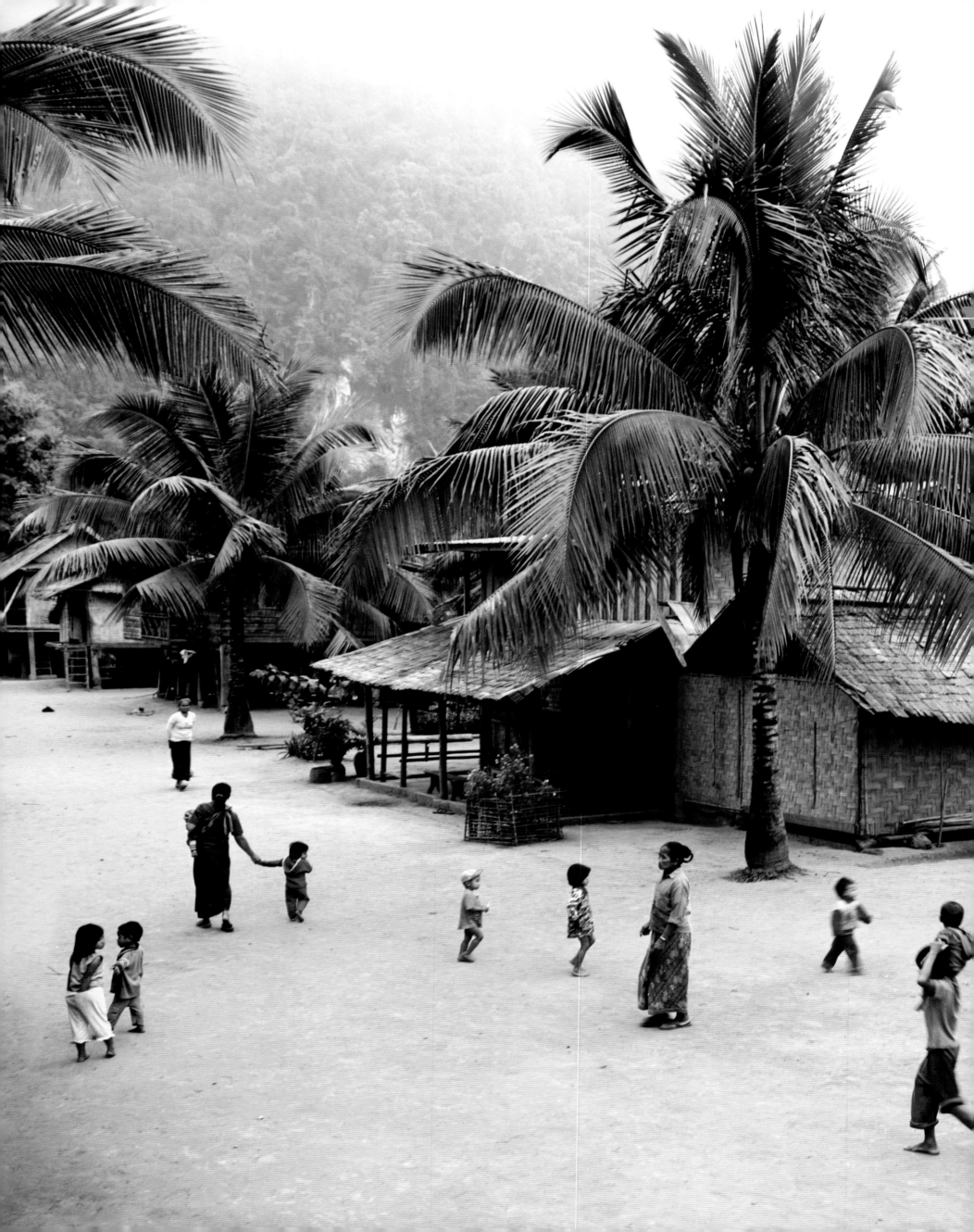

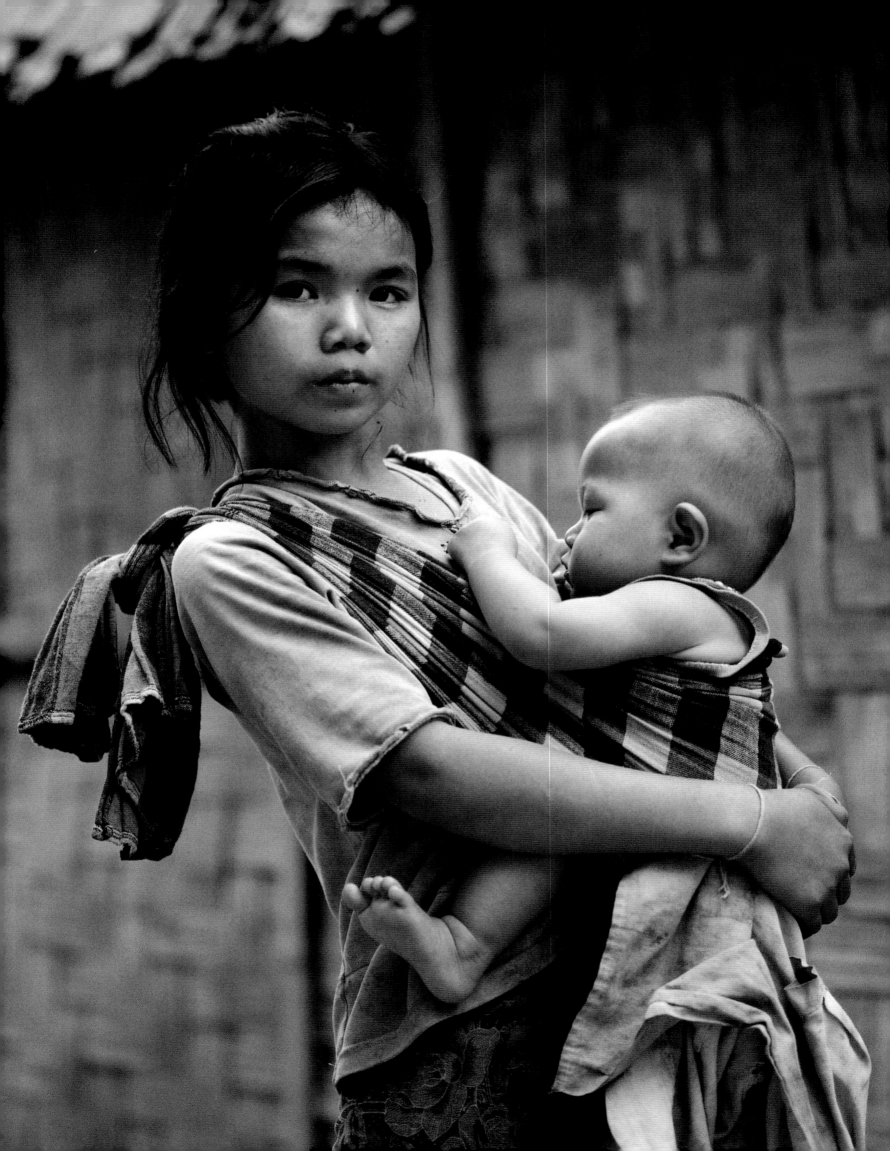

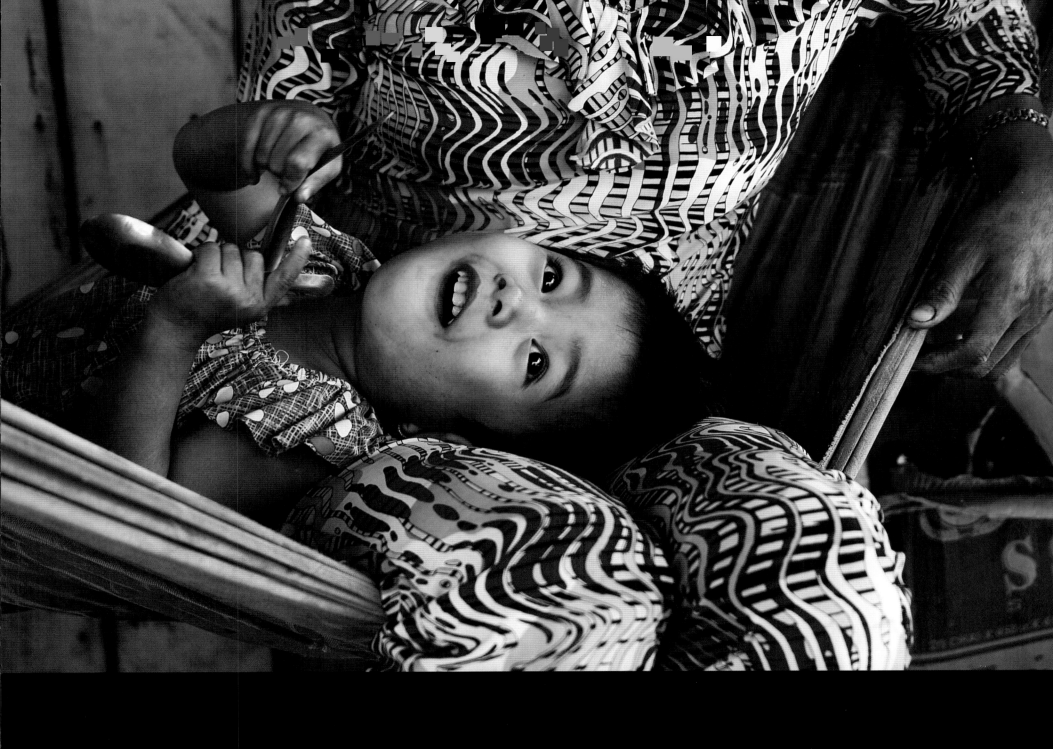

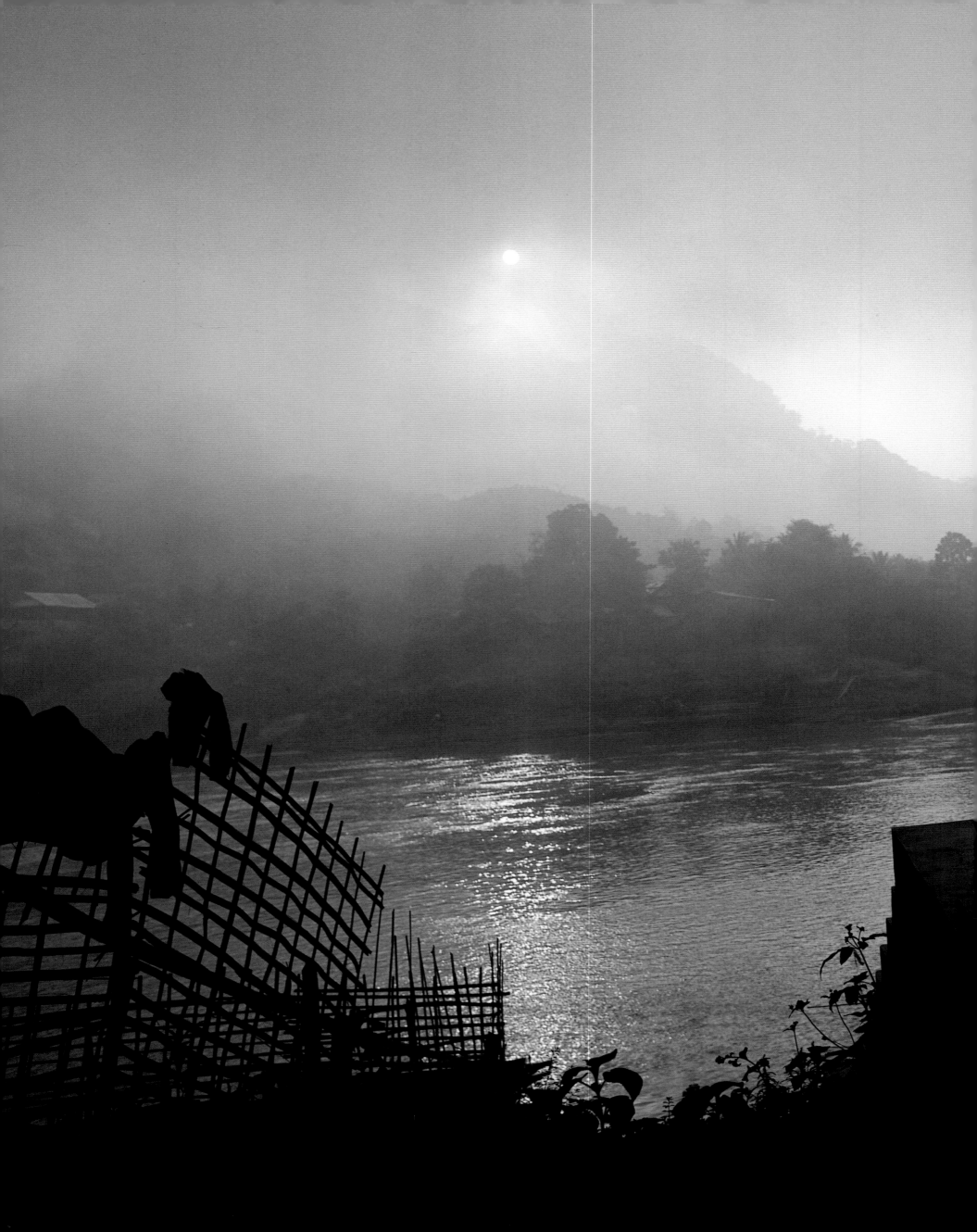

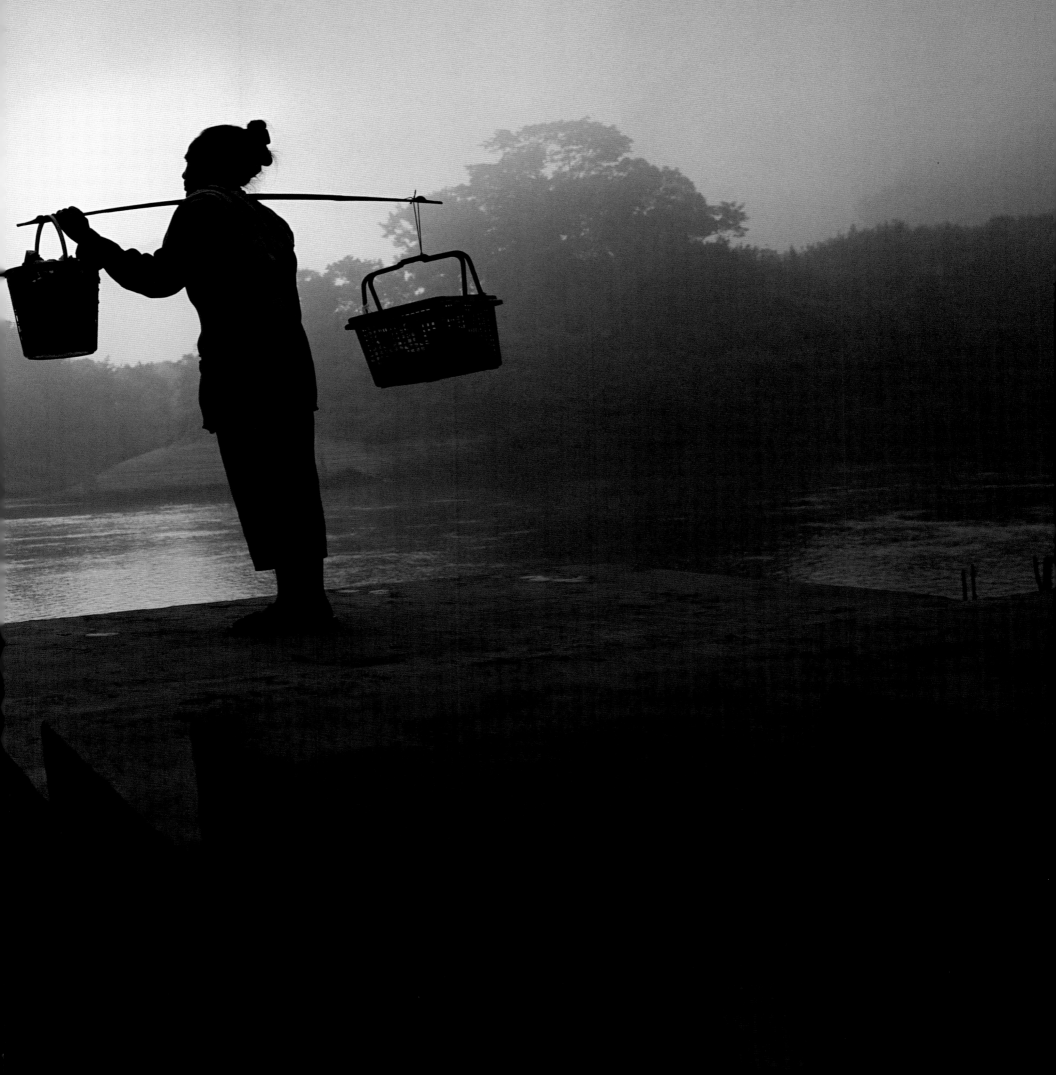

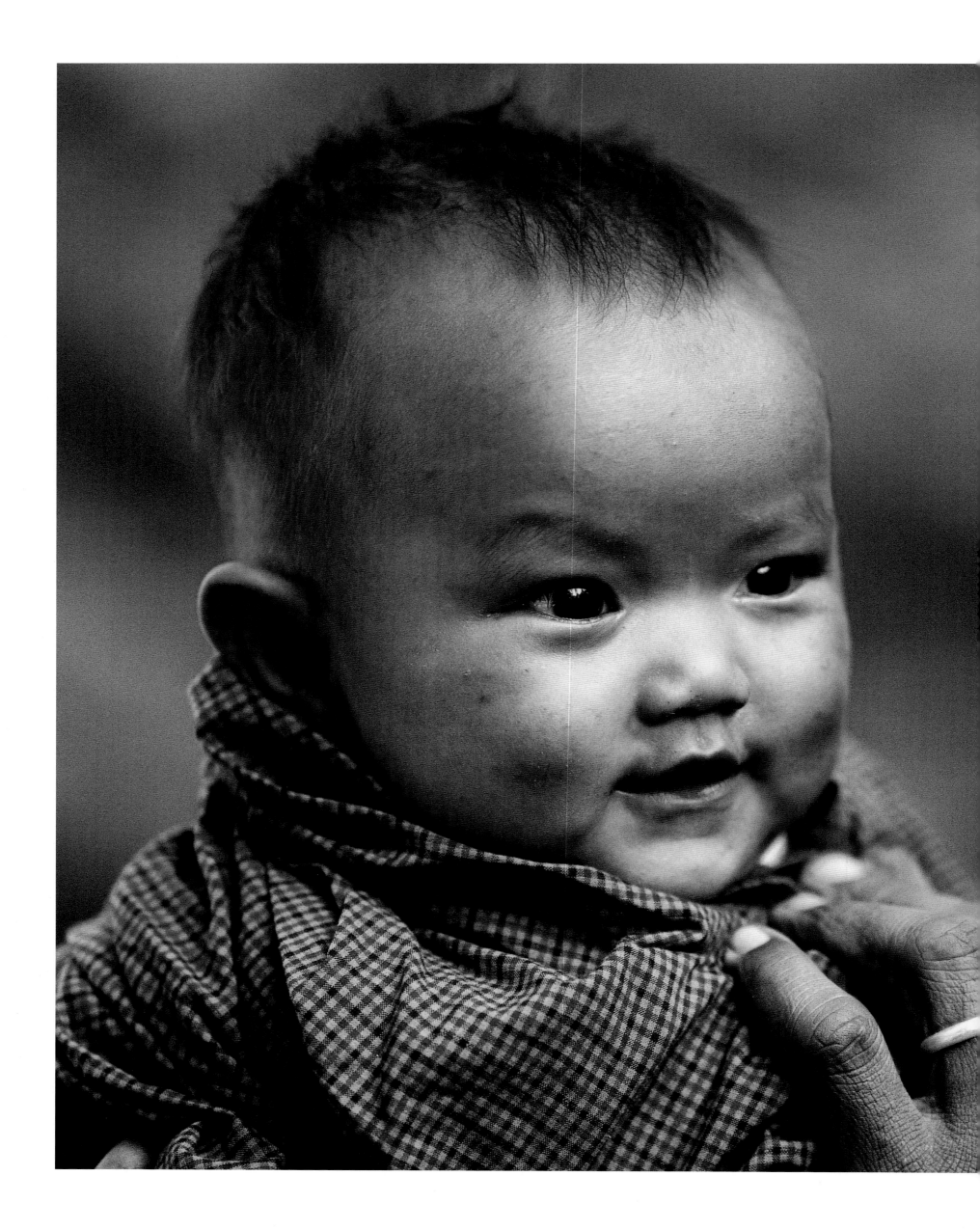

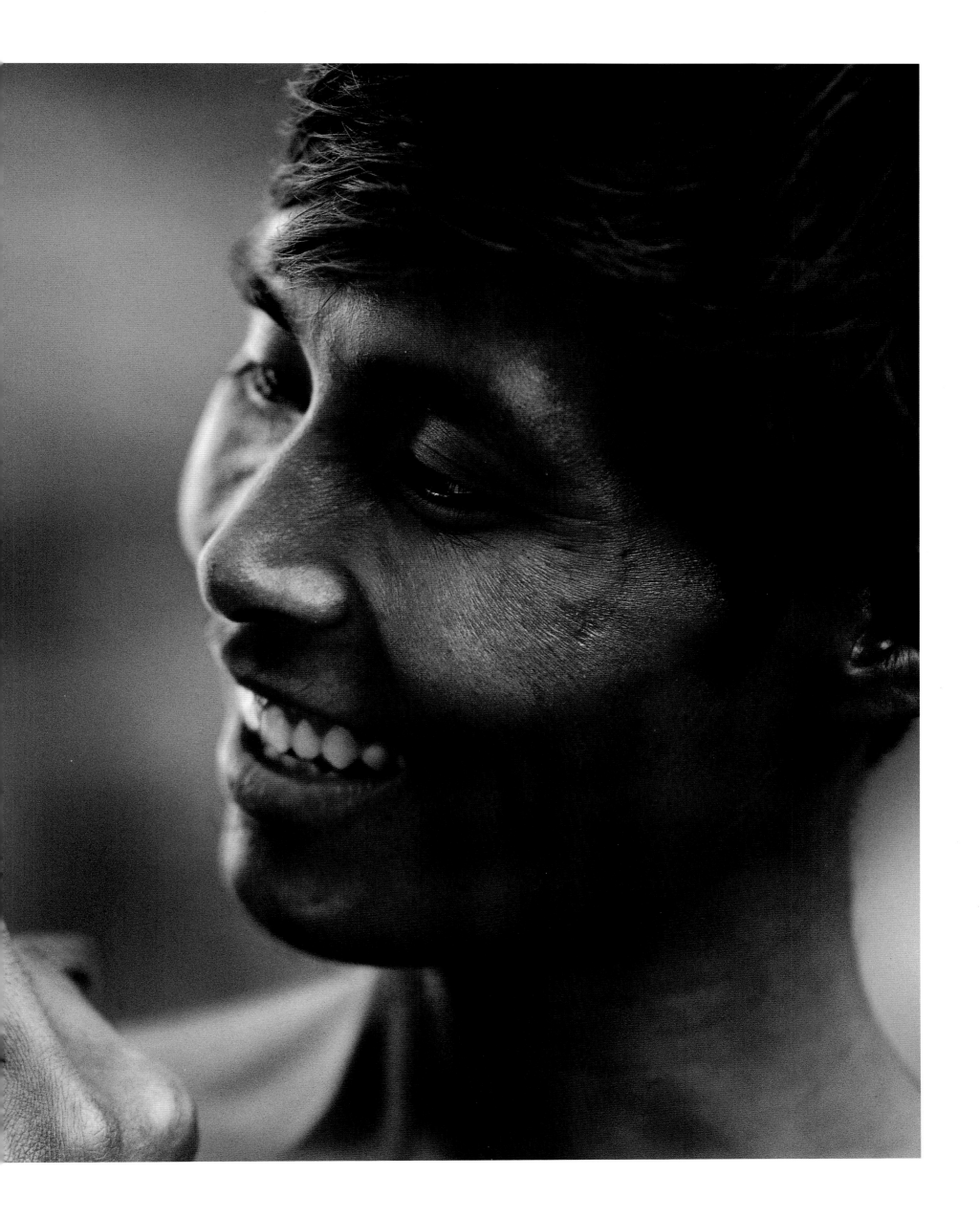

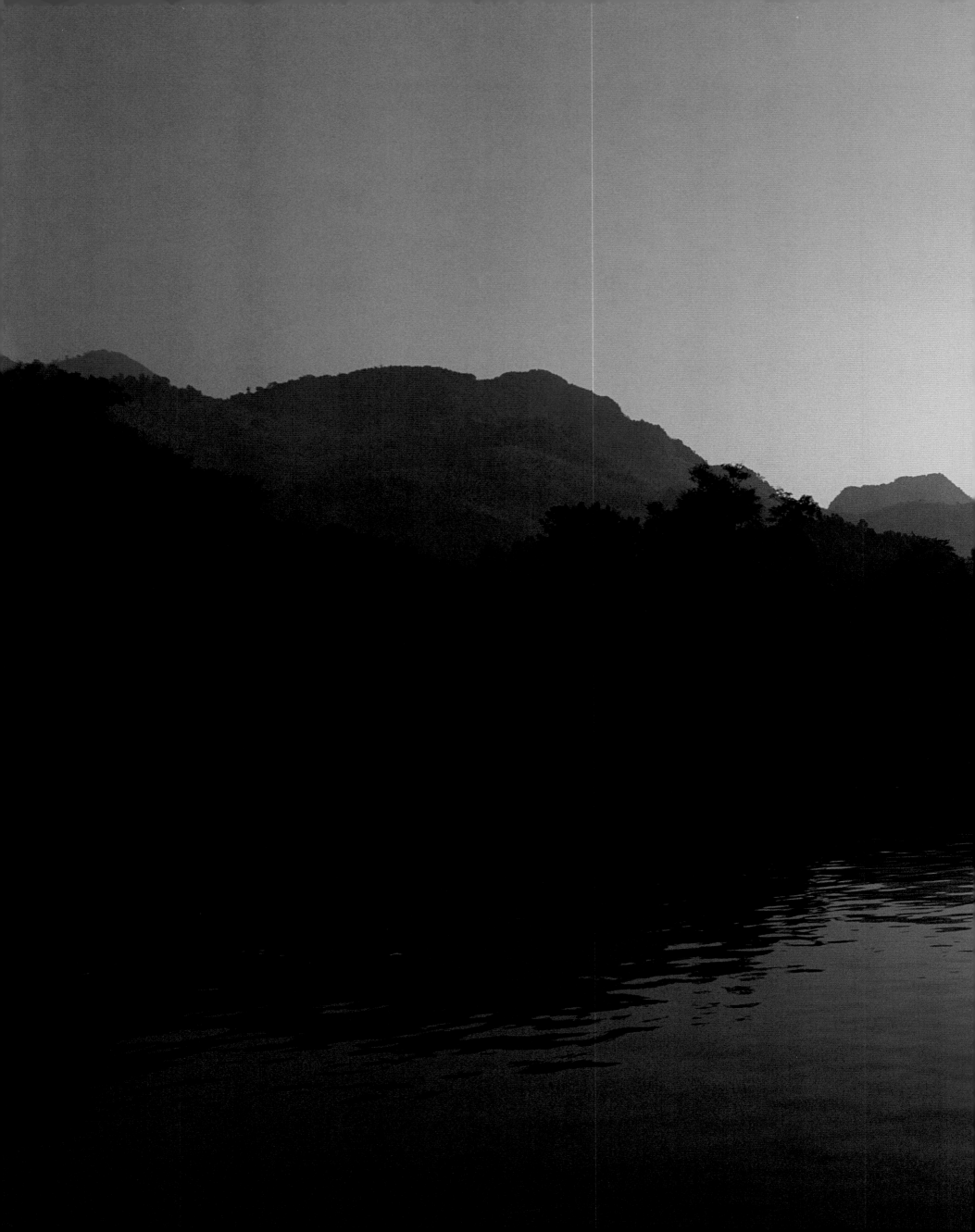

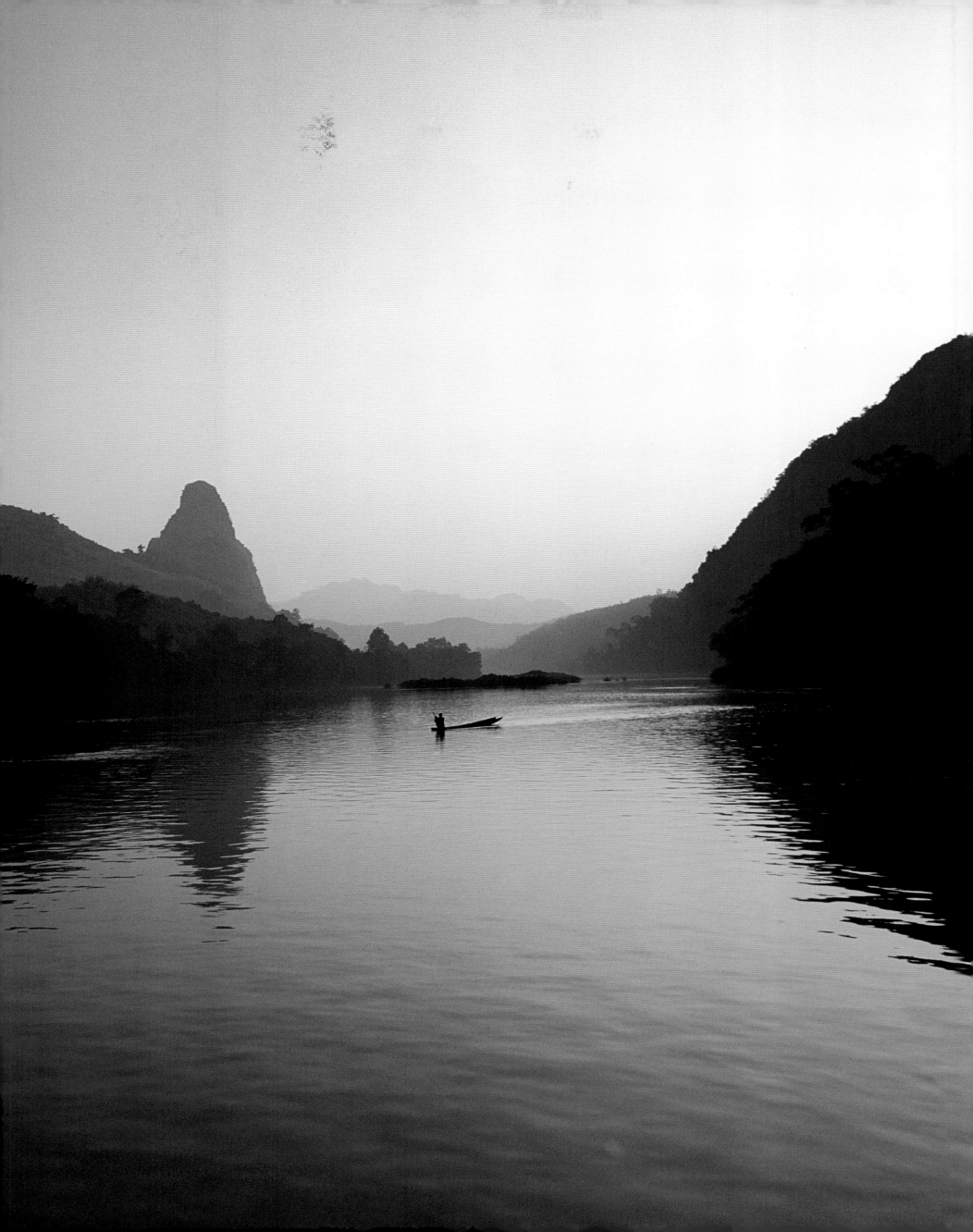

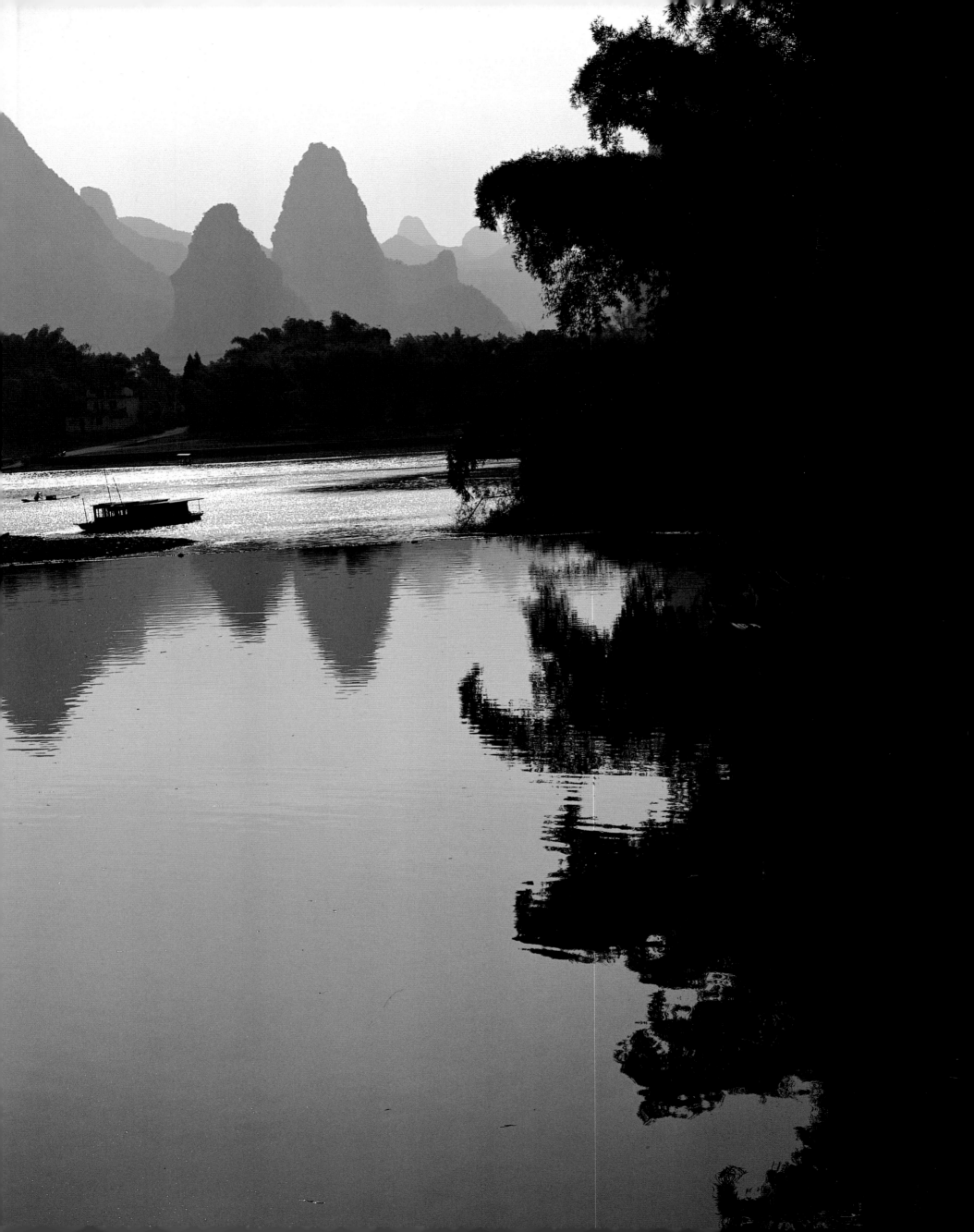

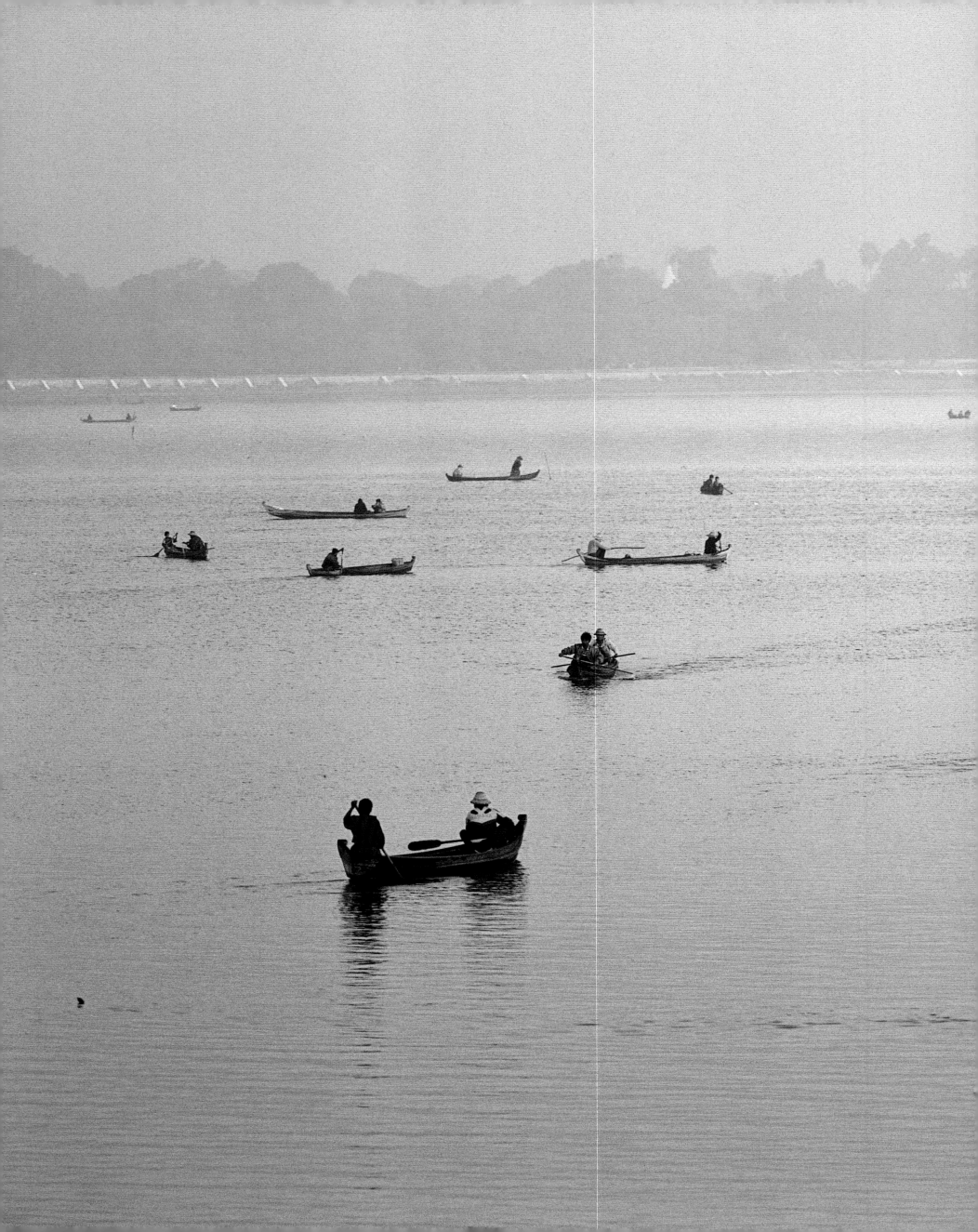

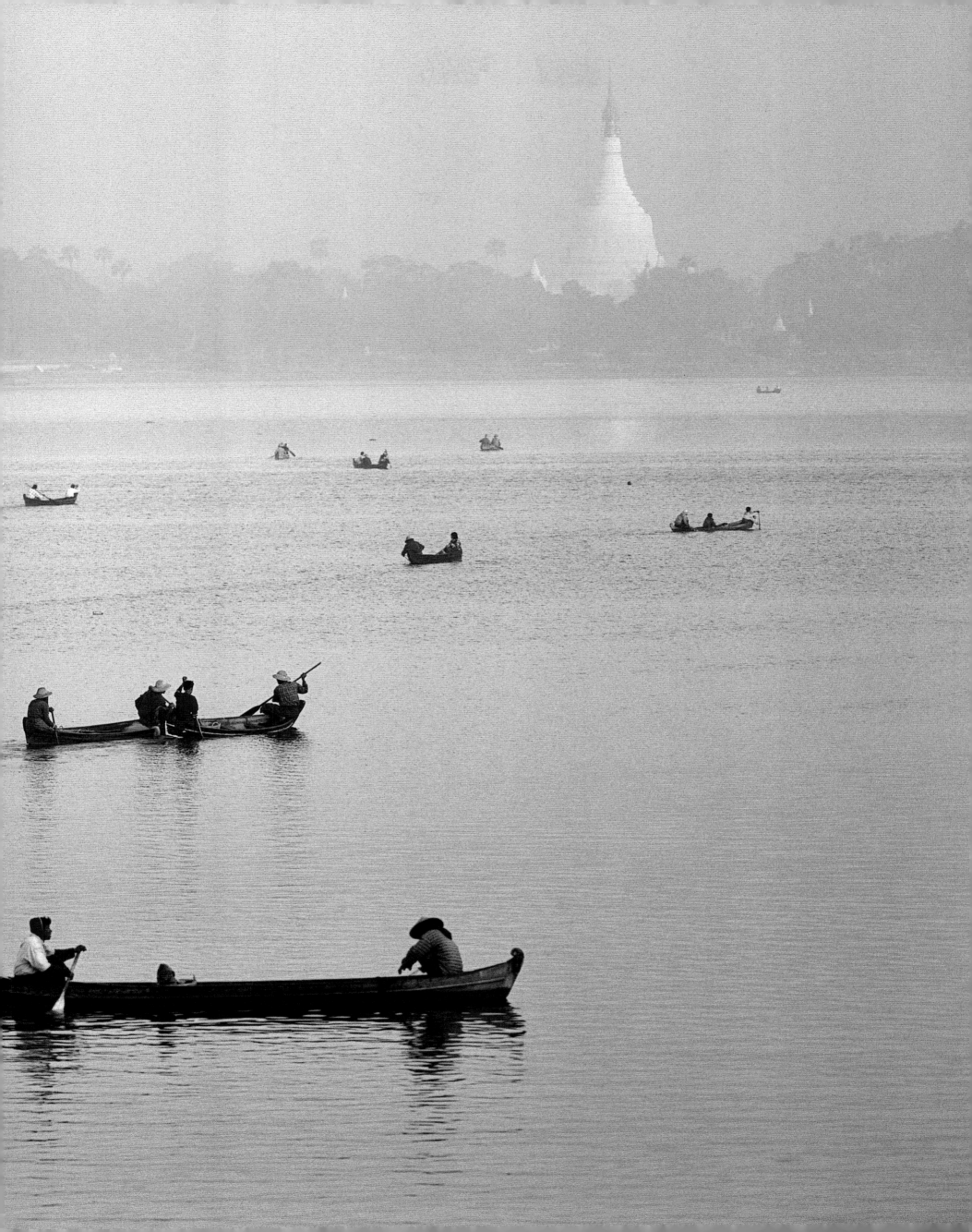

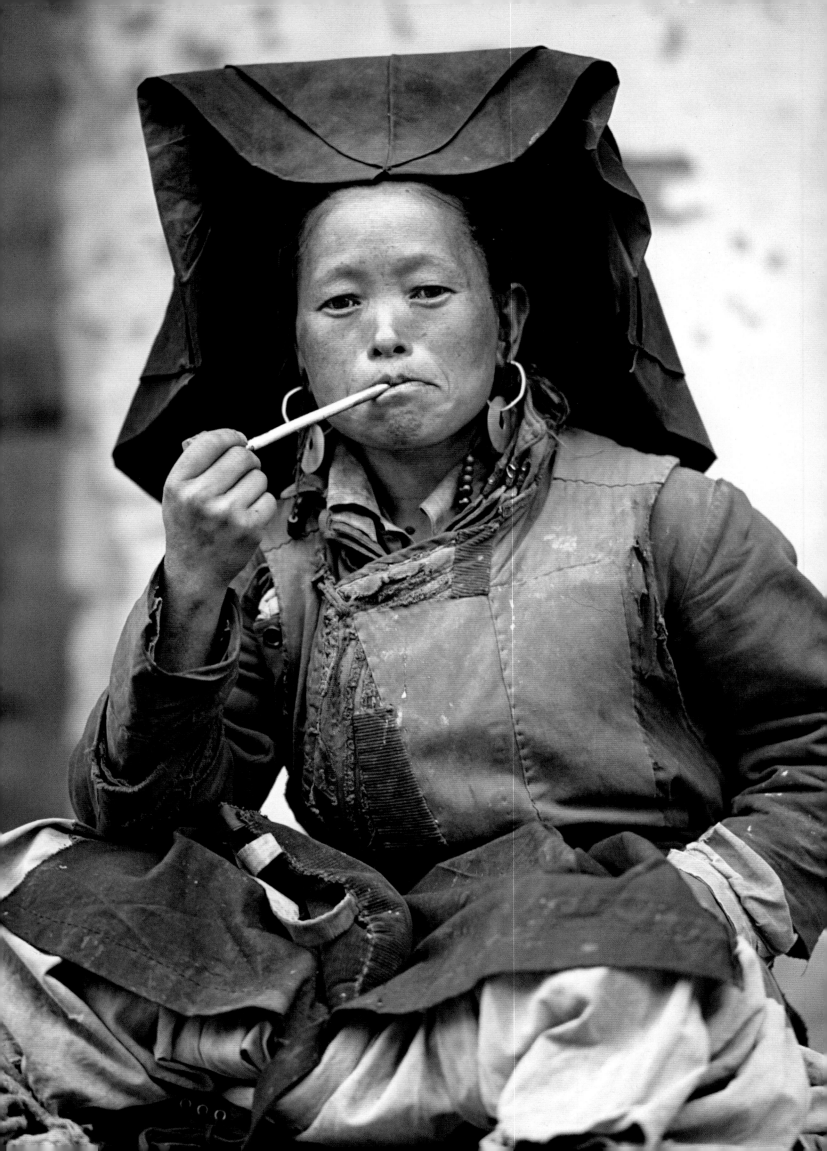

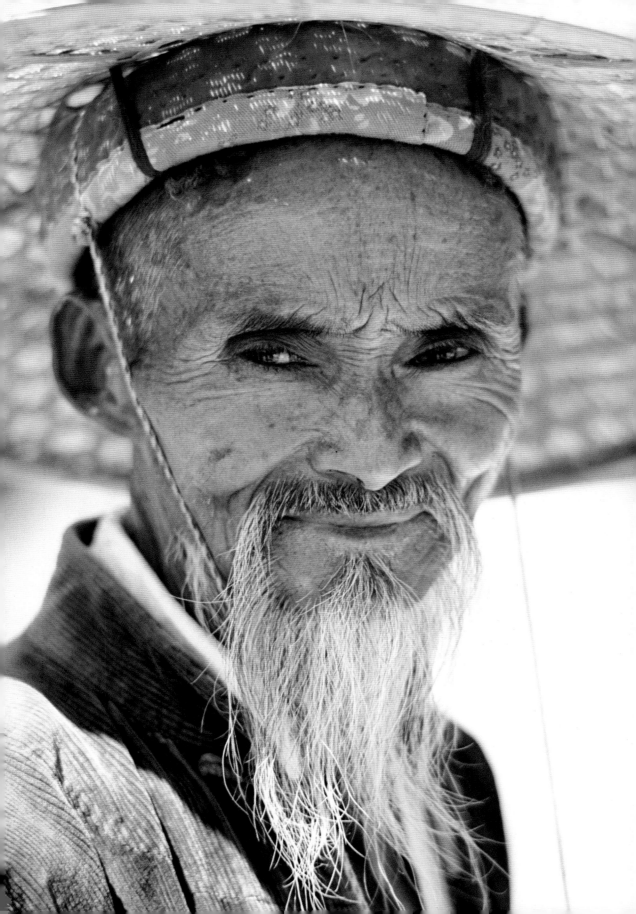

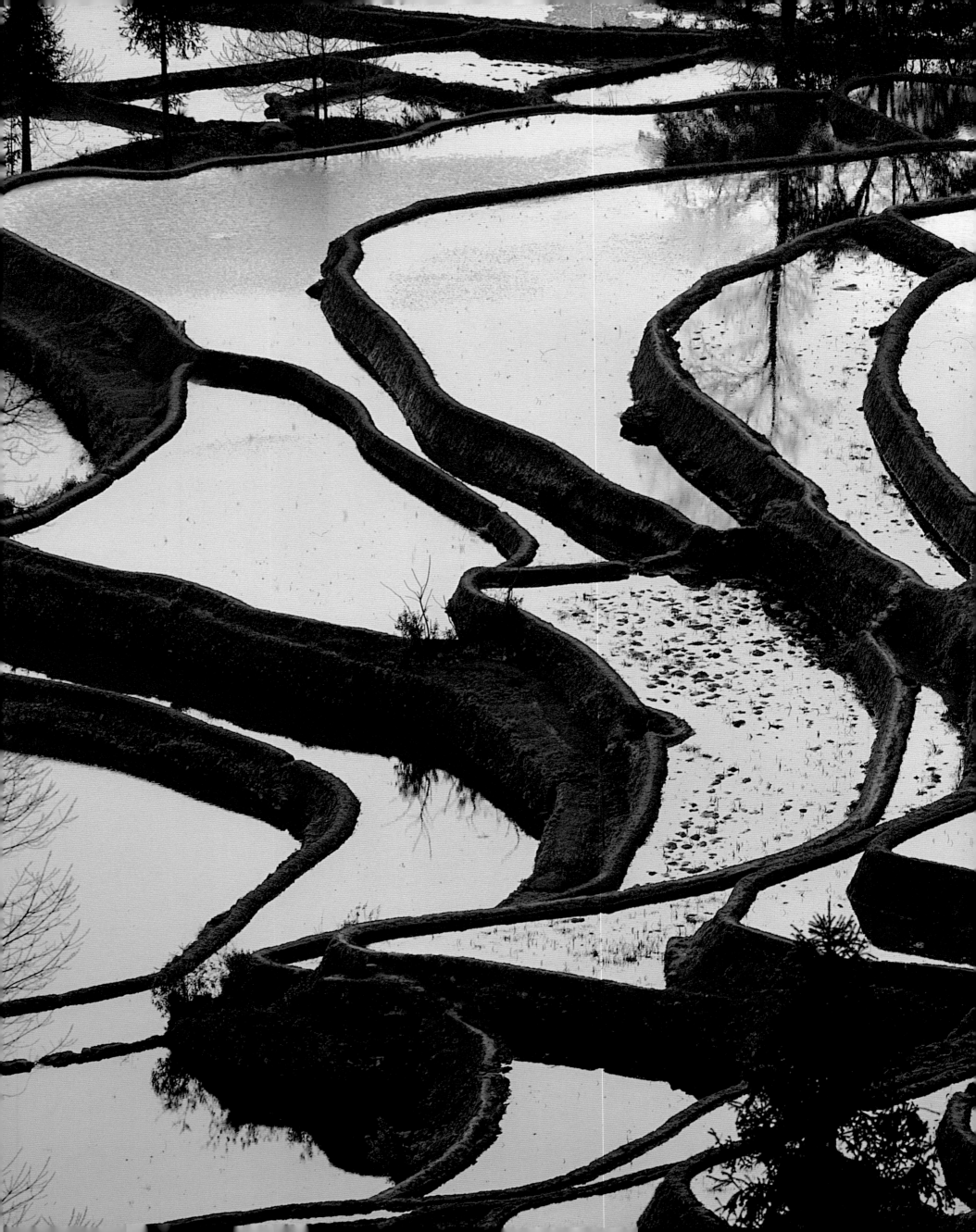

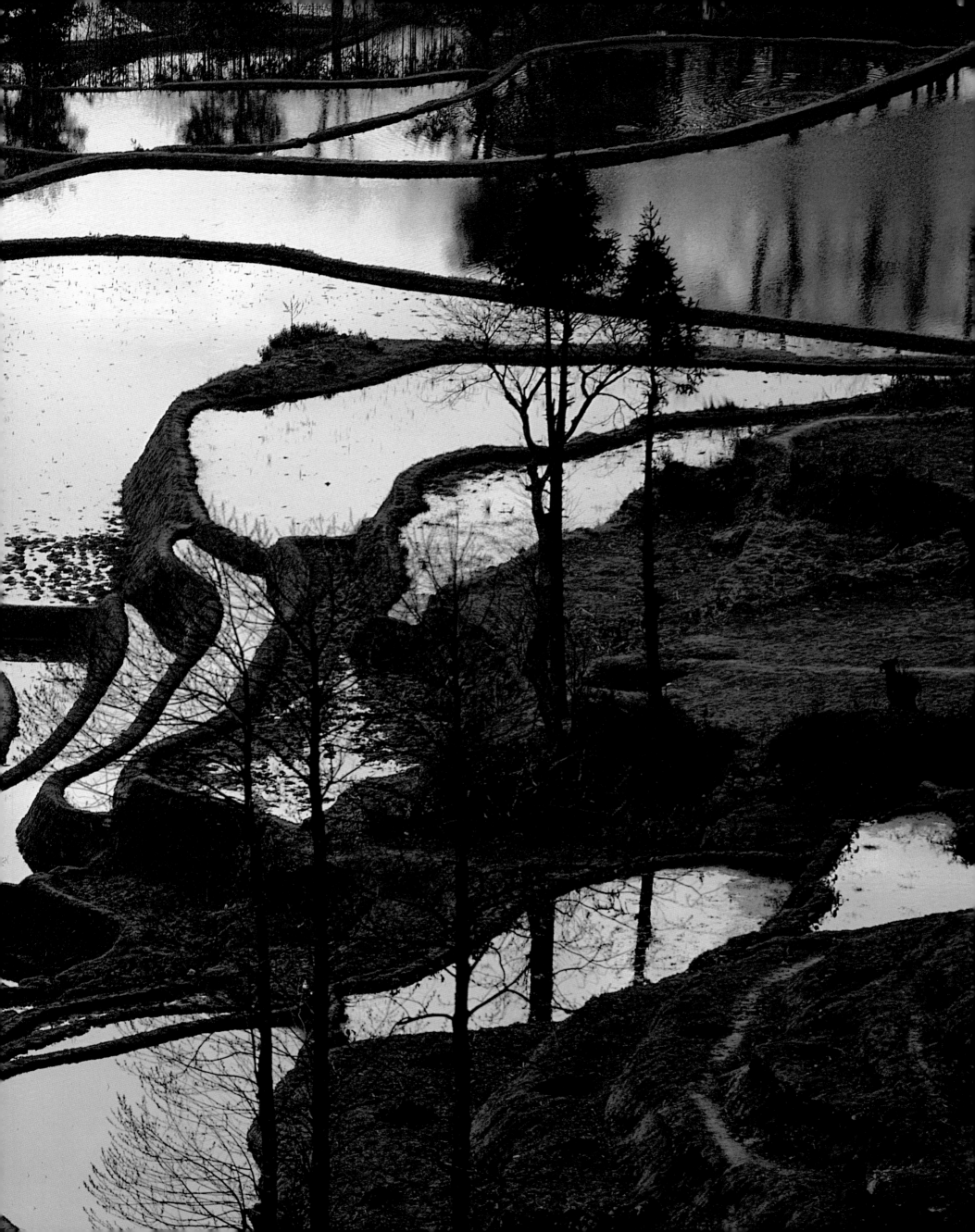

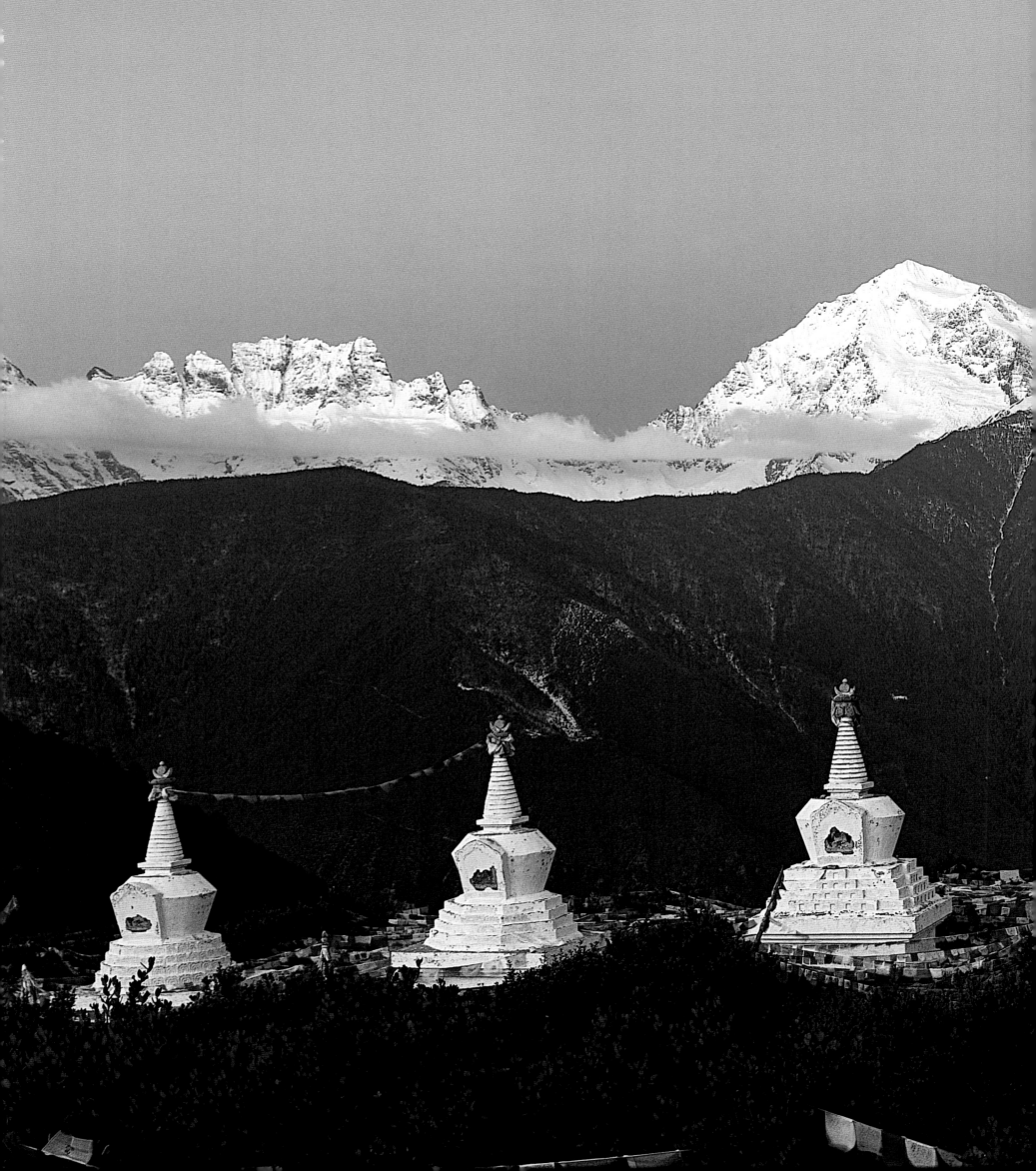

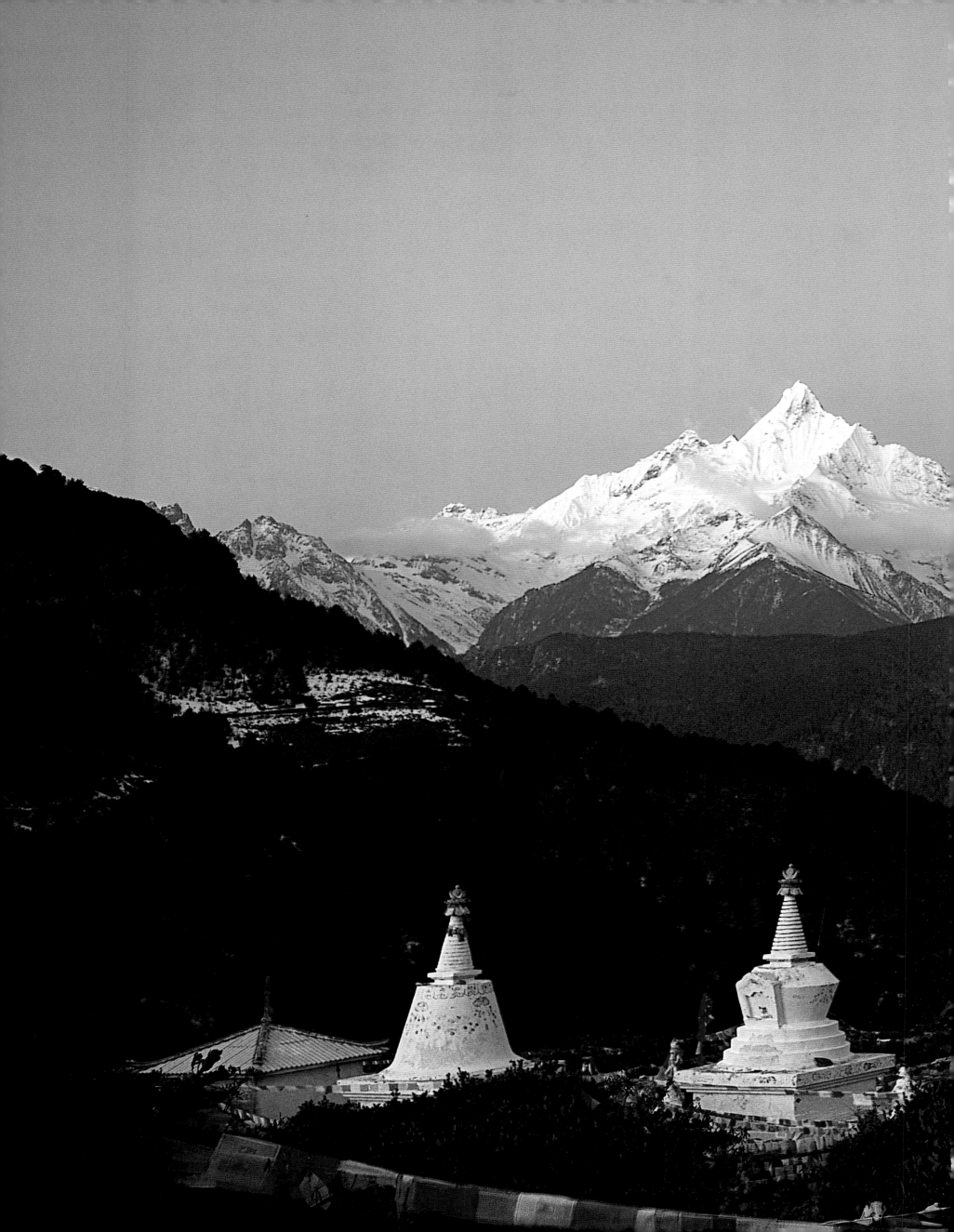

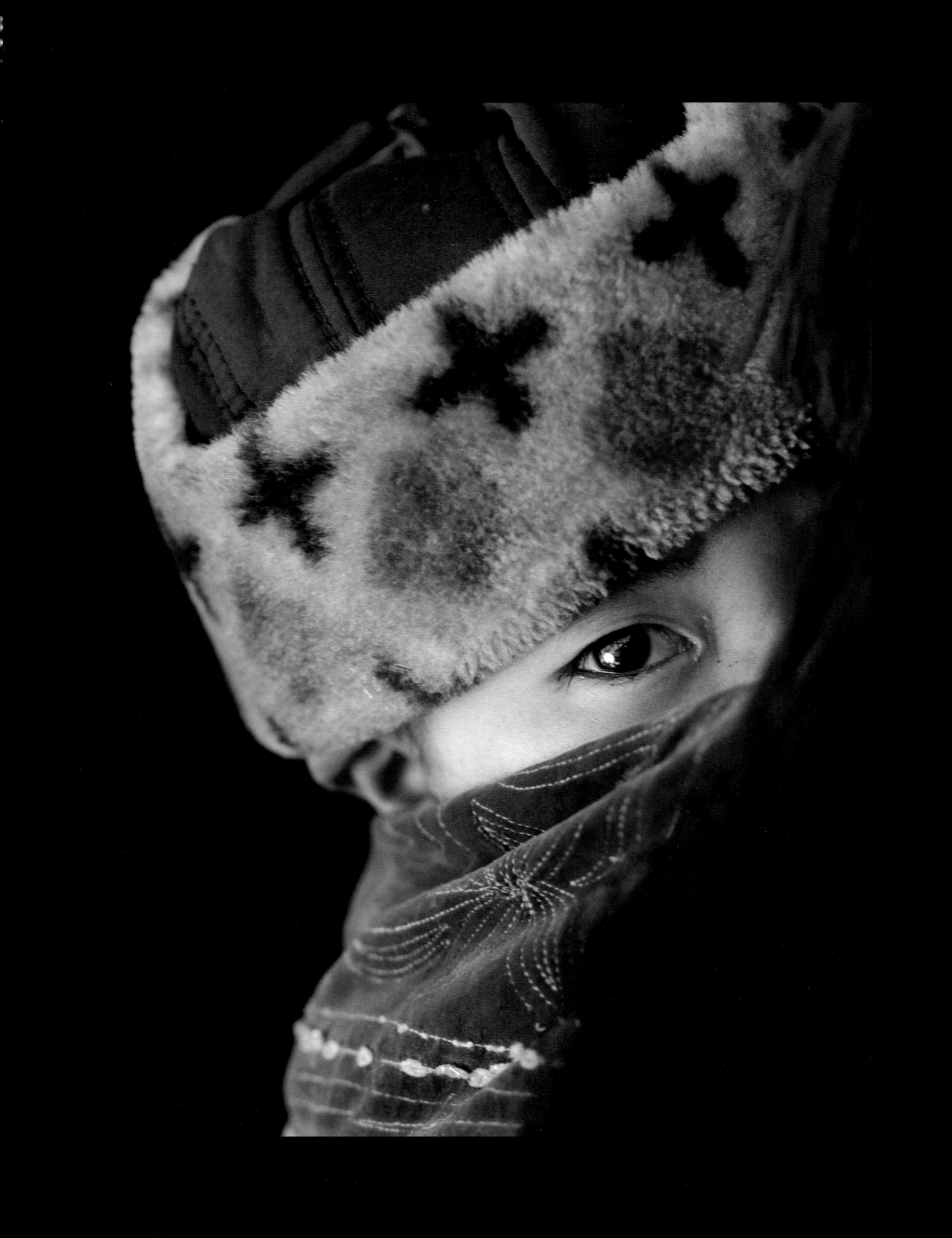

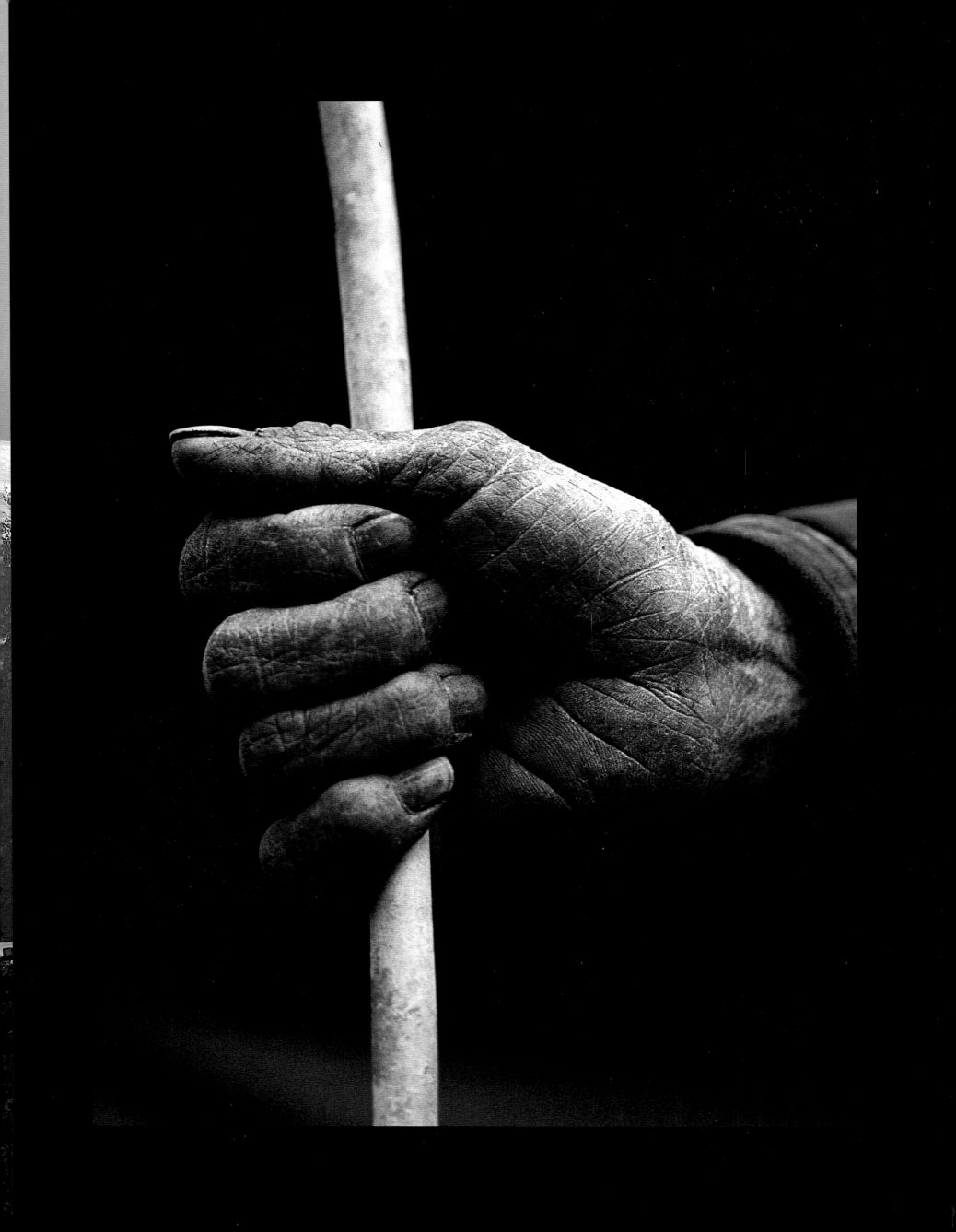

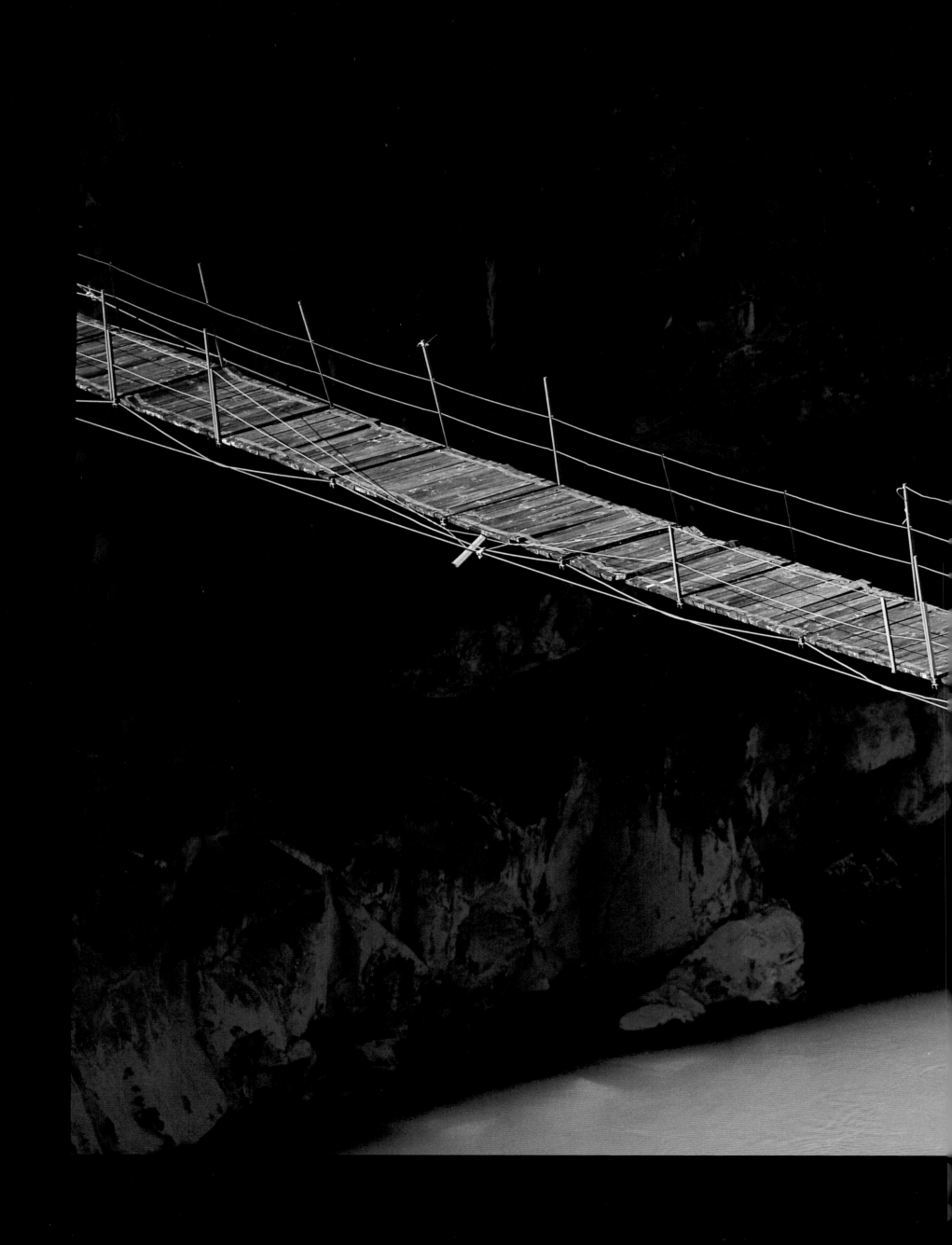

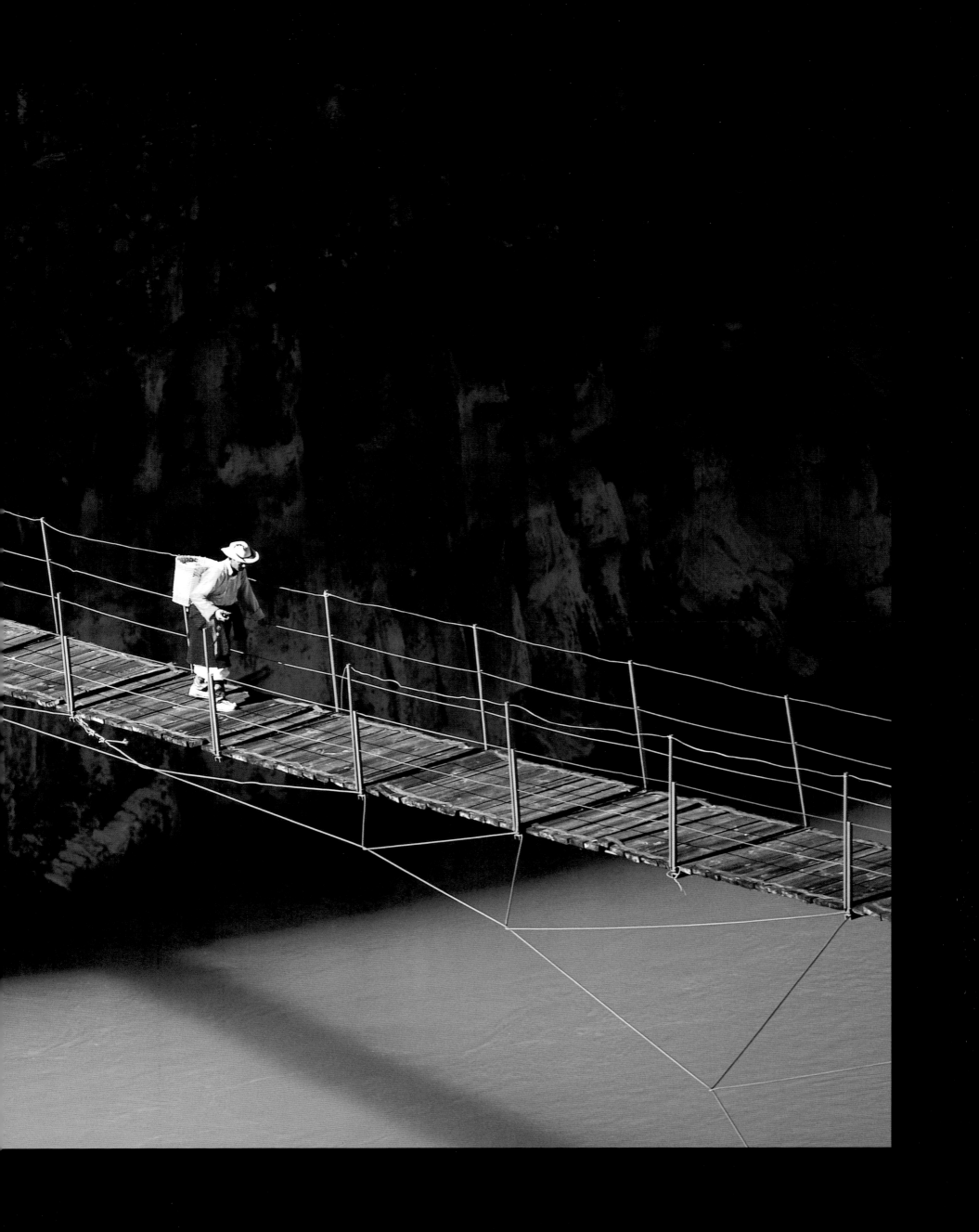

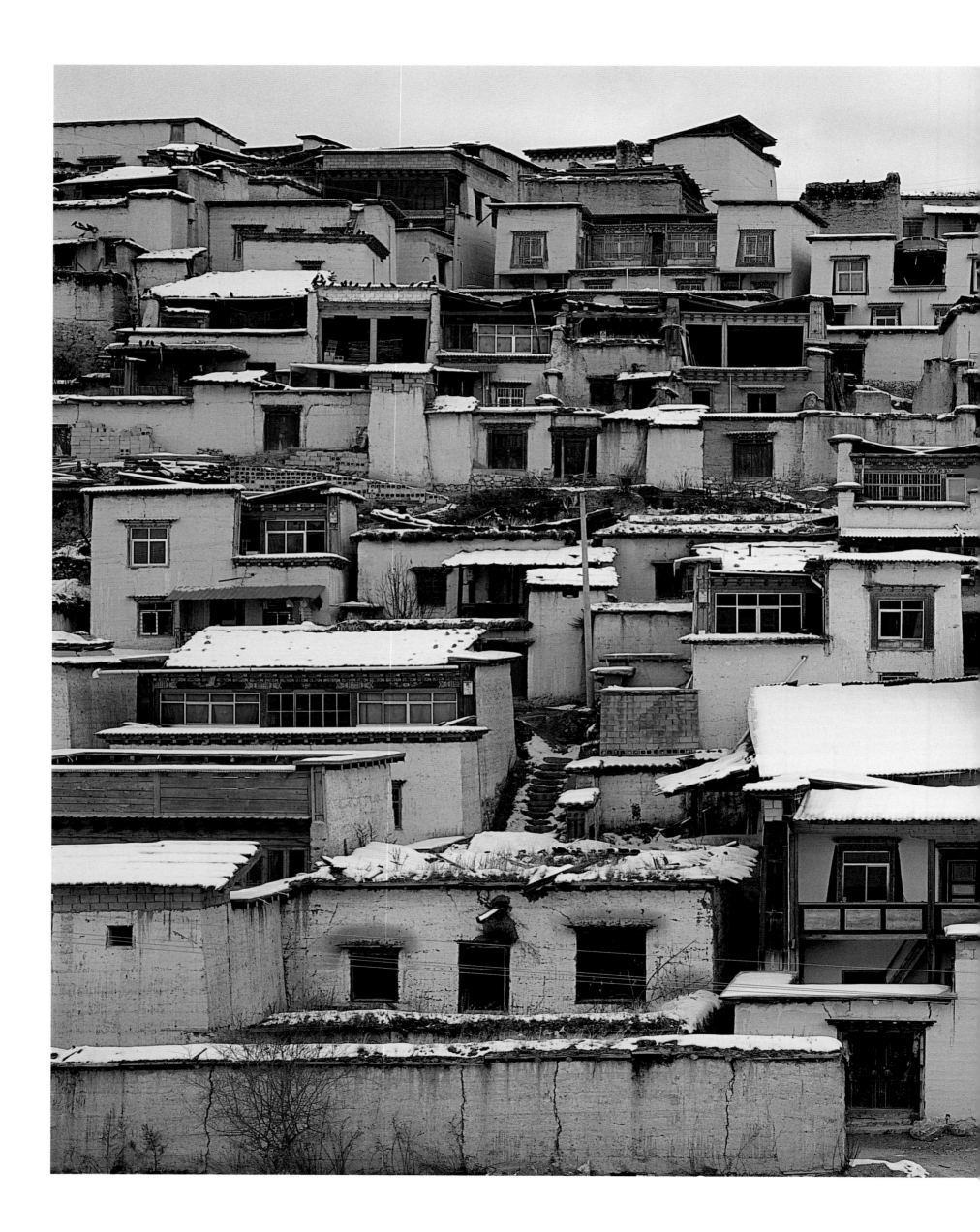

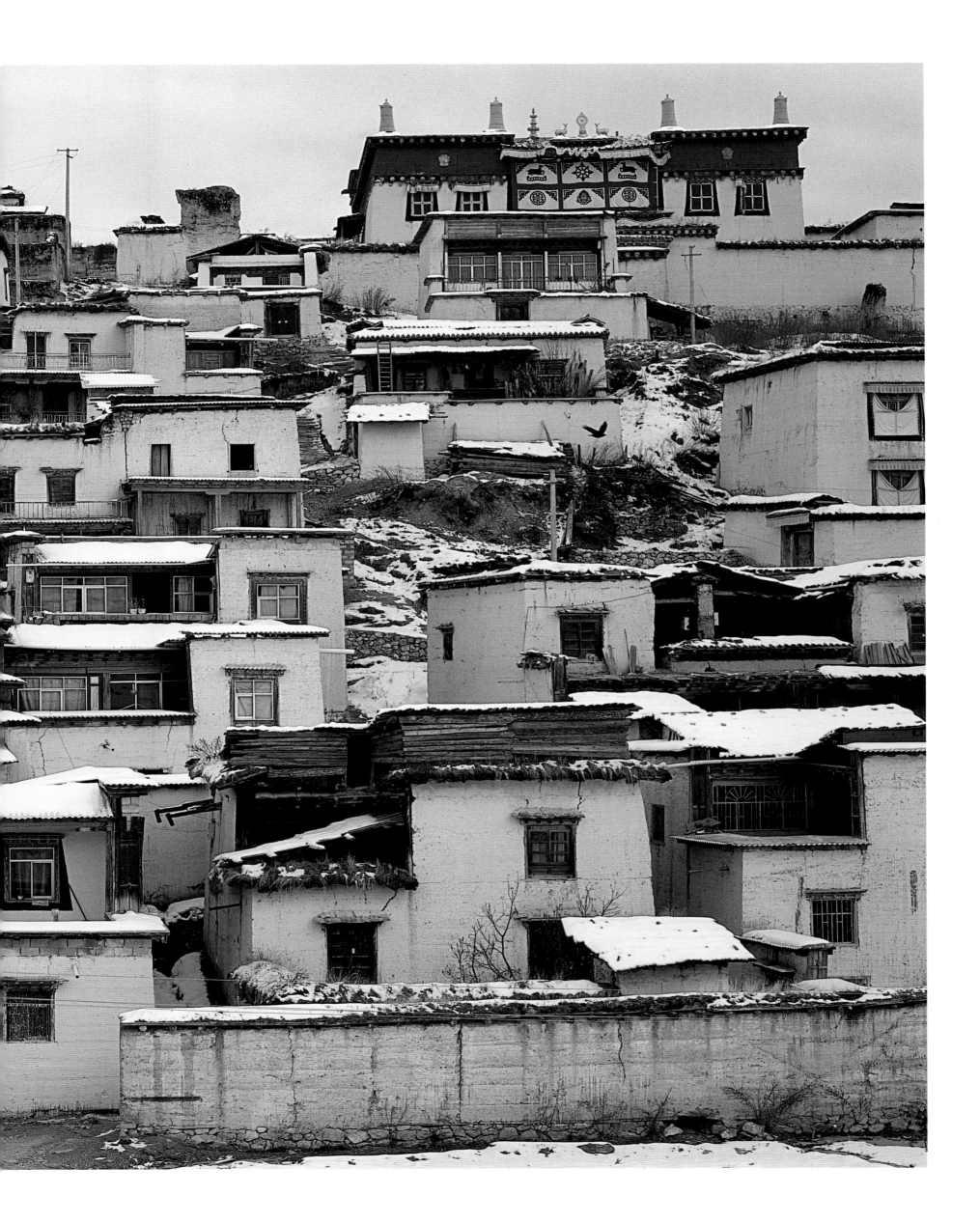

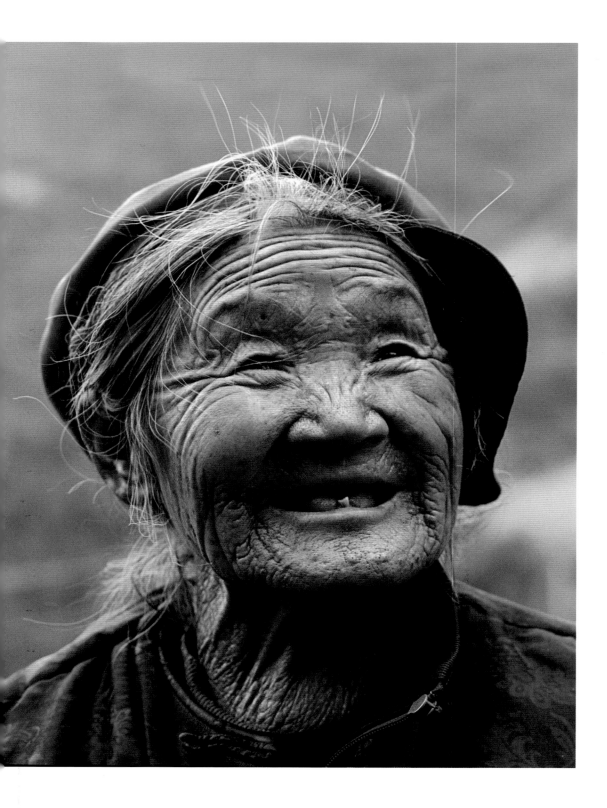

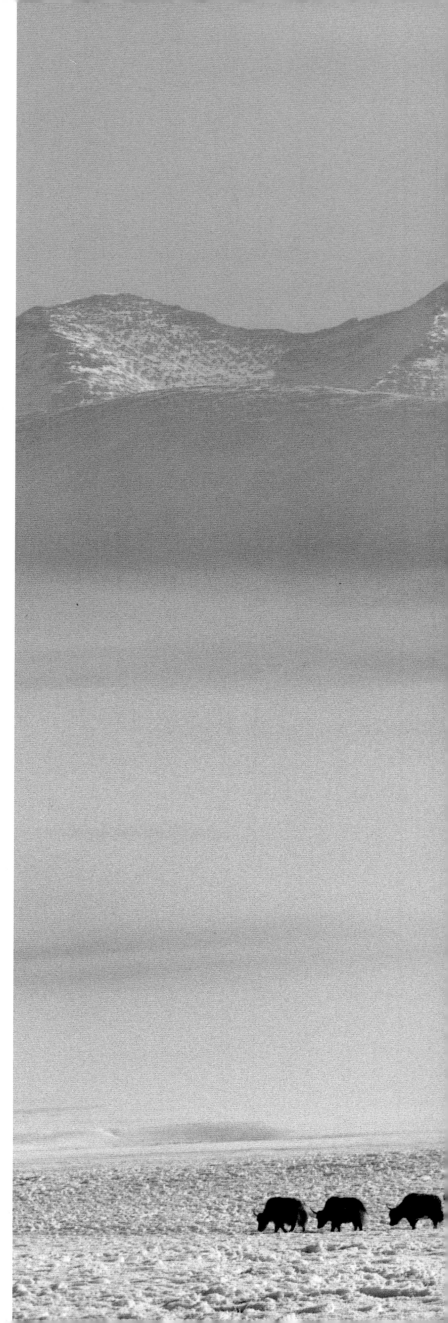

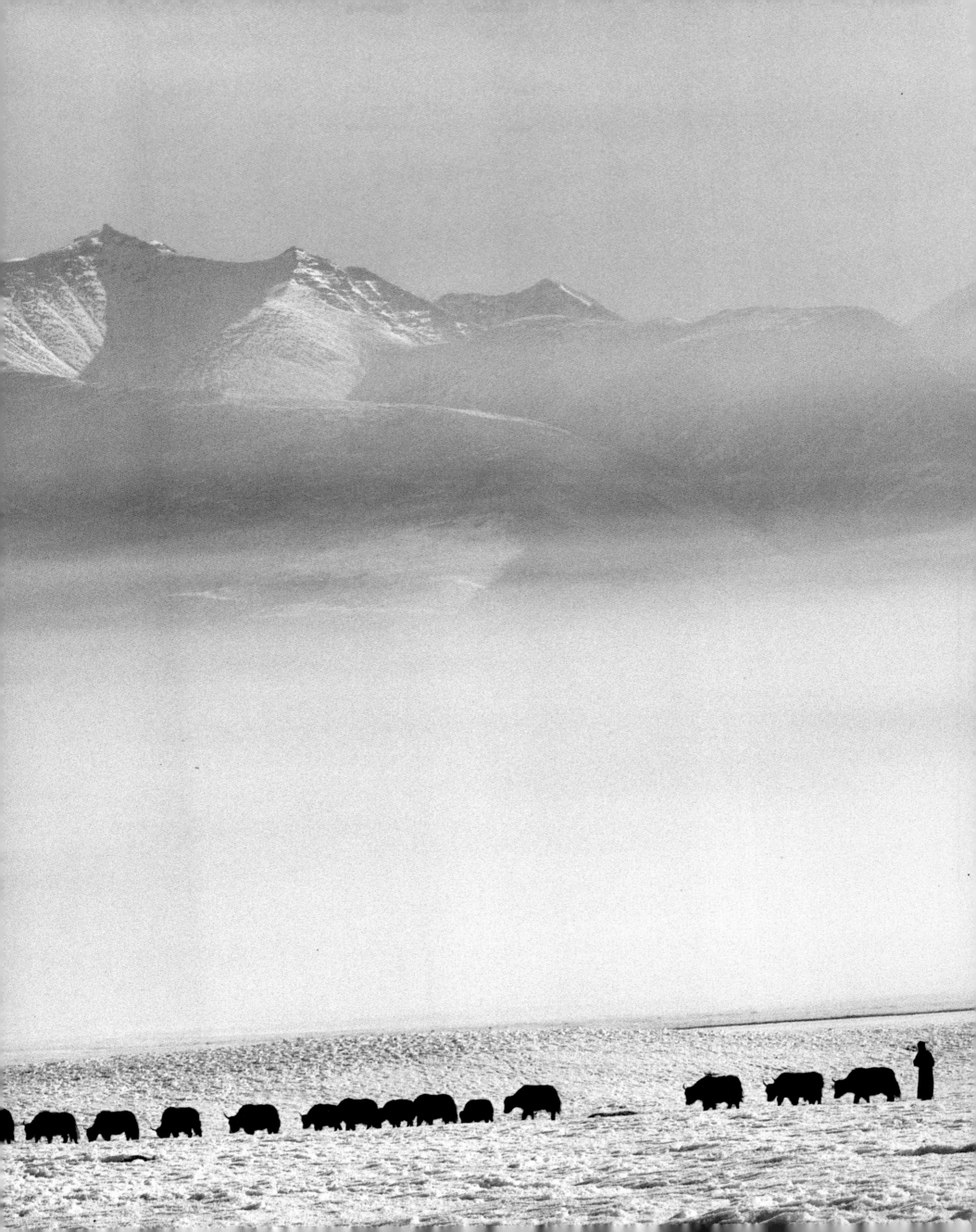

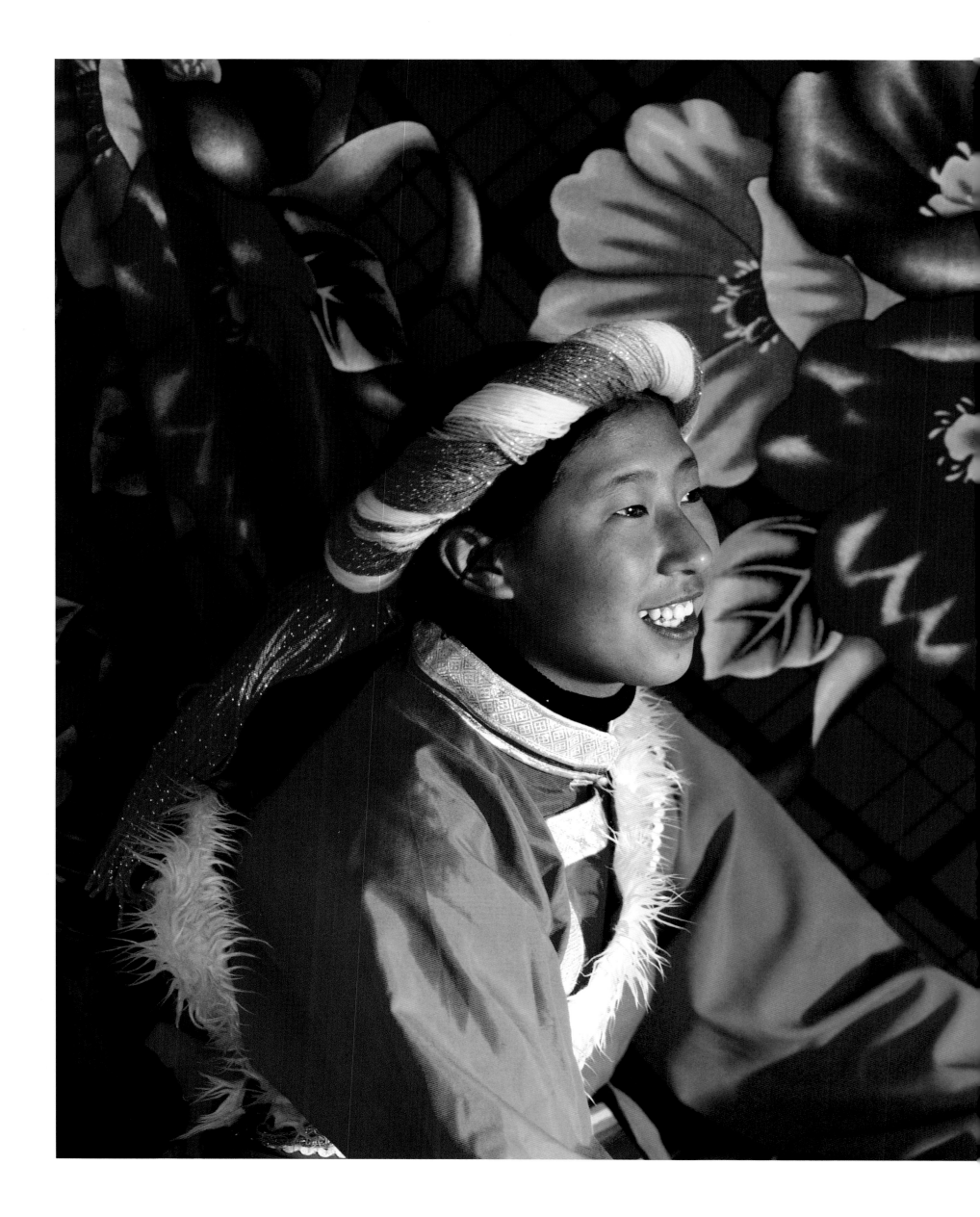

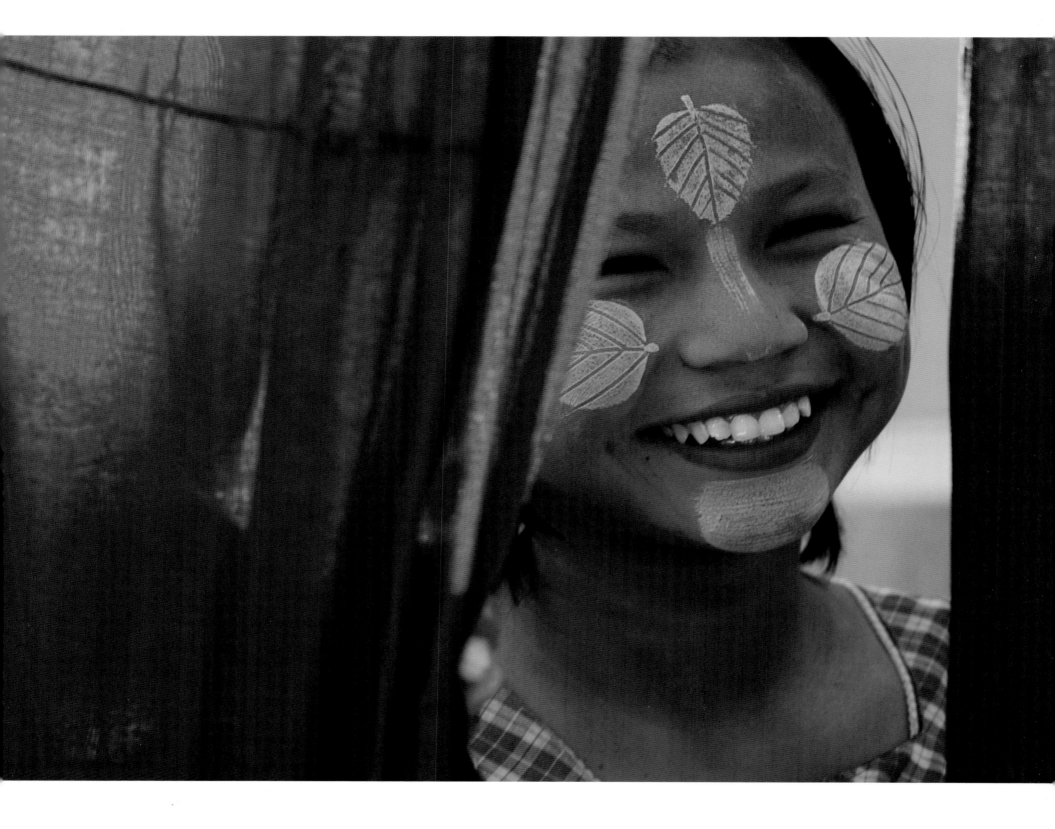

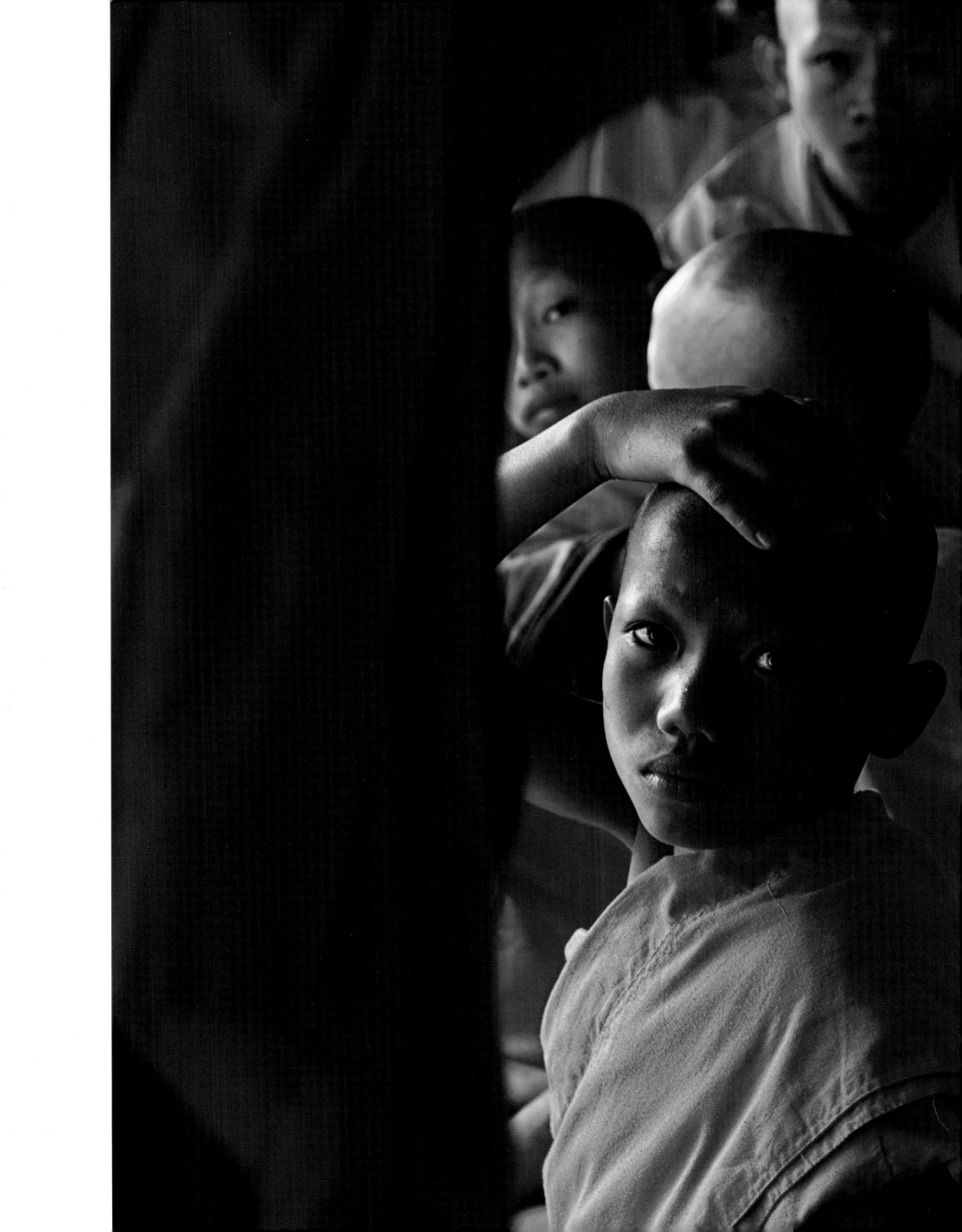

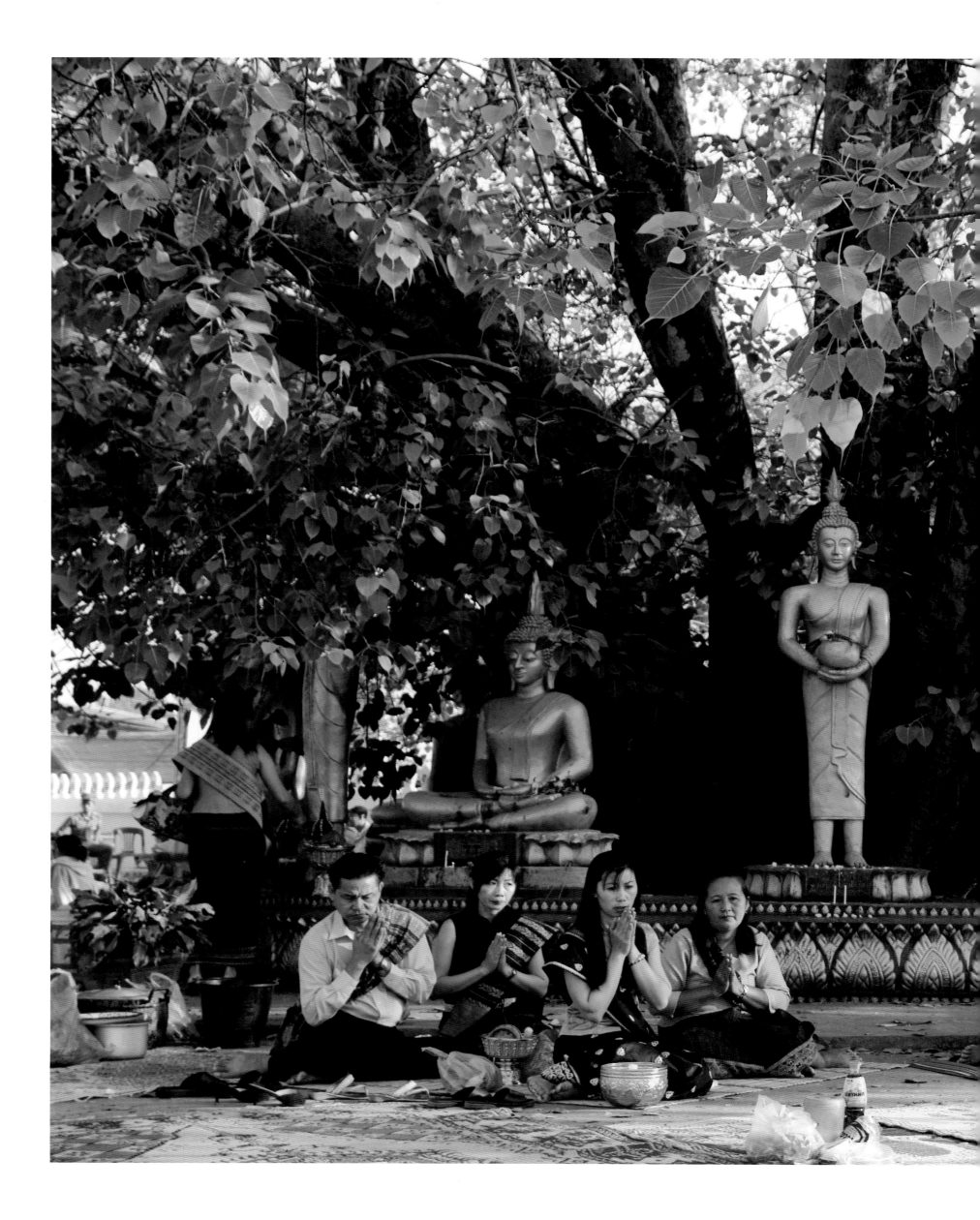

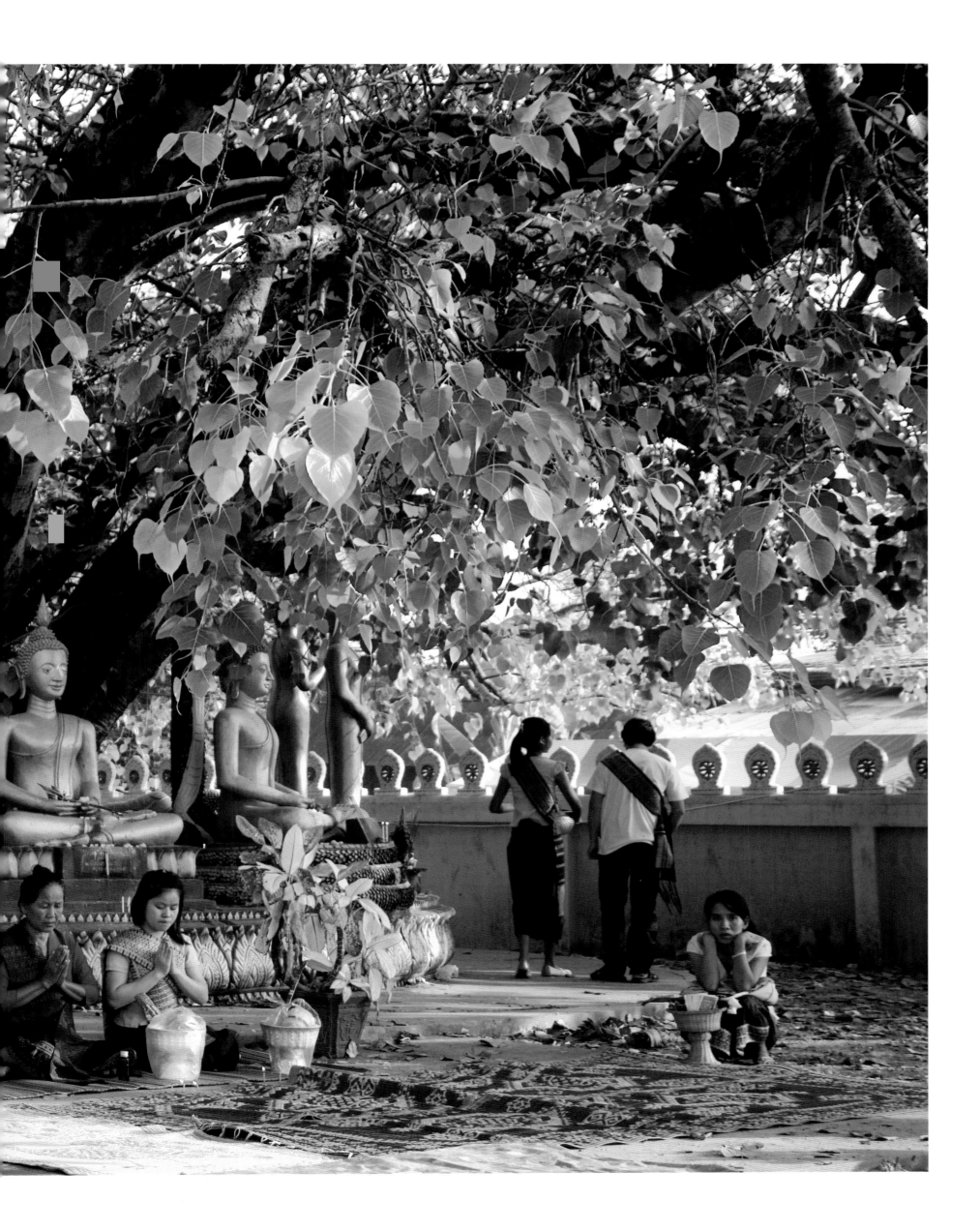

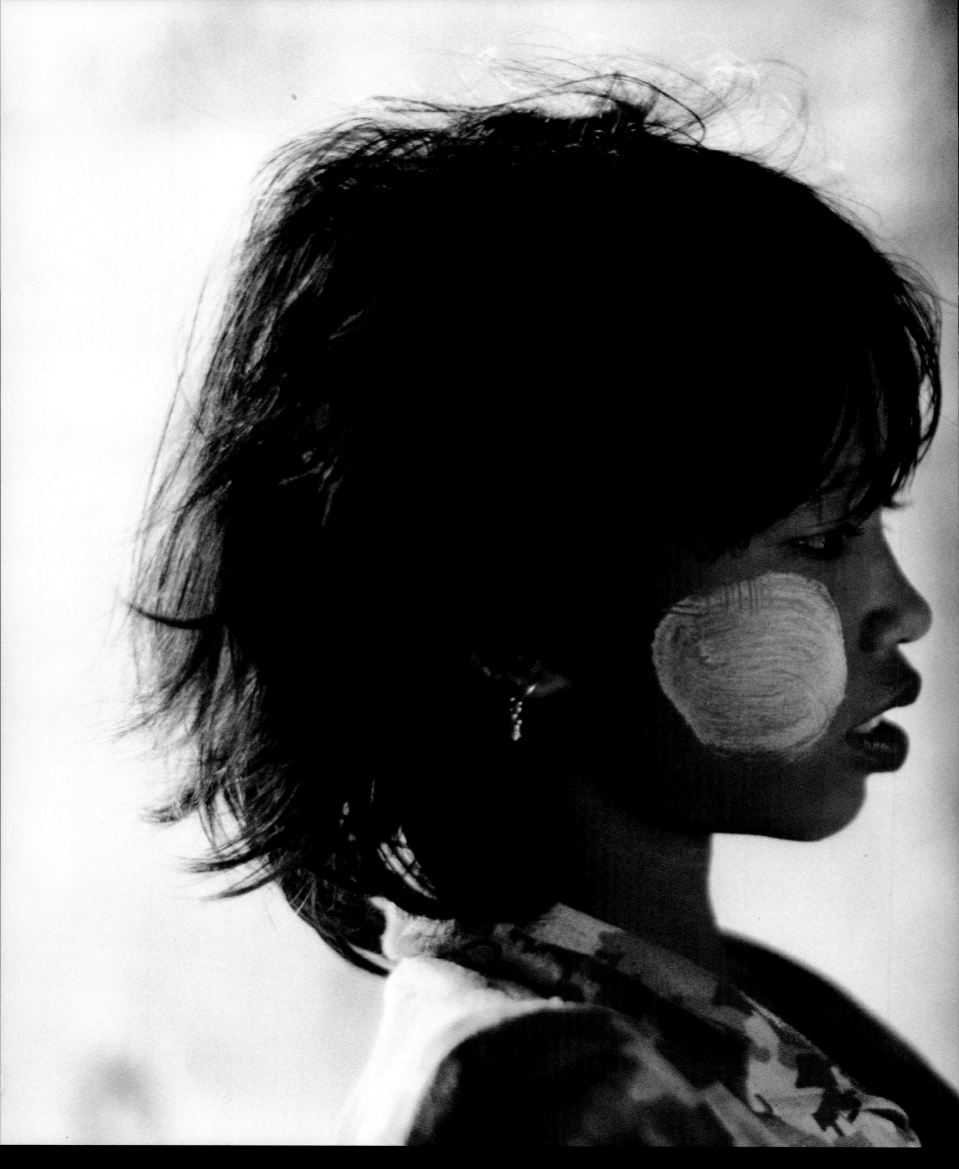

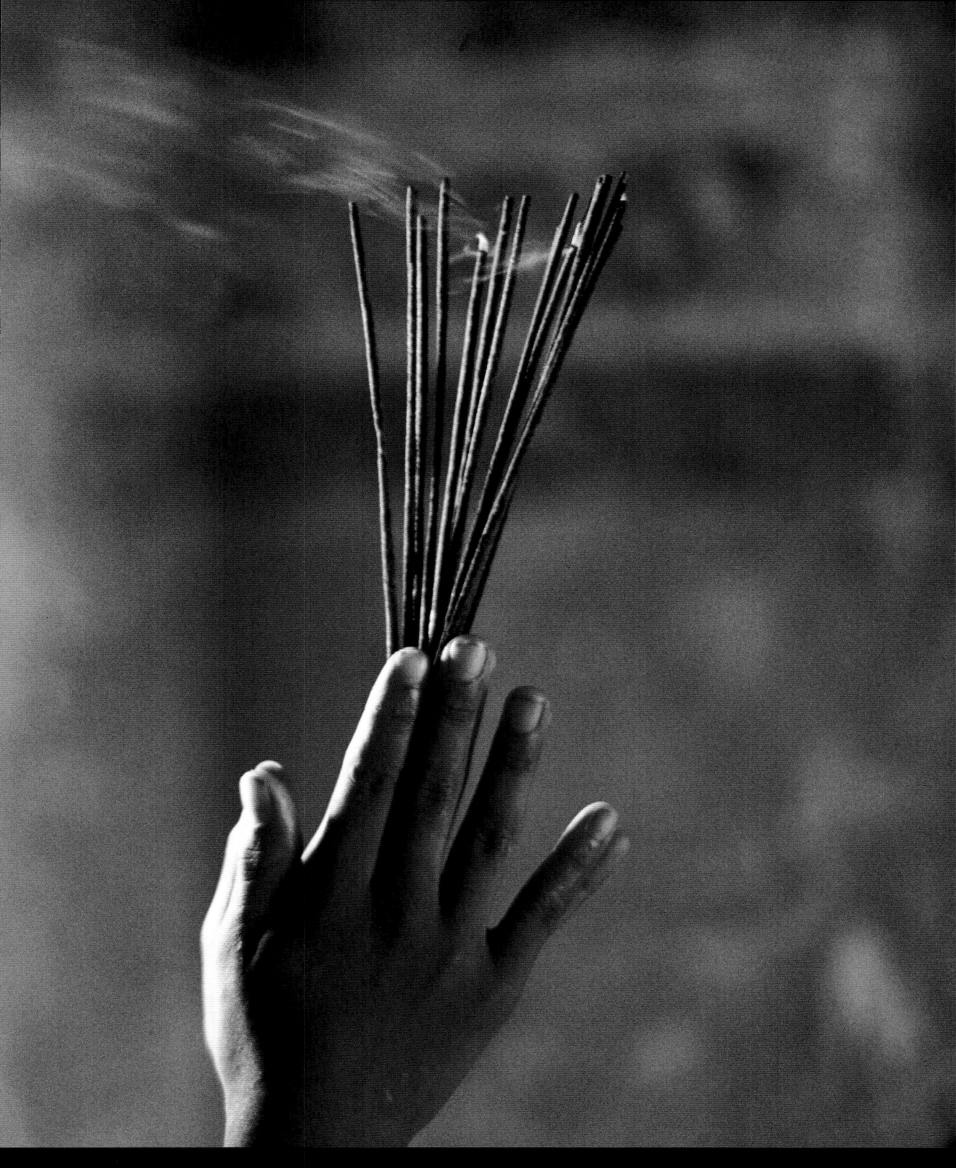

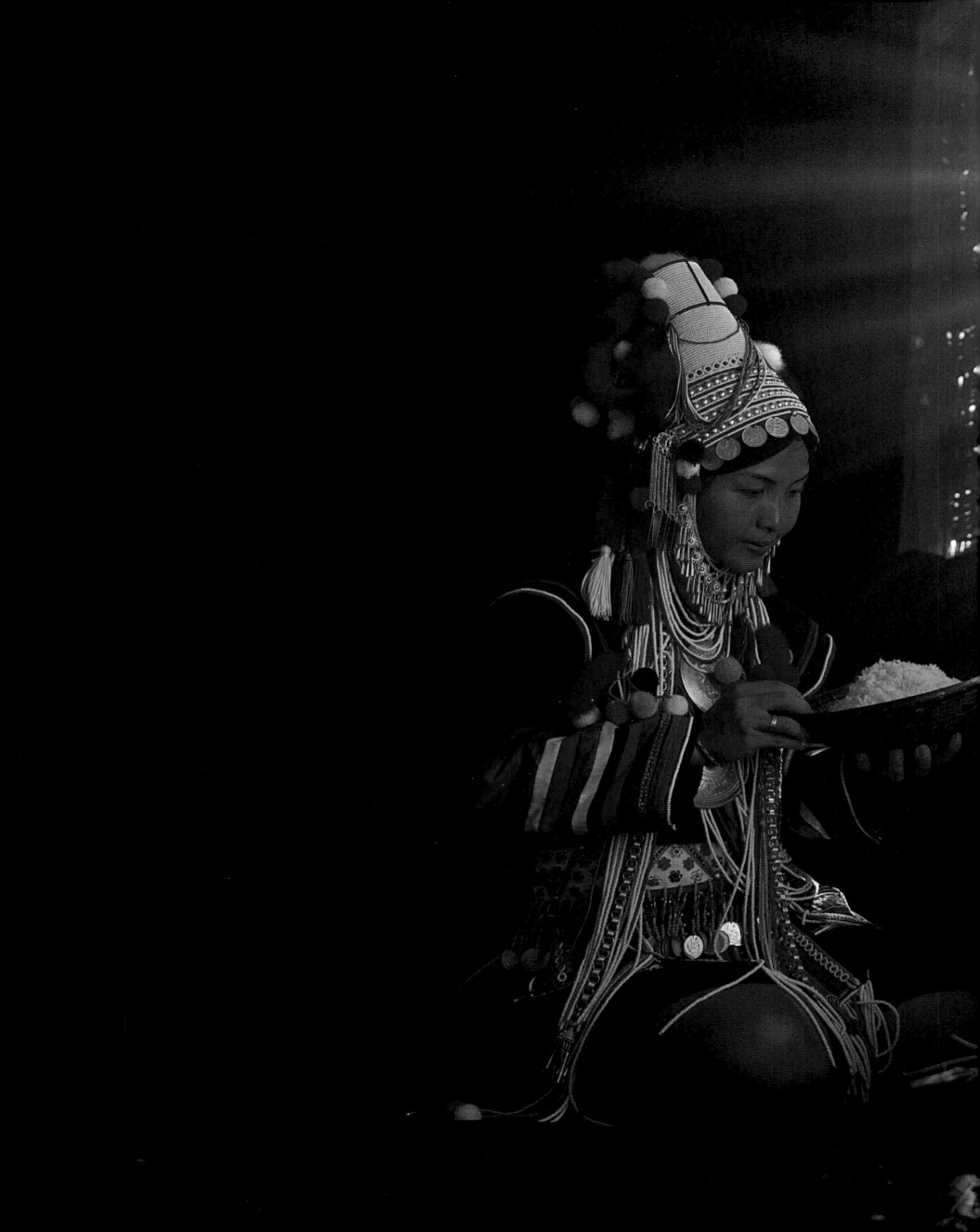

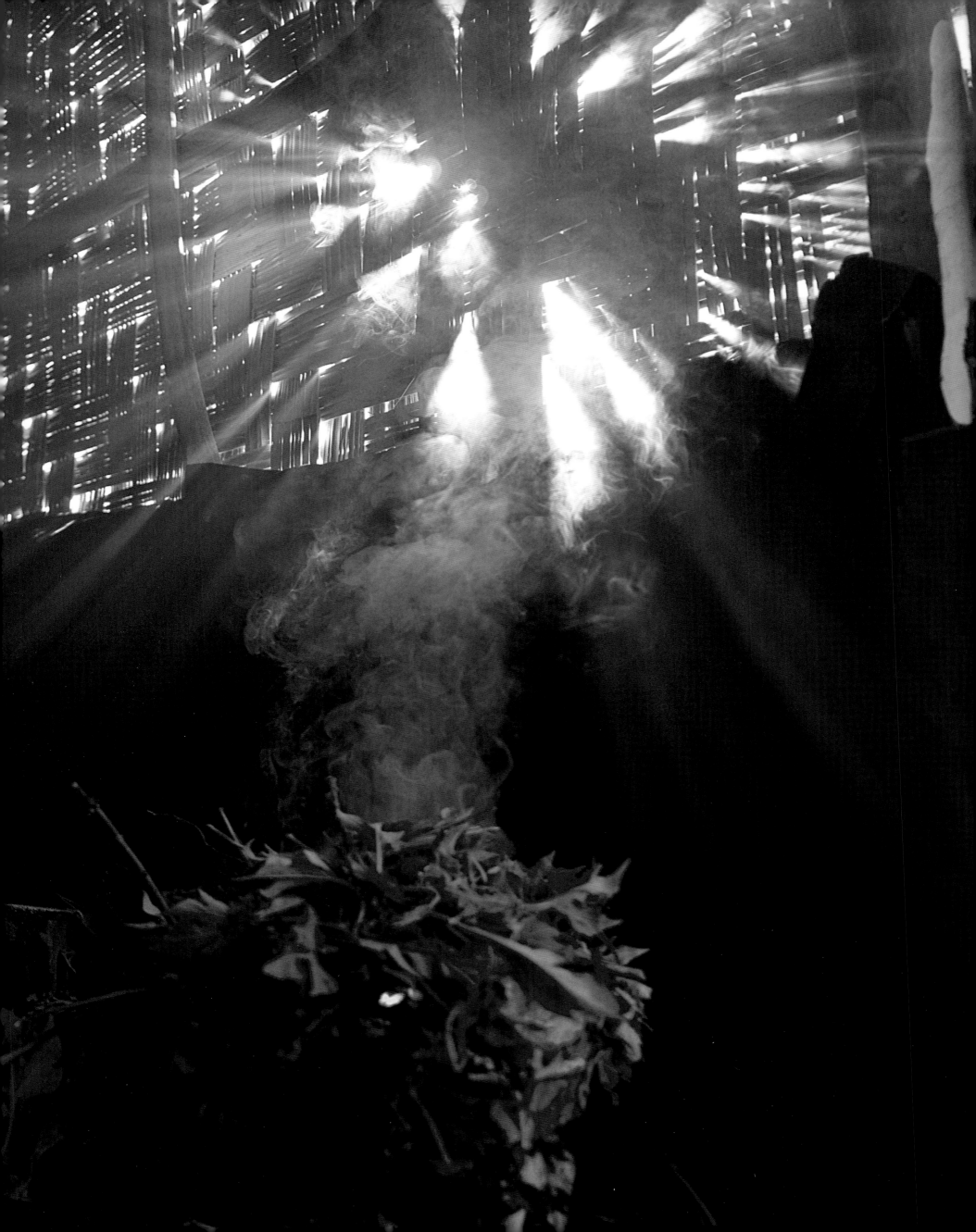

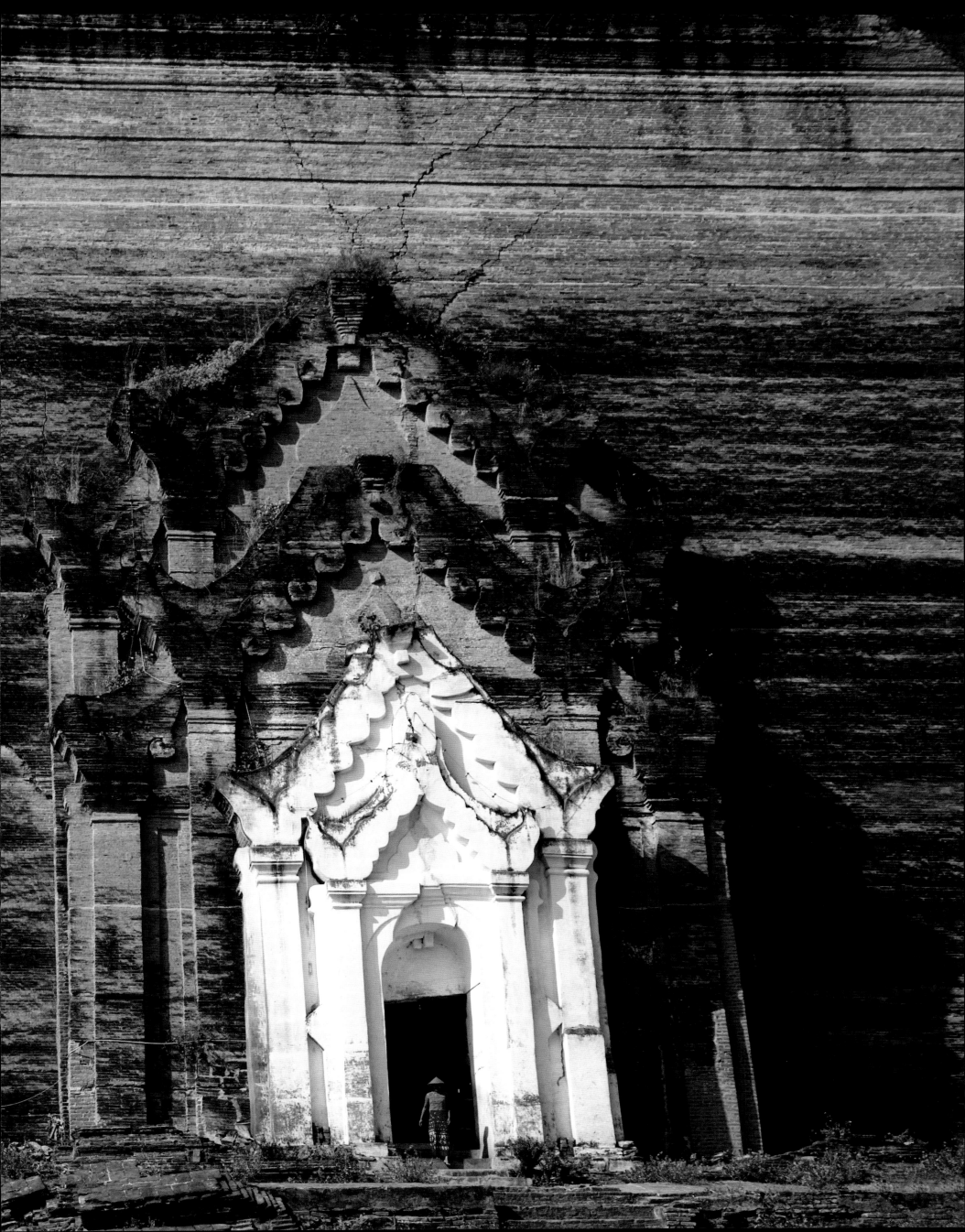

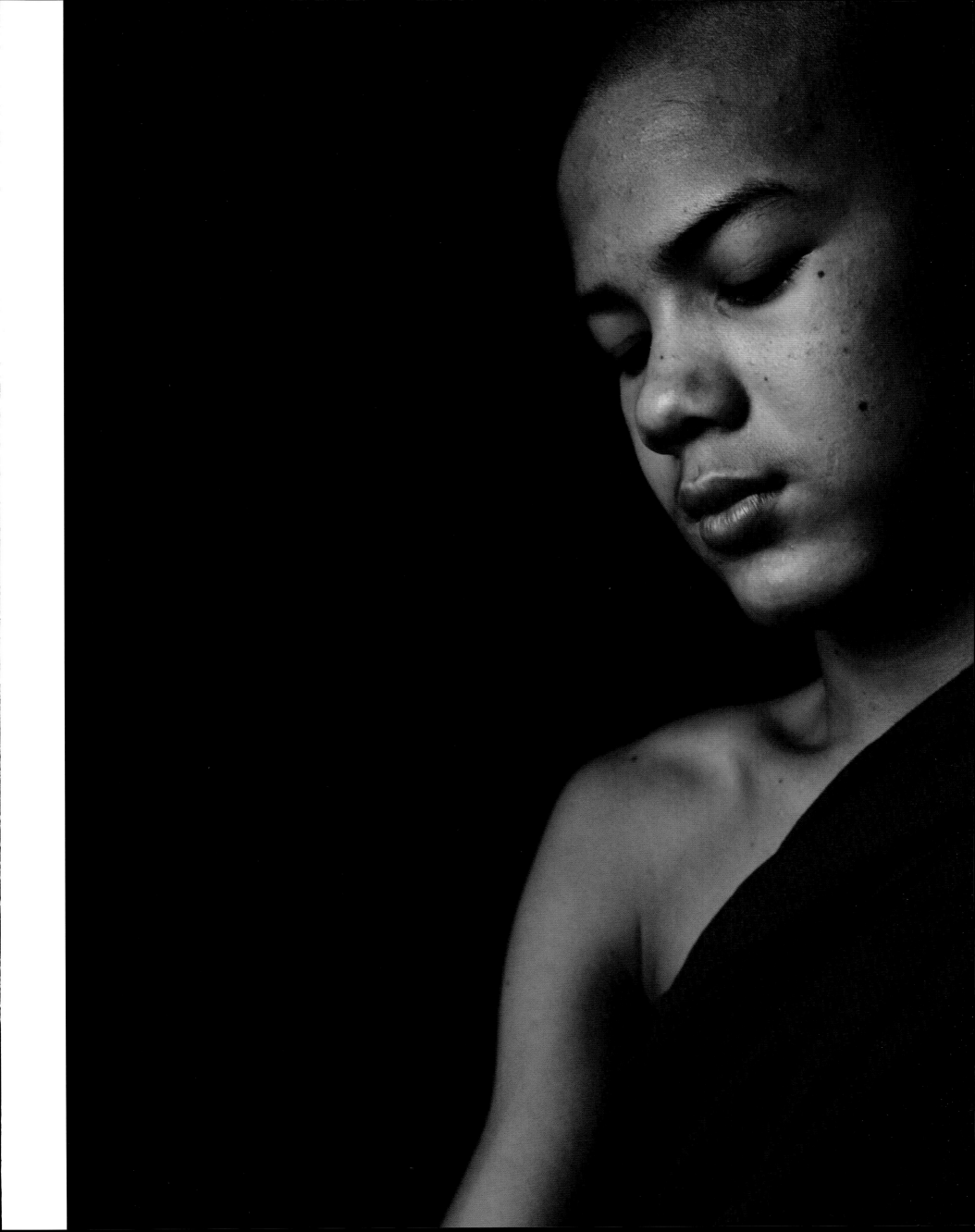

生最大的遗憾是时
去了以后才知道还
要了！……有珍惜时

记住：

学校出版 2016.6.1.

……是大地，

……上的树苗，

……的滋养，

长出强壮枝叶。

是乘风破浪的船，

一根篙……

那神圣的航程，

我感谢
我感谢
我感谢

我感

人们浪费了大好时光，人

不能倒流，珍贵的时间往往是先

珍贵自己的青春年华太重

的 圆 人，才能攀上理想的高

时间就是生命

时间就是胜利

时间就是财富

父母，因为他们养育了我，

老师，因为他们培养了我，

朋友，因为他们问候了我，

身边的每一个人，因为他们

很多很多

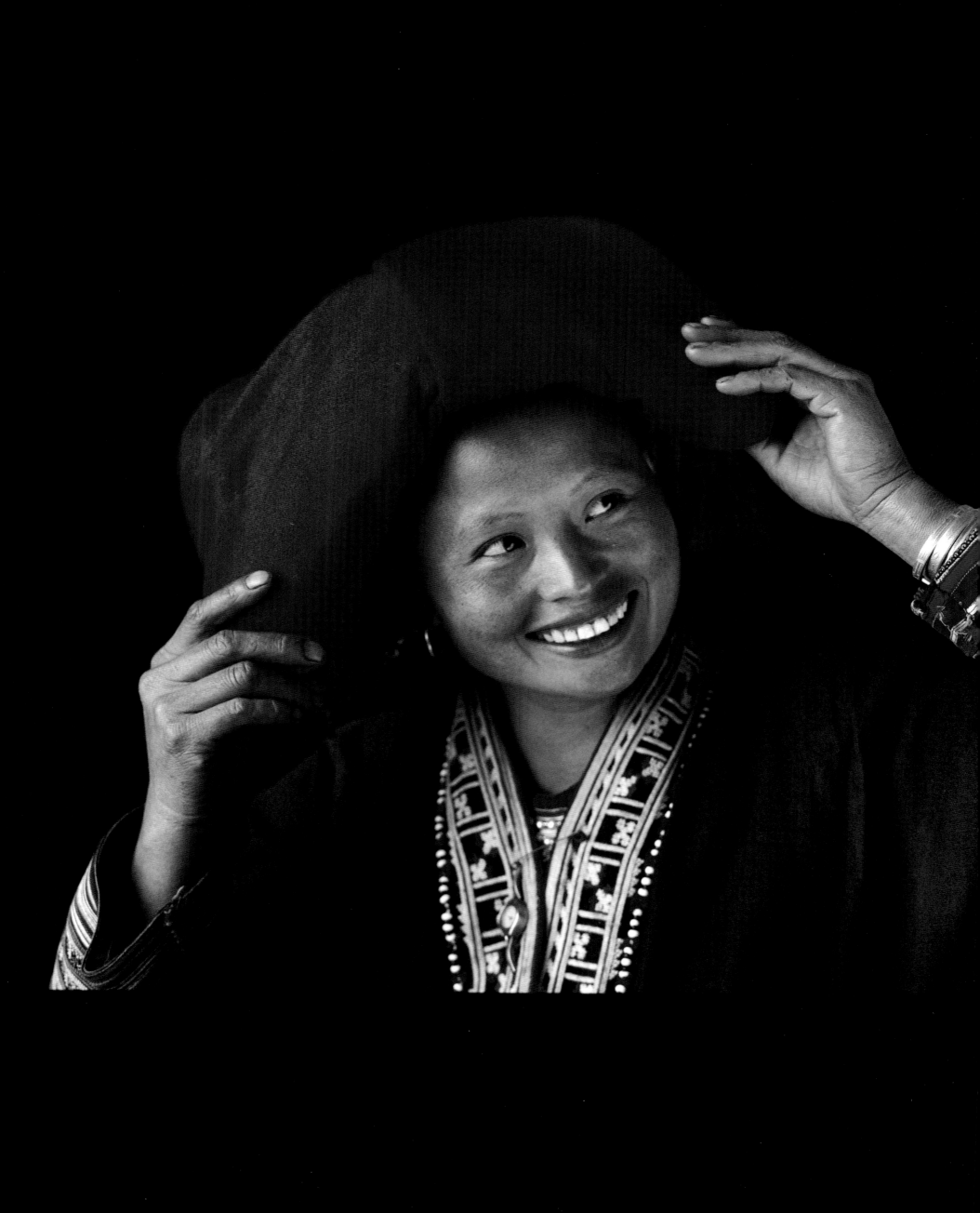

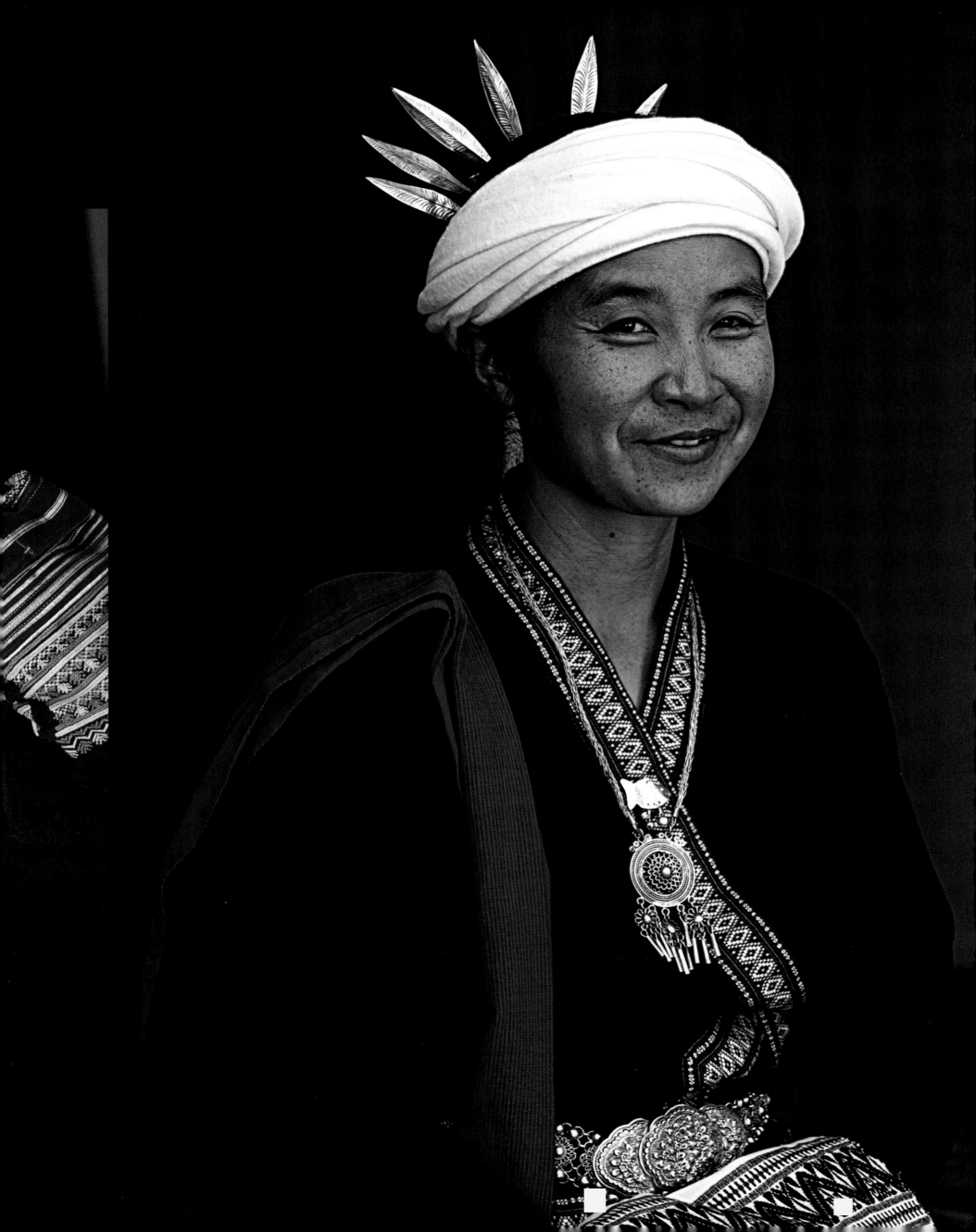

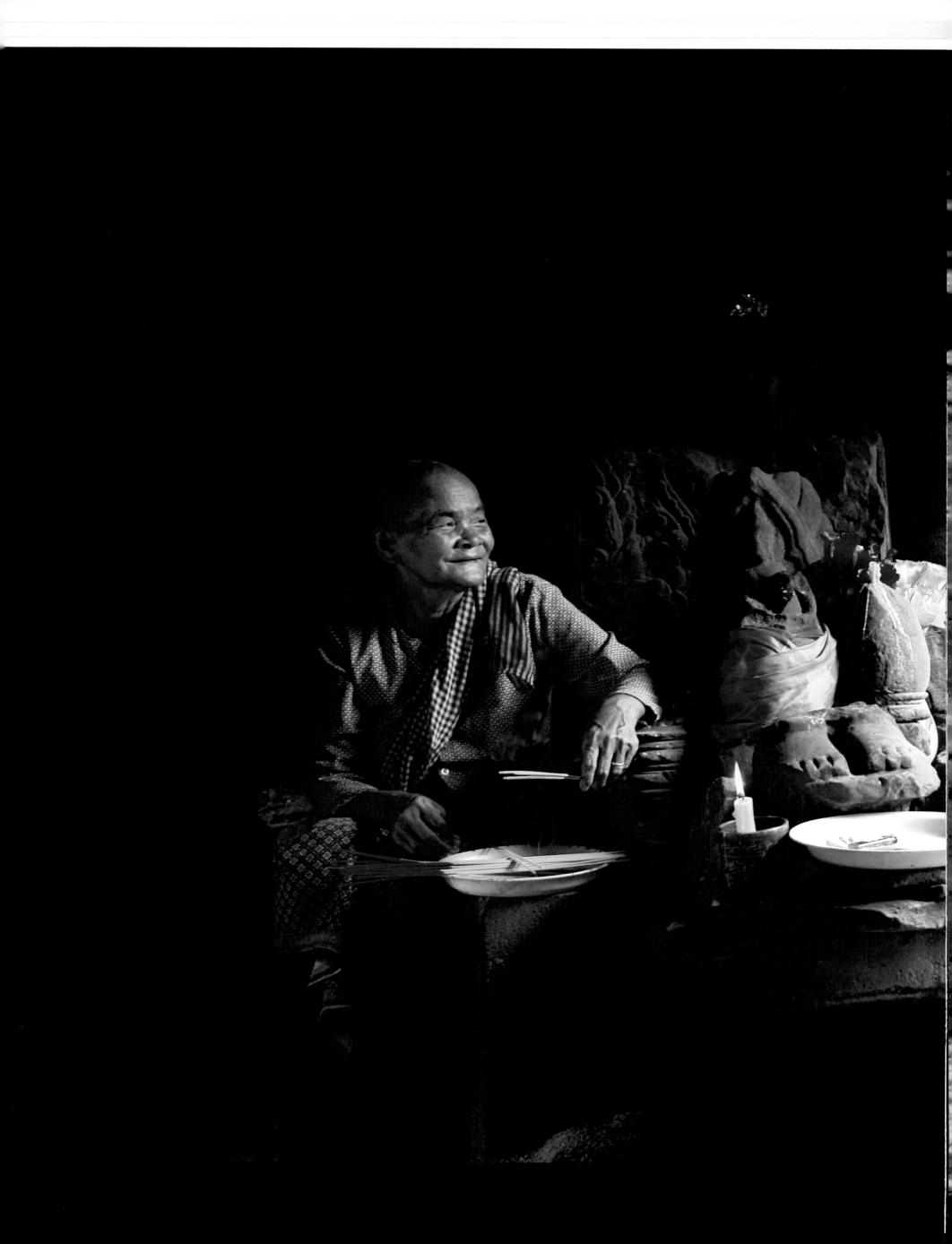

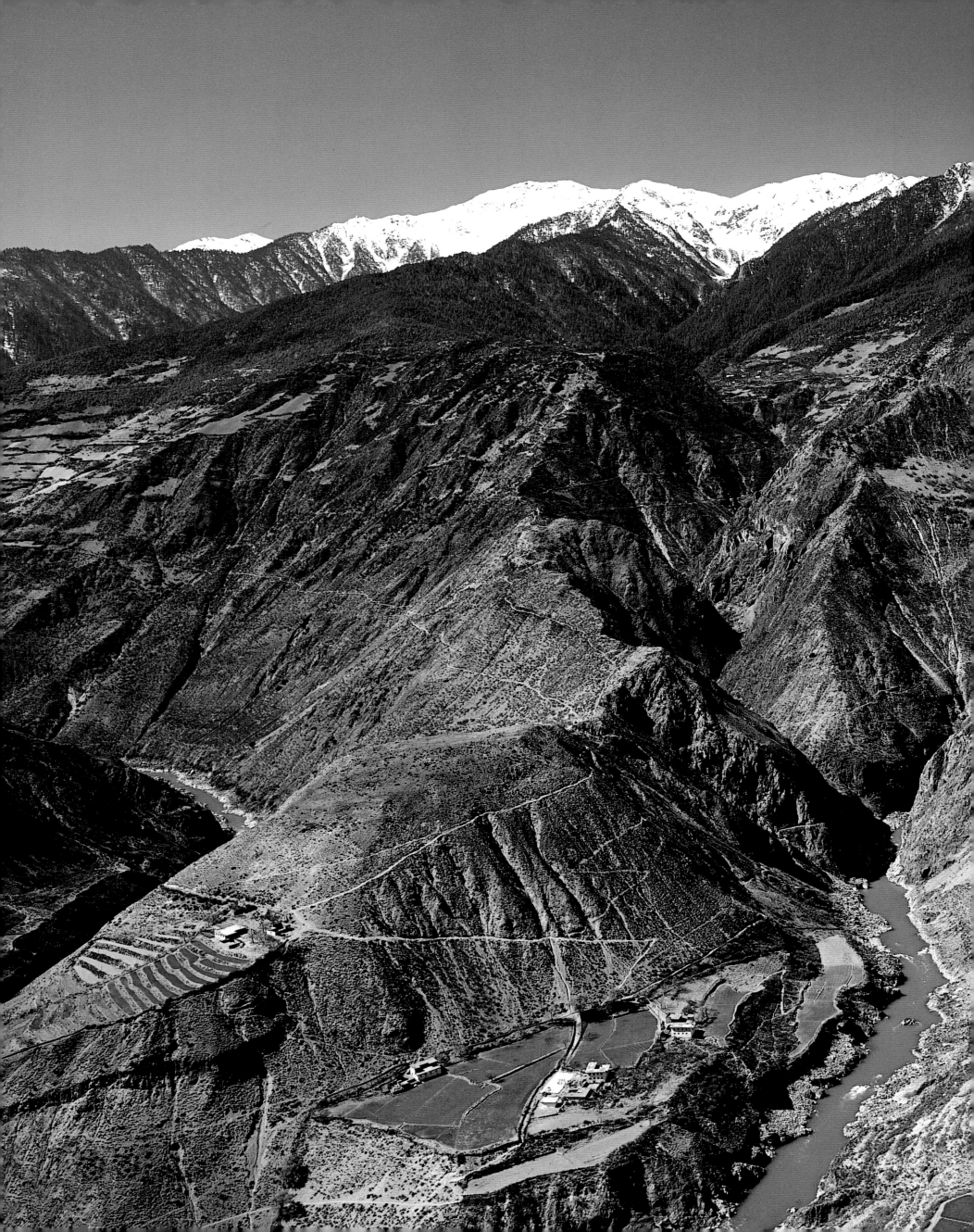

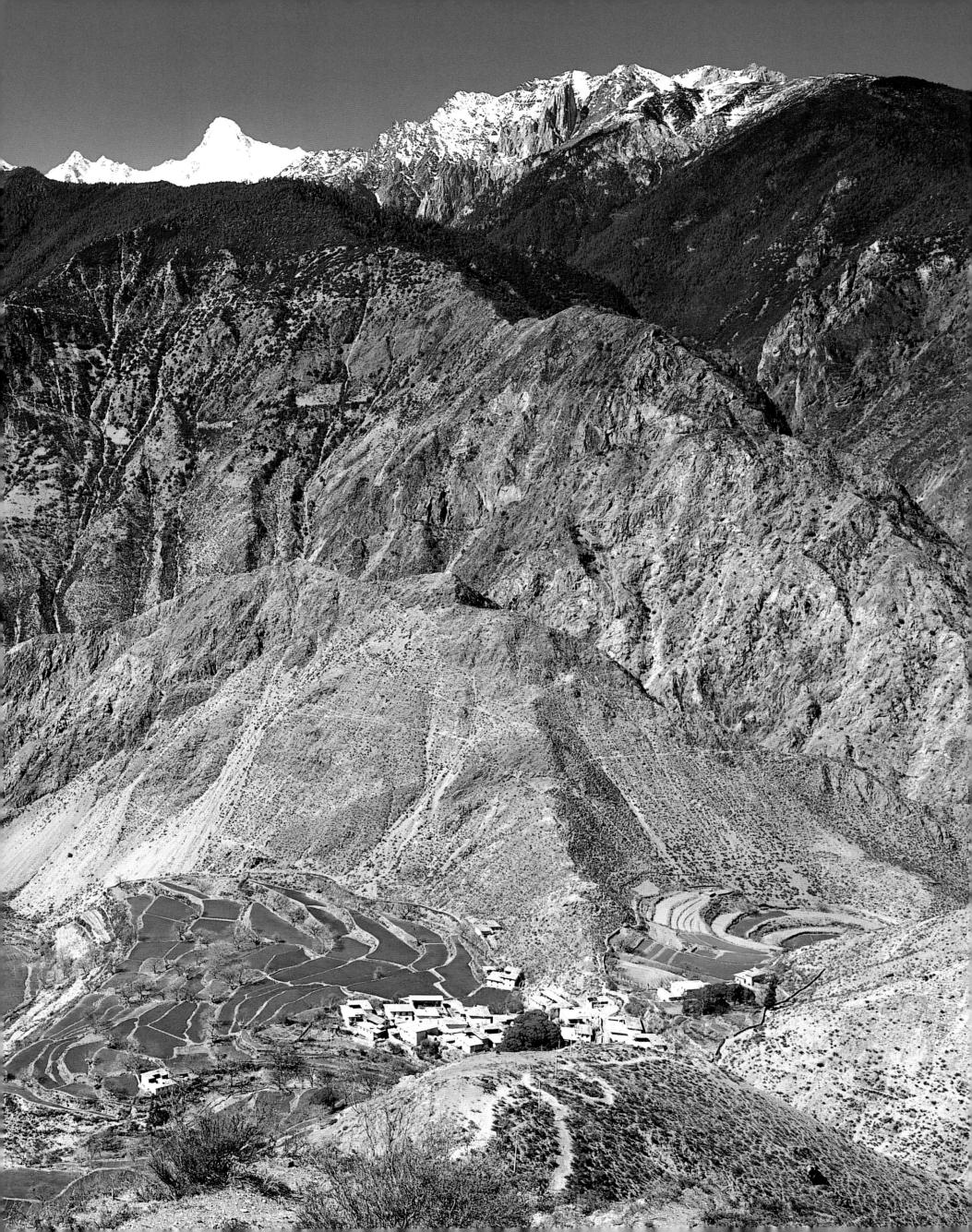

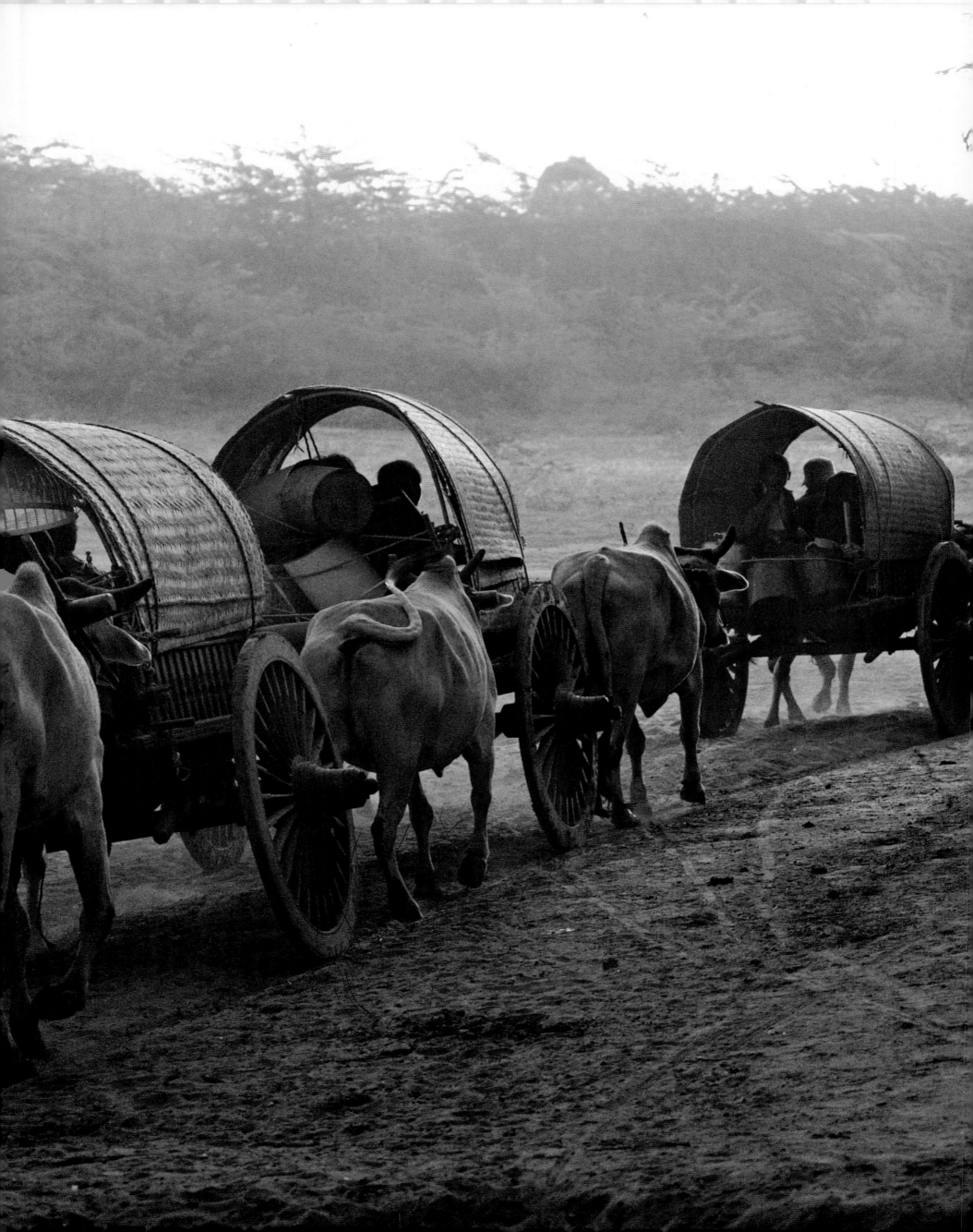

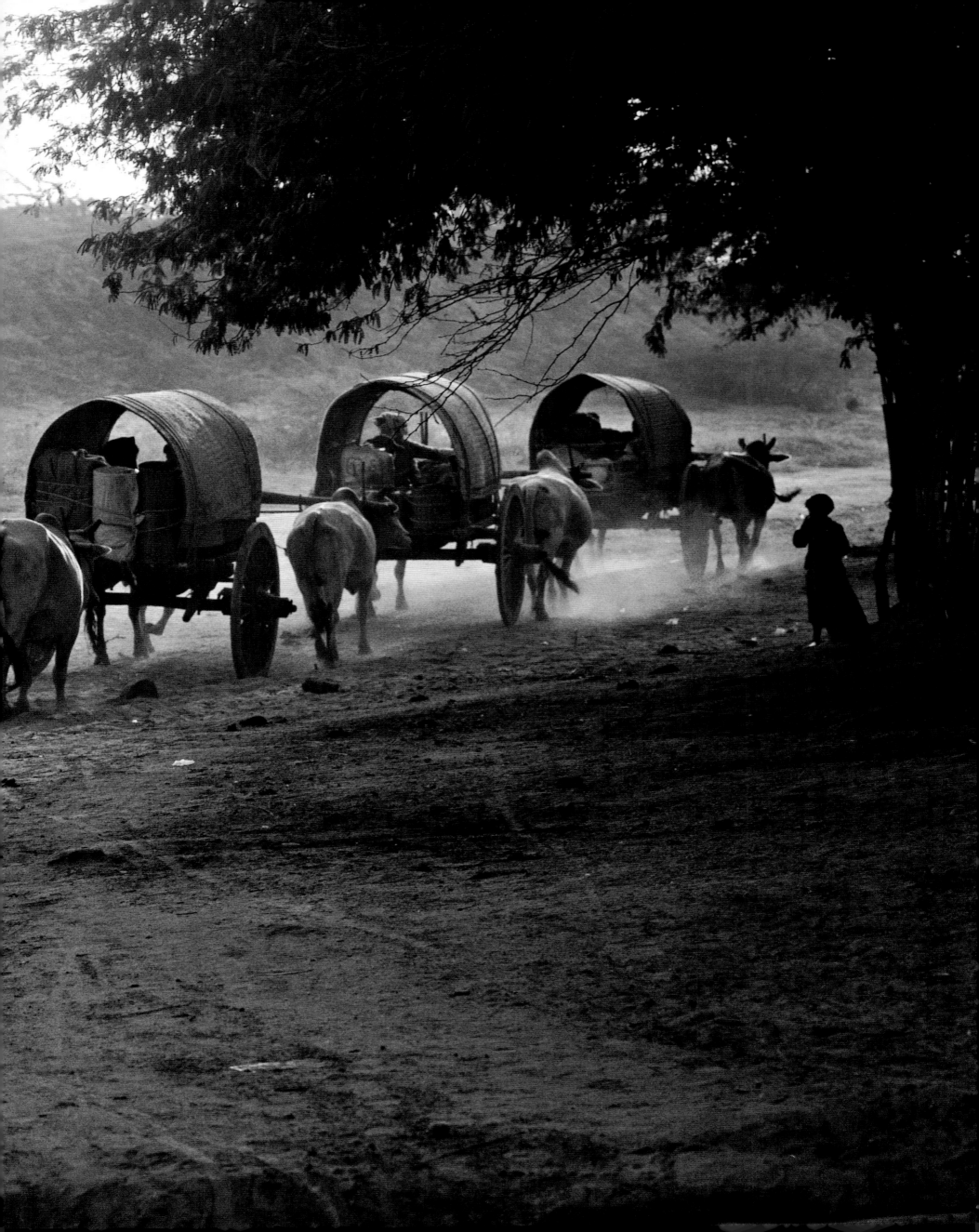

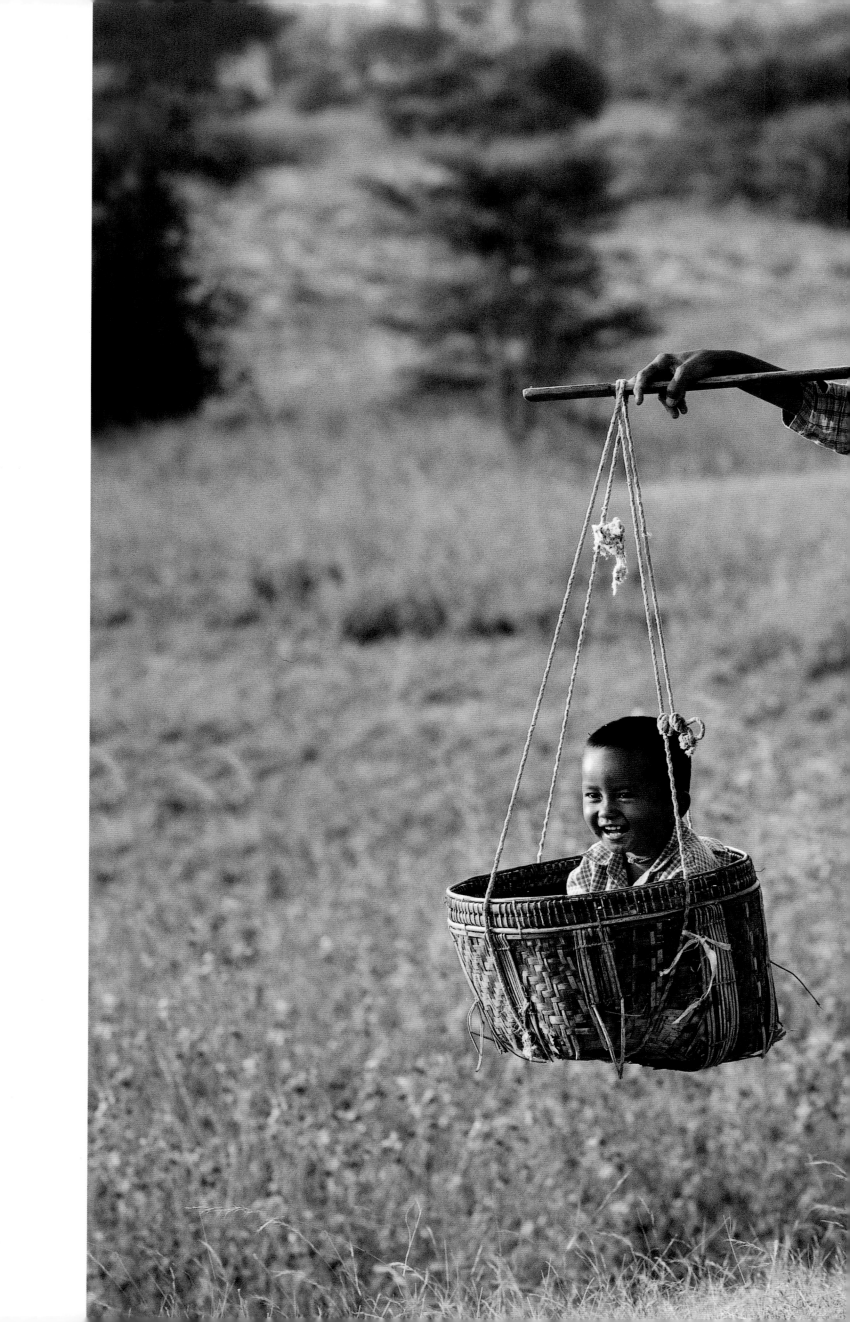

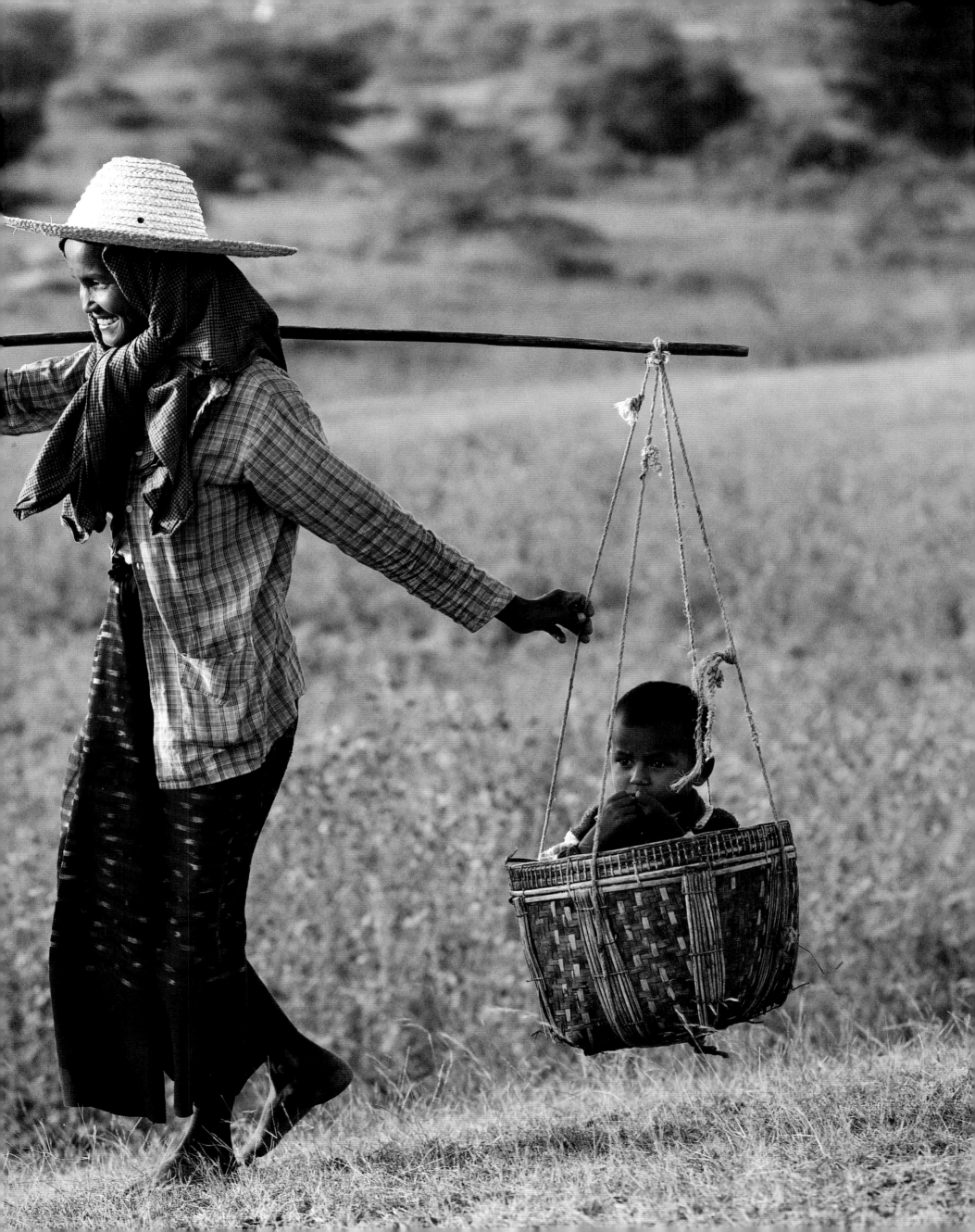

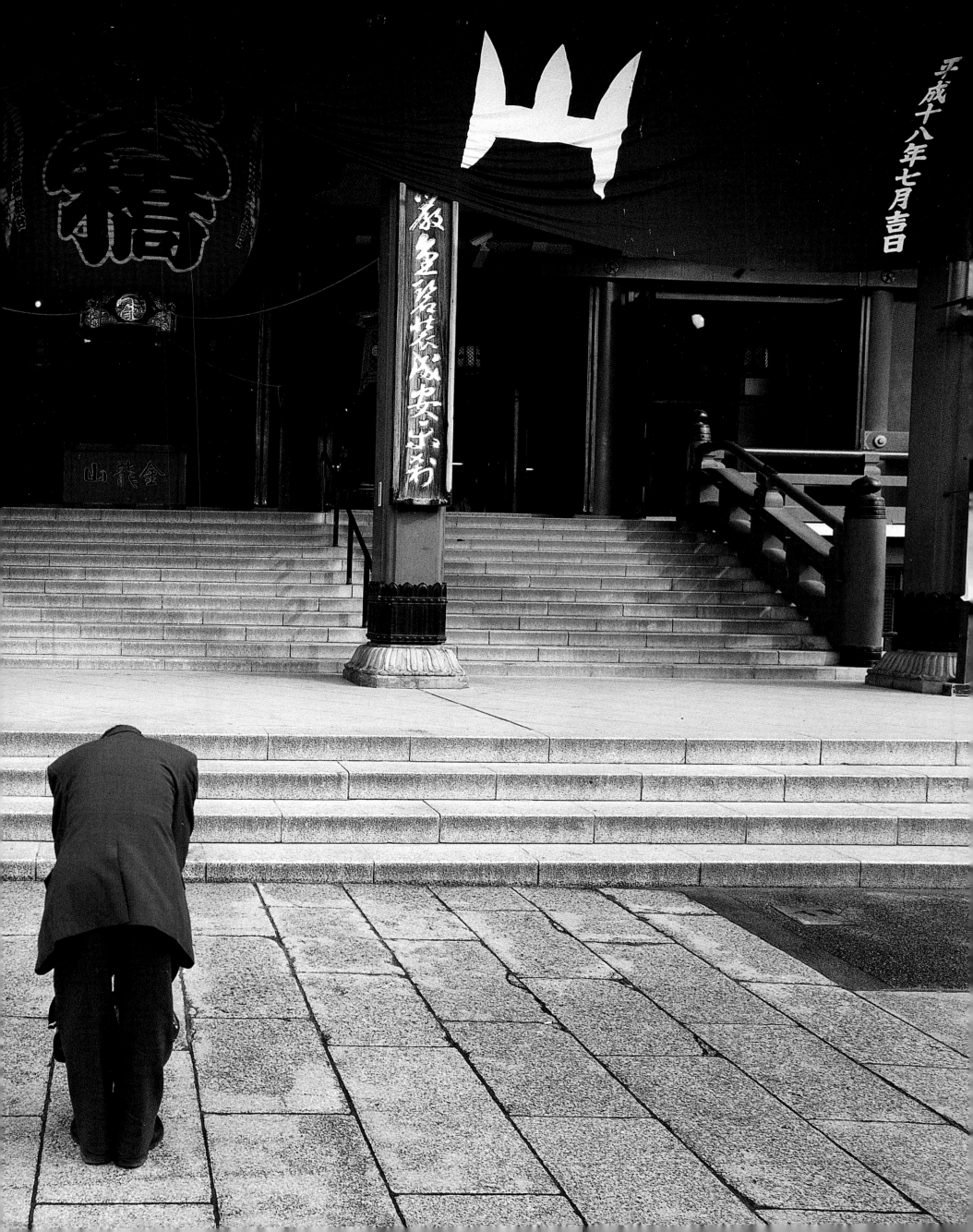

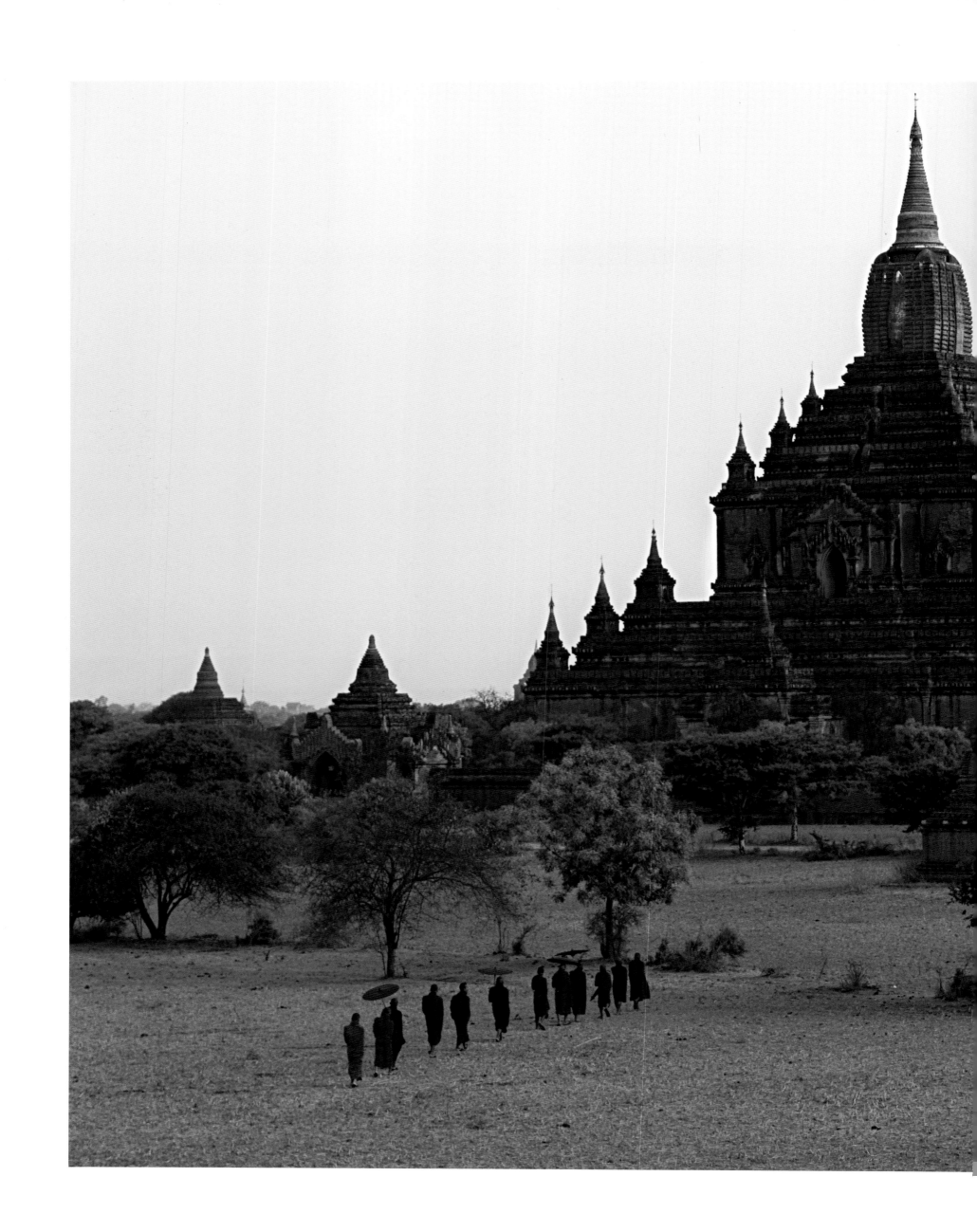

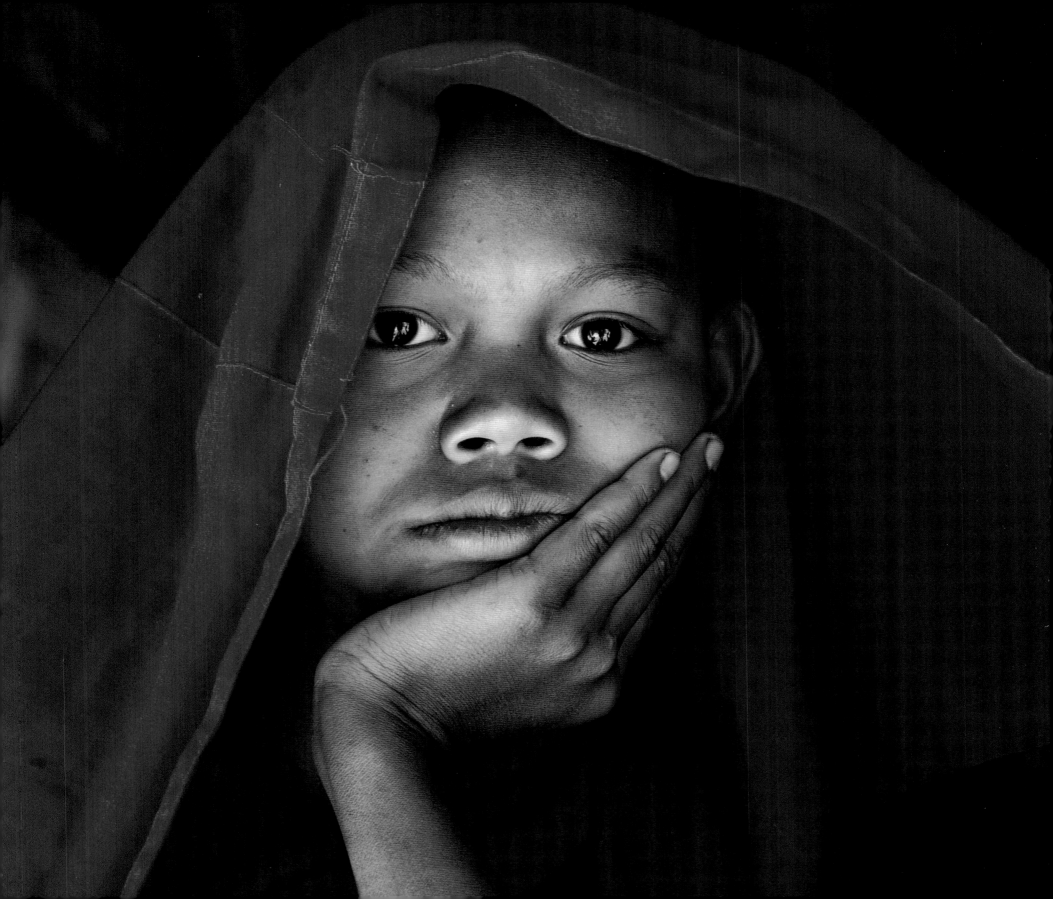

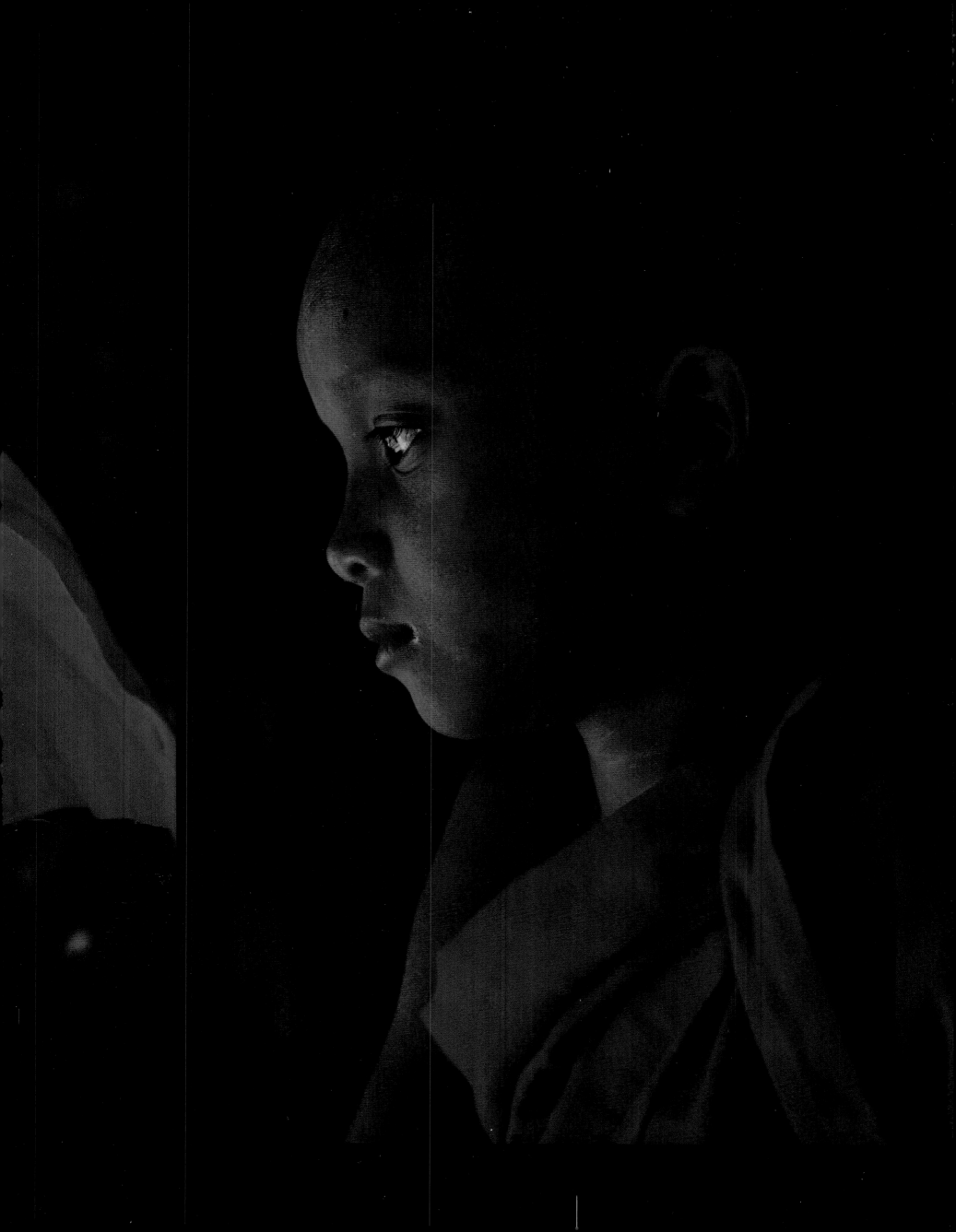

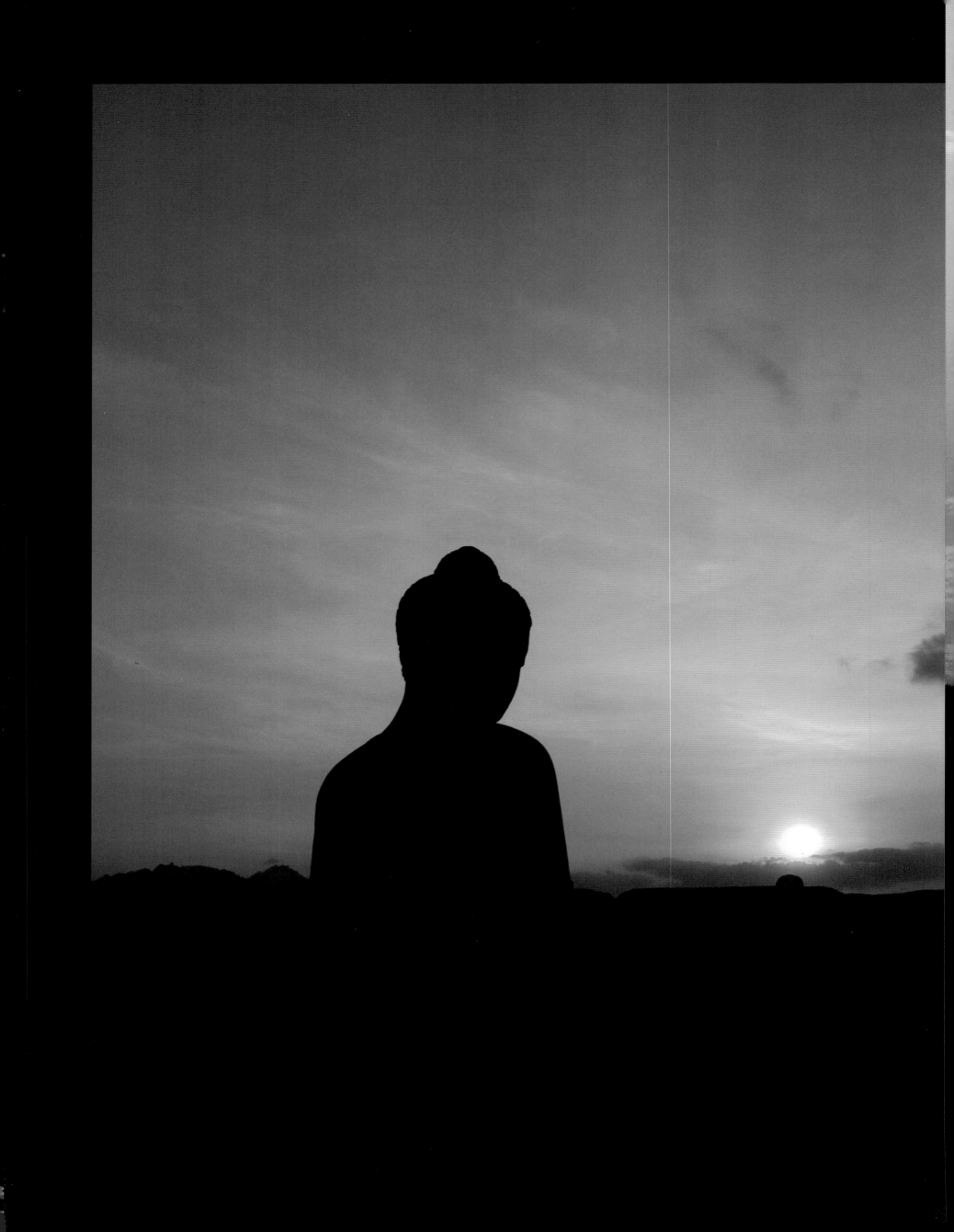

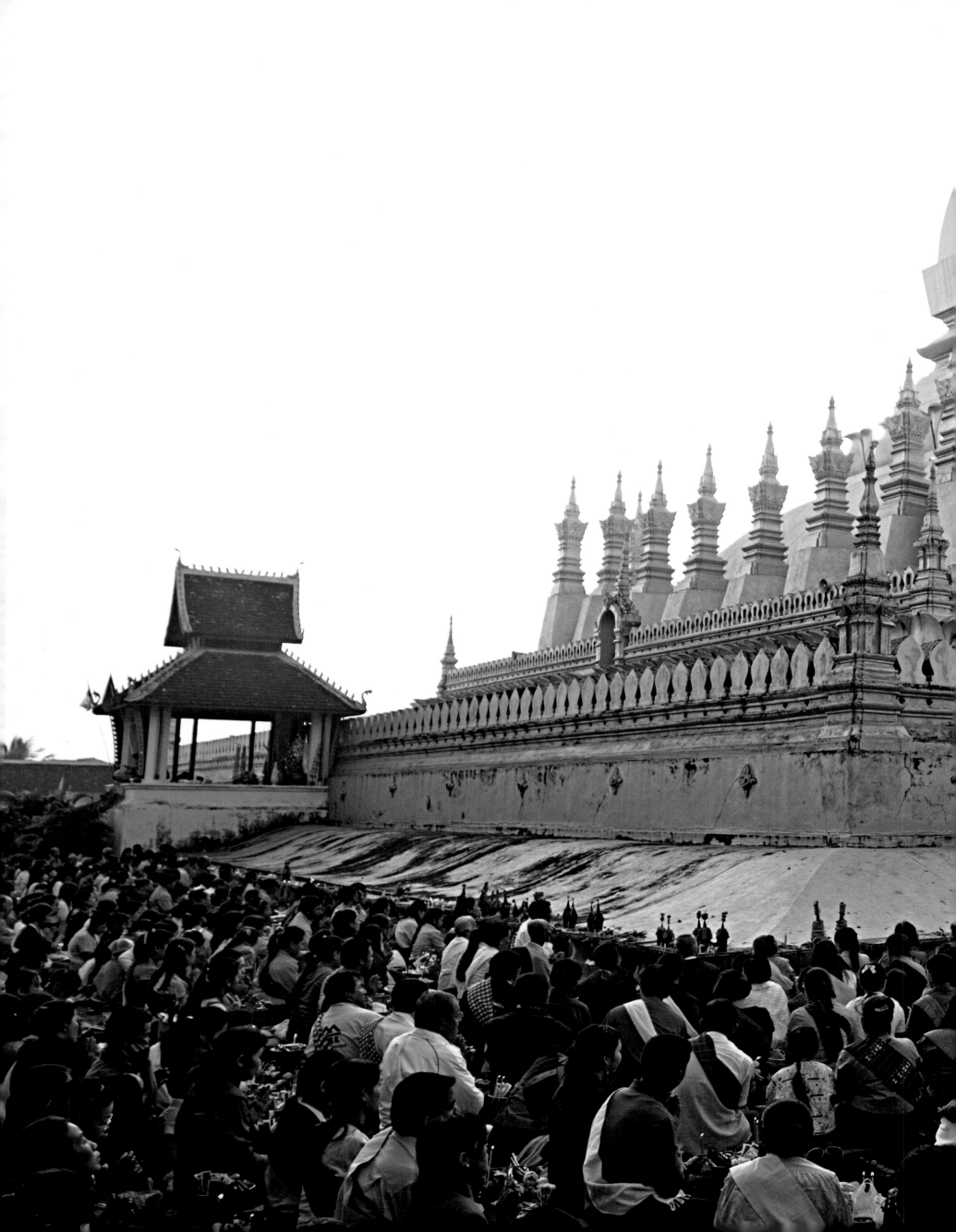

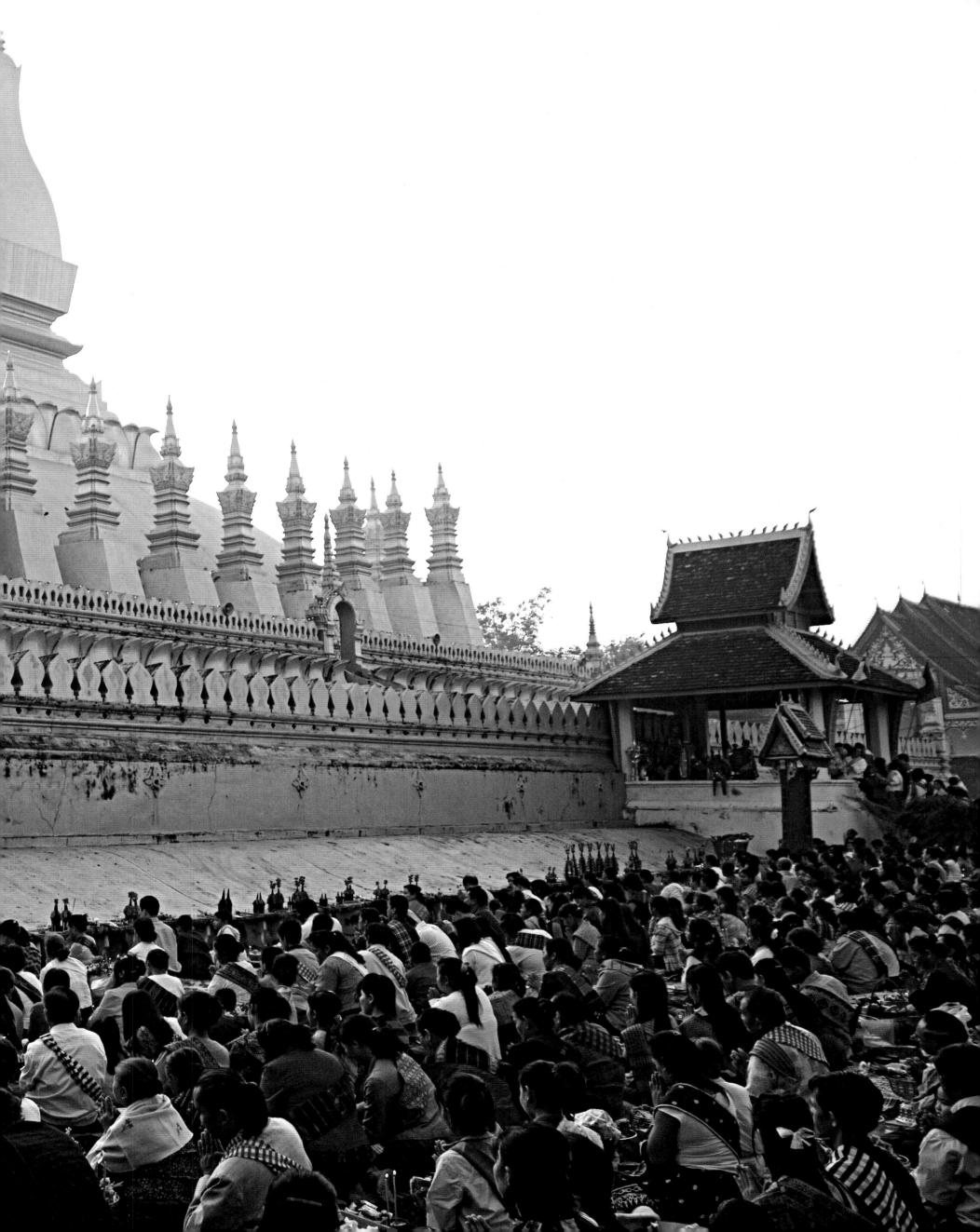

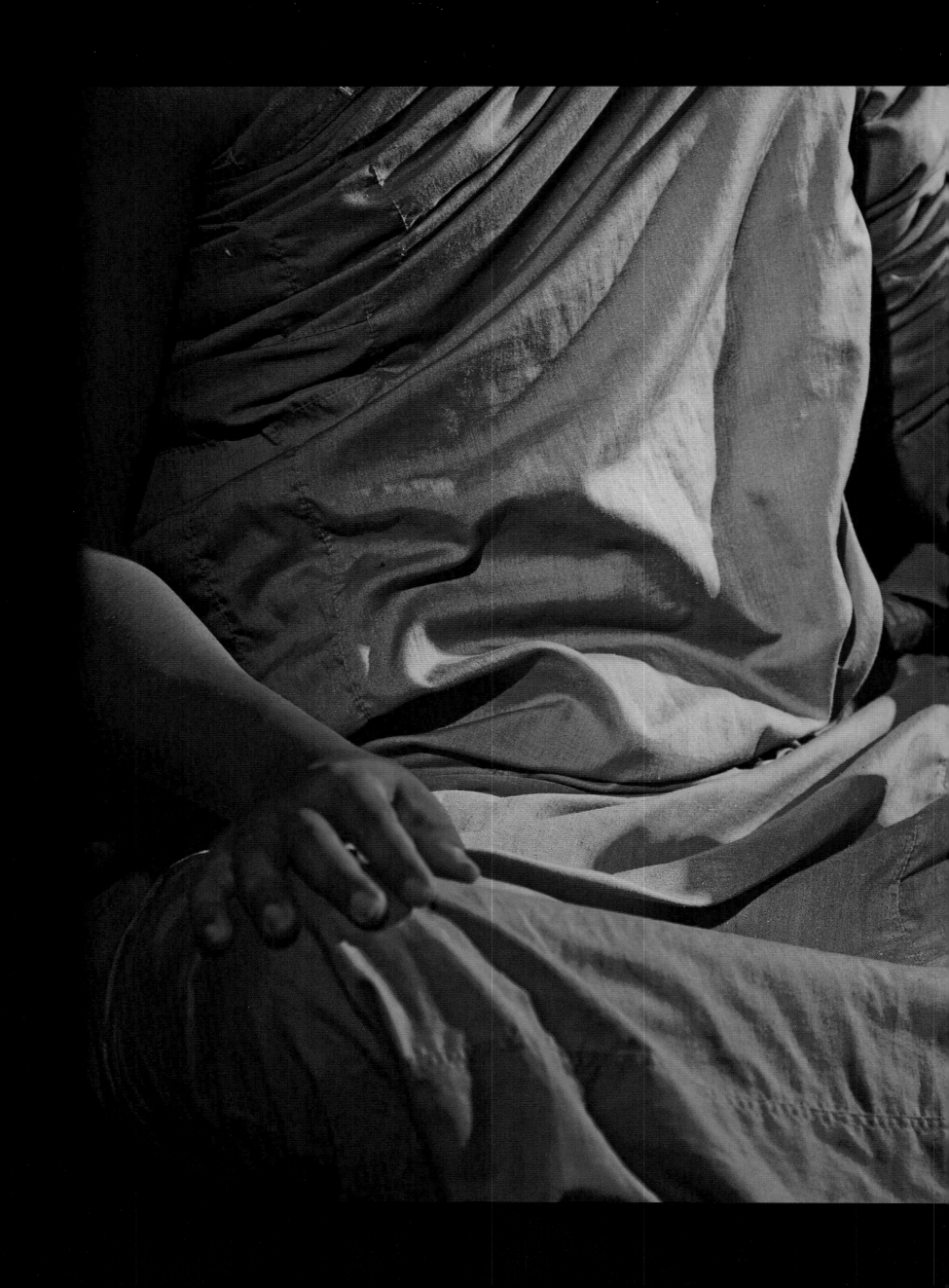

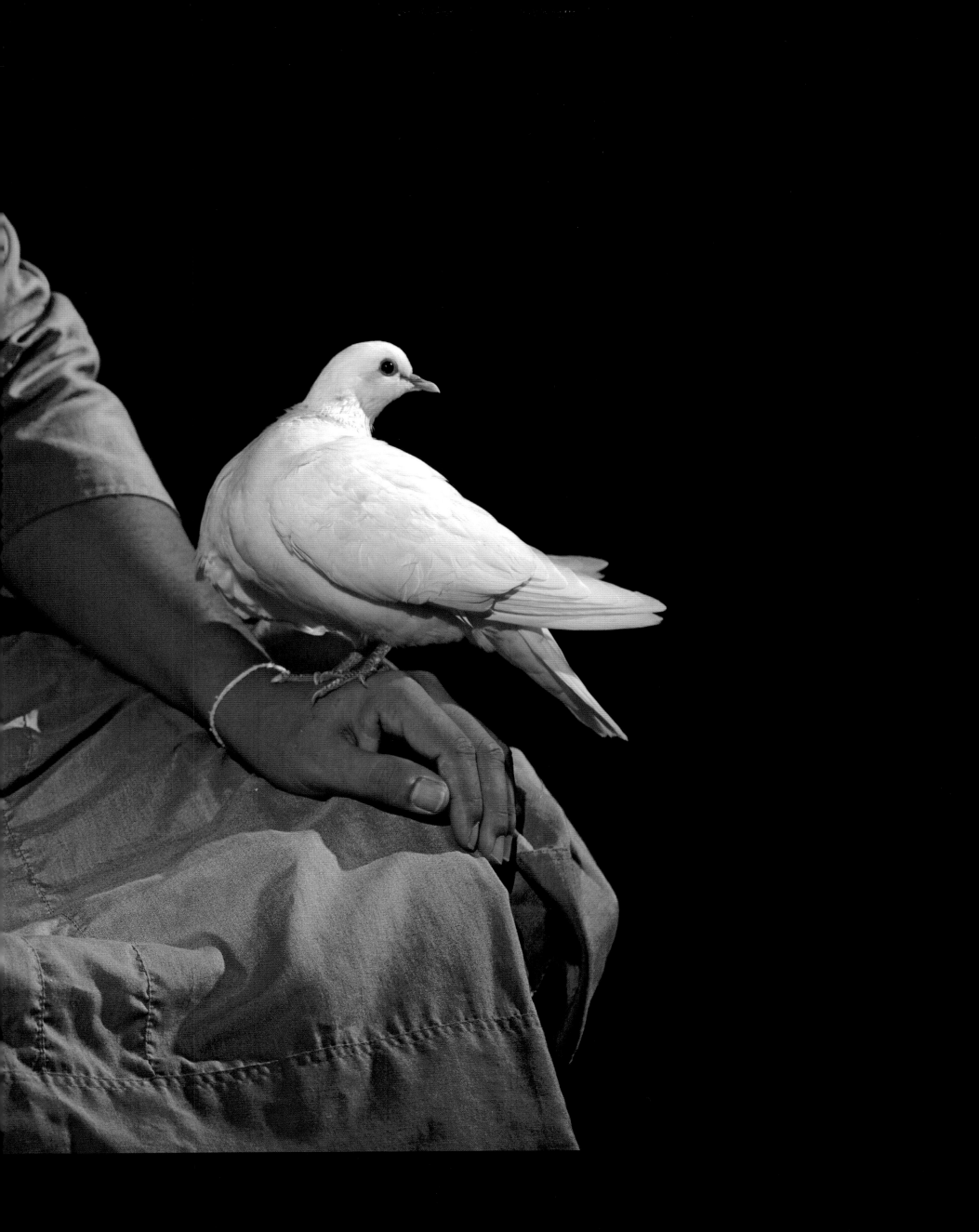

No other city compares to Bangkok—an ultramodern mecca of opportunity that still holds to a traditional way of life. The commercial centers of the city challenge the imagination in their displays of luxury, and to lose oneself in their gleaming towers is a great delight. The city is a hive of activity, a microcosm of the world, and each district is its own journey. There is no danger in the streets, where the people are calm and peaceful. Expressions are sometimes neutral, but never unfriendly, and smiles are often exchanged on the street. An elderly monk enters the subway: Someone gives up her seat for him. On the sidewalk, if space is limited, people step to the side to let others pass. At eight o'clock and six o'clock, in public places, everyone stops to listen to the national anthem, broadcast over loudspeakers. In the movie theaters, no movie starts without honoring the king, and it would never occur to anyone to talk over the homage or ridicule it. These daily courtesies make Bangkok extremely pleasant and humane, and this is why I have chosen Bangkok as my base for the eight months of traveling that will radiate out from it, from Thailand to Japan.

Japan: Art and Rigor Japan is a youthful dream, and Danielle and I go there as if on a honeymoon. On arrival at the airport in Tokyo, everything seems simple and clear: The city is a paragon of modernity. However, once you immerse yourself in this country, things begin to seem more complicated, and you realize that in Japan everything must be learned again, as everything is organized around courtesies. Nowhere can the meaning of the word civilized be more appreciated than in Japan. In Kyoto, during the festival of Jidai, thousands of performers and more than a million spectators overrun the parks and streets. Everyone patiently awaits the hour of the parade, without any uproar. In tranquillity, everyone eats, nibbles, and drinks from disposable containers. When the parade has passed by, when the streets are empty, it isn't necessary to clean up the city: no paper, no trash, nothing left behind. In Tokyo, on the sidewalks, pedestrians obediently wait to cross the street. A gloved policeman directs the traffic that calmly passes by. He stops traffic, turns to the passersby and nods as if to thank them for their patience, and everyone walks across. In Japan, no one need be on the defensive: If for some reason you should forget something somewhere, someone will bring it to your hotel. Stealing is an unconceivable shame, and in the cities, bicycles have no padlocks. Danielle and I have photographed the cherry blossoms in one of the great parks in Tokyo, among the thousands of city dwellers who also came to admire the trees in bloom. Tired of carrying my backpack, filled with heavy photo equipment, I left it lying under a tree in the middle of the crowd, and we left, unencumbered, to walk around for two hours, returning to find my backpack and my equipment untouched. . . . Japan is the only country in the world that offers such quality of life, such manners. And if I love this country so much, it is because it is also the kingdom of the photographer. Japanese people take photos and love photography. They are interested in the equipment, generous with advice, interested in the opinion of others. Photography, in Japan, is a collective pleasure.

We take the train to Osaka, then to Koyasan (Mount Koya), one of the most spiritual places in Japan. The ticket collector comes into the car, removes his cap, bows to the passengers, checks their tickets. When he leaves, he turns around, removes his cap, and bows again to the passengers. At every station, the train arrives on time to the minute; the passengers stand in line and get on one at a time, like robots. I am fascinated by such discipline. But does such regimentation allow enough room to adapt to the unforeseen? In India, one day, I was waiting for a train on a platform with thousands of others. The loudspeakers announced that the train would be delayed seven hours. Without any sign of irritation, all the passengers laid pieces of cardboard or newspapers down on the floor, unfolded their shawls, and went to sleep on the platform. But in Japan, the country is so organized, the culture so encoded, the people so disciplined, that the unforeseen seems unimaginable. Just as the gardens are perfectly clipped and weeded, nature tamed, the people are apparently made to format. When, after a train trip with many connections, we arrive at the top of Koyasan, we are force-fed secondhand travelogues and canned information. We are smothered in strictness. But we are not Japanese enough yet; we react as individuals, we are not integrated into the group. Because of its strictness, Japanese society offers the same freedom to everyone: the respect of all. The monks of Koyasan teach us

by example how much an implacable discipline creates a comprehensive flexibility, on the road to deliverance.

In the tall forests of black cedars, at nearly 3,000 feet above sea level, the various temples of Koyasan form the most venerated Shingon Buddhist site in Japan, visited by more than a million pilgrims each year. The first sanctuary of the site was built by Kukai in 816 AD, and became the center of the Shingon-shu sect, followers of an esoteric Buddhism. Mysterious, often shrouded in mist, a vast necropolis holds more than 200,000 tombs scattered throughout the cedar forest, where the most powerful families of Japan, samurais, and numerous unknowns have been laid to rest. Distributed over the plateau are more than a hundred temples, where the mandarins officiating are enrobed in silence and shrouded in mystery. We are housed in the temple of Rengejoin, set in the middle of a garden sculpted by centuries of discipline, nature tamed and clipped. A monk in gray robes gives us black slippers, and leads us to a room with white paper walls striped with bamboo. Dressed in kimonos, sitting on the beige tatami, we sink into a silence of another dimension. We stop talking.

A gong sounds to announce that the dinner hour is approaching, a single blow that vibrates for a long time, breaking the silence, summoning our thoughts back to the surface. We descend the creaking steps to the softly illuminated wooden chapel. It seems that we are alone as we sit in the half-light, but facing the altar, a monk, as motionless as a statue, is meditating, so silent that we did not hear him arrive. We stay there a long time, then go to dine in the great bare room that has been assigned to us. In the center is a minuscule wooden coffee table enthroned like a sober work of art; two flat cushions are set on each side of it, and there we kneel. A monk, so silent that we do not hear him coming, softly places before us two plates and retires without a sound. On the lacquered burgundy plates are arranged a black-lacquered bowl with lid, two sets of chopsticks, and two small plates, also lacquered black, on which are arranged some vegetables, like a subject for meditation. We contemplate our vegetarian plates—prepared in a tradition that is twelve hundred years old—for a long time before daring to take a bite. During our meal, a young novice has prepared our sleeping arrangements on the hard floor, unfolding two comforters in our paper-walled chamber. . . .

It is a restless night—too much emotion, too many thoughts; I am shaken up by the energy that pervades the somber forest and fills the monastery. At five in the morning, we return to the chapel, where four monks are already meditating. The silence sweeps us away on a profound voyage, where our senses pour out into space. We are receptive to the smallest breath, to the leaf that the wind sweeps across the balcony's deck boards. The world reveals itself perfectly to us. Suddenly, I become aware of a continuous low-pitched, vibrating sound; I can't quite identify it, but it captivates me. Finally I realize it is a water pipe! A lesson: Everything becomes sublime when the spirit is willing. Silence returns stealthily. The day begins like a soft prayer. The four monks chant their welcome to it in unison, receiving the day into their temple and in the mountain, in a low, sustained voice that summons up the first days of creation. We return for a lunch that looks like a work of art, with black-lacquered chopsticks. Then, in the mist, we leave for our encounter with Koyasan.

In the forest, autumn has created a festival air: The leaves of the trees outdo each other in color, from soft green to deep red, from golden yellow to the black of branches that, glistening in the rain, tilt down to give homage to the steles, to those who create history. Soft mosses collect on the stones and roots. Mankind, in death, rejoins the divine essence of nature. In the cemetery, we commune with the trees, the leaves, the moss, and the branches all morning, in an atmosphere of peace and of impermanence. We then try to catch the train, but are fifteen seconds late. It has already left. . . .

China: Center of the World

I expected to be surprised in China, but my expectations were largely surpassed, both in my hopes and in my fears. I was prepared in advance to dislike China, remembering earlier trips in 1984 to a Communist country oppressive in its indoctrination and in its "reforms." No one took the initiative; uniformity was obligatory; having a bicycle constituted a social promotion; the people were without joy. The foreigner was a curious animal to be openly mocked, and I endured the unhappiest experience I've ever had traveling, crossing the country as best I could manage with limited means. To obtain the smallest

piece of information required lim-
itless patience, and I confronted incessant
vexations and obstacles. I detested this stub-
born, dirty, ignorant police state.

Twenty years later, a completely transformed China
offers me a lesson in life as nowhere else ever has. Freedom to create,
to develop, has restored to its people a legitimate craving for life, and the
cities are booming and dynamic. Above all, China has built, developed itself,
organized to stretch out its commercial tentacles. Confidently, this effervescent country
is flexing the muscle of its vast numbers, and rejoicing in its renewed culture—the Middle
Kingdom regained, the new center of the world. English is spoken little here: This dialect hardly
interests the storekeepers, quite enough occupied with their more than a billion clients. On the chess-
board of the world, China moves its pawns briskly, and it's not a stretch to believe that the universal language
might soon become Chinese.

I meet up with Liao Yi Lin, my interpreter and guide, in Shanghai, an influential city that commandeers all of the
senses—imposing in its height, its numbers, its energy, its strength. On the facades of the skyscrapers in the Pudong district, on
the other side of the Huangpu River, sparkle frenzied advertisements, symbols of an arrogant capitalism that flaunts itself in lightbulbs,
neon, and lasers. On the boats on the river, gigantic luminous signs trumpet the luxury of the most prestigious brand names in the world. In
this profusion of ostentatious lights, on The Bund, the grand pedestrian boulevard along the river, a dense crowd strolls about, easygoing, in fam-
ily groups. Itinerant vendors offer an array of trinkets, gadgets, plush teddy bears, brilliant balloons. On Nankin Street, the crowd consumes every-
thing it can get, as if to make up for lost time. Undeniably, the twenty-first century was made for Shanghai.

At dawn we go to Lu Xun Park. The city is already abuzz: In Shanghai, life never stops. In this vast park studded with great groves of elegant-
stemmed bamboo, thousands of people celebrate the new day, each according to his or her own inspiration. Lined up in a row at the edge of the
pond, people are fishing, lost to the world. Others write calligraphic poems with large brushes on the concrete pavment. Groups practice kung
fu, in military cadence. In a square, under the hundred-years-old trees, three groups dance in couples, as if at a ball. Each group waltzes to the
sound of a different popular song, broadcast on three separate amplifiers. Nobody seems to mind the clash of the music: They are all in their own
universe, dancing to the rhythm of the music that they want to hear. Every morning, professors teach free dance classes to the unemployed and
to the retired, who start their day with ballet. Elsewhere, a group plays cards under a pagoda whose roof curves up elegantly at the corners; oth-
ers walk backward, as in meditation; under the weeping willow, people have come together with their caged birds to appreciate a concert. In a pavil-
ion, four people play the mandolin, while others listen. Lu Xun Park is a delight, a lesson in the good life, in how to exist for yourself, according
to your own inspiration, yet in harmony with others.

In the historic city of Suzhou, the Humble Administrator's Garden is one of the four most celebrated gardens in China. In Suzhou during the
Tang dynasty, Chinese gardens explored the philosophical concept of harmony between sky and man, re-creating the natural landscape in minia-
ture. "Change the scenery at every step" is the rule; and at every corner a new tableau appears. But the crush of visitors is enough to spoil
all my pleasure. Following one another shoulder to shoulder, from the entrance to the exit, Chinese groups follow their guides, who
describe the art of the gardens by shouting into microphones that broadcast their voices on speakers suspended from their
backpacks. Faced with such bedlam, I just want to retreat to the countryside. Liao Li Yin suggests we go to a village an
hour and a half from Suzhou. The prospect of fleeing the crowds to discover rural life tempts me, but I become
disenchanted by the tollbooths situated at the entrance to the village parking lot, where the cars are packed
like sardines in a can. . . . The reputation of Zhouzhuang has skyrocketed since 1984, when the
painter Chen Yifei made the town's Twin Bridge the subject of his famous painting *Memories
of Hometown.* On the canals, boats are at a standstill; families and couples enthusiasti-
cally photograph themselves on board, from every angle, with their cell
phones. Along the canal, the packed restaurants offer fish, crab, and
turtle. At the Buddhist temple of Quanfu, reconstructed in
1995, eight monks with cigarettes in their mouths
shield the chapel from curious eyes. However,
both tourists and inhabitants are gentle,
courteous, quiet. It is the proud
and smiling China,

300

happy to travel, happy to buy, rel-
ishing free life.

Leaving for the massif of Huangshan, I am
glad to rediscover wild, untouched nature. With its
twisted pines jutting out from granite peaks swathed in mist,
Huangshan is one of the chief inspirations for Chinese painting and
literature. Thousands and thousands of steps climb up and down the
painters' mountains, in a sublime landscape. Thousands and thousands of people
climb up and down the sides of these mountains. From one summit to another, in front
of the pine trees that salute the abyss and the breathtaking peaks, the guides praise the seren-
ity of nature . . . blaring from the speakers hanging from their backpacks. I have reached the end of
my tolerance. We take the train to Guilin, an inch or so from Wangshan on the map—and yet the voyage
takes twenty-three hours. Always excesses, without end. Guilin is a vast discotheque where tourists on their way
to walk along the Li, the river of painters, drop by. A succession of sightseeing boats passes on the river, their speak-
ers booming. We think we'll escape into the hills of Longji, known for the magnificence of their terraced rice fields. As with
all the tourist attractions in China, the logic is the same: an entrance fee, large parking lots, group leaders holding up signs, guides
equipped with their obligatory speakers. We decide to flee the crowds, to sleep in the village, to walk away from the well-lit paths. For
three days, I finally discover the China of my dreams: peaceful, traditional, profoundly human.

Filled with enthusiasm by the rice terraces and the splendor of the labors of mankind, I leave for Yuanyang with Noonie, the assistant who has
been with me since Bangkok. The hills of Yuanyang are a veritable work of art, two thousand years in the making, sculpted into an infinity of ter-
races. At sunrise, an abstract calligraphy is traced on the hillsides. On one of the dark curved lines of earth separating the terraces flooded with
water that reflects the sky, a minuscule farmer and his water buffalo work a parcel of land. I am enthralled . . . but I am not alone: Every day, at
dawn, hundreds of Chinese, Korean, and Japanese photographers descend to spread out over the slope a forest of tripods. On every level,
Yuanyang is a dizzying experience.

We return to the deep gorges of Kham, where the three great rivers of Asia meet. I am delighted to meet Tibetans, a people with whom I have
spent many happy years. At nearly 10,400 feet above sea level, Zhongdian, the portal to Tibet, is a peaceful little hamlet that is nestled in a valley
of flowers in the summer. In this region, Tibetans, Lisus, Nakhis, and Yis live peacefully, in harmony with nature. But soon there will be direct
flights from Bangkok and Singapore to Zhongdian. The government is determined to increase national tourism, to the tune of hundreds of thou-
sands of travelers, at the expense of these minorities. In China, things are not done by halves.

After two days on the road, following the curves of the earth along one of the great sinuous arteries of Asia, we come to a little village
perched high on the Yugong. At the bottom of the valley, along the brown waters of the Mekong River, we have to look high up to make out the
soft blue of the sky. A bold feat of construction, a road climbs up the steep slope. Every hairpin turn brings us closer to the still-distant sky. Below
us, the river is a slender thread nestled in the valley; yet we are only halfway up. Higher, much higher still, snow-capped peaks are buffeted by
the wind. Duji Kanzhu awaits us on the side of the road, dressed in his large Tibetan coat and pink vest. With two soft hands, he wel-
comes us with his broadest smile. How I love this world, simple and direct. Following his horse, which carries our baggage, we walk
up to Yong Zhi, isolated at the bottom of a little valley, where we will celebrate the Tibetan New Year. We spend three days
with the villagers, who dance around the *chorten*, clothed in thick coats and wide, colorful belts, wearing big hats of
snow leopard fur. On low stone walls, elderly women in red shawls pray softly while turning their prayer wheels.
Beside them, a young girl talks on her cell phone. Tibet, like the rest of the world, is being transformed.
My deepest wish for this China, new and full of hope, would be that its government would
accept the spiritual authority of the Dalai Lama and allow him to return to his country. This
decision would point to a changed China, its overture to the world. It would be the
greatest gift to the Tibetan people—a page finally turned.

Laos, Blessed by God
I had barely arrived in Laos,
in Luang Prabang, when I was already settled in, ready
to live there. This little town, which invites
a leisurely stroll, is tucked between
two rivers that protect it like
cupped hands. The

peninsula, a lotus tip set in a vase
of sacred water, unrolls like a ribbon of
pious images. Temples, adorned with gold and
with frescoes recounting the life of the Buddha, line its
two streets, their red-tiled roofs soaring into delicate points,
as if sending up a greeting to the sky. In the shaded courtyards of
the temples, under the broad, green leaves of the mangrove trees, monks in
bright orange robes read prayers from parchment scrolls. In the adjacent schools,
masters teach young novices with shaven heads the truths that have been declaimed for
twelve centuries. Everything seems to praise the gods in Luang Prabang, and the city is
blessed. At dawn, every morning becomes a prayer when, in silence, hundreds of monks make their
tour of the city on bare feet, in single file. Impassive, they carry black platters, which they hold out with
both hands to receive offerings of nourishment from the inhabitants, who stay up at night to cook. The monks
beg in humility and are grateful for what is offered them, usually rice, for their only meal of the day. Every morning,
I am in position before dawn on the long street to immerse myself, in rapture, into this scene of the time of Buddha. The
sleepy city is deserted. One by one, silent shadowy figures flow through the side streets and crouch to sit along the sidewalks, hug-
ging their offerings to their bodies. The day brightens below the grand trees and the peak topped by the temple of Wat Sensoukharam:
Down the road appears a procession of monks, like an apparition. A group of draped silhouettes emerges from the entrance of the first
monastery, then a second, then a third. In silence, in a graceful single-file line, the monks slowly file past the ancient whitewashed walls, stopping
beside the villagers, who, kneeling, hand out their offerings. The silent ceremony is celebrated by the singing of birds, and little by little, the day
breaks forth over Luang Prabang, as if curtains had been pulled back to reveal a devotional scene out of a wonderful fairy tale. Luang Prabang
basks in the tranquillity of its monks, in the devotion of its inhabitants. Here one can disregard the passing of time; this town is protected by the
gods for eternity. It is so unique, so precious. . . .

With Diskit, who is both my daughter and my assistant, we charter a flat-bottomed motorboat for a week to travel back up the sluggish
Mekong, then its more impetuous tributary, the river Nam Ou. How far up are we going? I have no idea. I hope to discover villages, meet people
on the river. I love to take off on an adventure like this, boat up a river not knowing where I will stop, eat, and sleep. Traveling this way, leaving
everything up to the gods, encounters are sweeter. Studded with rapids, the Nam Ou winds its way down the bottom of a deeply wooded valley,
secluded from the rest of the world. All along it, bare-chested fishermen in dugout canoes cast their nets out into water that reflects the black
shadows of the mountain. Sometimes we pass a water taxi that snakes through the rapids, filled with ten passengers who sit quietly on the tiny
wooden seats. Our boat is so small that navigating it is child's play. Thongbay, our captain, has brought along his beautiful young wife so that she
does not have to be alone for a week. I love this quiet little couple at the front of the boat. Thongbay, with a look of concentration, holds the wheel
with both hands to show everyone how important his job is. Seng, sitting at his side, is wise and in love. It is their first trip together, the first time
that he has shared his work, the first time that she has seen her spouse in his role as captain. With a furrowed brow, she scrutinizes every eddy
on the river so she can conscientiously point out treacherous rocks to Thongbay. At a wide section of the river, he entrusts the wheel to
her; she takes it, flushed with a mixture of pride, fear, and happiness. Then she worms her way to the back of the boat to peel a
banana, taking it back up to Thongbay, who grabs it with one hand, not taking his eyes off the turbulent current. She then
settles down on the little bench, huddled against her husband, and the two gaze at each other with an intensity reserved
for the great moments of life.

We stop in a number of villages to sleep, docking in the afternoon, when the time and heat impose
a siesta, and leaving again the next morning. At Ben Sop Jam, we stay two nights, trading stories
around a fire with the village elders in a house on stilts. Specializing in woven cloth, Ben Sop
Jam is a fairy-tale village. A grand central allée of white sand is lined with banana
trees, alongside houses built on stilts. Villagers promenade there after a day of
fishing; women in colorful sarongs carry their newborn babies on their
backs; young children form a circle, shoulder to shoulder; dogs
play; men debate. The residents of Ben Sop Jam live
simple and happy lives.
On the other hand, in the village
of Hat Ya, set in dense forest
on the banks of the

river, we spend only one night, as it is impossible to sleep there. The villagers, very poor, have only recently arrived at the river, forced to leave their isolated mountain homes by a poor harvest. A more profound distance than those between the dark gorges separates us. Not used to strangers, and timid, the villagers keep their distance. Our dinner is a lizard grilled before an audience that watches for our slightest gestures in silence, by the light of the fire. Then we lie down on loosely joined boards in a house made of branches and built on stilts: Twenty people are crammed together in the tiny room holding our beds when we fall asleep. Our sleep is broken: Dogs howl at the moon, pigs grunt under the floorboards, mice fidget in the branches, fleas jump from bed to bed, cockroaches fall from the ceiling made of leaves. At dawn, eight people are still there to watch us get up. We eat a breakfast of slices of snake and return to the water—where our captain and his wife, having slept on the boat, greet us with broad smiles.

Laos moves me like a fragile child that I want to hold safe in my arms. There I find a people whose values are those of ideal villagers—honesty, hospitality, and devotion. Nature is wild, but the temples are highly civilized. Life is difficult, but the inhabitants are incredibly gentle. Their gestures are like caresses, their words are soft murmurs, their looks are filled with generous humanity. In Laos I experience the culmination of a quest that has driven me for thirty years of world travel. Writing these lines, I have the urge to leave everything, and to go back there to live.

Burma, My Love I first came to know Burma more than twenty years ago, and the authenticity of this country left a mark on me then. But at that time I was so hungry for life that I couldn't breathe, and my goal was to become a photographer. It was a first step: I didn't know yet that photography is only the means to offer yourself to an encounter, until you dissolve into eternity. Twenty years later, I find a different Burma. Has my trip to Laos stirred up my emotions, so I experience everything with heightened sensibility? On the first day, on my arrival at the airport, smelling the damp air, the dust of the warm plain, I am already bewitched, inclined to love everything. Arriving in Yangon, I go directly to the Shwedagon Pagoda to prostrate myself before the Buddhas. My trip to Burma is a journey of love, filled with an uncontrollable urge to act irrationally, my heart beating. Sometimes I try to pull myself together, tell myself in a low voice, "You're sinking into sentimentality, come back to earth." I set out in the early hours, determined to photograph in a more objective state of mind, to be more of a stranger to the country, but much more effective. Yet at night, I returned overcome by more unshed tears than film in my bag. Because of a woman, a man, a monk, a child, a family. Because of those exchanges of looks that seemed to stretch out in time, as if we shared something far more profound, far more ancient, much deeper, than a simple fleeting smile.

Before leaving Burma, I return to see the Buddhas at the Shwedagon Pagoda, so that I can thank them for having led me back to the life that I must live on this earth. What gives the people of Burma such sensitivity? Does their rural lifestyle allow them to develop a different rapport with the world, with each other? Blessed with plenty of time and no ambition, since no development is possible, they are not seized by desire for worldly things, and they privilege feeling over intellect. Their devotion brings them closer to the souls of the gods, detaches them from those restrictions that make people less serene, less free, more enslaved. I have a profound love for the people of Burma.

Covered in gold leaf, the Shwedagon Pagoda is the most beautiful Buddhist monument in the world. Built a century after the birth of Buddha, it is 2,400 years old. Under its peak hang more than a thousand little golden and silver bells beneath an umbrella, and a weather vane adorned with thousands of precious stones that sway in the wind. At its summit, 315 feet in the air, a golden globe is encrusted with 4,350 diamonds. Within the vast surrounding wall of the pagoda, tiled with white marble, hundreds of altars hold golden Buddhas, before which the devout pray, barefooted, offering flowers in clasped hands. A monk meditates in a niche housing a Buddha, as immobile as the statue turned toward the pagoda. Sitting cross-legged on the hot marble paving stones, an Indian yogi on pilgrimage is lost in contemplation of the sun in an ecstasy that takes him far from people and the world of suffering. Each of the devout forms part of the procession of tradition and of beauty, clothed in a sarong that all men and women wear with elegance. Inside the outer walls, a pagoda undergoing repairs is

covered in bamboo scaffolding, ready to be covered in new gold leaf that has been offered by the devout. I am given the chance to climb the scaffolding by Swe Zin, my marvelous guide and interpreter, with the consent of the person in charge of the Shwedagon Pagoda. Accompanied by a guard, I cautiously scale an immense bamboo ladder, held together by hemp cords, to the very top of the pagoda. I am face to face with Shwedagon, who dazzles me with his gold and his majesty. Far below me, minuscule, the pilgrims are like dolls that wander about in a theatrical set. Such beauty takes my breath away. In such emotion, I miss many photographs. Once I'm back down, we purchase several pieces of gold leaf to honor the pagoda and thank the gods for such a welcome: It is my first day in Burma.

Su Su, standing on her doorstep, looks at me fondly again. Clothed in a long, royal blue sarong that is taken in at the waist so that her body looks like a mandolin, a jasmine flower pinned in her long, jet-black hair, she is like a phial of a rare perfume. I can't bring myself to leave her, in her office where she extends a gracious hand, her eyes lowered, to give me my tickets for my flight to Mandalay. Su Su's eyes follow me during my whole trip, and I am delighted to meet them again on my return to Yangon. But Su Su no longer works at her office: In the meantime, her family has married her off to a mechanic who works on a freighter that crisscrosses the world. He brings back the money earned on his long trips and drowns in alcohol when he comes home, a life too hard. Su Su has cried in despair for three days. I go to Shwedagon to pray for her. The Burmese suffer: Their political regime is a disgrace. Since I first knew Burma, nothing has changed, or almost nothing. The country still lives as during the time of the first king: The people are enslaved. There is no freedom of expression, too few schools in the villages, too few health centers. The government helps only itself, and families must do what they can to get by.

Arriving in Amarapura, near Mandalay, I meet another Su Su, who becomes my muse and our guide. She is ten years old and wears trinkets. When I plunge into her big eyes, which are filled with infinity, I glimpse a world in which I can drown. We go along the teak bridge of U Bein, almost two-thirds of a mile long, which spans Lake Taungthaman. For two days, we live in contemplation, in harmony with the world, meeting villagers and monks that use the bridge, the fishermen who throw out their nets from their dugout canoes, the peasants who work the fields, perched on a wooden harrow behind their cows. Su Su accompanies me like a shadow, carrying the tripod and humming to herself. I love her because of her gaiety, her trust in life, which she revels in each day. When we part, tears in our eyes, it feels like losing a part of me.

In Bagan, I meet Phyu Phyu, who overwhelms my unconscious. The profundity of her look is so intense that it charms one into wanting to leave everything. I keep her near me like a divine inspiration. We spend five days carrying equipment in serene silence, punctuated with simple words. Her radiant presence illuminates my days: The light becomes divine, the villagers appear to me like the emanations of the Buddha, the pagodas of the Pagan plain offer an interior peace never revealed to me before, and the sunsets are of a dazzling harmony. Tenderly, Phyu Phyu carries my tripod and my film. My photos have more than one meaning: To be near her brings me closer to serene nature.

I leave Burma not knowing any longer who I am, lost to myself, searching for the true meaning of my life. I live too intensely there, in the heart of a humanity surrounded by the gods.

Thailand: The Messengers of Peace
I dream of photographing a scene that I have marveled at for twenty years: In the middle of the Shwedagon Pagoda, a monk is meditating, and a dove flies down to rest on his knee. The monk is so gentle that the bird ends up falling asleep. I don't want my approach to disturb this harmony, but I keep this magnificent image in my head.

This year, ever since I arrived in Asia, I watch out for this image in all of the pagodas that I have visited, but I have never come across that scene again. We then decide, with my assistant Noonie, to re-create it in a studio in Bangkok, in the heart of the frenzied city.

Together we organize this vision, no small matter: We have to find a dove that will let itself be placed on a monk who will agree to come. It is decided to ask this of a Thai monk, who commands the deep respect of the people. But Noonie, who always has a solution, asks his aunt to contact a monk who she has made a donation to so that he could print sacred texts. The master is in Cambodia,

on a meditation retreat: We wait a
week. Meanwhile, Noonie buys Piu Piu,
our model dove, who we set up in a large and
beautiful cage. Back from his retreat, the master ques-
tions me for a long time on the telephone about the meaning
of my photo, the message that it is to convey.

"Master Mahar Pin Buddawiriyo, I would love to make the image of
a man on the road to Awakening and of a bird that is the messenger of peace.
This image will help illustrate my Awakenings, bearing witness that the world con-
structs itself according to the goodwill of men."

The master accepts our invitation, and we reserve a studio. Noonie leaves to pick up the mas-
ter, two hours by car from Bangkok. During this time, we set up the lights, we arrange the backdrop. In her
cage, Piu Piu is in a panic. I warn the studio team, "We are going to receive a monk just back from his retreat.
On his arrival, we will only communicate through gestures. There can be no noise." But this advice is needless in Thai-
land: Respect for the monks is an obvious fact for all. Waiting for the master's arrival, I isolate myself to put myself in a pos-
itive emotional state, in a state to be able to honor him with harmonious thoughts.

Smiling, the master arrives, clothed in his flowing yellow robe. A profound sense of serenity emanates from him. Noonie gives him
a seat and speaks to him on his knees, in a low voice, his hands clasped together. In the same manner, I offer him a garland of jasmine and
roses. The master speaks in a soft voice, and his eyes travel far away: He is again in the world of his retreat. It is an effort to speak with him, as he
is not talkative, simply satisfied. I attempt to explain the photo that I want to create, but he stops me with a reassuring gesture and quietly rises to
sit cross-legged on the scene. We bring in Piu Piu, who bats his wings in his cage, and attempt to reassure the bird. A great silence penetrates the
studio: the master closes his eyes, lays his hands on his knees, with his palms turned upward. Every assistant is frozen behind the lights. We walk
with delicate steps. Only Piu Piu makes noise in trying to get away. We pose the dove on the master's knee, but she flies off. Immersed in deep
meditation, eyes closed, the master doesn't turn a hair. We fetch the errant bird from a metal beam, place her again on the master's knee. Piu Piu
flies away again. A wave quivers through the studio. Anxiously, each assistant searches for the dove. Again we get Piu Piu, who Noonie brings
round in the hollow of his hands. The master seems to have left himself, in a world far away from us. He is like a statue that seems to be alive,
that emits a vibration that is imperceptible but nevertheless pacifies us all. Noonie places the dove on the master's knee, like a delicate treasure.
Piu Piu settles down and begins to coo; she doesn't fly off again. An atmosphere of tranquil serenity flows through us, and we are transported
elsewhere. The studio becomes a sanctuary of peace. An hour, perhaps, passes in which nothing happens, nothing moves. We are able to spend two
or three hours thus: We are in another silence, another time. Piu Piu is asleep, her wings folded, on the master's knee.

I take my photos, those that I have dreamed of taking for twenty years. In my viewfinder, I let myself imagine that if the monk lifted his arm,
the dove would climb up into his hand; that would be magnificent. But in his meditation, eyes closed, the master has left us far away, and I cannot
reach him. However, a few minutes later, he turns his arm, so slowly that I think I am dreaming. Softly, so softly, as if he has no weight at all,
the master raises his arm, and Piu Piu climbs into his hand. Deep in his meditation, the master holds his hand out for a long time. A
thought occurs to me: Might this image be more meaningful with the dove standing on one of the master's knees? A little while
later, the master lowers his arm as lightly as a chicken feather falling to the nest, with the bird on his hand. He takes up his
initial position, and Piu Piu stands perched on his knee. Then, after a time impossible to measure, he opens his eyes
very softly and smiles at me. I put my hands together for a long time. I feel like crying.

Later, Mahar Pin Buddawiriyo told me that he passed on his thoughts to the dove when she was
placed on his knees: "As you are the animal and I am the human, we have been brought together
to achieve something important: We have been chosen, the two of us, as messengers of
peace for our world. This is the time to deliver our virtues, for you and me. We will
have to help each other." It is a blessed bird who, tamed, is willing to follow
these instructions.

Piu Piu has become the family pet of Noonie, who
opened his cage for him. The dove flies free, but
returns regularly, like a blessing.

—Olivier Föllmi

p. 65 BANGKOK, THAILAND. Tharistree Thangmangmee, a traditional theater dancer.

In the seven distinct genres that make up traditional Thai theater, four include dancing. *Khon,* or classical dancing drama, with its masks and very strict rules, represents scenes from the *Ramakien* (the Thai version of the Indian *Ramayana*) and originally was performed only at court. Lakhon combines dance pieces and Western theater. *Likay,* a kind of slapstick, improvised popular theater, uses dance and music. *Manohraa* is based on two hundred years of Indian history. The three other genres are nang yai, or shadow puppet theater, common in the south of the country; *lakhon lek,* the royal puppet theater; and finally the *lakhon phúut,* contemporary theater based on the Greek model.

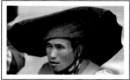

p. 66 THAILAND. Saeng Sae Kee (right) practices martial arts with his master, Sitta Wangtarawut (left). Asian martial arts are a very complete discipline, combining sport with philosophy and developing a harmony of body and spirit. There are dozens of styles, including aikido, jujitsu, judo, karate, kendo, kung fu, and tae kwon do, to mention only those that are known to the general public.

p. 67 THAILAND. Ta Thuy Chi writes "spirit" in ancestral Vietnamese script in a magnificent and acrobatic, choreographed calligraphy under the lens of a dumbfounded photographer.

pp. 68–69 YUNNAN, SOUTH CHINA. A Yi farmer at the Dali market.

The jewel of the south of China, nestled in the magnificent circle of mountains and surrounded with ramparts, Dali reaches 6,230 feet (1,900 m) above sea level. In the background the chain of Cangshan ("mountains green as jade") proudly claims the territory that it has held for five centuries during the independence of Yunnan. The best time to visit is the month of April, when people from all over Yunnan flock to buy, sell, and have fun at the huge market of Sanyue Jie, the fair of the third moon.

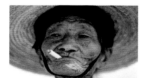

pp. 70–71 YUNNAN, SOUTH CHINA. In the Dali region, a weekly Nakhi farmer market.

Among the 39 million inhabitants that make up this province in the south of China, there are a large proportion of ethnic minorities. The Yi represent almost 10 percent; the Nakhi number less than 300,000. Descendants of the Qiang tribes originally from Tibet, they still live under the matriarchal regime that their language reflects: words with feminine endings convey a sense of the large, whereas those with masculine endings include a sense of restriction. For example, the word for "stone" plus a feminine suffix means "rock," whereas the same word with a masculine suffix means "pebble"! Their written language, a complex system of pictograms, is the only language based on hieroglyphs still used in the twenty-first century. A Nakhi man and woman are also free to become lovers without sharing a roof and common responsibilities. If a child is born of this union, the woman is responsible for his education and the man provides him with assistance, but only for the length of the relationship. The children then live with their mother, and their affiliation with the father is secondary. Nakhi women, heirs to all possessions, wear pants under a blue or black petticoat and a blue blouse, and are always covered with

a matching traditional cloak—its dark and light sides symbolizing the sky at night or in the day—to protect it from wear and tear.

p. 72 NORTHWEST VIETNAM, 60 MILES (100 KILOMETERS) FROM DIEN BIEN PHU. Phan Van Anh carries her twenty years with a joy that defies her difficult existence in Lai Chau, the little village situated at the confluence of the Song Da and the Nam Na, in the hollow of a magnificent and deep valley where she lives surrounded by dense forests, isolated from the avenues of commerce. Despite the increase in tourism, the inhabitants make a precarious living, their only significant revenue relying on wood and opium, two sectors in crisis, due to regular flooding from the Song Da, a dramatic consequence of deforestation. The history of Lai Chau has been eventful, from the fifteenth century, when the seigneurial family of Deo, known as the "black Thais," subdued the "white Thais" from a village a few miles away, to the intrigues of the royal court of Luang Prabang and the mandarin government of Yunnan at the end of the nineteenth century, to the French colonization of Indochina.

p. 73 BAC BO, NORTHWEST VIETNAM. Tinh Xan May, sixty-five years old, lives in Ta Phin, a red Dao and ethnic Black Hmong village (that has unfortunately become very touristy), a few miles from Sa Pa. Near the Chinese border, in the middle of this superb region, where the from January to June, terraced rice paddies can be glimpsed through mist, live many ethnic minorities, mountain dwellers who are often illiterate and very poor. Almost every day, they don their finest costumes and make their walk to the market in Sa Pa to sell their handcrafts to tourists. The reserved Hmong, the Dao, and the other ethnic communities that come to sell souvenirs have Asiatic traits, but differ from the Viets. The Hmong sell pants, shirts, and hats sewn by hand, while the Dao rework secondhand clothing, ingeniously adapting them to a European style. It is also the "market of love"—every Saturday young people from all over the region come to look for a mate in Sa Pa.

p. 74 SUZHOU, JIANGSU, SOUTHEAST CHINA. A hotel employee in Suzhou, a city legendary in the fifteenth century for its silk production, where aristocrats, scholars, painters, and actors came to live. Two centuries later, it was nicknamed the "city of gardens," and "Venice of the Orient," as its gardens are numerous and famous. Like the Zen gardens of Japan, those of Suzhou, composed of water and stones, have very few flowers. Occupied by the Japanese during World War II, then by the Kuomintang, the city happily escaped the worst ravages of the Cultural Revolution. Today it rivals Shanghai (forty-five minutes away by rapid train) as a center of technology and light industry.

p. 75 KYOTO, JAPAN. A monk of the Jodo Buddhist school, the most widely practiced branch of Buddhism in Japan along with Jodo Shinshu, in the sanctuary of Chionin.

The colossal door that marks the entrance prepares the visitor for the immense scale of this temple, erected on the site where Honen, the celebrated founding father of Jodo, began to divulge his teachings at the beginning of the twelfth century. Chionin is also today the general quarters of Jodo Buddhism. At the end of each

year Chionin is also the site for a televised spectacle: Seventeen monks together manage to move the eighty-ton bell, announcing the new year in 108 strikes, one for each sin committed by all humanity.

pp. 76–77 YUNNAN, SOUTH CHINA. Luoxiaoli, twenty years old, an ethnic Hani villager from Pugaolaozhai, carries her first child on her back. The Hani (pronounced "rani") originally from Tibet and related to the Yi, are the second largest Tibetan-Burmese nationality of Yunnan, both in numbers and in geographic expansion. Grouped principally in the south of Yunnan, in the basin of the Red River and the mountains of Xishuangbanna, they are also found in Myanmar, Laos, and Thailand, where they are called the Akha. According to their traditional folklore, they descended from the eyes of frogs. Cultivators of rice, corn, and poppies, they are famous for their terraced rice paddies on the steep mountain slopes. The Hani women generally wear a collarless jacket, fastened with silver buttons over long pants. The family is the base economic unit, and the woman lives in her husband's house for the birth of their first child. The cult of ancestors imposes the necessity of having children. Fertility rites are a part of their culture, which explains without doubt the sexual freedom of adolescent girls and boys, encouraged by dances, songs, and swings, like those seen in Thailand.

p. 78 TOKYO, JAPAN. Cherry trees in bloom at the temple of Kaneiji in the park of Ueno Koen.

Ueno is one of the few places in Tokyo that still retains the atmosphere of the ancient city. Here, it is not hard to imagine how the city looked before the economic burst of 1970. The park, with its dense concentration of museums and galleries, contains a remarkable four-storied pagoda, what remains of the Kaneiji temple, as well as the Shinobazu Pond, to which millions of birds migrate each year. In the seventeenth century, Ieyasu, the premier shogun of the Tokugawa period, decided to build in this area a temple to Kaneiji to prevent the *kami* (evil spirits) from entering the city. Given the length of the Tokugawa era, it seems his decision was good. Declared a public space at the end of the nineteenth century, Ueno Park has inspired a large number of prints and short stories. The first fortnight of April, during the hanami, Tokyoites particularly love to walk here to enjoy the cherry blossoms. . . .

p. 79 SUZHOU, JIANGSU, SOUTHEAST CHINA. In the Liu Garden, one of the largest in Suzhou and famous for its architectural harmony, a young artist plays the *pipa*. Dating back to the Ming dynasty, this garden escaped the destruction of the Taiping rebellion. It possesses a long, ornate gallery of celebrated calligraphy masters, as well as an impressive stone about twenty-three feet (seven meter) high that has been sculpted by water and decorated with plants.

pp. 80–83 MYANMAR. The young of Myanmar offer bougainvillea as a symbol of love.

pp. 84–85 YUNNAN, SOUTH CHINA. In the Kham region (the old Tibetan name for this part of Tibet, incorporated into Yunnan after the Chinese invasion), Du Jing Kong Xue sews new prayer rugs for her house in the village of Yong Zhi for the Tibetan New Year, or *Losar.* Tibetan festivals follow the Tibetan lunar calendar, which is one month behind our Gregorian calendar. Losar lasts the entire first week of the first lunar month, and is filled with theatrical presentations. Pilgrims wander the streets, making offerings of incense, and the Tibetans wear their finest clothes.

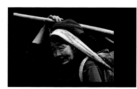

pp. 86–87 ANHUI, EAST CHINA. The jagged peaks of Huangshan—the poetically named "Yellow Mountains"—are known throughout the country for their beauty, and the surrounding countryside, with its traditional villages and colorful fields, is reputed to be one of the loveliest in China. A great inspiration for traditional Chinese painting and literature, this region has attracted numerous tourists for more than a century.

pp. 88–89 YUNNAN, SOUTH CHINA. Ma Hu Jiao, a sixty-five-year-old Hani farmer, returns from the fields carrying wood in a basket on her back for a cooking fire. A Tibetan-Burmese tribe related to the Yi, who speak the same language, the Hani, also called Akha in the neighboring countries, were the first terrace builders. It is to them that we owe these incredible mountainside amphitheaters, where water is distributed from step to step through gaps in earthen levees. The need to manage this distribution of water has structured and unified their society. On important occasions the Hani wear very beautiful headgear with pearls, plumes, silver rings, and pieces of money, among which can be found French coins from the old Indochina, as well as Burmese and Indian coins from the beginning of the twentieth century.

p. 90 BANGKOK, THAILAND. A transvestite with a tattooed back.

" 'Just a trick,' he told me in a pedagogical tone. 'A normal woman, she knows she is a woman. But a ladyboy always has to prove that he's a woman.'

" 'A ladyboy?'

" 'Yes, a transsexual if you prefer . . .'

"Ladyboy: We'll agree that it's a pretty word, anyway."
—Christophe Ono-dit-Biot, op. cit.

p. 91 SHANGHAI, CHINA. An acrobatic performance in Shanghai Center Theater. The Chinese are among the most adventurous gymnasts in the world, with a rare suppleness and agility. At a very young age, those intended for this vocation are subjected to rigorous training.

pp. 92–93 JIANGSU, SOUTHEAST CHINA. The village of Zhouzhuang, nestled in the middle of the countryside and built over and between a network of rivers, is riddled with canals crossed by stone bridges. In the early 1980s, it was like a ghost town, with only boats and water—not a hint of a tourist. Today numerous tourists come for a day trip from Shanghai or Suzhou to look at its Yuan, Ming, and Qing buildings. An ambitious conservation project has been undertaken to protect the ancient stone bridges and restore the historic houses; many residents were resettled in new developments built on the outskirts, to protect the village from modern affluence and the development that goes with it.

pp. 94–95 YUNNAN, SOUTH CHINA. A farmer at the big daily market in Dali, which also attracts a few tourists.

Two hundred and twenty miles (three hundred and fifty kilometers) from Kunming and 125 miles (200 kilometers) from Lijiang, Dali, sitting at around 6,200 feet (1,900 meters) above sea level, is without doubt the part of Yunnan where one really does want to set down one's bags and relax. Here, away from modern roads and infernal traffic, only pedestrians and hikers stroll along its back streets, among ancient houses, stone ramparts, and imposing medieval portals. A stone's throw from the town center—with the great Cangshan mountain range, craggy with peaks and ravines where numerous waterfalls crash down, as a backdrop—stretch out fields, rice paddies, and meadows. Inhabited for the most part by the Bai people, an aristocratic ethnic group that has lived in the region for more than three hundred years, the city still reflects its past glory. Dali is also known throughout China for the marble that has been extracted from Cangshan for three hundred years.

pp. 96–97 ANHUI, EAST CHINA. The mountains of Huangshan, celebrated throughout the country for their beauty, are a must not only for lovers of nature and scholars in search of inspiration, but also for lovers of tea. The region produces thirty different kinds of tea, among them black Qihong, sold the world over; Songluo, with its curative powers; and Shimo, which promotes long life. It is in Tunxi, at Lao Jie's place, that you can taste the best. Tea is made differently here from the rest of China; the tea is infused in the cup, with boiling water added as needed, and drunk in small sips to better appreciate the subtle aroma.

p. 98 JIANGSU, SOUTHEAST CHINA. A traditional lamp of ancient China, the color of happiness,

prosperity, and passion, on the roof of a house in the charming old village of Zhouzhuang.

p. 99 SHANGHAI, CHINA. From a large sightseeing boat, a night view of the celebrated Bund, certainly the most famous of all the boulevards of the Orient. Originally a muddy towpath before becoming a quay filled with every imaginable watercraft, The Bund is overwhelmed with activity and noise of the harbor and the beggars, coolies, sailors, and businessmen who work there. In the 1930s, the city held 60,000 foreign residents and was the largest international port in Asia. Today, the atmosphere is completely different, reflecting the rhythm and the complexity of contemporary Chinese society. But if the agglomeration that is Shanghai is overwhelming, the inner city itself is quite small, with a center divided into two zones: Pudong on the east of the Huangpu River, and Puxi on the west side, where one finds historical monuments like The Bund and the old foreign concessions, the commercial streets, hotels, restaurants, and nightclubs. The Bund forms the historic heart of the international business district. It is here that begins Nanjing Road, the busiest shopping street in China.

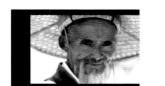

pp. 100–1 YUNNAN, SOUTH CHINA. In the Dali region, a Nakhi farmer goes to the weekly market. The Nakhi (pronounced "nassi"), divided into two groups of different cultures and dialects, settled Yunnan and Sichuan provinces on horseback. Descendants of the nomadic Qiang, from northeastern Tibet, they have become sedentary agriculturists over the course of two thousand years. Their economy is based on livestock, farming, and agriculture. The men, wearing tunics and cotton pants, with a wool cardigan or sheepskin over the shoulders, are monogamous and form patrilinear families, where divorce and polygamy is very seldom practiced. One also rarely finds among them more than four generations under the same roof. Although the sexual freedom of unmarried girls and boys is accepted, marriage decisions remain the prerogative of parents, who make known their intentions and negotiate using the services of a matchmaker.

pp. 102–3 YUNNAN, SOUTH CHINA. A Nakhi farmer in the Dali region.

Ancient capital of the kingdom of Nanzhao from the eighth to the tenth century and of the Bai kingdom of Dali, from the tenth to the thirteenth century, Dali reached its apogee as an essential stopping point along the southern Silk Road, controlling commerce between India, Myanmar, and China. Situated in the remarkable landscape between the Cangshan mountain range (1,300 feet [4,000 meters]) and the immense lake of Erhai and endowed with a sunny climate, the village has preserved the charm of its narrow alleyways and stone houses with flower gardens.

pp. 104–5 GUANGXI, SOUTH CHINA. A farmer returns home in the region of Longji. Although its hilly topography yields very little arable land, this area is essentially rural. In spite of the altitude, there is abundant vegetation, with bamboo, large ferns, and—unexpectedly—banana trees, reflecting the subtropical climate.

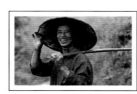

pp. 106–7 GUANGXI, SOUTH CHINA. A meeting with a Zhuang farmer on the way back from working in the fields. The Zhuang (the name means "brave, courageous, sturdy") represent by their number the most important non-Han ethnic group in China. Though they are principally found in Guangxi—thus the official name, the Guangxi Zhuang Autonomous Region—they are also found in Yunnan, Guangdong, Hunnan, and Guizhou. Rice farmers, they also grow corn, buckwheat, sorghum, taro, millet, beans, and sweet potatoes. Living in a mild and favorable climate, they grow an incredible variety of vegetables all year, but are known above all for their tropical fruits such as lichi, pineapple, papaya, banana, and persimmon, as well as pear and mandarin orange, and also farm fish. Zhuang society is patrilinear and monogamous. Originally, they were animists, though for the last centuries they have been influenced by the great currents in popular Taoism. Upon death, they believe, the three spirits of man leave: the first to the sky to find immortality, the second into nature, where it will wander in a wilder state, and the third into an incense burner on a domestic altar, among other honored ancestors.

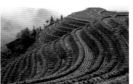

pp. 108–9 GUANGXI, SOUTH CHINA. Terraced rice paddies created over seven hundred years ago in the region of Longji, nicknamed the "Dragon Spine." This fabulous landscape, where the road weaves through an exceptional countryside of fields and terraced rice paddies, dominated by forested peaks up to nearly 5,000 feet (1,500 meters) above sea level, serves as a refuge for the Dong people (originally from southwest China), who share it with the Zhuang and the Yao. Isolated from outside roads and then from the avenues of communication created by the Han in this wild land, it was totally cut off until the eighteenth century. In the dry season, when the rice paddies are not flooded, the farmers grow beans and corn.

p. 110 NORTHWEST VIETNAM. A farmer from the region of Sa Pa.

p. 111 YUNNAN, SOUTH CHINA. Gao Song Si, seventy-two years old, is an ethnic Han farmer who, at his age, still works in the fields—with a smile.

pp. 112–13 JIANGSU, SOUTHEAST CHINA. The village of Zhouzhuang, swathed in mist. Of the some 17 million Zhuang (pronounced "djouang") who live in China, 90 percent live in Guangxi, often under difficult conditions. They live in villages around a pond in the middle of rice paddies, or near a river in a mountain valley. At higher elevations, one can find similar picturesque dwellings attached to the summit of a mountain carved into rice-paddy terraces, airy and spacious houses on stilts, covered in thatch or wooden roof tiles. The family lives on top, while the domestic animals live on the ground floor.

p. 114 ANHUI, EASTERN CHINA. A villager lunches on noodle soup in a tavern in Zhouzhuang.

p. 115 YUNNAN, SOUTH CHINA. A musician from Jianshui relaxes on the sunny square where the town's inhabitants meet each night. In this area south of Yunnan, home to the Yi, Hani, Miao, Yao, Dai, and Hui peoples, Jianshui, once a strategic stage of the silk route to Vietnam, is considered today as a museum of ancient architecture, the jewel of which is the Temple of Confucius, a sumptuous building from the Mongolian era (end of the eighth century). Temples, pagodas, bridges, patrician residences, and teahouses make this garrison town on the edges of the Chinese Empire very pleasant indeed, the most authentic and characteristic of the cities of Yunnan, and little known to Western tourists.

pp. 116–17 GUANGXI, SOUTH CHINA. The magnificent gorges of the river Lijiang situated in northeastern Guangxi, in the Lijiang District, celebrated for its poets as well as for its countryside. At the ultramodern international airport in Lijiang City, twenty planes land a day; large luxury hotels have been built by the Japanese and the Koreans, and the area attracts five million tourists a year. But what inspires such passion for this region? The answer: the Lijiang . . . a small and modest river, certainly, but one that twists through one of the most fabulous countrysides in China. A geological miracle has created a succession of limestone hills sculpted magically by the caprices of nature and the subtropical rains.

pp. 118–19 HIGH ALTAI, MONGOLIA. Wedged between Russia to the north and China to the south, the vast irregular plateau of Mongolia is divided politically between China (Inner Mongolia) and the Republic of Mongolia. Hampered by its harsh continental climate of hot summers and hard winters, the Republic of Mongolia has nevertheless been struggling to join the developed nations. It is here, in a camp in the huge mountain pasture of High Altai, to the northwest of

the plateau, that our photographer, indefatigable globe-trotter, came to recharge his batteries after his exhausting Latin American voyage.

pp. 120–21 YUNNAN, SOUTHERN CHINA. Mahaiyan, two years old, and his little brother Mayan, one year old, in traditional Hani dress.

Located principally in the south of Yunnan, the Hani are distinguished from other ethnic groups by their dialect and their clothing, but most of all by their headgear—a pointed bonnet or a round hat (as seen in this photo), ornamented partly or totally with nails, silver rings, pieces of money, and red wool pompoms—which is not only aesthetic but serves as an identifier. For the numerous ethnic groups of southern China, silver is the incontestable sign of prestige, wealth, and status: It is a social symbol on display. During festivals of the lunar calendar, the girls of the family wear impressive finery. In eastern Guizhou Province, the girls are covered from head to toe in pieces of necklaces, tiaras, and earings, that can weigh up to twenty pounds.

p. 122 GUANGXI, SOUTH CHINA. In the village of Ping'an, in a traditional wood house, Liao Li Zhou, ten years old, a little daunted by all that must be done.

Situated on the central crest of the Dragon Spine, the Zhuang village of Ping'an, six hundred years old, is an ideal base from which to explore this magnificent region of terraced rice paddies.

p. 123 LUANG PRABANG, LAOS. Lessons in Buddhism and general science for the young monks at the school of the temple Wat Sop. Declared a UNESCO World Heritage Site in 1995, Luang Prabang is home to a number of exceptional monasteries and temples still active today. Known as the most well-preserved city in Southeast Asia, young monks come here from all over to study Theravada Buddhism, which was introduced to Luang Prabang between the end of the eighth century and the beginning of the ninth. Theravada (in Pali, "School of the Elders") Buddhism spread from India in a southern direction: from Sri Lanka to Thailand passing through Myanmar, Laos, and Cambodia. By contrast, Mahayana Buddhism, whose language is Sanskrit, developed toward the north: from Nepal to Tibet, China, Mongolia, Korea, Japan, and on to Vietnam.

pp. 124–25 BAGAN, MYANMAR. Four young friends decorate their faces according to tradition with thanaka. An exclusively Burmese beauty product, this crushed bark has the advantage of protecting the skin from the sun, as well as controlling perspiration and oiliness.

pp. 126–27 BAGAN, MYANMAR. A moment of relaxation for Ma Than Myint, an amulet saleswoman at Nat Taung, an isolated monastery in the Bagan area. Like their Thai neighbors, the Burmese are very superstitious and regularly pray while offering gifts to their effigies, to atone for their sins, to attract the favors of Buddha, or as thanks for a service rendered.

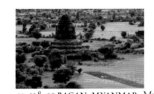

pp. 128–29 BAGAN, MYANMAR. Myanmar has known over the centuries many brilliant kingdoms that have left remarkable sites, of which Bagan is one of the most extraordinary examples. It is impossible not to be bewitched by the two thousand or so religious foundations constructed between the eleventh and fourteenth centuries on this plateau that dominates the Ayeyarwaddy River. For three centuries, Bagan was also a cosmopolitan center for Buddhist studies until Mongol raids, in the thirteenth century, brought about the end of the kingdom. It continued, however, to remain the literary capital of the country.

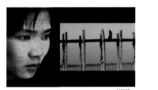

p. 130 BAGAN, MYANMAR. "The young girl sat down at her dressing table. . . . She thinned the thanaka a little with water and applied the paste to her face to make a refreshing mask. Then she pulled her hair back from her brow with a ribbon and began to make up her face while looking into the mirror. Her complexion was as clear and luminous as pearl, her features expressed sweetness. She had a well-made nose, and eyes of a remarkable brightness. . . . As the thanaka had gradually refreshed her skin, she could admire the reflection of her charm in the glass. She dusted a little rice powder over her glowing cheeks and finished her makeup quickly, not forgetting to define with a little brush the lovely arch of her eyebrows."
—Journal Gyaw Ma Ma Lay, *La Mal-Aimée.*

p. 131 AMARAPURA, MYANMAR. The U Bein Bridge, which spans two-thirds of a mile (1,200 meters) across Lake Taungthaman, is the most celebrated structure in Amarapura, the "Immortal City" abandoned by King Mingun in 1860 when he shifted the capital to Mandalay. Named for the clerk to the mayor who had it built in 1849 to facilitate passage from the city to the countryside during the monsoon period, this bridge is splendid at sunset, when monks and villagers stand out in silhouette. Built in "recycled" teak from dismantled houses in the former royal cities Sagaing and Innwa, deserted by the court when it moved to Amarapura, it used to rise to allow royal barges to pass. Now, however, concrete pillars have been added for support, making it immovable. A tour through this serene countryside—where one can see farmers working in the fields, ox carts, and fishermen during the dry season—is fascinating.

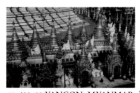

pp. 132-33 YANGON, MYANMAR. "Shwedagon Pagoda, the soul of Myanmar! . . . I feel melancholy and full of piety, reassured by the overwhelming yet airy presence of this stupa 300 feet (100 meters) tall. It contains, they say, eight hairs of the Buddha. When they were removed from their sacred shrine to be buried under the stupa, their unveiling restored sight to the blind and hearing to the deaf. The earth trembled, and the trees of the Himalayas covered themselves with flowers and fruit."
—Christophe Ono-dit-Biot, *Birmane.*

pp. 134–35 BAGAN, MYANMAR. In the monastery of Nat Taung, a monk rests.

This magnificent wooden structure, the oldest part of which dates back to the eighth century, possesses three beautiful statues, ancient chests, and a remarkable coffered ceiling. So delicately carved are the wooden doors that they resemble lace, a triumph of talent and finesse.

p. 136 MYANMAR. In the village of Minn Nan Thu, sustenance takes all the attention of this mother as she makes dinner for her family.

p. 137 HIGH ALTAI, MONGOLIA. A moment of bonding between a father and his son.

The Mongols—a generic term given to a large number of tribes in central Asia and the south of Siberia, in the region of Lake Baikal, united under Genghis Khan in 1206—have become famous the world over for the conquests that won them the Mongol Empire, which stretched from Peking to the Volga. The lightning speed at which this immense empire was established—in only twenty years—is due to the exceptional guerilla tactics of the Mongol people, their endurance, the mobility of their cavalry, and their skill as archers. These qualities can still be seen today in the Naadam Festival, when a crowd of nomads gather every July 11 in the capital of Ulaanbaatar to participate in three manly disciplines: wrestling, archery, and horse racing. This fascinating show, which has about a thousand participants, is the biggest national event for the Mongols.

Divided today between China, the Republic of Mongolia, and Siberia, the Mongols number a little less than three million, most of whom lead a nomadic life much like their ancestors. As Buddhists, they speak Khalkha.

pp. 138–39 SAGAING, MYANMAR. Three young nuns pray in the monastery of U Ponya on Sagaing Hill, one of the most important centers for Buddhism in Myanmar.

Here, everything is dedicated to Buddha; if the monastery is the place that perpetuates his words, the pagoda affirms the achievement of his way. Spiritual master, phaya, or lord, his image is omnipresent in the little thatched cottages of the ancient royal palace. As for the nuns, their status is never as high as that of the monks. No rite of ordination marks their entry into the monastic community, only the gift of their hair—a young Burmese woman's most precious asset—and the costume that declares their vocation. Under their purple monastic robes, they wear a *longyi* (similar to a sarong) and a Burmese blouse. While the monks receive every day their ration of food, the nuns not only must beg for money to buy salt and oil, but also must cultivate the earth to harvest fruits and vegetables. This leaves little time for meditation and study. Though the discipline in the convents is less strict than with the monks, to be a nun does not accord one any special status. Unsurprisingly, fewer women take up vocations: There are about 25,000 nuns, compared to more than 300,000 monks.

p. 140 NORTH LAOS. In the village of Ben Sop Jam, north of Laos, on the banks of the Nam Ou, a small girl plays with the photographer. Olivier Föllmi never poses a subject. He scrupulously observes a propriety that earns him the respect and intimacy of the people he photographs, always asking for permission before taking a photograph and most often arriving in a village without his equipment so as not to distort the start of a relationship. He always takes the time to get to know the people, to establish a sincere relationship. In the expressions and, above all, the eyes of these "portraits," you easily see the quality of this relationship with his subject.

p. 141 BAGAN, MYANMAR. By a pagoda, an encounter with a village girl who has come to commune with her soul.

pp. 142–43 THE AYEYARWADDY RIVER, MYANMAR. A traveler taking a ferry during the monsoon period. The Ayeyarwaddy (formerly the Irrawaddy) is the artery of Myanmar; history has shown that whoever controls the river, controls the country. This vital axis of the country not only links north and south but also provides a livelihood for many Burmese.

pp. 144–45 MYANMAR. An old woman smokes the cheroot, the traditional cigar of the country, which women roll by hand.

Sometimes mixed with sugar and spices, with an aroma of banana, tobacco is carefully placed in a leaf cut in a triangle, with a filter of dry corn husks. The Burmese cigar, which is made in all sizes, is difficult to keep lit. Even though the indigenous population of Myanmar and Cuba are separated by half of the planet, the similarities between these cultures are sometimes striking. In Asia, however, though women roll cheroots, they do not roll them on their thighs. The Burmese technique is less sensual but more poetic. . . .

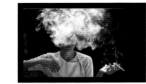

pp. 146–47 MYANMAR. The features of the Burmese betray their ancestry in both India and China, their two powerful neighbors. The driver of the ferry navigating the Ayeyarwaddy casts a wary glance at the photographer, this foreigner. . . . Formed by the confluence of two branches, one originating in China and the other in India, the Ayeyarwaddy stretches across the country for almost 1,900 miles (3,000 kilometers), half of those navigable. Its waters have allowed Burma to become, since World War II, the world's primary exporter of rice. It is impossible to understand this country without observing the continuous spectacle along its riverbanks.

pp. 148–49 MYANMAR. Three friends caught on film on the Ayeyarwaddy.

Articulated around its great river, Myanmar (formerly known as Burma) is above all an ethnic mosaic dominated by the Bamar, or Burmese, people. The minority peoples of the Union of Myanmar—the Chin, Kachin, Kayah, Kayin, Mon, Rakhine, and Shan—all preserve their own culture and religion. Here the traveler plunges into a singular universe, far from our modern era and global frenzy . . . an intense encounter with people eager to meet and understand others, who demand above all not to be forgotten.

pp. 150–51 MYANMAR. Young monk novices take a moment to relax in the southern monastery of Lan Tayar. Burmese families are large, and the boys are often sent at an early age to study at the monastery, which also acts as a school, giving them the rudiments of education.

pp. 152–53 YANGON, MYANMAR. The Shwedagon Pagoda.

"Not just a temple but a city in itself, perched on a hill that dominates the Rangoon. It is a labyrinth of cupolas, sanctuaries, gold-covered domes, and silver spires covered in bells that tinkle in the breeze like a symphony for fairies, punctuated by the murmurs of bonzes and believers, their clasped hands raised above their heads in contemplation."
—Christophe Ono-dit-Biot, *Birmane.*

pp. 154–55 ANGKOR, CAMBODIA. Three monks on the Elephant Terrace at Angkor Thom.

Angkor Thom, built in the late twelfth century by King Jayavarman VII, was the last and most enduring capital of the Khmer empire. The greater Angkor complex of ruins, sprawling over 1,150 square miles (3,000 square kilometers) northwest of Tonlé Sap, the "Great Lake," served from the ninth to the fifteenth centuries as the capital of the Khmer kings. Of its grand wooden villas, none remain, but there are ruins of more than a thousand temples of sandstone or laterite, a durable rock used for the walls and the doors of Angkor Thom, as well as *barays,* the gigantic basins whose role was both ritual and economic, moats, and roads. Abandoned as the capital after the Siamese occupation, Angkor was rediscovered and renovated at the end of the nineteenth century by French archaeologists. The site suffered pillaging and damage under the Khmer Rouge, who in 1971 set up there, installing rocket launchers and defacing sculptures. As long as the Khmer Rouge controlled the site, however, the temples were relatively protected; once the war was over in 1993, the law of the jungle reasserted itself, and many high up in the Cambodian government and military were implicated in the looting that ensued, diverting antiquities to Bangkok, Singapore, auction houses, and private art collections throughout the world. Finally declared a UNESCO World

Heritage site, Angkor has undergone significant renovation work in recent years, with the help of international financial aid.

pp. 156–57 BENG MEALA, ANGKOR, CAMBODIA. Of this grand complex of temples from the twelfth century, situated about twenty-five miles (forty kilometers) east of Bayon and dating from the same era as Angkor Wat, there remains only a group of ruins. The style of this complex had a great influence over Jayavarman II, as most of the Buddhist temples of this era (Preah Khan, Banteay Kdei, Ta Som, and Ta Prohm) were inspired by it.

p. 158–59 SAGAING, MYANMAR. Shin Nya Na, seven years old, is a very young novice monk.

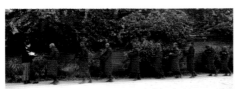

pp. 160–63 MYANMAR. Each morning, the monks depart on a quest for food that the inhabitants prepare for them: they are allowed to eat once a day, before noon. The population takes on the duty of providing them with the "eight necessities" (bowl for alms, razor, fan, umbrella, and so on), plus everything else for their daily needs such as soap and blankets, which are donated anew during the festivals of the Buddhist calendar.

pp. 164–65 TA PROHM, ANGKOR, CAMBODIA. A dream expedition for archaeologists and budding adventurers is to Ta Prohm, situated to the east of Angkor Thom in the deep jungle. Its tangle of vines, roots, and undergrowth make it one of Angkor's most magical and mysterious sites.

pp. 166–67 AYUTTHAYA, THAILAND. Fifty-three miles (eighty-five kilometers) north of Bangkok, Ayutthaya, at the confluence of the Lopburi, Pasak, and Chao Praya rivers, occupied a commercial and politically strategic position in Asia in the sixteenth and seventeenth centuries. More populous than London or Paris of the same period, it was sacked by the Burmese in 1767 and then abandoned for several centuries. Today, it offers nostalgic testimony to its past splendor. Here, the head of the Buddha of Wat Phra Mahathat is miraculously protected by the roots of a banana tree, the sacred tree of the region.

pp. 168–69 TA PROHM, ANGKOR, CAMBODIA. The young monk Khoeun Khon meditates in the temple of Ta Prohm.

At first constructed to house the divine representation of King Jayavarman VII's mother, Ta Prohm contains about forty sanctuaries, or *prasats,* nearly six hundred stone houses, and three hundred in brick. Later, the monastery housed about twenty high priests and almost three thousand monks. One can read on an inscription that their maintenance required 80,000 people and depended on the revenue of more than 3,000 villagers! The authorities have deliberately left the temple much as they found it, to give an idea of the appearance of Angkor and its ambience at the time of its rediscovery in the nineteenth century.

pp. 170–71 ANHUI, EASTERN CHINA. The mountains of Huangshan, a great place of inspiration for traditional Chinese painting and literature.

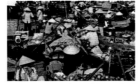

pp. 172–73 MEKONG DELTA, NAM BO, SOUTHERN VIETNAM. The floating market of Phong Dien, about twenty miles (thirty kilometers) or nine hours' journey by water by sampan from Can Tho, is without doubt the least touristy and most interesting in the delta. The welcoming and lively little city of Can Tho, which experienced a renaissance at the end of the eighteenth century, is the ideal point of departure. The political, economic, and cultural center of the Mekong Delta, it is linked to other cities in the delta by a tangle of rivers and canals full of floating markets. The Phong Dien market is very lively: Dealers dangle samples of their merchandise from bamboo poles to lure customers, while women steer their sampans from boat to boat to barter, haggle, or simply exchange the day's gossip. It is early in the morning, between six and eight, that one can best discover by sampan this garden of Eden, where orchards and kitchen gardens vie with each other in beauty.

pp. 174–75 AMARAPURA, MYANMAR. A boatman watches the ducks near the U Bein Bridge.

Even though Mandalay, the chief Burmese city, has lost much of its splendor and becomes every day more noisy, dusty, and Chinese, it is still the best point of departure for more enticing destinations such as Amarapura, Sagaing, and Bagan.

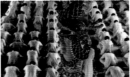

pp. 176–77 NAM BO, SOUTH VIETNAM. The Cao Dai temple of Tay Ninh, about 60 miles (100 kilometers) from Ho Chi Minh City. Cao Dai, literally "high place," is a syncretic Vietnamese religion that combines elements of Buddhism, Taoism, Confucianism, and Christianity and affirms the coming of a great salvation. Founded in 1926, it rapidly divided into a great number of sects. Tay Ninh is celebrated for its baroque architecture, in perfect harmony with the syncretic philosophy of its founding members. During the French colonial era, its adepts, fervent nationalists, were harassed by French authorities. The church doctrine was formulated by the "saints," among whom one

finds Victor Hugo, Winston Churchill, Joan of Arc, and revolutionary Chinese statesman Sun Yat-sen. Spiritualism is a vital element of Caodaism; one can consult the "saints," but a medium is needed to enter into direct communication with them, which adds to the mystery of the practice.

The priest is clothed in black; the members of the clergy in yellow (representing Buddhism), blue (Taoism), or red (Christianity); and the faithful in white robes. The faithful recite prayers before an altar where two candles burn, symbols of solar and lunar light, and five burning sticks of incense represent the five elements inherent in man on the road to purification.

No profession of faith or specific commitment is required to become a Caodaist, only a voluntary and spontaneous adherence to the rules of conduct, which require obedience, humility, honor, respect for the priests, and forbid members to kill, covet, get drunk, eat meat, or lie). Today, the sect claims more than two million adherents in Vietnam.

p. 178 NAM BO, SOUTH VIETNAM. The large ocher Caodaist Holy See at Tay Ninh, dating from 1933, combines the towers of a cathedral, the tiles a mosque, the triangular Hebrew windows of a synagogue, and the eye of the divine master of a Masonic lodge. Inside, cobras and dragons twine around pillars that recall the temples of this part of Asia. Graham Greene has described it as "a delirious Walt Disney in Asia."

p. 179 HAEINSA TEMPLE, GYEONGSANGBUK PROVINCE, KOREA. The carved eaves of the Buddhist temple of Haeinsa, one of three beautiful temples constructed in the ninth century on Mount Kaya. A UNESCO World Heritage Site, this temple is one of ten large temples of the Hwaom sect. It takes its name from a phrase of the *Avatamsaka Sutra,* which compares the wisdom of the Buddha to a calm sea: When the sea is without tempestuous waves of desire and madness, it becomes like a mirror, full of calm and wisdom, where the true image of existence is clearly reflected. At prayer time, which takes place three times a day, Haeinsa seems of another world.

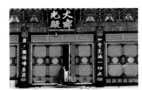

pp. 180–81 HAEINSA TEMPLE, GYEONGSANGBUK PROVINCE, KOREA. A monk takes part in a religious ceremony in the Buddhist temple of Haiensa, founded in the beginning of the ninth century by Suneung and Ljong, two monks returning from their studies in China. If this temple is one of the most important in the country, it is also one of the most beautiful, as well as home to the Tripitaka Koreana, 81,340 carved wood blocks assembling all of the Buddhist writings and numerous illustrations. It took sixteen years to carve this sacred text, considered one of the most important in Buddhism, on silver birch wood. It is kept in a fifteenth-century room, where it has miraculously escaped the ravages of Japanese invasion and fires.

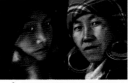

p. 182 **NORTHWEST VIETNAM.** Ha, an ethnic Black Hmong, twelve years old and living in Lao Chai, at the heart of the extremely beautiful valley of the same name. Here rivers where horses, pigs, and water buffalo come to quench their thirst run through terraced rice paddies and fields. On the border with China, 190 miles (300 kilometers) away from Hanoi, Lao Chai is a point of transit between north and south, where merchants have passed with their caravans full of merchandise since the dawn of time.

p. 183 **NORTHWEST VIETNAM.** Si, twenty-six years old, returns home to Hau Thao after a day working the fields.

With eighty different ethnic groups together making up 15 percent of the population, Vietnam possesses an incomparable ethnic diversity. The rural tribes share a rustic architecture and all work the land, but their ways of life, language, economic organization, and costume vary.

The population of Vietnam (more than eighty-six million people) includes the following major ethnic groups:

Kinh (Viet)—approximately 86 percent; Tay— approximately 2 percent; Thai—a little less than 2 percent; Muong—1½ percent; Khome—a little less than 1½ percent; Hoa and Nun—each approximately 1 percent; and Hmong—1 percent.*

Apart from the ethnic majority, the Muong people are one of the oldest ethnic groups and live in the mountains and high plateaus. The Thai, Tay, and Hmong peoples live in the mountains as well in different regions and altitudes. The Hoa people are originally Chinese and mostly merchants settled in southern cities.

* Data from *The CIA World Factbook* (1999 census)

pp. 184–85 **KYOTO, JAPAN.** Maikos during the festival of Jidai Matsuri.

A maiko is an apprentice geisha. During private parties, they serve drinks, light cigarettes, and chat with their clients, while the geisha plays the shamisen before dancing the traditional fan dance. Contrary to common belief, geishas are not prostitutes. The proudest of all geishas are those of Kyoto, who are called *geiko*, "children of the arts." Aside from festivals and dance performances that take place in spring and autumn, one can see geishas in private in the *ryotei* (restaurants), *ochaya* (teahouses), or even *ryokan* (inns) in the back streets of Kyoto.

pp. 186–87 **ZANSKAR, INDIA.** Accompanied by the monks of the Phuktal monastery, a Tibetan master travels from the south of India, where he is a refugee, to the isolated village of Shadé to perform an initiation. In spite of the dizzying height of the track, he cannot dismount from his horse, since the monks who wish to honor him do not want him to make any effort. But for the master, who is not used to horses and the archaic saddles of Zanskar, this journey is quite an ordeal.

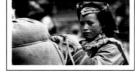

pp. 188–89 **YUNNAN, SOUTH CHINA.** A farmer from Yunnan at the Dali market.

pp. 190–91 **HIGH ALTAI, MONGOLIA.** A herd of goats and yaks enter their mountain pasture.

During the 1940s, Mongolia tried to diversify its essentially pastoral economy by developing parallel sectors (mining, metallurgy, forestry, cannery, leatherwork), financed in large part by the USSR. The fall of the Communist bloc and the development of liberalism, privatization, and easier trade with Chinese, Japanese, and Russian markets since the end of the 1990s has brought about a spectacular turnaround. Mongolia has burst onto the cinematographic scene in the past few years, with the release of director Byambasuren Davaa's films *The Story of the Weeping Camel* (2003) and *The Cave of the Yellow Dog* (2006)—an intelligent way of celebrating the country's eight hundred years of history and the end of its isolation.

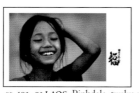

pp. 192–93 **LAOS.** Pinkdala, twelve years old, in the village of Ban Houey Ko on the banks of the Mekong.

A mosaic of ethnic groups and languages, Laos has sixty ethnic minorities, most of them independent and self-sufficient, though contact between them has increased the last few years. This patchwork is divided into three groups, who correspond to three ecological zones. The Lao Loum, who are more powerful politically than their number would suggest, are growers of rice who live in the humid lowlands; the Lao Theung, who represent a quarter of the total population of the country, live in the foothills; and the Lao Soung, or Lao, who represent a fifth of the population, live at higher altitudes and practice slash-and-burn cultivation.

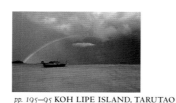

pp. 195–95 **KOH LIPE ISLAND, TARUTAO NATIONAL MARINE PARK, THAILAND.** The closer one comes to Malaysia, the more the look of the Thai people, along with their beliefs, costumes, architecture, and cuisine, changes, and the countryside continues to be extraordinary: limestone peaks stand out against the turquoise blue of the sea and the emerald green of the mountainous jungle, with its caves and waterfalls. Above all there is the long, deserted beach, where watching a storm break is a delight to the eye.

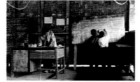

pp. 196–97 **NORTH LAOS.** Miss Nay, eighteen years old, in her first year at a primary school for the children of the village of Ben Sop Jam on the banks of the Nam Ou, in the Luang Prabang region. For those who see Laos as a fairy-tale land, forgotten by globalization, a still-wild place that can pride itself on the cleanest rivers, richest forests, and purest air in Southeast Asia, it is essential that you know the facts: more than a third of Laotians over fifteen years old cannot read or write; about one in five children die before they reach five; 87 percent of village dwellers are smitten with malaria, and 80 percent by dysentery, due to the absence of potable water for a quarter of the population. If that's not enough, there is the devastation of opium addiction.

pp. 198–99 **NORTH LAOS.** The students of Ben Sop Jam's primary school await the results of their first exam.

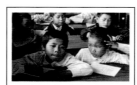

pp. 200–1 **NORTH LAOS.** A moment of intense concentration during the first exam at the primary school of Ben Sop Jam.

pp. 202–3 **NORTH LAOS.** A very pretty and picturesque scene of the village of Ben Sop Jam, made truer than nature under the photographer's camera, and worthy of a primitive artist. . . . This village, like others situated along the banks of the Nam Ou River, a branch of the Mekong in the countryside north of Luang Prabang, is peopled by fishermen, but also by mountaineers who travel down the river, forced by deforestation to find another trade to survive, and specialize in the making of shawls. The modest wood residences of Ben Sop Jam, like the magnificent temples patinated by time in Luang Prabang, make Laos a charming destination. The beautifully preserved traditional architecture is priceless, especially in contrast to other countries in the region, where often modern urbanization run amok is sadly engulfing everything.

p. 204 **NORTH LAOS.** Leun, twelve years old, from the village of Ban Sa Phiue, on the banks of the Nam Ou. At her age, Leun takes to heart her role as eldest daughter and takes care of her little brother like a true mother, both in the field and at the stove; as with the majority of the poor countries on the planet, Laotian mothers face overwhelming difficulties. Seventy-five percent of Laotians are farmers: they work the land to provide subsistence to their families and live in villages, only one out of ten which is near a road.

p. 205 **MEKONG DELTA, SOUTH VIETNAM.** Diem Le, five years old, lives in the Mekong Delta.

The third longest river in Asia (after the Chang, or Yangtze, in China and the Ganges in India), the Mekong, which has its source in the Tibetan glaciers about 16,000 feet (5,000 meters) above sea level, crosses six countries (China, Myanmar, Laos, Thailand, Cambodia, and Vietnam) over 2,800 miles (4,500 kilometers). Each year, it discharges 475 billion cubic meters of water and tons of silt into the Chinese Sea and the Gulf of Thailand. The head of its immense delta shapes the Khmer country of Cambodia: The kings of Angkor gained their power by controlling its flow. In Vietnam, it divides into nine branches called the Cuu Long, "Nine Dragons." The Mekong Delta holds 2,500 miles (4,000 kilometers) of canals in nine provinces linked to each other by dirt paths, roads, and waterways where sampans and other barges transport rice.

Diem Le's mother has a stall in the Mekong Delta.

Family is very important in Vietnam, but since one family cannot get by alone, the Vietnamese are organized into clans. For centuries, Vietnamese lived together harmoniously in communes in the countryside and guilds in the cities. Vietnamese society is patriarchal: The eldest son not only has the right to celebrate the cult of the ancestors and to pass his name to the clan, but also to direct the household and decide whether his children and wife work. In reality, however, the woman often has the last word.

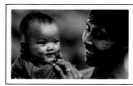

pp. 206–7 **NORTH LAOS.** In Nong Khiaw, a young village girl goes to the river to get water.

Laos is the poorest country in the region, and most villages do not have access to running water.

pp. 208–9 **AMARAPURA, MYANMAR.** A moment of bonding between Tin Htar Nwe and his first son.

Of the 52 million Burmese, 6 million live in Yangon, the capital, and more than 36 million work the land in the countryside. Contrary to the general rule in countries on the road to development, the rural exodus has been marginal, due to the country's meager economic resources. Myanmar's ethnic divisions mirror its geography: the Bamar or Burmese, the dominant group, occupies the central plain irrigated by the Ayeyarwaddy, while the ethnic minorities are still entrenched in the mountainous regions that border Thailand, Laos, China, India, and finally the sea of Andaman. Ethnologists distinguish more than 135 different ethnic groups.

pp. 210–11 **NORTH LAOS.** On the river Nam Ou, a fisherman returns to his village at dusk. In the north of Laos, the mountainous land with its majestic scenery and its gentle tribes, people until recent years traveled only by boat, on one of the numerous rivers that punctuate the region. This is still the best way to

explore this countryside, taking your time to appreciate the natural rhythm of life in one of the last places on earth where such serenity still exists. As the saying goes, in Thailand one buys rice, in Vietnam one plants it, in Cambodia one harvests it, in Myanmar one watches it grow, and in Laos one hears it growing. . . .

p. 212 GUANGXI, SOUTH CHINA. The river Li, inspiration for traditional Chinese painters, its banks lined with delightful little villages. In this traditional countryside of southern China, the mist softens the silhouettes of farmers bent over in the fields and rice paddies, fishermen on their bamboo rafts on water where cormorants dive beside water buffalos. A Chinese poet described this region a century ago: "The river is a green silk ribbon, and the mountains soar upward like jade needles."

p. 213 ANHUI, EASTERN CHINA. In the village of Zhouzhuang, the wives of fishermen repair nets.

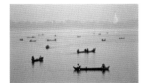

pp. 214–15 LAC TAUNGTHAMAN, MYANMAR. Fishermen out in the early morning.

East of Amarapura, Lake Taungthaman used to evaporate with the coming of the dry season, ceding the land to rice paddies. A dozen years ago, a dam was built to ensure the permanence of the lake's well-stocked waters. As all over the peninsula of Southeast Asia, fish and rice are the basic pillars of the diet, and the majority of Burmese either farm or fish. On the banks of the lake stand a number of abandoned palaces and pagodas, some of them maintained—Pahto Dawgyi, the minuscule Nagayon, the surrealistic Kyaw Aung San Tha, a green pagoda of giant, painted concrete effigies, and Taung Mingyi Phaya, which contains a brick Buddha forty-six feet (fourteen meters) high.

p. 216 YUNNAN, SOUTH CHINA. A farmer resting after the market.

Markets and fairs, where the farmer comes to sell his livestock and poultry, the products of the field, or handicrafts, but equally to buy basic staples such as salt, vinegar, or bean curd, serve as not only a milestone of daily life but also a social center for village farmers.

p. 217 YUNNAN, SOUTH CHINA. A farmer at the Dali market.

pp. 218–19 YUNNAN, SOUTH CHINA. A farmer ends his working day in the flooded rice terraces of Bada.

pp. 220–21 ZANSKAR, INDIA. The iridescent line made by the setting sun along the crest of a hill makes a dramatic geometric composition as it intersects a little whitewashed *chorten*.

The *chorten* (called a *stupa* in Sanskrit), which symbolizes the spirit of Buddha, leads from the daily life of sensual perceptions to the kingdom of the eternal consciousness. Guardians of spiritual influence, *chortens* radiate peace and goodwill. Along the road in this region you can see not only *chortens* but long walls of *mani* (prayer) stones, on which are engraved Buddhist mantras.

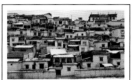

p. 222 YUNNAN, SOUTH CHINA. A Hani baby wakes from his nap, cozy in the shawl tied around his mother's back. Among the Hani, everything is organized around the household, which is the base economic unit. While the youngest son has a duty to stay with his parents, the others, once married, stay close to the family house. Normally, a married woman moves into the house of her husband's family after the birth of her first child.

p. 223 YUNNAN, SOUTH CHINA. An old farmer returns from the fields, holding the stick that he uses to drive his water buffalo. His hand tells the story of the life he leads.

pp. 224–27 CHINA. A line of *chortens*, holders of Tibetan Buddhist relics, facing the sacred mountain of Kawagabu, 18,800 feet (6,740 meters) above sea level.

pp. 228–29 YUNNAN, SOUTH CHINA. In the Kham region, a villager crosses the Mekong River on one of the suspended pontoon bridges that are common in Southeast Asia. Kham is the old Tibetan name for this part of Tibet, incorporated into Yunnan after the Chinese invasion.

After fifty years of planning, the Chinese government has fulfilled Mao Zedong's vision to build a railroad into Tibet, overcoming the mountainous land. In its first year, 2006, the Qinghai-Tibet railway claims to have transported one and a half million passengers on the 710-mile

(1,142-kilometer) train line that links the Tibetan capital of Lhasa to the rest of China. The collision of China's modernity and expansion with the ancient traditions of the mountain Tibetan culture is wonderfully told by Abrahm Lustgarten in *China's Great Train*.

pp. 230–31 YUNNAN, SOUTH CHINA. The monastery of Songzanlin in Zhongdian. The city of Zhongdian, the entrance to the Tibetan world (originally Gyalthang in the Tibetan language), stands 10,360 feet (3,160 meters) above sea level in the middle of a region of vast pastures and mountains with snow-capped summits belonging historically to the country of Kham (East Tibet). One hundred and twenty miles (two hundred kilometers) from Lijiang and nearly 1,300 miles (2,000 kilometers) from Lhasa, the capital's population is 45 percent Tibetan, but it also holds numerous ethnic minorities such as the Yi, Lisu, Nakhi, Bai, Pumi, and Hui (Chinese Muslims), as well as a large number of Chinese, originally Han. Zhongdian is also the last stop in Yunnan for intrepid travelers who wish to continue west into Sichuan.

p. 232 YUNNAN, SOUTH CHINA. A great-grandmother, 103 years of age, of the Nakhi community of the Kham region.

p. 233 LADAKH, INDIA. During winter in the valley of Tso Kar, which reaches 13,120 feet (4,000 meters) above sea level, a shepherd leads his herd to water. A place at the end of the world where the altitude fluctuates from 8,800 to 16,400 feet (2,700 to 5,000 meters), Ladakh is a desert wedged between the two highest mountain chains in the world, the Himalayas and the Karakoram. Geographically, Ladakh links Tibet and India, which explains why it was administered by the Tibetan dynasties (by order of the Red Hat and then the Yellow Hat sect, which is headed by the Dalai Lama). In 1993 it was granted the status of Autonomous Hill Council by India. Its most important ethnic groups are Indo-Aryans (Dardes and Drokpas); Sunni Muslims and Buddhists; the Tibeto-Burmese, composed of Ladakhi and Zanskari Buddhists; and the Balti, Shi'ite Muslims.

p. 234 KOH LIPE ISLAND, TARUTAO NATIONAL MARINE PARK, THAILAND. On the border with Malaysia, the landscape is magnificent and pristine: about fifty coral islands hold a large part of the planet's fish life. One can see sea turtles, whales, dolphins, and all sorts of multicolored fish. One suggestion: on the beach, be careful where you put your feet, as here shells are everywhere. . . .

p. 235 NORTH LAOS. In the village of Ban Houey Ko, a young boy skips rocks on the Mekong, a river that ensures his family's livelihood; his father is a fisherman, like most residents of the villages along these banks.

pp. 236–37 YUNNAN, SOUTH CHINA. In the village of Yong Zhi, Ting Xue Mue dons her best clothes to celebrate Losar, the Tibetan New Year.

pp. 238–39 MYANMAR. Merchants take advantage of the New Year festival of the Kayin, one of the many ethnic minorities in Myanmar, to display their wares. A heterogeneous group divided into many subgroups, the Kayin have never managed to organize to gain political power. They represent 7 percent of the Burmese population, and live in the southeast of the country.

p. 240 MANDALAY, MYANMAR. Ei El Phyo, thirteen years old, lives in Mandalay, the cultural capital of the country, where she cares devotedly for her sick father after her mother's death. Somehow she still manages to make herself look pretty with the celebrated cosmetic thanaka bark. In Myanmar, it is easy to meet people; smiles are the common currency, and manners are mild and gentle.

p. 241 VIENTIANE, LAOS. Monks at the temple of That Luang. In Laos, Buddhism and communism still have a close relationship, and the government takes an active part in important Buddhist festivals.

pp. 242–43 JAPAN. In this country, where nature is revered, the importance of the seasons is great, as can be seen in garden design, where a subtle harmony reigns. Trees and bushes are placed and clipped with this in mind. One can often see gardeners picking up petals, which may be placed on the path to a teahouse to dramatize the season. Some gardens are created expressly for spring, others for autumn—the two best times to visit the country—while others employ evergreen and deciduous trees for their appealing form in winter.

No one can understand Japan without understanding the way nature is omnipresent in daily life; the Japanese live intensely in the four seasons that give rhythm to the year. It is magical to walk when the cherry trees are in bloom or when the maple leaves fall, but not only because of the trees themselves; they are the key to a world of aesthetic refinement. The Japanese strive to capture this ephemerality in the art of origami, ikebana flower arrangement, the *miyako-odori* cherry dance, and more. . . . Aesthetics as a philosophy penetrates all domains, from the tea ceremony (*chanoyu*) to gardening, calligraphy, and cuisine. In spring, when

the cherry trees are in bloom, one drinks tea with cherry blossoms or the "new" green tea, like Beaujolais Nouveau! In summer, one eats grilled eel and fresh fruits and vegetables. In the fall, there are dishes prepared with freshly harvested buckwheat. And in winter, there is *fugu*, the pufferfish.

pp. 244–45 VIENTIANE, LAOS. The faithful pray during the November ceremony of the full moon at the sumptuous temple of That Luan, jewel of the capital, symbol of the country's unity, and the most sacred Buddhist monument in Laos. Although Laos has officially adopted the Gregorian calendar, it still follows the traditions of the lunar calendar, based on the movements of the sun and the moon. Though the official New Year falls in December, the Laotians celebrate it in April, in more pleasant weather.

pp. 246–47 MYANMAR. Used as makeup, perfume, sun block, antiseptic cream, and body lotion, thanaka, a yellowish paste extracted from the bark of a tree, is the beauty product nonpareil in Myanmar.

pp. 248–49 CHIANG RAI, FAR NORTH THAILAND. In traditional Akha costume, Thiwa Morpoku, twenty-five years old, eats a dinner of rice and vegetables.

For these northern tribes, the costume ornaments reveal social, familial, and economic status, as well as the age and geographic origin of the person who wears them. Akha women are celebrated for their impressive hairstyles, ornamented with silver, pearl, and feathered disks, worn every day once the woman reaches adulthood, even while working in the fields. Although authenticity is now hard to find—unfortunately, all these tribes are exploited for tourism—those in the mountains, thanks to their isolation, remain the guardians of a culture unchanged for centuries and are considered by the Thais to be foreigners. In fact, most of these peoples were driven here from Laos and Myanmar by war or ethnic conflict, and have lived on Thai soil for barely a century. Very few enjoy Thai citizenship.

pp. 250–51 MINGUN, MYANMAR. In this peaceful village, the eighteenth-century king Bodawpaya had an ambition to construct the largest stupa in the world, nearly 500 feet (150 meters) high, to proclaim to the world the power of Buddhism. An astrologer predicted that when the stupa was finished, the king would die, so it remains an impressive ruin. In 1838 an earthquake

gave it a final blow, cracking the terrace and roof and beheading the two giant lions that guard the sanctuary.

p. 252 RANGOON, MYANMAR. A monk praying before the Shwedagon Pagoda.

Shwedagon is in every way one of the most important Buddhist sanctuaries. A social center as well as a religious one, it attracts visits from families who come here to take walks or picnic, as well as individuals who come to meditate at nightfall, when its illumination radiates across the whole city.

p. 253 BAGAN, MYANMAR. A young monk channels his thoughts to a single subject in meditation. For the majority of poor children, the only access to education is the monastery, the linchpin of Burmese life, which provides both religious and traditional knowledge. The Buddhism practiced in Myanmar is Theravada (85 percent of the population is Buddhist; the rest are Protestant Christians, Muslims, Hindus, and animists). Buddhism is a path to spiritual well-being through rigorous discipline: control of one's words, desires, actions, modes of life, aspirations, thoughts, and concentration. To master them all, one must develop discipline through meditation, the primary path to control of both spirit and mind.

pp. 254–55 YUNNAN, SOUTH CHINA. A primary school in a village in the region of Longji, as beautiful as the countryside the students see through the window of their school, and in which they live their daily lives. We are here at the heart of one of the loveliest regions of China, the "Dragon Spine" with its terraced rice paddies, where forests cover the peaks of the surrounding mountains, which undulate between 3,200 and nearly 5,000 feet (1,000 to 1,500 meters) above sea level.

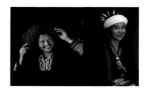

p. 256 BAC BO, NORTHWEST VIETNAM. In the village of Ta Phin, between Lao Chai and Sa Pa, Chao No May, twenty-five years old, wears the traditional costume of her ethnic group, the Hmong, who strongly resemble the minority Chinese on the other side of the nearby Chinese border. Experienced weavers, these peoples display their membership in a group with a costume that signifies the cultural heritage of each clan and indicates social standing with precision. In their modest lifestyle, finery is often the only sign of wealth, and both men and women embellish their costumes with copper or silver jewelry. But clothing is also a means of seduction: A girl looking for a husband, a woman who is widowed, declare themselves in the details of their clothing as well as their hairstyle. Although women still often wear traditional clothes, men increasingly tend to adopt Western styles, and families often sell their best costumes to tourists in the markets.

p. 257 NORTHEAST THAILAND. Kasemsi Prasom at the temple of Wat Nong Bua, about twenty-five miles (thirty kilometers) north of Nan, a typical Lü temple that serves as the center of this delightful village. The Lü Thais are one of a number of minority groups, located in the Chiang Rai and Nan regions, each with their own dialect that can be traced back to 2,000 years BC and originated in central and eastern China. The cloth headdresses that the women wear can be explained by the rough climatic conditions of the mountains of the north. Their long hand-knitted blouses, dyed black or indigo, are fastened with silver jewelry and a belt around their waist.

pp. 258–59 NORTHEAST THAILAND. In the village of Huany Yuak, Sua Tapreuk nurses her child. She is a member of the Mlabri mountain tribe that lives along the border of the provinces of Phrae and Nan, near Laos. The Mlabri are called *phi tawng leuang*, or "spirits of the yellow leaf," by the Thais because they covered their temporary shelters with banana leaves, moving on when the leaves turned yellow. Nomadic, they lead traditional hunter-gatherer lives. No more than 150 are alive today.

p. 260 NORTHEAST THAILAND. In the village of Nong Phua in the Nan area, unchanged for two centuries, the villagers of the Lü Thai community weave silk and cotton cloth on looms in their pretty wooden houses, which are raised on thick stilts. They make a superb indigo and red cloth ornamented with very refined motifs. For those in search of authenticity, the valley of Nan in the east of Chiang Mai, isolated for a long time from the rest of the country, is particularly attractive, with its lovely countryside, many temples, and numerous tribes, including Yao, Hmong, Lü, Htin, and Mlabri.

p. 261 NORTHEAST THAILAND. Lang, six years old, lives in the village of Huany Yuak. He is a member of the Mlabri nomadic mountain tribe, in which women change partners every five or six years, taking with them all of the children from the previous unions. They become experts on medicinal plants, both in the areas of fertility and contraception and venomous snakebites. Exploited by the Hmong and other tribes because they will accept menial work, believing that they cannot farm for themselves, they have been made the object in recent years of a project by the Thai government, which hopes to integrate them into rural society.

pp. 262–63 LAKE TAUNGTHAMAN, AMARAPURA, MYANMAR. Fishermen at dawn on the shallow waters of the lake spanned by the famous U Bein Bridge. One finds innumerable species of fish in Myanmar, where a festive meal always includes a fish dish. Fish is also used daily in a paté or liquid form that the Burmese are crazy about, used on salads and noodles. It is delicious mixed with fresh chilis, lime juice, and green onions, although those with delicate stomachs might wish to abstain. . . .

p. 264 NORTH LAOS. A tender moment between a father and his very young child in the village of Ban Hoeuy Ko, on the banks of the Mekong.

p. 265 NORTH LAOS. A young mother and her first child in Ban Houey Ko.

These two photos represent the image of love that Olivier Föllmi found in Laos, where the residents possess a gentleness, a serenity, a natural kindness, and piety rivaled only in Myanmar, the other country closest to his heart.

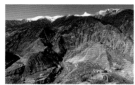

pp. 266–67 ANGKOR, CAMBODIA. The archaeological jewel of Asia, the ancient capital of the powerful Khmer empire, spiritual and cultural heart of Cambodia—the marvelous architectural footprints of mystical power in Angkor fascinate whoever has had the chance of coming upon them, of strolling through them at her own pace, enveloped by the stone's smell, by the muffled sounds of the jungle all around. . . .

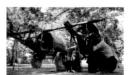

pp. 268–69 YUNNAN, SOUTH CHINA. Bare mountains, snow-covered in the distance; closer, slopes with terraced rice paddies: a majestic setting shelters the village of Shiden, overlooking the Mekong in the region of Kham, an ancient Tibetan province before the Chinese invasion.

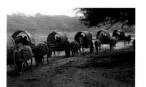

pp. 270–71 BAGAN, MYANMAR. A village woman comes to the festival of the Ananda Pagoda, the most prestigious, imposing, and ancient of Bagan, which was completely restored after the earthquake of 1975; its spires were recently regilded to commemorate the nine-hundredth anniversary of the pagoda's construction.

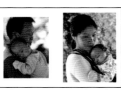

pp. 272–73 BAGAN, MYANMAR. Farmers return from the festival of Pyatho. Burmese festivals, which are legion and play a large role throughout the year, are quite difficult for a Western traveler to plan to see, as their dates are calculated according to the lunar calendar, though more recent festivals are set up according to the Gregorian calendar. The Pyatho festival, which celebrates Myanmar's independence, takes place every year on the same date, January 4. It is celebrated throughout the country, but with the most splendor in Yangon.

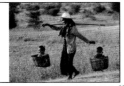

pp. 274–75 **BAGAN, MYANMAR**. Kin San Nwe, twenty-seven years old, returns from the fields with two small boys, walking across the plain of Bagan, where almost two thousand ruins testify to more than three hundred years of activity under the protection of the kings and the patronage of their wives.

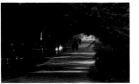

pp. 276–77 **SAGAING, MYANMAR**. Two young nuns, among the thousands that come to this holy town, returning to one of the hundred monasteries scattered on the hills, where they study and meditate. These women have not always chosen for themselves this austere spiritual life.

pp. 278–79 **BAGAN, MYANMAR**. Phyu Phyu Lin, twenty-four years old, prays at the monastery of Nat Taung, in the tiny village of Taung Be, between Old Bagan and Nyaung Oo—a place far off the beaten path.

pp. 280–81 **TOKYO, JAPAN**. Before returning to work, a man bows before the Buddhist temple of Senso-ji, one of the most venerated and spectacular temples in Tokyo. Built at the site where two seventh-century fishermen pulled a golden statue of Kannon, Buddhist goddess of mercy, from the water, this temple's fame has increased through the centuries. In the seventeenth century, its vicinity to the entertainment district only heightened the attraction of the temple, which survived all earthquakes but not the American bombardment in World War II. Rebuilt in the style of the era, it is a symbol of rebirth and peace to the Japanese people. Inside, the grand sanctuary holds an original effigy of the Kannon, before which the faithful come to bow and light incense. The Japanese believe that modern efficiency does not exclude tradition and values; on the contrary, these give modernity its sense and form.

pp. 282–83 **BAGAN, MYANMAR**. Monks in charge of the Ananda Pagoda for the celebration of the festival of Pyatho. There are more than two thousand temples in Bagan, scattered over this vast sunlit area; in pride of place sits the Ananda Pagoda, 184 feet (56 meters) high and nearly 200 feet (60 meters) wide. Inside, each of four niches contains a superb, immense sandalwood Buddha, covered in gold leaf.

p. 284 **SAGAING, MYANMAR**. Shin Yay Wata, a very young novice monk in this city, which is often compared to Bagan. Pagodas and monasteries scattered about the nearby hills and valleys around the Ayeyarwaddy River can be seen from afar, giving Sagaing its special atmosphere. Legend has it that the Buddha came here to commune with himself. Of the four royal capitals of the region, Sagaing is the most charming. Built in 1315 after the fall of Bagan (1287) by the Shan dynasty, it lost its status as capital to Ava in 1364.

p. 285 **MYANMAR**. Sagaing. Shin Nya Na, seven years old, a young novice monk in this great center of Burmese Buddhism.

"A swarm of small bonzes popped up from the structure, happy to wander about in their red robes, heads smooth as polished wood. Seeing me, they paused. Their eyes took me in with an amused curiosity. Those carefree faces were made to smile."

—Christophe Ono-dit-Biot, *Birmane.*

pp. 286–87 **BOROBUDUR, INDONESIA**. This celebrated Buddhist monument in central Java, with its gigantic proportions, is like a stone book depicting a journey through Buddhist cosmology and legend across more than 2,672 extraordinary narrative relief panels. It was constructed between the eighth and ninth centuries by the sovereigns of the Sailendra dynasty, on a fertile plateau that crosses two valleys fed by the Progo and Elo rivers, about thirty miles (fifty kilometers) from the Indian Ocean. Its name comes from the word *bharabhudara*, "virtuous mountain of ten sages of Bodhisattva." Over 400 feet (123 meters) in length, with nine levels rising to 115 feet (35 meters), three miles (five kilometers) of bas-relief, and 504 statues of the Buddha, it is the largest Buddhist monument in the world. Declared a World Heritage Site by UNESCO, it is above all an invitation to true meditation.

pp. 288–91 **BAGAN, MYANMAR**. Between India and China, the kingdom of pagodas, Buddhas, rubies, and jade, of gold that sparkles everywhere, Myanmar is a meeting place with a beautiful image of this sunset that caresses the monks with its rays while they return to their monastery near Bagan, after celebrating the January 4 festival of independence called Pyatho.

pp. 292–93 **VIENTIANE, LAOS**. The faithful in prayer at the temple of That Luang during the ceremony of the full moon in November, when pilgrims render homage to Buddha in a procession around the *stupa.*

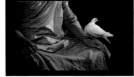

pp. 294–95 **THAILAND**. The venerable Buddhist monk Maha Pinn Bhutawiriyo in deep meditation.

The Thai people, 90 percent of whom are Buddhists, have great religious tolerance. Theravada Buddhism is the branch practiced in Thailand, as in Sri Lanka, Myanmar, Laos, and Cambodia. The Buddhist belief that nothing is stable and permanent, and that it is useless to try to establish certainties in an existence that is perpetually evolving, has profoundly influenced the Thai character.

pp. 296–97 **KYOTO, JAPAN**. Detail of a Buddha in the temple of Nanzen-ji.

Nanzen-ji, which played a central role in Japanese Zen history from the fourteenth century on, is one of the "Five Mountains"—the five great Zen temples of Kyoto—and one of the most charming of the city's temples. Three of its twelve sub-temples are open to visitors. Today it is the seat of the Rinzai school of Zen Buddhism. Fifteen hundred years ago, monks from the Asian continent introduced Buddhism to Japan. Since then, certain well-defined schools have developed throughout the archipelago. Each social group was attracted to divergent beliefs; the nobles, the samurais, and the popular classes each adapted a religious practice to their own needs. Seen from the outside, the Zen adopted by the samurais is the quintessential Japanese religion, but it only represents one branch of Japanese Buddhism. Tendai and Shingon Buddhism have an esoteric tendency. Zen Buddhism found its origin in the Chinese Chan school that spread across Japan during the Kamakura period (1185–1333). There are three principal Zen branches: the Soto, the Rinzai, and the Obaku, which attaches much importance to sitting meditation (*zazen*) and personal achievement. The stripped-down aesthetic and austere frame of mind of Zen have profoundly influenced Japanese society.

Biographies

© D. Föllmi

Born in the Alps in 1958, **Olivier Föllmi** lived for more than twenty years with the Buddhist peoples of the Himalayas. Since 2003, he and his wife, Danielle Föllmi, have worked on their humanist project Offerings for Humanity, which has taken them to a different continent each year. Olivier is the author of numerous books, including the best-selling *Awakenings: Asian Wisdom for Every Day* (2007), which has been translated into nine languages. (A full listing can be found on his Web site, www.follmi.com). The two are also the founders of the organization HOPE (www.hope-organisation.com), which supports education throughout the world.

Born in India, **Tenzin Diskit Föllmi**, the daughter of Olivier and Danielle Föllmi, has studied in Tibet and India as well as in France. Passionate about photography, she was Olivier Föllmi's assistant for more than two months in Thailand, Burma, and Vietnam. Her charisma, her multicultural background, the versatility of her abilities, and her intimate knowledge of the Buddhist world have made Diskit an irreplaceable assistant. Diskit helped to establish contacts in the villages, set up the equipment, organize the photographs and their captions, handle the accounting, and organize the trips. Diskit speaks English, French, Hindi, Zanskari, Ladakhi, and Tibetan. She lives in India, in Ladakh, where she has built up the travel agency Dharma Voyages.

Born in Thailand, **Varunee Skaosang** (Noonie) was Olivier Föllmi's assistant for this book in Thailand, China, Vietnam, and Burma. With her passion for photography, her lively personality, her knowledge and respect for tradition, her capacity to adapt, and her indefatigable willpower, she could be entrusted with any task. Noonie assisted on the ground, took care of the logistics of the trips and the shootings, organized the photos, and sorted out the captions. Noonie, who has lived in the United States, speaks Thai, English, French, and Arabic, and presently lives in Bangkok.

Born in Yunnan, China, **Wen Yutao** (Jacky) was invaluable in this project for his great qualities of the heart, his open mind, and his indomitable spirit. A master communicator, he was Olivier Föllmi's assistant for this book in China, Thailand, and Burma, as well as assisting Noonie in the difficult tasks of climbing, portage, and organizing. In his free time, he led the photographers through the countryside and villages of the Yuanyang region. Jacky speaks three Chinese dialects as well as English, and lives in Yuanyang, Yunnan.

© V. Skaosang

Passionate about traveling all her life, journalist **Virginie de Borchgrave d'Altena** wrote all the captions for this book. After earning a degree in Latin philology from the Catholic university of Louvain in Belgium, she covered Asia for more than twenty years and has traveled the world incessantly since; her travel writings have been featured in many magazines, in Belgium and abroad.

Asia is the fifth volume in the art photography series Wisdom of Humanity. The series presents different cultures through photographs, philosophy, and spirituality as an homage to humanity.

This project started in 2003 and will last seven years. It was made possible by the generous support of:

an anonymous donor

Lotus & Yves Mahé

And the involvement of

FUJIFILM **Canon**

the photography laboratories

DUPON

as well as

TRAVELS

Wisdom of Humanity is made possible by sponsorship from

UNESCO

Under the patronage of UNESCO's Swiss Commission

Acknowledgments

So many kind and generous people helped me with this photographic project in Asia. I would like to give my deep thanks to all of them:

In Asia

CAMBODIA

Khon Sakhoeun, Seng Samoeurn and Yorn Malay, monks in Siem Reap as well as Fabienne and Benoît Ferir-Legrand.

CHINA

Yida Wang in Kunming; Laure Raibaut in Beijing; Lan Wang in Shanghai; Jacky Wen Yutao as well as Stary and family in Pugaolaozhai, and Hu Shi Zhong and Tang, Zhu Nan, and Liu Feng for their help; Lin Ke Zi and family in Xingping; Duji Kanzhu and family in Yongzhe; Dakpa Zhabagedan and Khampa Caravan as well as Anwularong and Kesang Gerongpichu in Zhongdian.

JAPAN

TOKYO: FUJIFILM and Mick Uranaka as well as Shin Yamaguchi from Knock on Wood, Sakata Masako and Amana Images, Kaoru Yunoki, Chie Jo, Hiroyuki Takahashi, Émilie de Cannart, and Ray and Diane Brook for their wise advice. Thanks also to Daniel Blade Olson and Keiko Yamada Olson in Kamakura for their warm welcome and generous help.

KOREA

The Venerable Do Young, the Venerable Popchin and the Venerable Kakchong at Haeinsa Buddhist College, as well as Kim Ji Yoon for their warm welcome.

LAOS

Olivier Planchon, director of the Centre Culturel Français and Émilie Huard, in Vientiane; Virada Sitthisak who opened the doors of Laos to me; Thongdy Siphanthong, as well as Tu, Sem, and family in Ban Nong Khiaw; Jason Smith; and Joy Ittihepphana.

MYANMAR

Stéphane Dovert, cultural advisor to the French Embassy in Yangon, and his wife Agnès, as well as Wah Wah Tin, Alicia Thouy, and Carine Blache; Raymond Imperiali, Massana Sandar Myint, and all the team at Kinnari Travels, plus Su Su in Yangon, who all made our travels possible, along with Swe Zin Oo, my wonderful guide and interpreter; Su Su in Amarapura, Phyu Phyu Lin in Bagan, and Maung Maung and his wife.

SINGAPORE

Didier and Marie-Claude Millet, for their trust and for having gotten me involved in the project *Thailand: Nine Days in the Kingdom*, and their marvelous team, including Tanya Asavatesanuphab, Laura Jeanne Global, and Melisa Teo.

THAILAND

BANGKOK: Mahar Pin Buddawiriyo, *mon kat* of the Intrararam temple for his openness and for his prayers; Laurent Aublin, French ambassador, and Madame Aublin for their help and advice; Rodolphe Imhoof, Swiss ambassador, for his warm and enthusiastic welcome; Aruna Adiceam and Rafaël Grynberg, at the Centre Culturel Français; Sitta Wangtarawut, martial arts master, and his student Saeng Sae Kee; Hasachai Boonnueng and Chanpen Boonwiparat, Borpit Nakapiw, Teera Uhpadee, Kamonpan Khonsongsaeng, Kong, and Wanchai for their excellent photographic assistance in Chiang Rai, as well as Thiwa Morpoku, Tanachot Uhphadee, Yuphin Saelee, Nattharicha Yoo-luemg, Wannaporn Weerawatpongsatorn, Wasinee Maryoe, Ditpong Maryoe, and Panawan Maryoe; Ekaphop Duangkha and Kiattisak Janepaii from the studio Creatimage for their photographic assistance; the team from Nex Studio for their photographic assistance; Pimchan Monthawornwang and Tharistree Thangmangmee—wonderful models—as well as Weerachai Saemongkol, Arisara Nammondee, Yawee Koedjuntuek, Wiboon Petritt, and of course Phyu Phyu; Bowki Ithtiraviwongse for advice; Yvan Van Outrive, Pitipat

Srichairat, Korakot Punlopruksa and Am in Bangkok; Wichit Yawichai and his wife in Nan for their support during the project *Thailand: Nine Days in the Kingdom*; Jatupat Sarikaputra for keen picture advice; Sampan Tosawang and Pitiphan Luenganantakul for their advice; Boonchai Heng for the original paintings in this book; Bernard Farkas and Henri Sallaz at Objectif; and special thanks to Maythee, Suwanna, Varunee, Pattama, and Pimpapa Skaosang, in Bangkok, for their trust and friendship.

VIETNAM

Ven Vân Chiêù in Tri Tôm; Ta Thuy Chi, calligrapher, and Trong Luu, painter, in Hanoi; Anh Tuan in Ho Chi Minh-City and Ho Ngoc Anh Tu in Vinh Long; Christian Chauvreau and his wife Thanh Thuy as well as Thong in Can Tho, who opened the door of the Mekong delta to me; Si in the village of Hau Thao; Ha; Phan Van Anh in the village of Lao Chai; Tinh Xan May; Chao No May in the village of Ta Phin; Hang Thi Chi and Cheo Su May in the village of Ta Van.

In Europe

Marie-Laure de Villepin, ambassadress of our project; Franck Portelance and FUJIFILM France for their trust and support; Madeleine Viviani, at UNESCO's Swiss Commission in Berne, for her invaluable support throughout this project; Jean-Pierre Boyer and Janine d'Artois in Paris at UNESCO's French Commission; Bruno Baudry, who gave us the wings we needed for this projct to take off; Pierre Bigorgne for his faithful support and constant enthusiasm; Jean-Marc and Deki Youdon Falcombello, Myriam Rossi, Michel and Hye Sook Herlemont, Matthieu Ricard, Raphaëlle Demandre, and

Jean-Michel Strobino for their friendship and generous advice; Lama Denys, Lama Lhundroup and Lama Sengye at the Institut Karmaling in Arvillard for their guidance on this project, as well as Bernard Montaud; Claude Levenson for friendship and advice; Corneille Jest, our precious adviser; Jean Sellier for guiding my geographical choices throughout this project; Bernard Gachet for his invaluable support and constant encouragement; Philippe Lavorel for his generosity and advice throughout this project; Stéphane Méron in Annecy for technical assistance; Matthias Huber, friend and publisher at Éditions Olizane in Geneva and a specialist on Asia, for his generous informed advice; Renaud Neuenbauer, our friend in Quito, Ecuador, and a specialist in the cultures of Asia, who guided me in the preparatory stages of this project; Jemel Giray Alyamak, and Richard Petit from Mondo Fragilis, for their support with the Offerings for Humanity project; André Capurro for his invaluable help, along with Philippe Roux, Magalie Madec, and Carine Malbosc from Orkis; Julia Summerton for her translation; Kitty Sabatier for her drawings and calligraphy.

PHOTOGRAPHIC ASSISTANCE IN ASIA

Tenzin Diskit, my assistant in Thailand, Myanmar, Laos, and Vietnam.

Varunee Skaosang, my assistant in Thailand, China, Vietnam, and Myanmar, and in charge of selection and logistics in Bangkok and France.

Jacky Wen Yutao, my second assistant and guide in Yunnan, China.

Lin Liao Yi, my guide in China.

Virada Sitthisak, my second assistant in Laos.

PHOTOGRAPHIC ASSISTANCE IN EUROPE

ATELIER FÖLLMI:

Viviane Bizien, Corinne Morvan-Sedik, Emmanuelle Courson, Stéphanie Ly, and Nicolas Pasquier, who provided the framework needed for the creation of this book.

Guy de Régibus, in Paris, for his detailed and discriminating selection of photos.

Virginie de Borchgrave, in Brussels, for editorial assistance and travel preparations.

Éditions de La Martinière: Emmanuelle Halkin and her team, Dominique Escartin and his team, Valérie Roland, and Marianne Lassandro and her team.

Articrom, in Milan: Elia Fumagalli, Carlo Fumagalli, Giancarlo Pinali, Elio Perego, Sara Scopel, and Sabrina Zorloni.

Special thanks to Hervé de La Martinière for his unswerving support and deep trust.

—Olivier Föllmi

Sources

Barthes, Roland. *Empire of Signs.* New York: Hill and Wang, 1983.

Claudel, Paul. *Knowing the East.* Princeton, NJ: Princeton University Press, 2004.

Gyaw Ma Ma Lay, Journal. *La Mal-Aimée.* Paris: L'Harmattan, 2000.

Lustgarten, Abrahm. *China's Great Train: Beijing's Drive West and the Campaign to Remake Tibet.* New York: Macmillan, 2008.

Ono-dit-Biot, Christophe. *Birmane.* Paris: Plon, 2007.

Segalen, Victor. *Stèles.* Middletown, CT: Wesleyan University Press, 2007.

White, Kenneth. *Scènes d'un monde flottant.* Bilingual ed., translated by Marie-Claude White. Paris: Grasset, 1983.

By the same author, in the same collection:

Latin America

Africa

India

Homage to the Himalayas

By the same publisher, in the collection Offerings for Humanity, with Danielle Föllmi:

Devotions: Wisdom from the Cradle of Civilization

Awakenings: Asian Wisdom for Every Day

Revelations: Latin American Wisdom for Every Day (also available in Spanish)

Origins: African Wisdom for Every Day

Wisdom: 365 Thoughts from Indian Masters

Offerings: Buddhist Wisdom for Every Day

www.follmi.com

Captions pp. 2–3, 90, and 132–33 ©2007 Plon, Paris

Caption p. 130 ©2000 L'Harmattan, Paris

Translated from the French by Krister Swartz

ENGLISH-LANGUAGE EDITION:

Magali Veillon, *Project Manager*

Miranda Ottewell, *Editor*

Shawn Dahl, *Designer*

Michelle Ishay and Neil Egan, *Jacket Design*

Jules Thomson, *Production Manager*

Library of Congress Cataloging-in-Publication Data
Föllmi, Olivier, 1958–
 [Asie. English]
 Asia / by Olivier Föllmi ; preface by José Frèches ; captions by Virginie de Borchgrave d'Altena ;
design by Benoît Nacci ; translated from the French by Krister Swartz.
 p. cm.
 ISBN 978-0-8109-7121-9
 1. Asia—Description and travel. 2. Asia—Pictorial works. I. Title.
 DS10.F65 2008
 950.022'2—dc22
 2008023804

Printed and bound in Italy
10 9 8 7 6 5 4 3 2 1

Abrams books are available at special discounts when purchased in quantity
for premiums and promotions as well as fundraising or educational use.
Special editions can also be created to specification. For details, contact
specialmarkets@hnabooks.com or the address below.

HNA ▪▪▪▪▪
harry n. abrams, inc.
a subsidiary of La Martinière Groupe

115 West 18th Street
New York, NY 10011
www.hnabooks.com